THE
COLLECTIONS
of the
BRITISH
MUSEUM

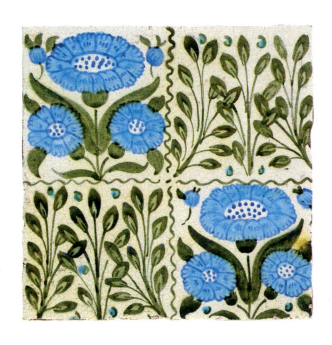

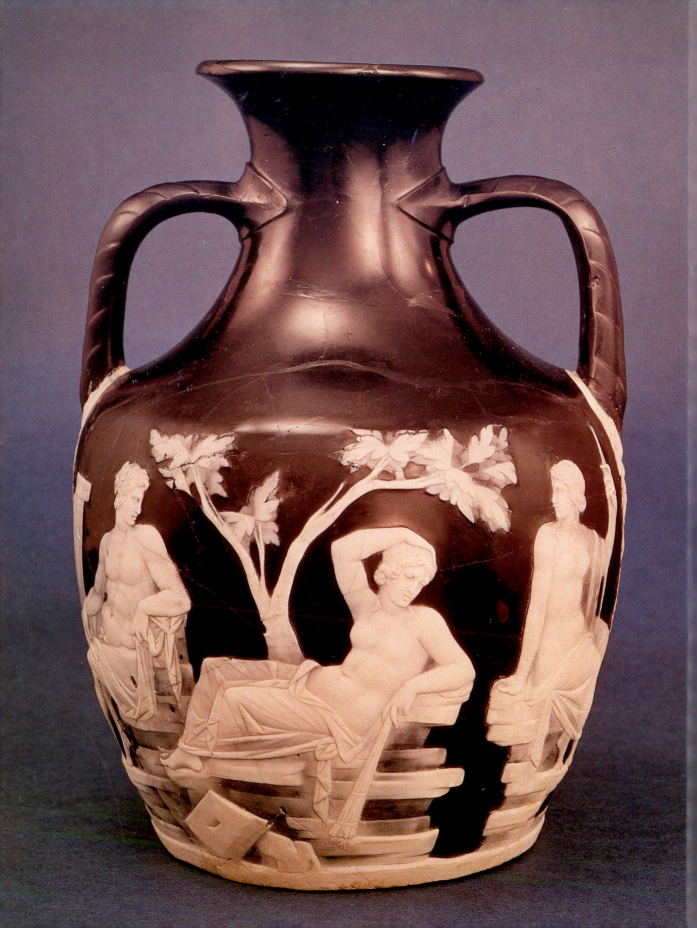

THE
COLLECTIONS
of the
BRITISH
MUSEUM

◆

EDITED BY
SIR DAVID M. WILSON

The right of the
University of Cambridge
to print and sell
all manner of books
was granted by
Henry VIII in 1534.
The University has printed
and published continuously
since 1584.

Cambridge University Press

Cambridge
New York Port Chester Melbourne Sydney

Published in North America by the Press Syndicate of the University of Cambridge
40 West 20th Street, New York, NY 10011, USA

© The Trustees of the British Museum

First published 1989

Printed in Italy

Library of Congress Cataloging-in-Publication Data

British Museum.
 The collections of the British Museum.

 Bibliography: p.
 Includes index.
 1. British Museum – Guide-books.
 I. Wilson, David McKenzie.
AM101.B85 1989 069'.09421'42 89-755
ISBN 0-521-37539-8 hard covers

CONTENTS

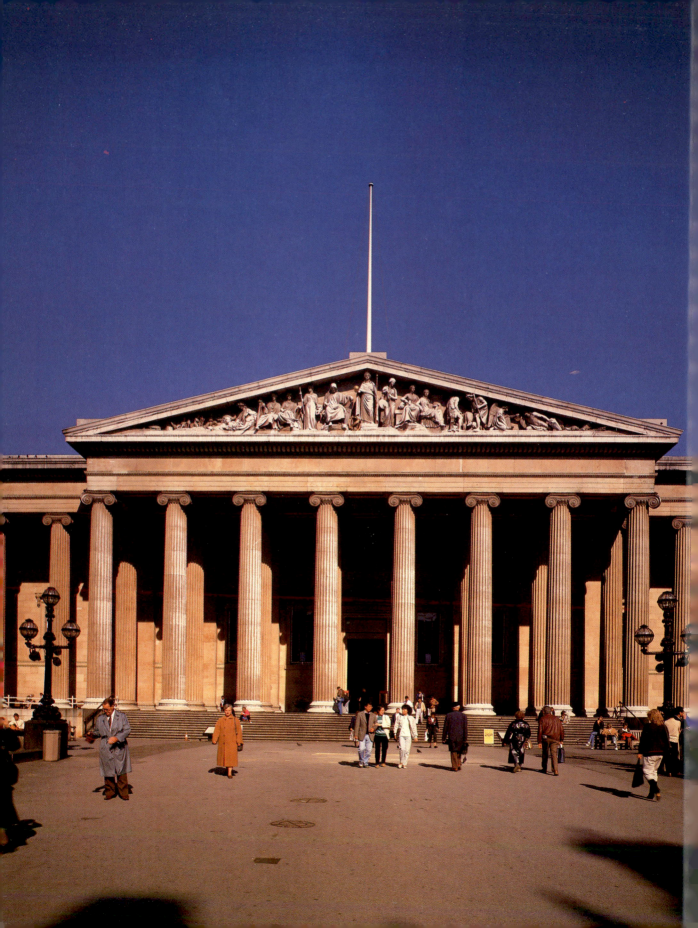

INTRODUCTION

◆

*T*he British Museum belies its name. It is not the national museum of Great Britain, although it is that too. Rather it is the museum of the cultures of the whole world. It was founded with this aim in the atmosphere of the universality of knowledge that was the true expression of the rationality of the eighteenth century. In 1753, inspired by the vision of its founder, the physician Sir Hans Sloane, the first Trustees dreamed of a great storehouse of knowledge – of books, of antiquities and of the products of nature – all under one roof open freely to the public, to the curious, to the learned. Attitudes and visions have shifted through the succeeding centuries and the physical constraints and demands of a growing collection have contributed to change and fission; but at base the Museum remains the universal institution that it always was. The two parts which have been separated out in the course of the last two centuries – the British Museum (Natural History) and the British Library – remain part of the original vision and have become very much part of the world intellectual scene.

The British Museum is not only an international institution, it is a building. Its great Greek Revival façade is almost the symbol of a museum. The architectural ambition and calculation of Sir Robert Smirke created between 1823 and 1850 both a vision and a symbol. The entrance through a massive portal, past strong iron gates, instils a sense of awe and security which enables the visitor to appreciate the treasures and the curiosities it houses not only as something it is a privilege to see, but also as something that is cared for on behalf of the whole world. In an age of popular culture it expresses to the visitor the sense of man's achievement in the material world by showing the art and artefacts themselves, not cluttering them with explanation in many languages and for many ages, but with information sufficient to provide the intelligent person of whatever age or nationality enjoyment, satisfaction, awe, or fulfilled curiosity at his own level: for the scholar, the registration number and find place; for the novice, a clue to the circumstances of its conception; for the curious, light and taste to see.

It is a vital and vibrant place, full of visitors at all times: in a good year as many as four million people, more than half of them from foreign countries, will visit the place. It is a home of scholarship: all the year round its Students Rooms rustle with scholarship, as students and researchers of all ages work in half a hundred languages on as many cultures. To its doors come those who seek an opinion on objects in their possession; a drawing that might be a Turner (but most often is not); a sherd of pottery found in a garden; a piece of carved bone (is it really medieval?); or, from the more knowledgeable, the urgent need to discuss whether an object was made in Kyoto or Nara, in Belize or Guatemala. The staff who answer these queries are often amongst the world's greatest experts in material culture and are themselves actively engaged in research. They excavate in Egypt or Iraq, they examine the culture of the Yemen or Borneo, they travel to sophisticated print-rooms to view rare drawings, or crouch over a computer terminal waiting for the results of a long series of radiocarbon dating experiments. They travel from Fiji to Nepal, from Sweden to Mexico; they work on objects made 400,000 years ago or objects made in this century. They publish their results in learned journals, in popular books or in monographs of heavy scholarship. The British Museum runs a publishing company to help in the dissemination of this knowledge; a company which not only publishes between thirty and forty books a year, but also handles the production and sale of replicas and souvenirs eagerly sought by the visitors in the shops.

There is an education department, a design department, a vast conservation complex which gives advice to colleagues throughout the world. There are restaurants and printing shops, carpenters and glaziers, architects and press officers, post rooms, secretaries and security guards. These last, the public face of the museum, are there to help as well as protect. Some of this large working population is invisible to the public, but all is essential to the proper functioning of this great international institution.

The Museum is structured around twelve departments. Two, Coins and Medals and Prints and Drawings, specialise in the materials contained in their title. Eight are titled for the cultures they study and display – Greek and Roman; Medieval and Later; Prehistoric and Romano-British; Western Asiatic; Egyptian; Oriental; Japanese; and Ethnography (which is temporarily out-housed as the Museum of Mankind in Burlington Gardens behind Piccadilly). Two departments

1 *The portico of the British Museum, perhaps the finest, and certainly the grandest Greek Revival building in Britain.*

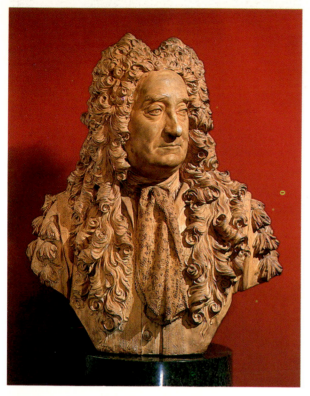

deal with material in a different fashion: the Research Laboratory, which works chiefly on the physical analysis of antiquities to determine their age, provenance, method of manufacture, genuiness or composition; and the Department of Conservation, which monitors the physical condition of the collections and, where possible, stabilises damaged or deteriorating objects or cleans material for display.

With nearly a hundred galleries in which to display the Museum's treasures it is inevitable that there will be a continuing programme of renewal. The basement and ground-floor galleries at Bloomsbury (with the exception of those presently occupied by the British Library) have been redesigned and their displays renewed in the course of the last twenty years, the most radical redisplay being the basement Wolfson Galleries which have brought back to the public sculpture of the Greek and Roman world that has often not been seen in context for hundreds of years.

A campaign of renewal has seen the opening of new galleries for South Italy, Cyprus, European jewellery, medieval art and antiquities, early medieval Europe and modern European and American applied art. A gallery of Islamic antiquities, a suite of Japanese galleries, a gallery of post-Renaissance European art and a gallery of Stone Age cultures are to be opened in the late eighties or early nineties, together with a number of other galleries which have been more or less unaltered since the Second World War. In the Museum of Mankind new galleries have been created and a series of splendid exhibitions have been built, which in their scale and execution often outshine the equivalent, if more prestigious, exhibitions held in Bloomsbury. Among the most notable were *Nomad and City* (treating of Arabs), *The Asante* and *The Living Arctic*. These established new standards of display and enabled the public to see material which, because of its fragility and sensitivity to light, can only rarely be exhibited. Here were reconstructed streets, rivers and palaces, sometimes even with the smells (at least the more pleasant smells) associated with them. One of these exhibitions, for example, which reconstructed part of a Gujarati village, later travelled to Leicester, enabling the local Asian community to provide their children with a taste of their original homeland.

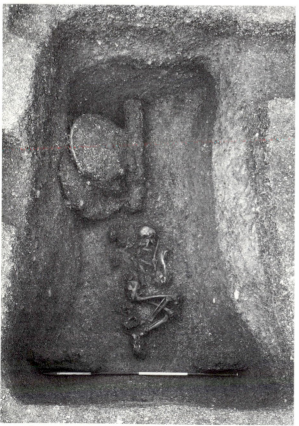

3 *Excavation is one of the Museum's core activities. The Iron Age chariot burial from Garton-on-the-Wolds, Yorkshire, was one of a number excavated by the Museum in the 1980s. It is dated to the first century* BC.

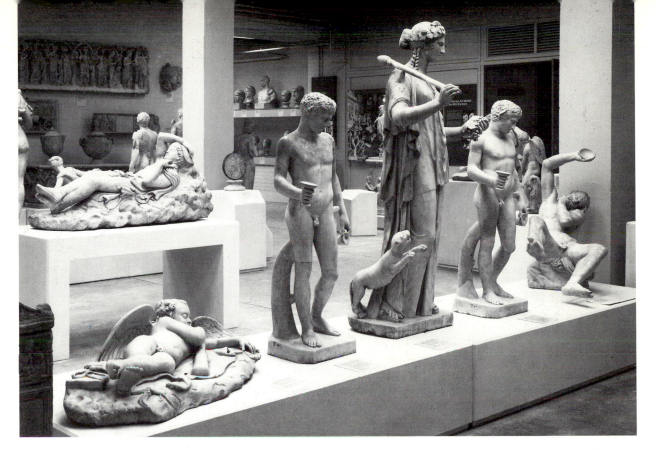

4 *The Townley Collection of classical sculpture, formed in the late eighteenth century, greatly influenced English taste for classical art. It is now newly housed in the Wolfson Galleries, brought together for the first time for many years.*

In the main building the Museum provides a series of special exhibitions which have stimulated the public taste and entertained our visitors for a quarter of a century. Here was seen the first exhibition of Tutankhamun to be shown outside Egypt, an exhibition which broke all records in visitor numbers. Here was created the great *Vikings* exhibition and the exhibition of Rubens' drawings which drew more crowds even than Turner. But other exhibitions have been as beautiful or as influential – exhibitions of Roman glass, of English banknotes, of heraldry, of medals, of the treasures of San Marco in Venice, of Chinese ivories, of modern Japanese prints, of German Expressionism, of Raphael, Dürer and Hollar; exhibitions which have celebrated events like the Olympic Games, the appearance of Halley's Comet, a century of English exploration of Egyptian antiquities, forty years of archaeology in Britain or the restoration programme of the Acropolis. Others have explained Buddhism, adventured into Tibet, displayed Thracian treasures, shown material from the frozen tombs of the central Soviet Union or examined the French provincial landscape through drawings.

Many of these exhibitions have been created round material in our own collections. The manuscripts of the British Library and the jewellery and sculpture of the British Museum were the core and inspiration of an exhibition of tenth-century English art which drew on collections as widely dispersed as Cleveland, Ohio, and Stockholm. Through the expertise of the Museum's curators it is possible – although often hideously expensive – to create such exhibitions which, long after they have closed, remain through their associated publications and seminars a potent force in the development of scholarship. More than twenty books, for example, were written or reprinted as a result of *The Vikings* exhibition, some of them of lasting scholarly value. The uninformed cannot begin to estimate the added value of shows which they come to admire. But the Museum rarely mounts an exhibition without regard to its academic potential.

At the same time it must be emphasised that the Museum is not selfish with its treasures. It is often accused of hoarding, but those who delight in reading the fine print of official reports will realise how much is loaned to exhibitions outside its walls. Few acknowledge the whole exhibitions which are lent at some expense by the Museum to provincial centres. But, for example, between 1984 and 1987 the Museum lent complete exhibitions to thirty-four centres in the British Isles on subjects as diverse as the Gujarati village mentioned above, to the caricatures of James

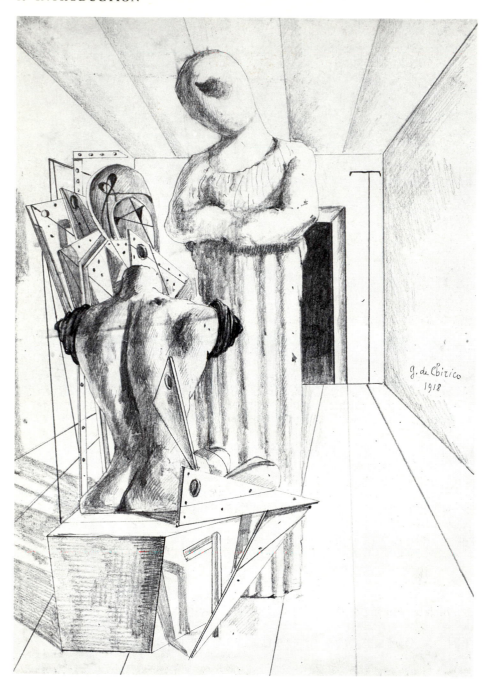

5 *The Museum does not concentrate exclusively on ancient material. It has always collected objects of recent manufacture or production. Here a pencil drawing,* Figure Metafisiche *by Giorgio de Chirico (1888–1978), executed in 1918 and acquired in 1982.*

Gillray, from Buddhist sculpture to modern German prints. In the same period individual objects or groups of material were willingly lent to some 180 exhibitions in Britain alone, and to a similar number abroad. *The Asante* was one of the rare instances where a complete exhibition has been lent to the United States. The over-riding importance of the British Museum's collections is well evidenced by the loan of a large exhibition of Japanese prints of the Ukiyoe period to three centres in Japan itself during 1985.

The Museum's large holdings of foreign material from time to time occasion demands for the return of some of the more important objects to their country of origin. Indeed, it is not unknown for local patriotism in Britain to lead to campaigns which demand the return of 'treasures' to provincial museums in this country. In relation to the latter it should be said that such demands are usually inspired by people outside the museum profession who do not understand the measure of the British Museum's co-operation with local museums –

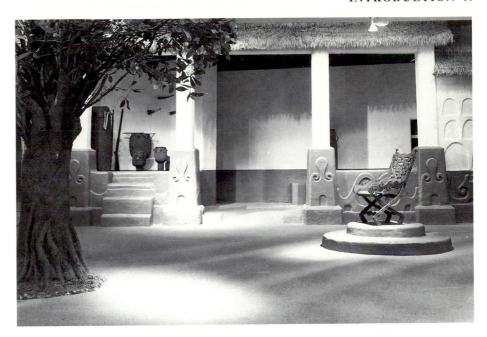

6 *Exhibitions by the Department of Ethnography in the Museum of Mankind have set new standards. Here the reconstruction of the entrance to an Asante palace provides a realistic experience of life in Ghana at the end of the nineteenth century.*

co-operation which results in such important services as the loans just mentioned, but also specialist advice, technical help and indeed help in steering gifts and purchases in their direction. When the famous Warwick Vase, for example, was being sold it was the British Museum which encouraged the Trustees of the Burrell Collection in Glasgow in their successful attempt to purchase it.

When we do acquire British material it is normally only accessed by agreement with the local museums, often after the Museum has expended a considerable amount of money on excavation, conservation and publication. The Museum occasionally acts as a safety net to prevent material being lost and occasionally attempts to acquire national material of a kind unrepresented in our collections so that it can be seen by the maximum number of people in the circumstances uniquely provided by a comparative museum. The Museum has a collecting policy which tries hard not to cut across local British interests.

International claims for the return of objects are becoming more clamorous and headline-catching. Rarely, again, are such campaigns led by professional museum people; indeed, the motives for such demands are often mixed. The commonest cause is nationalism – real or imagined. It is not unknown, for example, for a country to claim an object which was found outside its borders. In other cases a country claims all the objects owned by the British Museum from within its boundaries. The most emotive claim at the moment concerns the Parthenon sculptures, which the Museum has held since 1816. The Museum's position in this matter has often been stated and receives general support, namely that we are a storehouse of the world's treasures –

unique and useful. We will not return any material which we legally own: if we did, demands would increase and one of the greatest museums of comparative culture in the world would be destroyed for narrow nationalistic purposes: an ironic outcome in an age of internationalism.

As a footnote, it cannot be too strongly stressed that the Museum's Trustees have a strict policy of never acquiring material which has left its country of origin illegally. The Museum has often assisted international authorities in the return of such material. It respects the antiquities laws of other countries and applies the strictest standards in dealing with every foreign object it acquires.

The Museum is sensible of the fact that the building housing its collections is one of the world's great monuments and the Trustees do their best to treat it with the respect that it deserves. It is a grand Greek Revival building, perhaps the finest in the country, and it was purpose-built to house a museum, replacing the grand gentleman's residence (Montagu House) which became inadequate for museum purposes. Over the years taste has changed and the use to which a museum is put has changed. The three or four million people who visit the British Museum each year have taken the place of a tenth of that number who visited the museum when the main building was opened to the public in the middle of the last century. Electric light has been invented, as has photography – both having considerable application to the work of a museum. New paints, new fabrics and new materials have been developed and have tempted museum curators to adventure into new methods of display. At various periods new colours, new furniture, new mounts have been introduced into

the Museum; skylights have been blacked out or removed, bombs have damaged the structure and have tempted architects to an excess of modern enthusiasm (look at the ceiling in the Greek and Roman Life room).

A museum is, however, a place in which objects are kept safe and displayed in a manner which will do them no harm. Change is inevitable as we understand more clearly the need to respect objects in regard to their environment. It is also correct that, as new techniques and materials become available, curators should experiment with new methods of mounting and display. Spot-lights, darkened rooms, carpeted floors have all been used with varying success in the British Museum, as in every other museum. When Smirke designed the British Museum he was working with light and shade, with plain paints of light colour to match or blend with the Portland Stone façade. There was to be no artificial light and all the floors were of stone or hardwood. Soon after he retired from the job of architect contemporary taste changed and bold colours, reds, blues and golds, were introduced into the decorative scheme. These

were later succeeded by blush colours and creams. The Trustees' present aim is to provide a neutral background in the manner of Smirke and in keeping with the architecture: to return as far as possible to the use of daylight, blended (we hope skilfully) with artificial light. The floors in the upper galleries are carpeted as a protection against noise and against wear caused by millions of feet every year. But we are trying to restore the ceilings and rooflights as best we can, removing excrescences which have been added over the years. In some instances (in the Prints and Drawings gallery for example) light must be kept low to protect fragile colours and materials. In some areas galleries have been created by the infill of empty space and the architecturally rather inelegant galleries which resulted (the Nimrud ivory room, for example) have been redesigned as unobtrusively as possible.

As technology has advanced, the form of display cases has altered. In only one room in the Museum (73) have we preserved, deliberately, the original Smirke wall-cases. They are undistinguished and inefficient, but we owe a duty to posterity to keep them. But the Museum must not become a museum of itself. Present-day conservation demands a great deal of a display so that objects will not fade, become too dry or too wet, be too hot or too cold. So conservators must control the environment in the show-cases and check the materials used to see that they do not affect the antiquities. A

7 The sculpture with the pediment of the Museum's portico, by Richard Westmacott, represents Man emerging from savagery through the influence of Religion. The composition terminates with a group of animals representing Natural History.

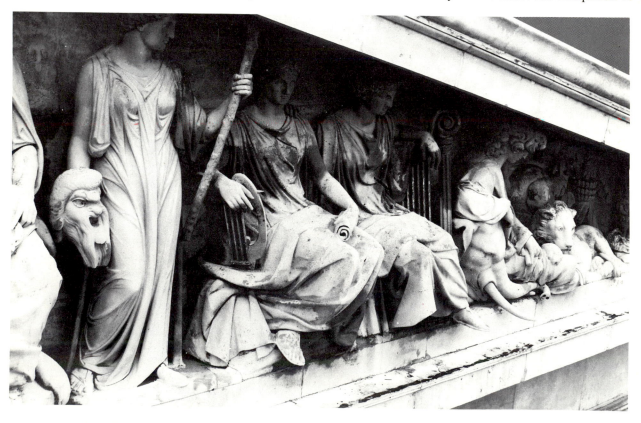

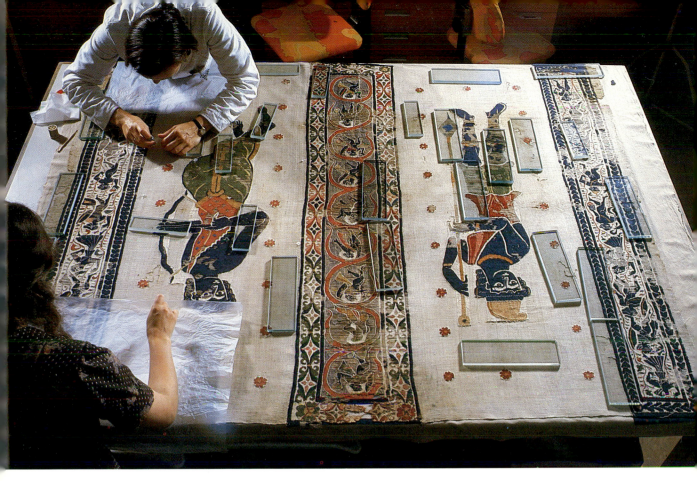

8 *Working on a Coptic textile. The care and careful conservation of the objects in the collection is a major element of the work of the Museum. Scientific research in this field is also carried out in order to back manual dexterity. See also 105.*

stability of atmosphere is now attainable that was impossible only fifty years ago, consequently the new galleries have pleasantly designed inoffensive showcases, which present the material to the visitor in as near a stable environment as is possible. Labels and information panels are kept to the minimum, the scholar and the general visitor can thus be informed and stimulated to further reading or research. It would be impossible to have multilingual labels, so we sell cheap, multilingual guides.

Only in the Museum of Mankind does the design take over from the architecture. This building was originally the Senate House of the University of London: it was not built as a museum. Here more dramatic displays are possible and, because the nature of much of the material makes it undesirable to have it on display for long periods of time, objects are shown for a short time in reconstructions of their original environment, be it an Inuit encampment, or a Madagascan cemetery.

The Museum is governed by a body of Trustees who act truly in the sense of that title, protecting it from ephemeral media pressure and political clamour. The Trustees are not fuddy-duddy; they are genuinely interested in advancing the interests of the Museum, its collections and its public usage. Nor do they function simply as a rubber stamp: they help to raise money for projects which cannot be funded by government (the Museum's main running costs are largely met by the State) and lay down policies of acquisition, display and image in consultation with the professional staff of the Museum. Without the protecting and caring interest of the series of most distinguished members of the Board of Trustees, the British Museum would be a much poorer place than it is to-day. The Museum is buffeted from time to time by uninformed clamour and it needs the backing of such powerful figures, as it needs the support of its friends, made formal in that most supportive of institutions, the British Museum Society.

A museum is not a dead institution and anyone who accuses the British Museum of being dusty and boring is either ignorant or lacks a soul. The British Museum is full of life. To hundreds of thousands of school-children it each year provides a sense of adventure; to millions of tourists and visitors it brings a sense of renewal, and to thousands of scholars a deep well of knowledge. It belongs to the whole world and is kept secure for all mankind.

THE CLASSICAL COLLECTIONS

*T*he collections in the Department of Greek and Roman Antiquities range in date from the beginning of the Bronze Age in Greek lands about 3200 BC to the establishment of Christianity as the official religion of the Roman Empire by the Edict of Milan in AD 313. The Greek material comes not only from the Greek mainland and the islands of the Aegean, but also from many lands around the Mediterranean, including Asia Minor and Egypt in the east and the Italian peninsula and Sicily in the west. Some non-Greek eastern cultures, in particular those of Cyprus, Lycia and Caria, are also represented. The collection of material from the native cultures of Italy, including the Etruscans, begins in the early Bronze Age. There is little material from the Roman Republic, but later the whole of the Roman Empire except for Britain falls within the scope of the Department.

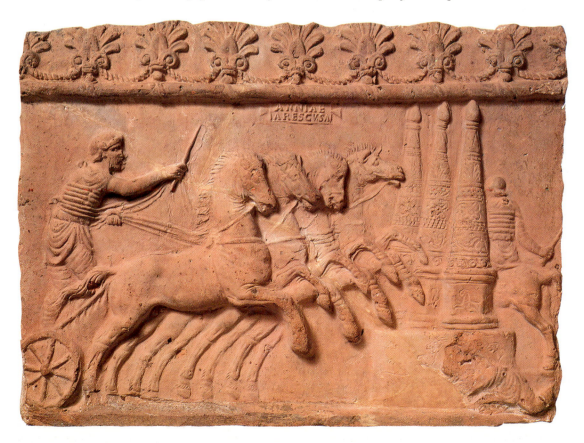

9 Terracotta relief. A four-horse racing chariot approaches the three columns of the turning-post. A jubilator (rider who encouraged the contestants) has already turned. First century AD. H 30cm.

THE GREEK BRONZE AGE

The Greek Bronze Age, so called because bronze gradually replaced stone as the material most commonly used for tools and weapons, began in about 3200 BC. During the Early Bronze Age (*c.* 3200–2000 BC) the Cyclades, in the middle of the Aegean Sea, were the home of a flourishing and influential culture. Perhaps the most characteristic products of this culture are Cycladic figurines. Carved from local marble, these naked female figures with tranquilly folded arms exhibit a simplicity of form and purity of line which make them most attractive to the modern eye. Fine examples were brought to the Museum by J. T. Bent, who excavated in the Cyclades in the 1880s and whose finds, including pottery and stone vessels, form the core of the Museum's Cycladic collection.

Towards the beginning of the Middle Bronze Age (*c.* 2000 BC) the Cycladic islands came ever more under the growing influence of Minoan Crete. The palaces of Crete were established in about 1900 BC, and it was the largest and most important of these that Sir Arthur Evans discovered when he began his excavations at Knossos. He revealed an elaborate, multi-storeyed and richly decorated building that he called the 'Palace of Minos', naming it after the legendary King of Crete. The large Minoan 'pithos' (storage jar) in the British Museum came from an early excavation at the palace, before Evans began work there.

Minoan artistry and craftsmanship reached high levels of achievement, and the British Museum's collections include fine pottery and bronzes. Notable is a bronze group of an athlete leaping over the back of a bull. The miniature art of gem-engraving was particularly skilfully practised, and both Minoan and Mycenaean seals of high quality are preserved in the Museum. Minoan jewellery is represented particularly by the Aegina Treasure. Found on the island of Aegina, this jewellery is actually of Minoan craftsmanship, dating from about 1700–1500 BC. It includes four remarkably large and elaborate ear-rings, a pendant showing a nature god, and a variety of other ornaments.

The Late Bronze Age, beginning about 1550 BC, saw Crete in a position of considerable influence in the Aegean world. The Mycenaean civilisation of the Greek mainland, centred on the citadel of Mycenae, was beginning to come to prominence and felt this influence strongly. While indebted to Crete in artistic matters, however, the Mycenaeans were more warlike, and were destined to take over Crete's dominant position.

Amongst the most impressive remains of the Mycenaean civilisation are the tholos tombs. 'Tholos' is the Greek word for a circular building, and these large, stone-built, domed tombs were circular in plan. Probably the finest example is the so-called 'Treasury

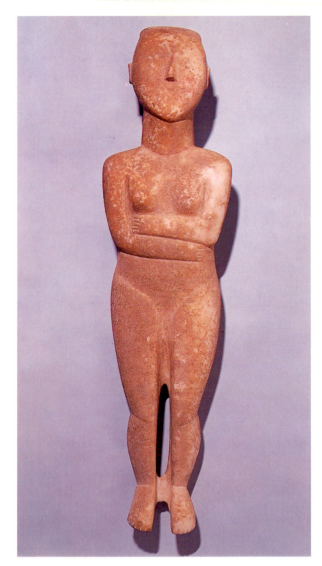

10 *Marble Cycladic figurine with traces of black and red painted decoration. Such figurines, usually found in graves, perhaps represented their owners, or may have been representations of a goddess, possibly connected with fertility. About 2800–2300 BC. H 76.8cm.*

of Atreus' at Mycenae, which dates from about 1350–1250 BC. Special features of this tomb included the elaborately decorated façade, and the British Museum contains sections of two carved pillars which flanked the doorway, as well as fragments of green and red decorative marble slabs which originally faced the triangular space above the door lintel.

During the fourteenth and thirteenth centuries BC civilisation became remarkably uniform throughout the Aegean, as colonisation and trade extended Mycenaean culture over a large part of the Greek mainland, Crete

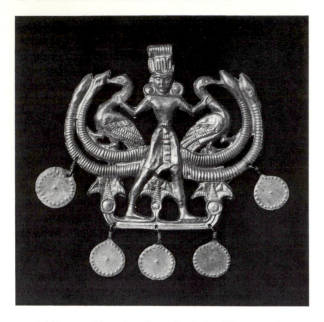

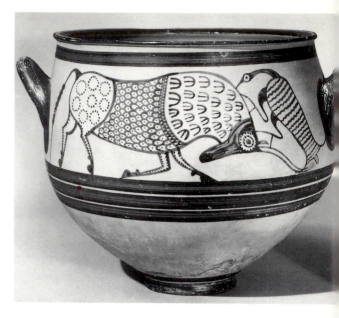

11 *A Minoan gold pendant from the Aegina Treasure. A nature god, the 'Master of Animals', is shown holding two geese. He stands amongst lotus flowers, an indication of Egyptian influence. About 1700–1500 BC. H 6cm.*

12 *A pottery bowl found at Enkomi in Cyprus, decorated with a bull and a bird, perhaps removing a tick from its hide. The vase is typical of Mycenaean pottery imported into Cyprus. About 1300–1200 BC. H 27.2cm.*

and the islands. Much of the Mycenaean material in the British Museum comes from tombs at Ialysos on Rhodes, which produced pottery, bronzes, jewellery, weapons and ivories. Further fine Mycenaean pottery came from excavations in Cyprus: a result of Mycenaean trade with that island, where pictorial vases, and particularly those showing chariot scenes, were popular.

In about 1100 BC, after a century of warfare and disruption, Mycenaean civilisation came to an end. The following Dark Age (*c.* 1100–900 BC) was a period of depopulation, poverty and isolation in many parts of Greece, and most of the arts and crafts of the Bronze Age were forgotten. Though some areas remained relatively prosperous, in general archaeological finds of the period are few. However, pottery continued to be made, and its continuous development can be traced in the British Museum's collections.

The Geometric period (*c.* 900–700 BC) saw Greece gradually emerging from the Dark Age, and by late Geometric times (*c.* 760–700 BC) this process was well advanced. The British Museum's late Geometric pottery includes vases with figured scenes. Particularly interesting is a large krater (mixing bowl) showing a man and a woman beside an oared ship. This may be an early representation of Greek myth, perhaps showing Theseus and Ariadne. Small votive bronzes of the Geometric period are well represented, while luxury

objects can be seen in the Elgin jewellery. By the end of the Geometric period the Greek renaissance was complete, and the stage set for the achievements of the Archaic and Classical periods.

THE GREEKS: ORIENTALISING TO HELLENISTIC

In Greece the eighth and seventh centuries BC are often described as the Orientalising period, because the major advances in Greek culture at this time were the result of contact with great eastern civilisations, such as Syria, Phoenicia and Egypt. Making contact with the east through trade and colonisation, the Greeks learned new techniques of metalworking and ivory-carving, and new decorative motifs, including floral patterns, lions and fantastic animals like griffins, sphinxes and sirens. Many of these motifs appear on the gold and electrum plaques found in tombs at Camirus on the island of Rhodes; they were worn in rows, strung across the chest and fastened to the garment at the shoulders. Eastern models were modified and adapted by Greek artists, and gradually the linear formality of the old Geometric tradition was dissolved into a new and less restricted style of art. This process may be observed very clearly on the painted vases of the period, especially those of Corinth, where a delicate, miniaturist style ('Protocorinthian') was developed to decorate tiny perfume flasks

and bottles, often no more than 5 or 6 cm high. At first the animal and human figures in these intricate scenes were shown in pure silhouette, or occasionally in outline, but as time went on details were incised through the silhouette with a sharp engraving tool, and so the 'black-figure' technique was born; this technique was to dominate the decoration of painted vases throughout Greece until about 530 BC. A perfect example of the developed Protocorinthian style is the Macmillan Aryballos, named after a Mr Malcolm Macmillan, who is said to have bought the vase on the platform of Corinth station, giving it to the Museum in 1889. Less than 7 cm high, this perfume pot, with its beautifully modelled lion-head mouth, bears three friezes of decoration: a battle scene with eighteen fully equipped warriors, a horse-race and a hare-hunt, all rendered in immaculate detail.

In the Archaic period of Greek art, the sixth century BC, the techniques learned in the Orientalising period were refined and developed. The sixth century saw the emergence of distinct regional styles in the minor arts,

alongside the rise of monumental sculpture and architecture.

During the sixth century the inspiration of the Corinthian vase-painters began to flag, and vase after vase carried the same friezes of animals prowling nose to tail through thickets of blob-like filling ornament; Athens now became the centre for the production of painted pottery. The Sophilos Dinos, made in Athens around 570 BC, is a bowl and stand designed to hold wine at a feast, and while the lower registers of the bowl, and the whole of the stand, are occupied by Corinthian-like animals, the upper frieze has a mythological, and appropriately festive subject, the arrival of guests at the wedding of Peleus and Thetis. Peleus stands at the door of his house, to receive the gods, goddesses, nymphs, Muses and others, who arrive either by chariot or on foot. Garments, chariots, harness, even horses' manes and tails, are shown in minute detail, and to aid identification and enhance the decorative effect of the whole, the names of all participants are written up beside them.

As the sixth century wore on the black-figure technique grew to perfection in Athens. In Rhodes and the coastal cities of Asia Minor a more relaxed and decorative animal style was favoured, but in Athens it was the human figure, in both mythological and everyday contexts, which absorbed the artists' attention. Two of the finest were Exekias and the Amasis Painter, both artists

13 *Detail from the Sophilos Dinos. Guests arrive for the wedding of Peleus and Thetis. The centaur Cheiron brings game; Hebe and Dionysos follow Leto and Chariklo, goddesses associated with marriage. About 570 BC. H (frieze) 8cm.*

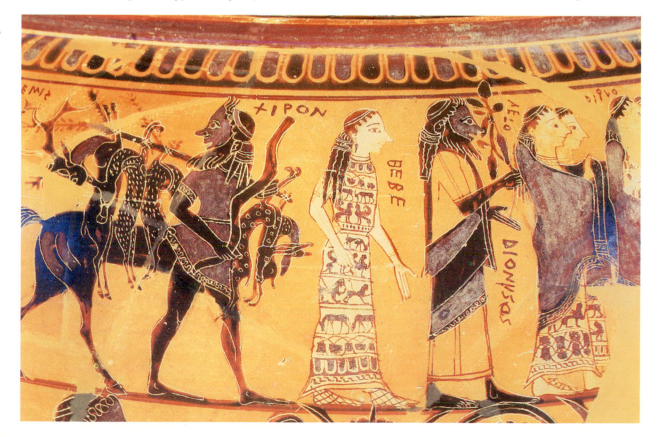

of enormous precision and imagination, sympathetic describers of the human form, past masters at the art of fitting their designs to the rounded surfaces of their pots.

Most of the British Museum's collection of Greek vases, bronzes and terracottas comes from Greek and Etruscan tombs, but some of it was found in sanctuaries. In the comparatively humble sanctuaries of Naucratis, a Greek trading port in the Nile Delta, were found vases, terracottas, bronzes and limestone statuettes which vividly illustrate the cosmopolitan life of a community in contact with Egypt, Cyprus and most parts of the Greek world; of very immediate appeal are the graffiti scratched on some of the pots, showing they were offerings made to the gods by named individuals. On a much more sumptuous scale was the sanctuary of Artemis at Ephesus, where, as we shall see, the first large-scale temple was built in the sixth century BC, with the financial support of King Croesus of Lydia. In

the foundations of this temple was found the earliest known coin hoard, along with a votive deposit of small objects in gold, electrum, bronze and ivory – mostly articles of personal adornment offered as gifts to the goddess.

Wealthy visitors to sanctuaries dedicated statues in bronze or marble, usually, in the Archaic period, *kouroi* (naked youths, standing stiffly with one leg slightly forward and their hands by their sides) and *korai* (girls in similar pose, usually dressed in elaborately draped and patterned garments). At the oracular sanctuary of Apollo at Didyma, however, the preferred type of dedication was a seated figure, possibly a representation of the donor. Twelve of these seated figures, who formerly lined the route of the Sacred Way leading from the sea to the temple, are now in the British Museum. Even in their weathered state these statues still evoke the characteristics of Archaic east Greek sculpture, with its massive, smoothly rounded forms, punctuated and articulated by crisp, precisely cut fold-lines of drapery.

Around 530 BC the 'red-figure' technique of vase-painting was invented at Athens. On a red-figured vase the figures are left in the reddish colour of the clay, while the background is filled in with black glaze, and

14 Detail from an Athenian red-figured stamnos (jar). Odysseus passes the Sirens' island. Odysseus has plugged his crew's ears with wax, and is himself bound to the mast so that he can hear the Sirens' alluring song with impunity. 480–470 BC.

14

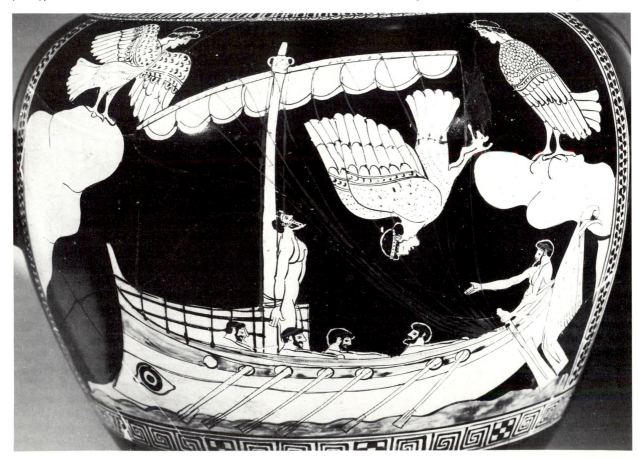

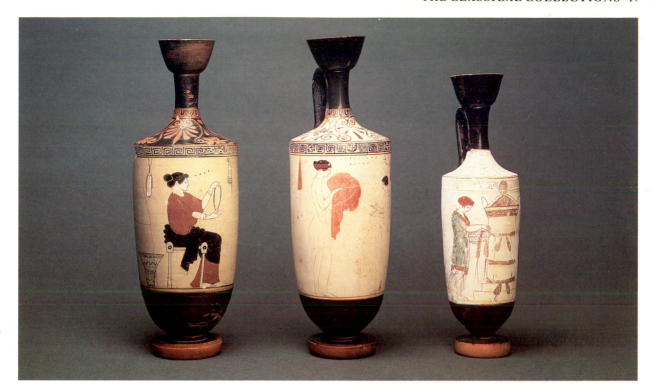

15 ABOVE *Three white-ground lekythoi (oil flasks), showing the development of technique and style between about 460 and 400 BC; the white slip grows whiter and the range of colours expands to include blue, green, and violet. H (tallest, centre) 36.3cm.*

inner details are painted in in glaze. Black-figured vases continued to be made for many years, but most enterprising painters switched to the new technique. Some of the first, like Epiktetos, were equally fluent in both techniques, and would sometimes combine them on one vase. At much the same time the white-ground technique was pioneered. This involved applying a thin layer of white clay to the surface of a vase, on which figures could be drawn partly in outline and partly with washes of colour. Between about 500 and 480 BC the finest red-figure vases ever produced were made by such artists as the Berlin and Kleophrades Painters. As the century wore on, the red-figure style became looser and more florid, as seen in the elaborate creations of the Meidias Painter, working around 420–400 BC. Throughout the century on red-figured vases a wide variety of subjects drawn from both daily life and mythology appear. On white-ground vases the range

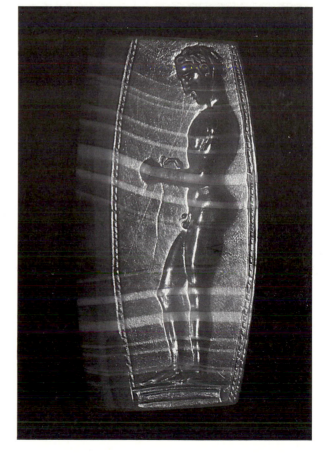

16 RIGHT *Agate sealstone showing a boxer binding thongs around his wrists. Many sealstones were originally set in rings. They were both worn as jewellery and used to mark and seal their owners' property. Greek, 450–400 BC. H 2.2cm.*

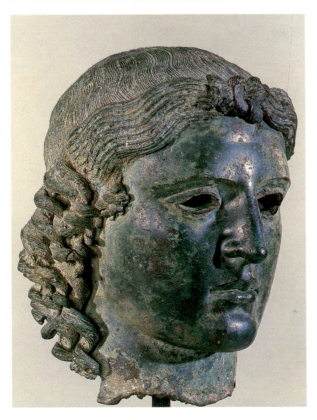

17 ABOVE *The Chatsworth Head, perhaps a representation of the god Apollo. The finest Classical sculptures were of bronze, but very few survive intact, since most were melted down in antiquity. From Cyprus, about 470–460 BC. H 31.6cm.*

was more limited. The commonest white-ground shape was the lekythos, designed to hold perfumed oil offered as a gift to the dead, and this function is often reflected in its iconography, which may show two people parting, or a woman engaged in the domestic pursuits which no longer concern her after death.

Many other minor arts, including the manufacture of terracotta plaques and figurines, the casting of bronze statuettes, and the engraving of sealstones, flourished at Athens and elsewhere in Greece during the Archaic and Classical periods. But throughout antiquity the most highly regarded branch of art was sculpture. A rare surviving bronze example of the earlier Classical style is the Chatsworth Head, an over-life-size head, perhaps from a statue of Apollo, found in Cyprus in 1836 and preserved for many years at Chatsworth House in Derbyshire. The eyes were originally inlaid, probably in glass and marble, the curly locks of hair cast separately and attached.

The finest extant Classical sculpture in marble is that of the Parthenon, the great Doric temple of Athena on the Acropolis at Athens, built and decorated between

447 and 432 BC. The architect of the temple was Iktinos, and the artist whose name is associated with the sculptural decoration is Pheidias. Pheidias' exact role is uncertain: he very probably worked on the gold and ivory cult statue of the goddess, and he may also have had some say in the overall conception of the sculptural programme. This was basically in three parts. At the east and west ends the pediments were filled with groups carved in the round. Above the columns of the colonnade on all four sides was a Doric frieze of panels carved in high relief (metopes), alternating with vertically grooved blocks (triglyphs). Over the inner porches this arrangement was replaced by a continuous Ionic

18 RIGHT *A metope from the Parthenon. The wounded centaur tries to flee, but the Lapith restrains him with one hand, drawing back the other to deliver the final blow. Straining apart, the two figures are drawn back together by their struggle and by the Lapith's magnificent cloak. 447–432 BC. H 1.34m.*

19 BELOW *Three figures from the east pediment of the Parthenon, perhaps Hestia, goddess of the hearth, Aphrodite, goddess of love, and her mother, Dione. 447–432 BC. L (group) 3.15m.*

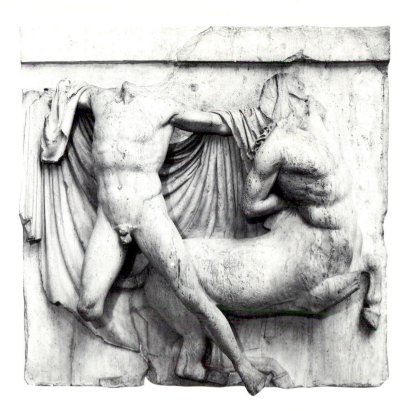

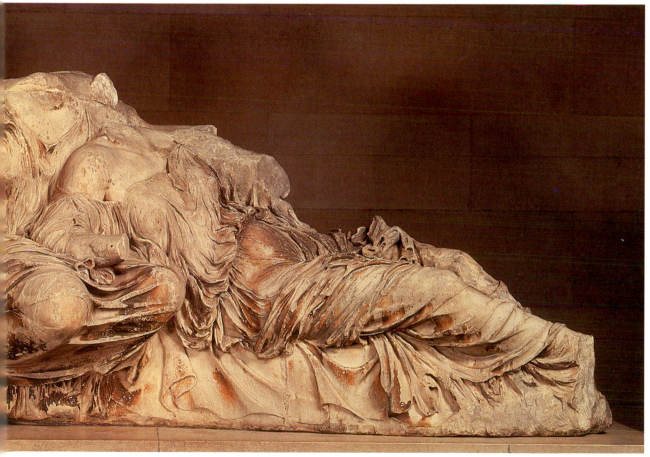

frieze carved in low relief. This extended down the sides of the inner building to form an uninterrupted band around it, below the ceiling of the colonnade.

The Parthenon was designed to glorify Athena, goddess of the city. It was a replacement for a temple which had been unfinished when the Acropolis was sacked by the Persians in 480 BC, before their decisive expulsion from Greece in 479. The subject matter of the Parthenon sculptures reflects both the idea of the triumphs of civilisation over the barbarian, and the self-conscious pride of Athens in the leading role she had played during the Persian wars and subsequently. The metopes were carved with such traditional heroic themes as the battle of gods and giants, the struggles between Greeks and Amazons, Greeks and centaurs, or the sack of Troy. While these subjects showed the triumphs of civilisation, the pedimental compositions were more specifically Athenian. At the west end Poseidon and Athena were represented competing for control of Attica, Poseidon striking the rock with his

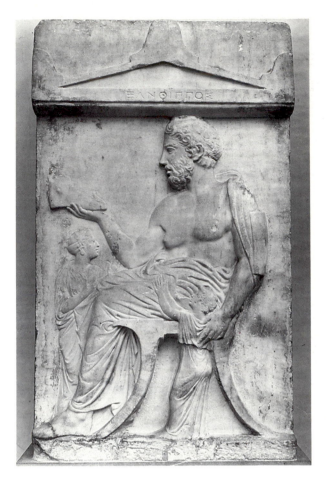

20 RIGHT *Athenian grave stele of Xanthippos. Seated on an elegant chair, Xanthippos holds up a model of a foot, perhaps a last, suggesting he was a shoe-maker. His two daughters are shown as miniature adults. About 430 BC. H 83.3cm.*

21 BELOW *Detail of the frieze of the temple of Apollo at Bassae, showing the battle between Greeks and Amazons, a subject of perennial appeal for the Greeks, who may have felt it reflected their victories in the Persian Wars. About 410–400 BC. H 64.2cm.*

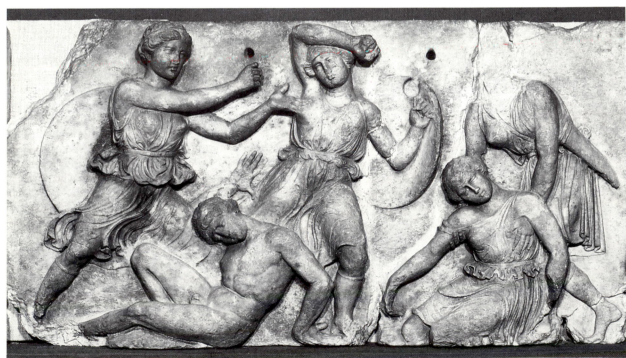

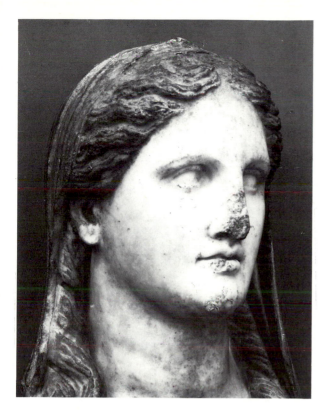

22 Marble head of Demeter from Cnidus. The mantle drawn up over her head like a veil recalls the myth of Demeter mourning the loss of her daughter Persephone, abducted by Hades, god of the Underworld. About 330 BC. W (face) 14.5cm.

Amongst the antiquities from the Athenian Acropolis shipped back to England by Lord Elgin were frieze blocks from the temple of Athena Nike (Wingless Victory), depicting battle scenes, and architectural members and sculpture from the Erechtheion. This temple, which housed the cults of, amongst others, Poseidon and Erechtheus, besides the ancient olive-wood statue of Athena, was completed in 408 BC. By then Athens was losing the Peloponnesian War to Sparta and her allies, and the pride and confidence which had characterised the building of the Parthenon was giving way to a mood of retrospective nostalgia. Traces of this may be detected in the Caryatid from the Erechtheion's north porch: one of six, with her archaic stance, formally patterned drapery and flowing hair, she is slightly archaising in style, recalling the earlier statues of *korai*.

There are, however, no traces of nostalgia detectable in the sculptured frieze from the temple of Apollo at Bassae in Arcadia, built between about 430 and 400 BC. Like the Parthenon, the Doric temple at Bassae incorporated an Ionic sculptural frieze, running along the top of the wall of the inner building, but inside rather than outside as on the Parthenon. The subjects of the frieze are the battle of Lapiths and centaurs, and of the Greeks and Amazons. The frieze is carved in much higher relief than that of the Parthenon, and cruder in style, yet in its own way lively and characterful.

Around the time that the Parthenon was completed the tradition of sculptured gravestones, curbed by legislation around 500 BC, was revived in Athens, and a fine series of funeral monuments was produced down into the fourth century. Free-standing sculpture also flourished into the fourth century, at the hands of such masters as Praxiteles. The Aberdeen Head, named from a former owner, the fourth Earl of Aberdeen, exhibits many of the known characteristics of the Praxitelean style – soft, full contours, protuberant forehead, deep-set eyes and exuberantly carved hair. If not the work of Praxiteles himself, it should be attributed to one of his followers. Belonging to much the same date, around 330 BC, is a seated statue of Demeter, found in a sanctuary of Underworld deities at Cnidus in Asia Minor. The goddess is heavily draped, and sits on a cushioned throne. Her face and neck are made of a separate piece of marble, highly polished so as to contrast with her hair and drapery. Her expression, like her attitude, is calm and pensive.

A new period in Greek history was inaugurated by the conquests of Alexander the Great, which embraced Asia Minor, Egypt, Persia and Western Asia to the Indus. On Alexander's death in 323 BC this enormous empire was carved up by his generals into a series of independent kingdoms, and the Hellenistic period began. Hellenistic art was markedly different from that of the Classical period. It displays a greater interest in the

trident to produce a spring of salt water, Athena winning the day with her olive tree. At the east end was shown the birth of Athena from the head of Zeus. Most Athenocentric of all, however, was the continuous Ionic frieze: interpretations of this vary in detail, but there is general agreement that it must evoke the Panathenaic procession, in which the people of Athens brought, every fourth year, a new robe for the statue of Athena.

The sculptures from the Parthenon now displayed in the British Museum were removed from the temple and brought back to England by the seventh Earl of Elgin between 1801 and 1804. Greece was at this time under Turkish rule, and it was from the Turkish government in Constantinople, where Lord Elgin was British Ambassador, that he obtained a permit entitling him not only to commission artists and other workmen to examine, draw and make casts of any sculpture on the Acropolis, but also to remove 'any pieces of stone with figures and inscriptions'. After protracted negotiations, the British Government bought the Elgin Marbles for the British Museum in 1816.

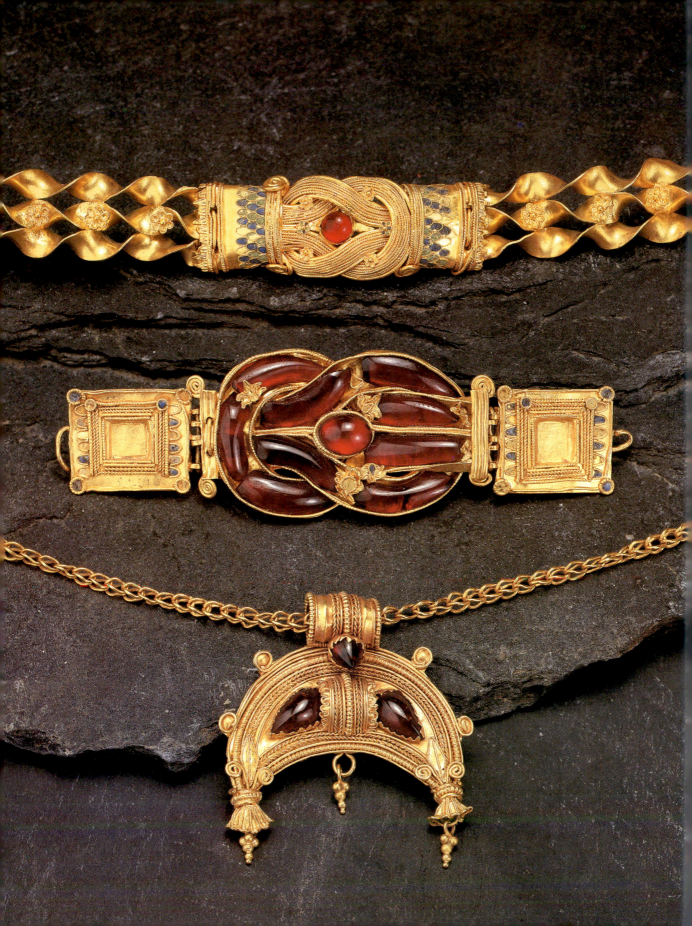

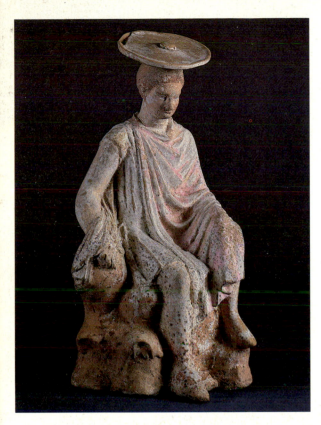

24 ABOVE *Terracotta figurine of a youth seated on a rock, from Tanagra. Most Tanagra figurines were found in tombs; others were dedicated in sanctuaries or served as decorative ornaments in private houses. About 330–300 BC. H 20cm.*

23 LEFT *Hellenistic gold jewellery: rich polychrome effects were created with the aid of enamelling and precious stones like garnets, imported from India in the wake of Alexander's conquests. New motifs were also introduced, such as the reef-knot, the 'knot of Herakles'. 300–100 BC. L (diadem, centre) 8.6cm.*

individual – in youth, old age, physical deformity, or racial differences. It is more cosmopolitan than before; it is often ostentatious, even theatrical; and its subject matter not infrequently displays an obsession with the ideas of chance and fortune. Most of these characteristics are more easily observable on the large-scale sculpture and architecture commissioned by Hellenistic rulers to embellish their states. Yet the interest in realism, at least, is readily observable in the terracotta figurines from Tanagra, produced in quantity in the third century BC: these are remarkably life-like in terms not only of poses and drapery, but also of their subject matter – ordinary people going about, dressed for shopping or travel, rather than the gods and goddesses

of earlier years. An ivory statuette from the Townley Collection portrays a hunchback in such detail that it is possible to diagnose his condition as Pott's disease. Small objects also demonstrate the taste for show and luxury, from glass bowls decorated with gold leaf to intricately worked gold jewellery, lavishly inlaid with precious stones.

Macedonia became a Roman province in 148 BC; and with the defeat of Antony and Cleopatra at Actium in 31 BC the whole of Alexander's empire came under Roman rule. But this was by no means the end of Greek art, for Greek artists continued to work for Roman patrons, and much of the art of the Roman period is their work.

CYPRUS

The first settlers reached Cyprus some time before 7000 BC, probably from the nearby Syrian coast, but the Museum possesses little or no material belonging to the earliest prehistoric phases. The collections begin with the Early Bronze Age (2300–1900 BC), and include fine examples of red polished ware, the dominant pottery during this period. A series of weapons, wedge-shaped axeheads and dress-pins are all typical of early Cypriot metalwork, which, after a spectacular beginning, changed little until about 1600 BC. A new tradition of painted wares marks the beginning of the Middle Bronze Age around 1900 BC. Towards the end of that era Cyprus emerged from her isolation. Goods were imported and Cypriot products reached Egypt and the Near East.

The Late Bronze Age (1650–1050 BC) was a period of great prosperity and wide-ranging commercial connections. Life was particularly prosperous in the towns established mainly on the east and south coasts. Many had good harbours, including Enkomi, where excavations were carried out by the British Museum in 1896. Finds from here and other sites excavated by the Museum provide a fine picture of the civilisation of Late Bronze Age Cyprus. Cypriot workshops made pottery, bronzework, jewellery, sealstones and artefacts of glass, ivory and faience. Raw materials like gold, ivory and faience were imported, as were some finished articles, including a great quantity of pottery from Mycenaean Greece. Cyprus exported copper, her principal natural resource, and perhaps opium and perishable goods like textiles, grain and timber.

In the twelfth century some settlers may have arrived from the Greek world, but large-scale immigration probably occurred around 1100 BC. New Mycenaean Greek burial customs were practised in some eleventh-century BC cemeteries and the native Cypro-Minoan script died out to be replaced by Cypro-Syllabic and the Greek language.

The beginning of the Iron Age is dated about 1050

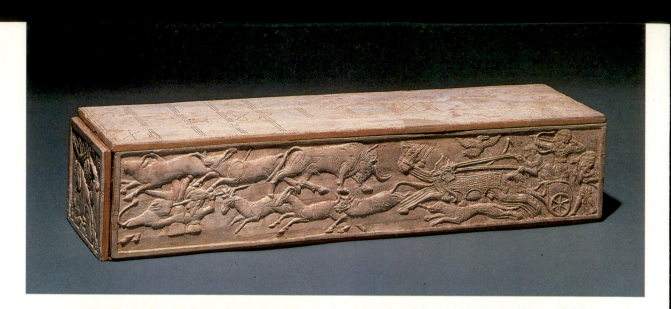

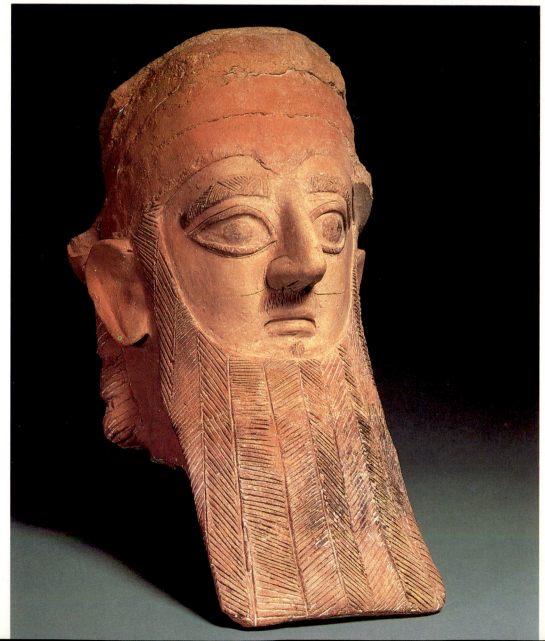

25 LEFT *Ivory gaming-box from Enkomi, decorated with hunting scenes and animals. The squares on the top are arranged for the Egyptian game of* tjau; *underneath is a drawer for the gaming-pieces. Probably carved in Cyprus in the twelfth century* BC *from imported ivory.* L *29.1cm.*

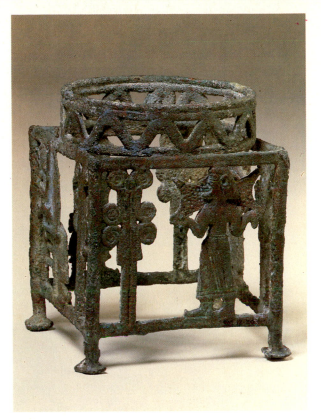

27 *Bronze four-sided vessel-stand with openwork decoration showing on each side a man approaching a stylised tree. Here he carries an ingot shaped like an ox-hide, the form in which copper was transported at the time. Made in Cyprus in the twelfth century* BC. H *11cm.*

BC; the bulk of the Museum's collection from that era again comes from excavations. The first two hundred years are usually described as a Dark Age, although contacts were maintained with both east and west. The arrival of the Phoenicians in the mid-ninth century prompted a Cypriot revival. Typical 'Phoenician' pottery was now made locally, and a fine series of metalwork produced by Phoenician residents is represented in the Museum's collection by decorated metal bowls and lampstands. The following centuries saw the island, now divided into autonomous city-kingdoms, ruled by a succession of foreign overlords, Assyria (*c.* 709–669 BC), Egypt (*c.* 570/60–526/5 BC) and Persia (*c.* 526/5–333 BC). Among the products of the seventh and sixth centuries are vases with pictorial decoration, including flowers, birds, human figures and mythological beasts. Around the middle of the seventh century, during a period of independence, large-scale sculpture in limestone and terracotta began. Many of the sculptures in the Museum's collection come from the excavations at the sanctuary of Apollo at Idalion. Some of the fine jewellery of the fifth and fourth centuries was imported from the Greek world, but bangles, hair spirals and ear-rings with animal-head terminals, were made in Cyprus.

The beginning of the true Hellenisation of Cypriot culture and the end of the city-kingdoms were marked by the voluntary submission of the Cypriot kings to Alexander the Great in 333 BC. In 294 BC Cyprus became part of the large state of Egypt ruled by Ptolemy I (one of Alexander's generals) and his Greek successors. She remained in Ptolemaic hands for nearly 250 years. Her closest relations were now with the Greek world.

Rome annexed Cyprus in 58 BC, but the island was briefly returned to Ptolemaic rule during the civil wars of the Roman Republic. In 30 BC Cyprus again became a Roman province. The language and culture remained basically Greek, in common with the rest of the eastern Roman Empire. In both the Hellenistic and Roman periods (323 BC–AD 395) Cypriot craftsmen followed cosmopolitan fashions, and although the limestone sculpture retains some of its native qualities, it is

difficult to distinguish between locally produced artefacts and those made elsewhere. This is well illustrated by the Museum's collections. The events of the fourth century, with Constantinope replacing Rome as the capital of the Roman world in AD 330 and the allocation of Cyprus to the eastern Roman Empire in AD 395, mark the end of this era in the island's history.

THE GREEKS' EASTERN NEIGHBOURS

Since remote antiquity south-western Asia Minor has been isolated from the mainstream of Anatolian life. The history, language and art of the people of ancient Lycia reflects their dogged determination to maintain an independent identity. From 540 to 470 BC and again from 400 to 334 the Lycians were controlled, remotely through the agency of local nobles, by the Persian Great King. In the interim (470–400 BC) Lycia fell within the orbit of the Athenian Empire. Persepolis and Athens influenced Lycian funerary architecture, which was nonetheless dominated by a distinctive local style,

26 *Painted terracotta head from a statue of a bearded worshipper in the earliest style of large-scale Cypriot sculpture which began in the middle of the seventh century* BC. *From the Sanctuary of Apollo at Phrangissa, Tamassos, 650–600 BC.* H *36cm.*

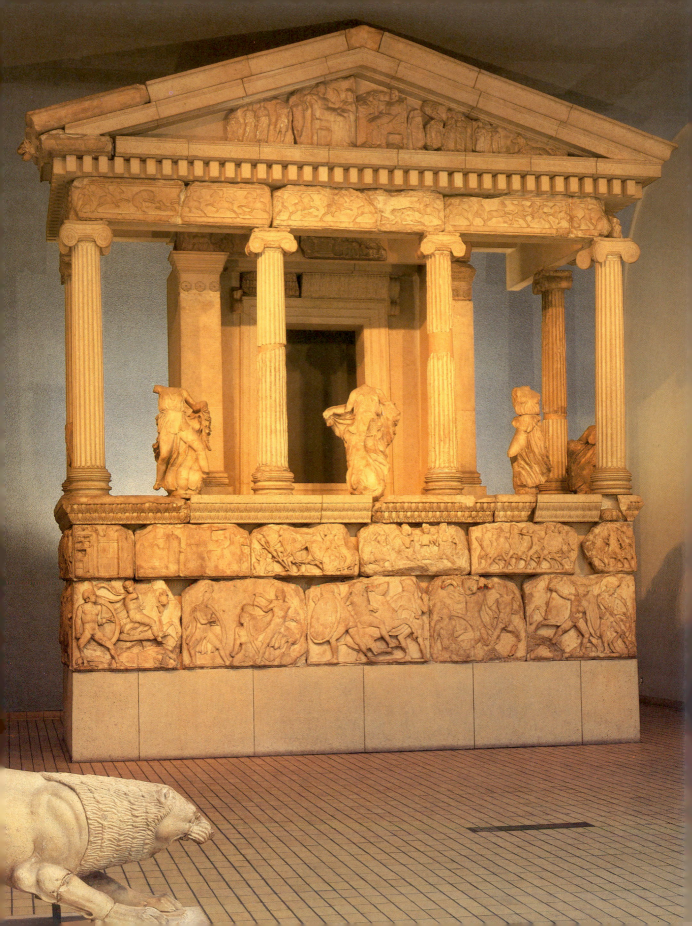

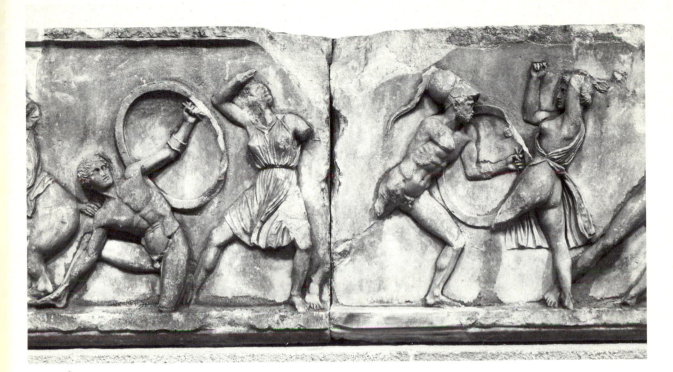

29 ABOVE *Part of a frieze from the Mausoleum at Halicarnassus showing Greeks fighting Amazons. The frieze originally ran around the monument just below the colonnade. These slabs were excavated by C. T. Newton in 1857. About 350 BC. H (slab) 90.2cm.*

28 LEFT *Reconstructed façade of the Nereid Monument from Xanthos. The elegant Nereids were set between the columns of this temple-like tomb, made for a dynast about 400 BC. On the podium are friezes with real and mythological battle-scenes. H 8.3m.*

featuring projecting rectangular frames and, on free-standing sarcophagi, steep ogival roofs. These surely reflect the direct translation into stone of the features of less durable timber-framed buildings.

The surviving monuments date to the two periods of Persian rule. The later tombs were expressly intended as an eternal record of the pursuit of advantage and privilege for the Lycian cities. Thus his inscribed sarcophagus represents Payava, a noble responsible for the administration of the lower Xanthos Valley, in audience with Autophradates, satrap of Sardis. Sadly more frequent are scenes of battle, gruesomely rendered on the otherwise decorative Nereid Monument from Xanthos, named for the lovely figures poised between its columns.

The Nereid Monument and earlier tombs also portray the traditional aristocratic pursuits of hunting, banqueting and cock-breeding. Though ferociously independent, no Lycian would wish to appear un-

cultured, and Greek influence is as apparent in the choice of decorative motifs as in the execution of the work. The earlier monuments such as the Harpy Tomb were evidently inspired by the art of Ionian Greece.

Persian authority was eventually undermined in western Lycia; the vacuum was filled by a powerful neighbour, Mausolus of Caria (d. 353 BC). Mausolus, too, preserved the memory of his splendid court in a tomb which has given us the word 'mausoleum'. One of the Seven Wonders of the Ancient World, the Mausoleum at Halicarnassus profoundly influenced Roman architectural design. The leading Greek architects Pytheos and Satyros and the sculptors Scopas, Bryaxis, Timotheos and Leochares designed and decorated the tomb. They contrived a three-dimensional tableau of courtly life animated by portraits of the ruling family and their courtiers. The figures were set on a stepped podium. Lions patrolled the base of the pyramidal roof, which was crowned with a chariot group. A conventionally Greek frieze depicting the battles against the Amazons decorated the top of the podium.

Another formidable neighbour of the Greeks, King Croesus of Lydia, contributed columns to the Temple of Artemis at Ephesus (550–500 BC). Fragments of exquisite sculptural decoration survive from this temple, destroyed in 356 BC by the arsonist Herostratus. A second temple was promptly commissioned. With striking figured decoration on its columns, this too became a Wonder of the Ancient World.

THE GREEKS IN THE WEST

The contacts re-established with the peoples of the eastern Mediterranean after the fall of the Mycenaean world were closely followed by exploration in the west. Traders from the island of Euboea led the way, as they had in the east. By 750 BC they had established a thriving trading post on the beautiful island of Ischia (ancient Pithekoussai), off the coast of central Italy, near Naples. Several Greek cities, from the mainland, the islands and the coast of Asia Minor, soon followed this lead and established colonies along the coasts of southern Italy and Sicily: some had superb harbours, like Syracuse in Sicily, others had access to rich agricultural plains, such as Metaponto, whose badge on coins was to be an ear of corn. The heyday of this great colonial adventure was the late eighth and seventh centuries BC.

The Greeks brought with them their language, their religion and their customs, but they also brought their arts and crafts. In the sixth and early fifth centuries the Greek artists in southern Italy produced many fine

bronzes, decorated vases of fired clay and terracottas. The British Museum has a rich collection of bronze statuettes, one of the finest of which came from Armentum in Apulia. It was probably made at Taras (modern Taranto) in about 550 BC, and shows a warrior on horseback. It is remarkable for both its size and its quality, and is particularly evocative of the military power of the Greeks in southern Italy. On mainland Greece heavily armed cavalry was rare, but in southern Italy the wide plains allowed the rearing of fine horses and their deployment in battle.

Each of the Greek city-states followed its own independent course and almost all flourished, although there were inevitably clashes with neighbours, both native and Greek. Syracuse was to emerge in the fifth century as perhaps the greatest Greek city in the west, ruled by a succession of vigorous tyrants: an Etruscan

32 RIGHT *Gold choker-necklace made in Taras (modern Taranto) about 350 BC. The individual elements were produced by hammering thin sheets to shape and adding details in wire in the delicate technique of filigree.* L *30.6cm.*

30 *Bronze cavalryman from Armentum, made in southern Italy about 550 BC. It was cast solid in two main pieces – horse and rider – with smaller pieces (reins, spear and shield, all now missing) added separately.* H *25.3cm.*

31 BELOW *Detail from a bell-shaped krater (mixing-bowl) painted by Python at Paestum about 330 BC. Alkmene is on a pyre which is being lit by her husband Amphitryon; Zeus orders the Clouds to put out the fire.* H *(picture) 26m.*

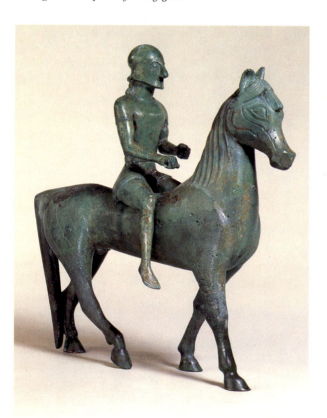

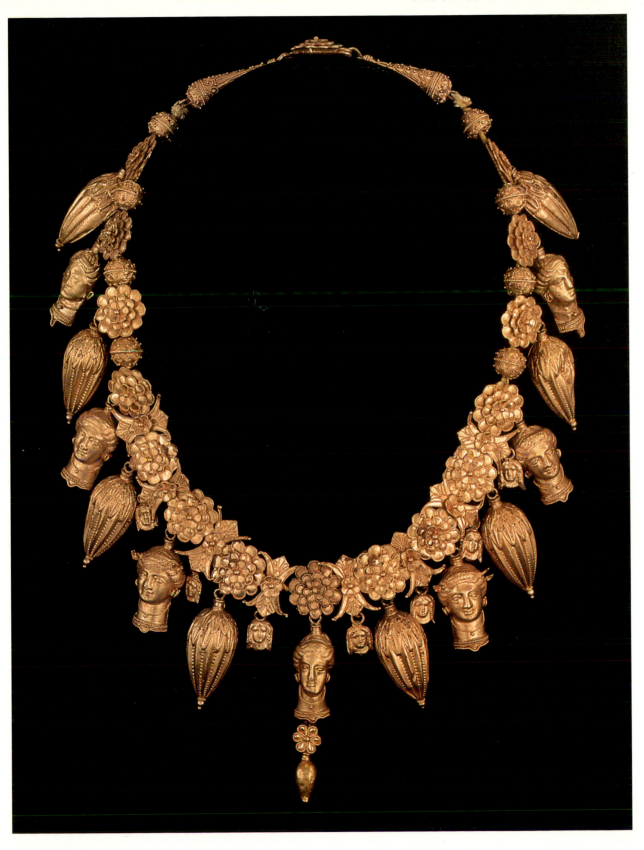

bronze helmet from Olympia is a dedication by one of them after their victory over the Etruscans at the battle of Cumae in 473 BC.

The colony founded by Athens in 443 BC at Thurii seems to have encouraged some Athenian potters to emigrate to the neighbourhood of Metaponto, for from this date begins a series of vases decorated in the red-figure technique. A number of local schools of vase-painting soon developed, not only in Lucania and nearby Apulia, but also to the north in Campania and to the south in Sicily. The finest school, which is well represented in the British Museum, was the Apulian, based at Taras. It produced a host of monumental funerary vases covered with elaborate decoration. At Paestum, however, a rich city on the borders of Lucania and Campania, a potter called Python also produced some particularly fine vases decorated with scenes from plays both tragic and comic, for the Greeks brought with them their love of the theatre.

By the early fourth century Syracuse had gained control of most of Sicily and much of southern Italy, with the exception of Taras, which became particularly powerful in the fourth century and a flourishing artistic centre. Indeed, at Taras, in addition to talented potters and makers of terracottas, there was a school of jewellers, active from the middle of the century, that produced a series of exceptional pieces. From a single tomb, perhaps that of a priestess of Hera, comes a wonderful sceptre, a splendid ring and a spectacular necklace with pendant female heads, two of which have horns, identifying the figure as Io, the priestess of Hera who was turned by her into a heifer.

In the later fourth century, however, the power of Rome began to be felt and by 272 BC all of Greek Italy was in Roman hands. Sicily held out longer, but by the end of the third century it too had been absorbed into the centralised culture and economy of the Roman world, a fate that spelled the inevitable decline of all the fiercely independent Greek communities in Italy. Greek artists, however, continued to work for their new patrons and much in Roman art owes both its origins and its creators to the Greek artistic traditions of southern Italy.

THE NATIVE ITALIC CULTURES AND THE ETRUSCANS

The impact of Greek settlement in southern Italy was all the more powerful because the native population was culturally and technologically less advanced. Nonetheless research into Early Iron Age Italy (9th–8th centuries BC) now presents a complex picture of a multitude of peoples, each with its own customs, religion, occasionally also its own language, and types of artefact. Distinctive local products of the Italic peoples as represented in the British Museum include a

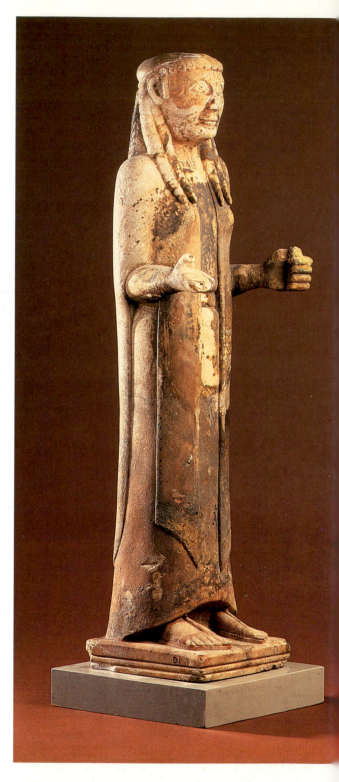

33 *Gypsum figure of a lady. This is a rare surviving example of a carved statue from the Etruscan Archaic period, found in the so-called Isis Tomb in the Polledrara Cemetery near Vulci. About 570–560 BC. H (figure) 85cm.*

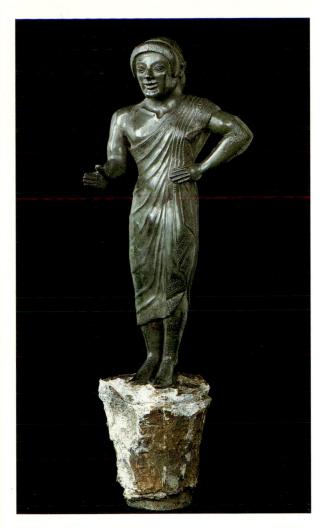

34 *Bronze statuette of a young man wearing pointed boots and a tebenna (Etruscan form of toga). This figure is one of the finest Etruscan Archaic bronzes in existence. From Pizzirimonte, near Prato, about 500–480 BC. H 17.1cm.*

35 *Etruscan bronze mirror with a bone handle. The engraved back shows Perseus (Pherse), who has just decapitated Medusa, Athena (Menerfa), holding aloft the head, and, on the right, Hermes (Turms). From Perugia, about 350–325 BC. H 24cm.*

comprehensive collection of native Apulian pottery, Samnite bronze armour, including breastplates and broad belts, impasto pottery from Latium and the Faliscan territory, and bronze jewellery from Picenum. From a much earlier period, the Italian Bronze Age (*c.* 2000–900 BC), there is an impressive array of bronze weapons, brooches and implements, and a selection of Nuraghic bronzes, including statuettes, from Sardinia (12th–9th centuries BC or later).

The boundaries of the territories inhabited by the Italic tribes are blurred; each was influenced by its neighbours and, especially in the south, in Sicily and in Sardinia, not only by the Greeks but also by the Phoenicians who settled there. The most dramatic effects of foreign contact, however, are demonstrated by the

inhabitants of Etruria, who by the eighth century BC were already the most sophisticated and developed people in Italy. They lived in part of the western central region, broadly speaking between the valleys of the Arno and Tiber, where they benefited from rich agricultural resources and plentiful metal ores which enabled their craftsmen to excel in the production of metalwork throughout Etruscan history. The Etruscan civilisation had developed out of the so-called Villanovan culture of the ninth and eight centuries BC, but it has become customary to use the term Etruscan for the period following 700 BC only, when the Etruscans began to write, using a version of the Greek alphabet, and we know that Etruscan was spoken.

In the seventh century BC increasing trade and many

imports from the eastern Mediterranean brought new wealth to Etruria; this is known as the Orientalising period. Beautifully carved ivory, sea-shells and other luxury goods appear, and much Greek pottery, and perhaps also Greek craftsmen, arrived in Etruria. The most characteristic native Etruscan pottery was bucchero, a distinctive black, lustrous ware whose production lasted down to the early fifth century BC; painted Etruscan pottery through the centuries generally followed Greek styles and shapes. Ostentatious gold jewellery, famed for its decoration with filigree and granulation (minute gold spheres formed into patterns) was produced by Etruscan craftsmen, and many examples have been found in the fine family tombs built by the nobility of the seventh and sixth centuries. Cemeteries of all periods have yielded the greatest quantity of Etruscan artefacts.

Among the most impressive objects of the Etruscan Archaic period (600–475 BC) in the British Museum are the contents of the so-called Isis Tomb, excavated by Lucien Bonaparte, Prince of Canino, from the Polledrara cemetery on his estate near Vulci. The tomb-goods, mainly dating from 600 to 550 BC, include many sumptuous objects, some imported and others made locally. From the Archaic period also are two limestone cinerary urns in the form of male figures, examples of the monumental sculpture which, along with the practice of tomb-painting, had begun to appear in Etruria at the end of the previous century. In addition, there are numerous examples of the exquisite bronze sculpture, including many votive statuettes dedicated at shrines, and decorated utensils, especially mirrors with scenes engraved on the backs. These continued to be produced by the Etruscans down to the second and first centuries BC. This fine metalwork and engraved sealstones attracted discerning nineteenth-century collectors such as Richard Payne Knight, who bequeathed his collection of classical antiquities to the British Museum in 1824. In the sixth century BC Etruscan power and prosperity were at their zenith; Etruscan kings ruled Rome, and Etruscan colonies flourished in Campania and the lower Po Valley. By the end of the century, however, defeats by the Greeks at sea and on land severely reduced Etruscan domination; according to tradition the last Etruscan king was expelled from Rome in 509 BC, when the Roman Republic was established.

The Etruscan Classical period (475–300 BC) saw a continuing decline of Etruscan fortunes at the hands of the Greeks, Romans and Gauls who were now settled

36 Painted terracotta sarcophagus of Seianti Thanunia Tlesnasa. She is shown reclining on the lid, wearing rich jewellery and holding a mirror while she adjusts her mantle. From a tomb at Poggio Cantarello, near Chiusi (ancient Clusium), about 150–130 BC. H 1.22m.

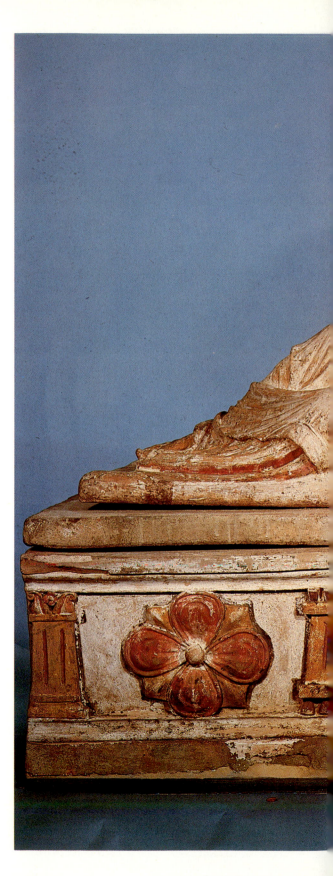

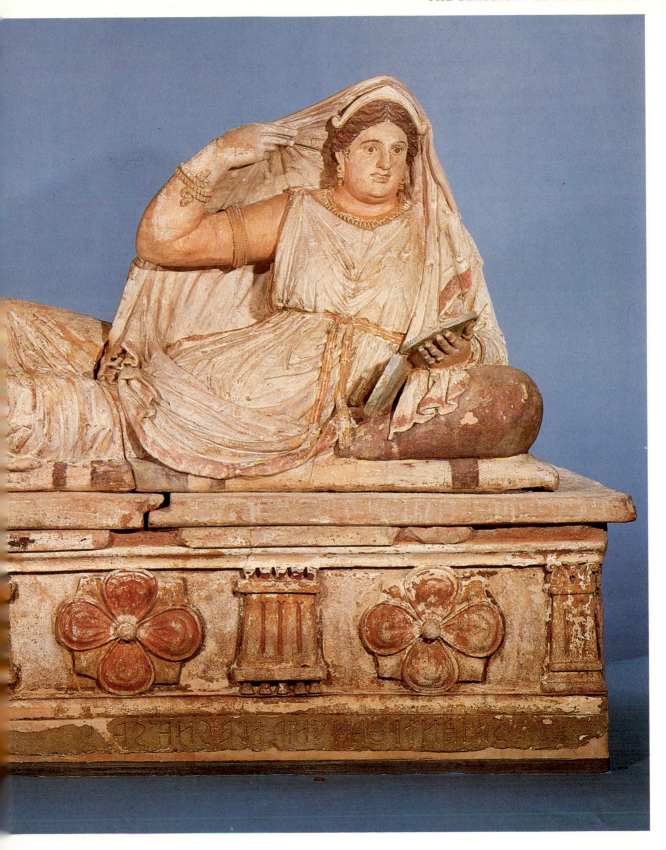

in the Po Valley. Lacking outside stimulus, Etruscan art retained the Archaic style much longer than Greek art, and it occasionally became rather provincial-looking. Nonetheless, tomb-painting and engraved bronzework reached new heights, and painted terracotta roof decorations from Etruscan temples of the sixth to third centuries BC give a lively impression of the colour and showiness of the religious architecture of the period.

During the Hellenistic period Etruria shared an artistic style in common with most areas around the Mediterranean, but some traditional Etruscan elements persisted, particularly in the production of painted terracotta and carved stone cinerary urns and sarcophagi. It was during this period that Rome conquered the Mediterranean world, and by 280 BC the Etruscan city-states were subject allies of Rome. The Etruscans were given Roman citizenship after the Social War in 89 BC and were finally assimilated into the Roman world: the latest art of Etruria, especially the bronze figures depicting Herakles, priests and priestesses, heralds the beginnings of Roman Imperial art.

ROME AND THE EMPIRE

Some elements of Etruscan and Italic religions and civic ritual survived at Rome, but most Roman patricians (men of noble family) were educated by Greeks. Their taste for Greek culture was strengthened by the removal to Rome of classical works of art stripped from Greek cities and sanctuaries following Roman domination of the eastern Mediterranean in the second century BC. The generals of the later Roman Republic were rightly perceived in the Greek world as the successors to the Hellenistic kings. At home, amidst criticism from men of more traditional views, some generals acquired personal collections of Greek art. As the fashion spread, marble copies of Greek bronze originals were commissioned to adorn the houses and gardens of the wealthy. Greek artists were much in demand.

In Republican Rome the right to portraiture was restricted to the families of magistrates and the nobility. Portrait busts, of wax, terracotta and, later, stone, were arranged in cupboards at home to form a three-dimensional family tree. At funerals the busts were paraded and ancestral masks were worn to encourage the younger members of noble families to live up to the reputations of their ancestors. The unflattering portraits expressed respect for the traditional Roman virtues of authority and austerity.

By the reign of the emperor Augustus (27 BC–AD 14) the court favoured a Greek style of portrait, and the old patrician style was taken up by freed slaves of alien origin who now enjoyed prospects of citizenship. The growth of enfranchisement and opportunities to hold

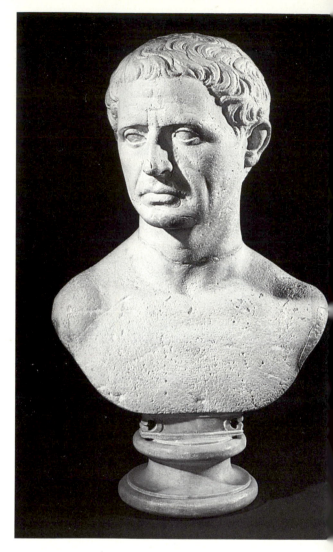

37 *Marble portrait bust of a Roman. The shape of the bust suggests that it was made about AD 100, but the subject's severe expression deliberately recalls the style of Republican portraits of the first century BC. H (with base) 54.8cm.*

public office encouraged the spread of the traditional Roman portrait to the provinces. The style was to re-emerge at Rome at the courts of emperors of relatively humble origin, such as Vespasian (AD 69–79) and many of the third-century emperors.

Such complex currents of artistic influence, generated by the relatively open nature of Roman society, and by the mobility of the army and wealthy provincials, give Roman art an eclectic and uncertain identity. But many Roman works have a striking historical immediacy. A bronze head of Augustus, cut from a statue in a Roman fort in Egypt by raiders from the kingdom of Meroë (Sudan), brilliantly portrays the first Roman emperor as

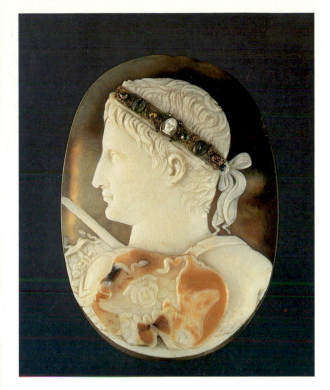

38 *Sardonyx cameo portrait of the first emperor, Augustus (27 BC–AD 14), wearing the protective aegis of Zeus with the heads of Phobos (Fear) and Medusa. The jewelled diadem was added later, and may have replaced a laurel wreath. H 12.8cm.*

39 *Gold mouthplate of a scabbard. As head of state Augustus receives a statuette of Victory from his stepson and field commander Tiberius. The emperor's victory is confirmed by Victoria. From Mainz (Germany), about 15 BC. W 8.6cm.*

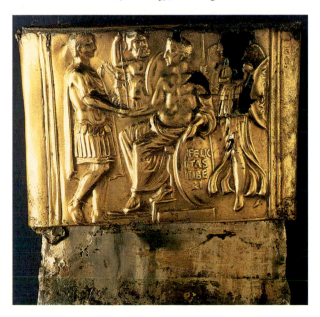

successor to the Hellenistic kings. A softer regal image is offered by the Blacas Cameo. On the mouthplate of a scabbard of a ceremonial sword from Mainz (Germany), Augustus appears in the pose of the god Jupiter. Cameos and ceremonial weapons were made for loyal individuals; in sculptures and on coins seen by many Augustus was more modestly presented.

Made of glass cut in layers like a cameo, the Portland Vase is the finest example in the collections of the Augustan taste for Greek culture. That the interpretation of its scenes is still disputed is perhaps a reflection of the profound Hellenisation of the Augustan court.

The Roman imperial army, increasingly recruited from provincials, was instrumental in spreading Roman citizenship and culture to the frontier provinces. A diploma from Pannonia (Hungary) offers a precise record of the enfranchisement by the emperor Hadrian on 17 July AD 122 of the auxiliary cavalryman Gemellus after twenty-five years of military service. Also of historical interest is the set of inscribed silvered bronze horse-trappings from Xanten (Germany), most likely awarded to an officer serving under the prefect of cavalry Gaius Plinius Secundus, better known to us as the writer Pliny the Elder. Pliny's German command overlapped the reigns of the emperors Claudius (AD 41–54) and Nero (AD 54–68).

Nero's passion for the theatre, considered unseemly in an emperor, reflected the apparently insatiable Roman appetite for entertainment. Even more popular with the populace than mime were gladiatorial fights and chariot-races. A terracotta plaque of first-century date, possibly from a tomb, illustrates a race in progress. An ivory bust of a charioteer closely resembling the emperor Caracalla (AD 203–17) is said to come from the Roman amphitheatre at Arles (southern France).

As in their pleasures and cultural life, so in religious belief the Romans were open to external influence. A highly superstitious people, the Romans worshipped many deities beyond the Latin version of the classical Greek pantheon. The surviving traces of civic and personal commitment are legion.

The growth of material prosperity under the *Pax Romana* encouraged the building of houses of refined comfort and decoration for the wealthy. The large Roman townhouse was designed for the formal reception of clients and friends of the owner. An impression of cultured ease was evidently desirable. Rare intact survivals suggest the careful coordination of decorative schemes on painted walls and mosaic floors (and presumably painted or stuccoed ceilings).

The frequent reuse and recutting in late antiquity of marble statues and architectural decoration reflects the dependence of Roman sculptors and architects upon a fluctuating trade in white marbles. Mosaics, popular throughout the Empire, were not subject to such constraints; a mosaic floor could be assembled from off-

38
39

title
page

40
9

42

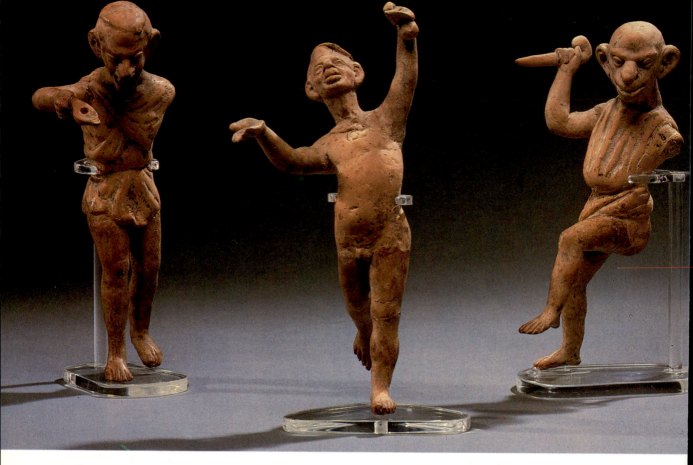

cuts of stone, glass and tile, and the many surviving late Roman examples are of striking appearance and lively design. The portrayal of the rich at their favourite sports of hunting and fishing was especially popular in North Africa. The wild beasts destined for the universally popular games were another favourite subject, possibly illustrating a lucrative source of income for the owners of North African estates.

Large quantities of surviving Roman tablewares offer further evidence of sustained material prosperity. The perfection of the technique of glass-blowing in the later first century BC led for the first time in classical antiquity to the manufacture of large glass vessels for common use at table. Production of decorative glasses spread from Syria, which remained a key centre of glass-making, to north-east Italy and the Rhineland. Plain wares were made in numerous local centres. The more luxurious glass vessels were elaborately decorated with coloured glass blobs or trails, or with applied figures. Glass was also wheel-cut; late Roman glass-cutters were very proficient at figured scenes.

The earliest imperial ceramics rivalled fine glassware. Unsurprisingly, Roman potters imitated the fine

40 ABOVE *Three terracotta figures of actors performing a mime. First century* AD. H *16.9cm.*

41 RIGHT *Roman gold jewellery. The necklace with butterfly pendant is from Rome, and was made in the first century* AD. *On a second-century necklace, probably from Italy, gold links alternate with emeralds. A third-century hair ornament from Tunis is decorated with emeralds, pearls and sapphires.* H *(hair ornament) 10.7cm.*

ceramic and metal wares of Hellenistic Greece and Asia Minor. The most elaborate vessels were thrown into moulds decorated with as many as thirty stamped impressions; the potter's name, or that of the owner of the workshop, was often stamped on the pot. Most Roman fine wares were given a distinctive red gloss, inspired by the finish of Hellenistic fine wares from Pergamon. Many Roman decorative motifs, like those of contemporary sculpture and painting, were drawn from the Classical Greek repertoire, and served the same purpose of endowing the owner with an air of cultured refinement.

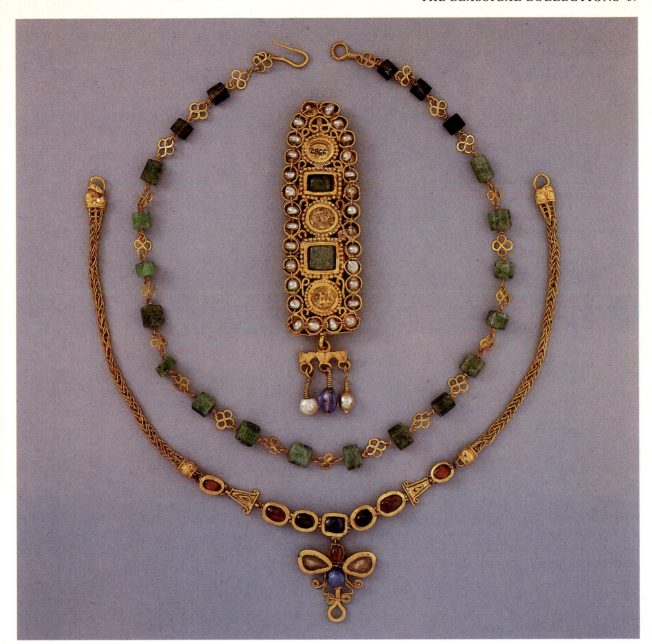

By the mid-first century AD the production of fine ceramic tableware had moved from Arezzo (Italy) first to Lyons and La Graufesenque, then to Lezoux (central France). The owners of the kilns could thus more easily supply their main clients, the armies in Gaul and the Rhineland. The design and decoration of the vessels became less refined. New centures of production emerged to the north and east, but by the third century AD the Gaulish producers had been supplanted in the Mediterranean basin by workshops based in northern Africa and western Asia Minor. African Red Slip ware was often undecorated, or adorned with figured appliqués closely related in form to contemporary silverwork. In the northern provinces red wares were supplanted by local products.

A red slip was also applied to pottery lamps made in Italy. The workshops are approximately contemporary with those producing Arretine tableware, but the lamp workshops lasted into the second century AD. They produced innovative designs, mostly with figured decoration on the disc. Italian lamps were exported and copied throughout the Empire.

The third century AD was to see centralised imperial authority drastically weakened. Hoards of precious

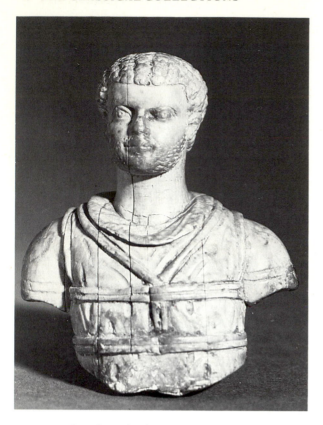

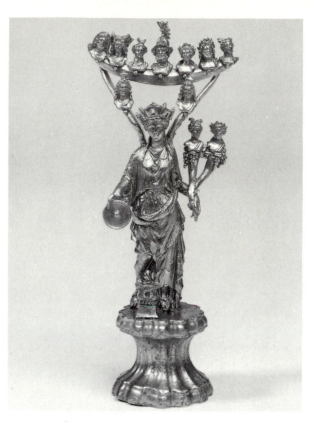

42 ABOVE *Ivory bust of a charioteer closely resembling the emperor Caracalla (AD 198–217), who rebuilt the Circus at Rome. Said to be from the amphitheatre at Arles (France), early third century AD. H 5.3cm.*

43 ABOVE *Silver statuette of Tyche, the good fortune of a city. The wings of the goddess support a crescent with seven busts representing the gods of the days of the week. From Mâcon (France), second–third century AD. H 14cm.*

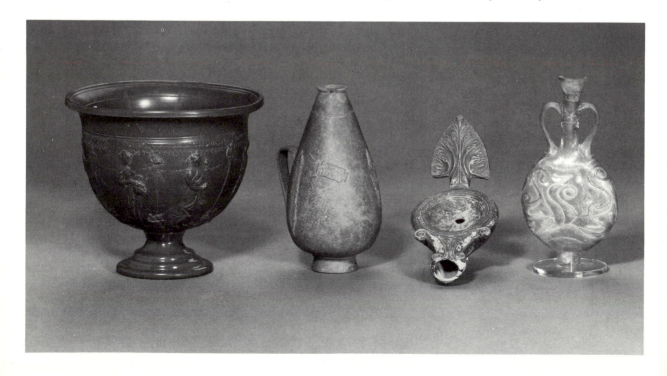

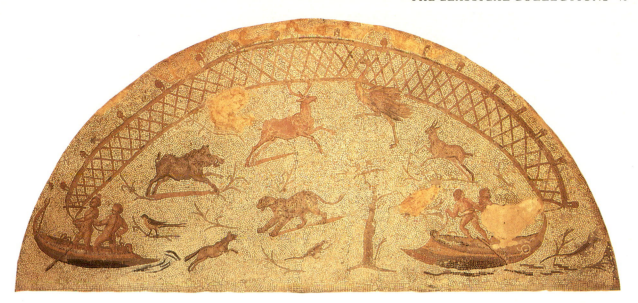

45 *Mosaic pavement. Men in boats hunt animals in marshland with a long net. From Utica (Tunisia), early third century* AD. *W 3.39m.*

metals have been found in various provinces, where communities were threatened by political instability and barbarian invasion. Among the most spectacular of surviving hoards is that from Mâcon (central France), buried about AD 261 and sadly dispersed since its discovery in 1764. The hoard originally comprised silver vessels and statuettes, jewellery and some 30,000 gold and silver coins. The statuettes may have been dedicated in a private shrine.

The restoration of central authority after fifty years of chaos under a college of emperors led by the Illyrian Diocletian (AD 284–305), was to change for ever the nature of Roman society, and to accentuate the distinctions, long masked by Romanisation, between the Greek east and Latin west. A new eastern capital was founded by Constantine (AD 307–37) at Byzantium (modern Istanbul), and the city was renamed Constantinople (city of Constantine). As Rome centuries earlier had been furnished as an imperial capital with looted Greek statues, so under Constantine and later emperors works of art and symbols of culture still surviving in the Greek cities and sanctuaries were stripped for the adornment of Constantinople. Even today the serpent column from Delphi may be admired in that most Roman of settings, the hippodrome.

The drastically changed presentation of the emperor to his subjects encapsulates for the modern viewer the distinction between the early imperial principate, or rule by 'the first citizen', and the later Roman dominate, or absolute rule. The anonymous image of the college of four emperors was thus replaced by that of a distant figure, his eyes no longer gazing reassuringly at his subjects but raised as if in search of divine approval of his authority. The portrayal of various levels of Roman society in sharply divided horizontal bands, in Augustan art discreetly employed in objects of restricted circulation, became a commonplace on monumental relief sculpture seen by the masses.

Bastions of pagan culture survived the adoption of Christianity as the official religion of empire. To these we owe the transmission of classical culture into the medieval and modern worlds. Some indication of the prosperity of the late Roman university town of Athens is offered by the chance survival of a gold ring set with precious stones, as by the traces of extensive city walls designed to protect the residences of the rich. It is fitting that Athens, since the days of Pericles a model of cultural supremacy, played a major role in the preservation of pagan culture in late antiquity.

44 LEFT *Roman pottery and glass: a) Arretine krater from Capua, made about 20* BC–AD *20; b) red-slipped jug with applied decoration celebrating the victory of a team of gladiators, made in Tunisia in the third century* AD; *c) lamp with boxers, made in Italy about* AD *1–50; d) glass flask with snake-thread decoration, made in Cologne in the third century* AD. *H 14cm.*

COINS AND MEDALS

◆

The Department of Coins and Medals contains the national collection of coins, medals, tokens and paper money. It embraces all cultures and periods, and is thus uniquely equipped to cover the history of coinage and money in East and West. As in other areas of the British Museum's collections, the Department has expanded its holdings by purchase and by the generosity of innumerable donors, but it is also able to buy gold or silver objects which have been declared Treasure Trove, and the vast majority of these are coins. In this way important hoards of coins, buried during the many periods of crisis and instability throughout Britain's history, have entered the collections of the British Museum. This has proved a useful source for filling gaps in the collection of common coins, as well as allowing the acquisition of some spectacular pieces.

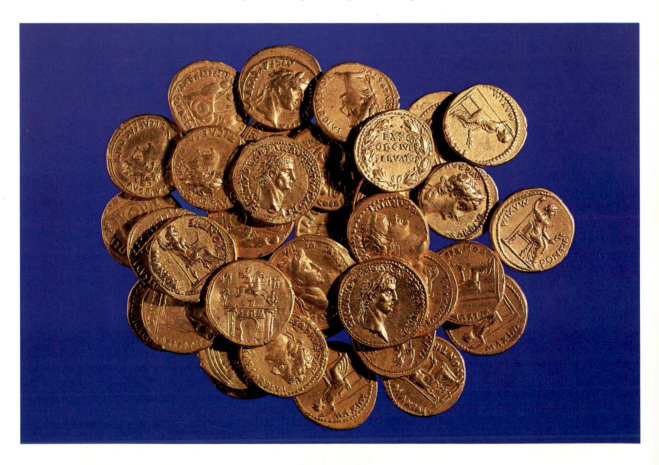

46 Treasure Trove of thirty-seven Roman gold aurei from Bredgar, Kent. They probably belonged to an officer with the Roman invasion of AD 43, who may have fallen in the battle to cross the River Medway.

All coins in this chapter are reproduced 1⅓ actual size.

GREEK COINS

The history of coinage has its origins in the Greek world of the early seventh century BC: the first metal coin was struck in the kingdom of Lydia in western Turkey around 625 BC and was long erroneously associated with King Croesus. The Department's collections chart the development of coinage in Greek lands from its earliest beginnings to the last of the Greek city coinages in Asia Minor about AD 276. Nearly 1,500 states and cities are represented, both large and small; many of the rulers and some of the cities themselves are known only from their surviving coins. Geographically the collection includes not only the heartland of the Greek world, but also the areas on its fringes whose peoples adopted the form of Greek coins for their own issues: from Spain to India, and from South Russia to North Africa. It embraces, therefore, a broad range of cultures with inscriptions not only in Greek, but also in Aramaic and other western scripts, such as Kharoṣthi, and even in demotic Egyptian.

The coins provide a closely dated sequence of designs that trace the history of art in different areas over this period; at the same time, because of their official nature, they provide a considerable amount of information, not available from other sources, about the social, religious and political history of the areas. The early

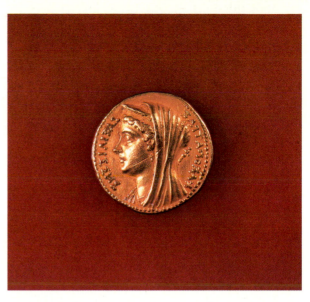

48 Portrait of Cleopatra I on a gold octadrachm of Ptolemy V of Egypt, issued under her regency (180–176 BC). The obverse bears a portrait of Ptolemy, and this is the only coin to portray Cleopatra I with her son.

47 Silver coins of Greek cities: a) tetradrachm of Athens with a Gorgon's head (c. 515 BC); b) stater of Poseidonia (Paestum, Italy), with Poseidon, patron deity of the colony (c. 520 BC); c) half-stater of Sardis, Turkey, with the fore-parts of a lion and a bull.

coins in silver and gold carried a design on one side only, but were to be recognised by the distinguishing badge of the issuing authority – such as the tortoise of Aegina, the griffin of Abdera, or the Pegasus of Corinth. By the fifth century BC coinage was attracting engravers of the highest calibre, and dies cut deeply and in exquisite detail were being made. Those of south

47

49 BELOW *a) silver tetradrachm (c. 315 BC) of the Carthaginians struck while campaigning against the Greeks in Sicily; b) silver five-shekel piece depicting Alexander the Great victorious against an Indian potentate (c. 325 BC); c) bronze coin of Commodus (AD 80–92), Abydos, Turkey.*

50 ABOVE *Silver tetradrachms of the Greek kings of Bactria, illustrating the distinctive and striking portraiture found in this series (from the top, left to right): a) Demetrius I (c. 200–185 BC); b) Antimachus (c. 185–170 BC); Eucratides (c. 170–145 BC).*

Italy (Magna Graecia) and Sicily, in which the collection is particularly strong, are especially beautiful, and occasionally bear the name of the artist. A great variety of different designs is found.

The Persian Empire had already absorbed the tradition of coinage in its western realms, but it was the spread of direct Greek influence under Alexander the Great (336–323 BC) that suddenly resulted in purely Greek coins being struck as far east as India.

Portraiture, although rarely used before the fourth century BC, provides a gallery of the rulers of the Hellenistic kingdoms unparalleled in any other medium. The series issued by the Greek kings of Bactria and north-west India is noteworthy. The coming of the Romans had a dramatic effect on the coinage of the Greeks and political decline was matched by artistic decline. A particularly fine collection of the coinage of Rome's enemy, Carthage, illuminates the course of the struggle for power. Under the Empire coinage in gold was not permitted to the cities of the Roman provinces, and coinage in silver was much restricted, eventually becoming purely imperial in character. The bronze coins of the Greek cities under the Roman Empire, however, many of them of large medallion size, provide a fascinating array of designs, usually associated on the obverse of the coin with the portrait of the emperor or of members of his immediate family. Reverses illustrate local temples and statues, refer to periodic games, and generally provide copious evidence of the preoccupations of the cities in the first three centuries of our era. Economic and political changes in the Empire led to their cessation, though a few quasi-civic coins inscribed in Latin were issued in the early fourth century.

ROMAN COINS

The British Museum has one of the finest collections of Roman coins in the world, spanning the period from the beginning of Roman coinage around 300 BC to the death of the last emperor in the west in AD 480. The earliest Roman coins in the collection are a small group of relatively rare silver and bronze coins of the third century BC, struck in imitation of the coinage of the Greek colonies of southern Italy. At the same time the Romans were continuing to cast large bronze 'bricks' and discs; this was a practice they had copied and adapted from their central Italic or Etruscan neighbours, who used heavy cast-bronze ingots as currency.

This dual system survived until the crippling cost of the war against Hannibal (218–201 BC) forced the Romans to debase their silver and reduce the weight of the bronze coinage. The Museum has a particularly good collection of the cast bronzes and of the struck silver, notably of the latest issue known as 'quadrigati', because of the design of a four-horse chariot.

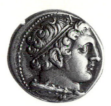
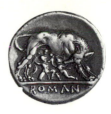

51 *Silver didrachm of the Roman Republic (c. 265 BC). On one side Hercules is depicted; on the other Romulus and Remus with the she-wolf.*

In about 210 BC the new 'denarius system' was inaugurated. This coinage was named after its principal denomination, and it lasted for some four and a half centuries. Although the early bronze 'asses' are not very well represented in the Museum, it has an excellent collection of silver denarii from the latter part of the Roman Republic (c. 150 BC–c. 31 BC).

During the civil wars following the death in 44 BC of Julius Caesar, the first living man to be portrayed on a Roman coin, the leaders of the various factions tried to buy the loyalty of their armies, and minted large quantities of money; some of them continued the Hellenistic Greek practice of adding their portrait. This had two permanent consequences for Roman coinage. First, it added a gold coin to the range of denominations regularly produced – the aureus, worth 25 denarii. Thereafter gold remained important until the end of the second century AD. The Museum has one of the world's best collections of aurei, deriving principally from the British royal and other eighteenth- and nineteenth-century private collections; in addition, hoards of Roman gold coins found in Britain have been acquired, notably those from Bredgar, dating from AD 43, the very year of the Roman invasion, and Corbridge, deposited just after the middle of the second century. The second change, portraiture, was continued by the emperors and became a normal feature of imperial coins. The series of fine portraits of the early Empire were eagerly acquired by early collectors to illustrate the events described by Roman historians, and so have come to represent one of the main strengths of the Museum's Roman collection, notable for its remarkable state of preservation as well as its comprehensiveness.

From the end of the second century AD the stability of the Roman monetary system was strained by a shortage of precious metals and an expensive succession of frontier wars against the Germans and Persians. The consequence was a reduction in the quantity of gold issued and in the weight and purity of the silver coinage, and an increase in the number of mints and their output. At the same time bronze coins ceased to be

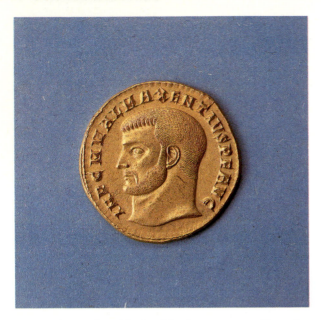

*53 Gold solidus of the Byzantine emperor Justinian II
(AD 685–95). On the obverse Christ is shown as ruler of the
world, with the emperor as his humble servant on the reverse.*

*52 The obverse of a gold coin of the Roman emperor Maxentius
(AD 306–12). The depiction of Maxentius is characteristic of
the powerful portraiture of emperors of this period. The value of
the coin was four aurei.*

struck. Although poorly made and unattractive, these coins are an important source for the history of an otherwise poorly documented period and recent acquisitions, particularly from British coin hoards, have increased the Museum's holdings in this area. The most notable of these was the find of almost 55,000 at Mildenhall (Wiltshire) in 1978, and generally known by its ancient name of Cunetio, in order to avoid confusion with its Suffolk namesake.

The main elements of the coinage system of the late Roman Empire as established by Diocletian (AD 284–305) were the gold solidus and a plentiful base metal coinage, produced at a dozen or more mints, including London for a time; it consisted of coins of various weight-standards during the first half of the fourth century, most issues containing a small quantity of silver. This fourth-century coinage is well represented in the Museum collections, partly as a result of the acquisition of gold hoards from Water Newton, Corbridge and Rockbourne, important finds respectively of the 380s and 390s. Late fourth-century silver coinage is particularly characteristic of British finds, and the Museum has an especially rich series. Base metal coinage has also been systematically collected, with the issues of the London mint and of the so-called 'British Empire' of Carausius and Allectus (AD 286–96) receiving notable attention.

The fifth century AD saw the break up of the Roman Empire and the cessation of its coinage in Western Europe. Britain had already been abandoned in about 410, after which time no coinage circulated for two centuries. This and a lack of antiquarian interest in the fifth century has deprived the Museum of one of its main traditional sources of acquisition, British hoards. However, private collections, particularly drawing upon finds from the Balkans, North Africa and Egypt, have ensured as good and representative a collection of base metal coins as can be found in any museum, and many important pieces in gold and silver are here.

Successor kingdoms to the western Roman Empire, the Vandals, Visigoths, Ostrogoths, Franks and others, began coinages of their own based on the Roman model in the course of the fifth century. Together with issues of later migrants such as the Lombards, these ultimately gave rise to the national coinages of Western Europe and good representative collections may be found in the Museum, thanks mainly to Count de Salis. Roman coinage continued in the eastern Mediterranean basin, where it eventually adopted characteristic inscriptions and types that we call Byzantine. This coinage, together with numerous derivatives in eastern Europe as far west as Italy, lasted almost down to the fall of Constantinople to the Turks in 1453. Though not large, the Museum's Byzantine collection is fully representative and contains a high proportion of unusual pieces.

EUROPE AND GREAT BRITAIN

Outside the immediate political influence of the Greeks and Romans, gold and silver coinage came to be produced by the Celts and other inhabitants of Central Europe during the last three centuries before Christ. At first these were mostly barbarous copies of issues of the kings of Macedon, and even in faraway Britain gold coins showed evidence of this origin. The Museum has only a representative collection of Continental material, but has an excellent series of ancient British pieces, built up in recent years by acquisitions from such hoards as Waltham St Lawrence (Berkshire) and Wanborough (Surrey). Something of the political structure

54 The Celts in Britain: gold 'staters' of the Catuvellauni (left to right): a) King Tasciovanus (late 1st century BC), an important ruler in southern Britain; b) his son and successor Cunobelinus (Cymbeline), who died shortly before the Roman invasion.

56 Coins of Offa, King of Mercia, England (AD 757–96): a) gold copy of an 'Abbasid dinar, said to have been found at Rome; b) silver penny: following Frankish coinage, Offa made the regal penny the normal coinage in England.

of this period is revealed by the find spot distribution and designs of the coins of such rulers as the 'Great King' Tasciovanus And his son Cunobelinus, Shakespeare's Cymbeline.

All non-Roman coinage in Europe ceased during the heyday of the Roman Empire. It began to revive tentatively during the fifth century AD, imitating first Roman

55 Barbarian successors to the Roman Empire (from top to bottom); a) gold solidus of Theoderic (AD 489–523), founder of the Ostrogothic kingdom, struck at Rome; b) gold tremissis, struck at Saragossa, Spain, by the Visigothic ruler Reccared I (AD 586–601); c) Merovingian gold tremissis, struck at Limoges, France, by the moneyer Saturnus.

and later Byzantine prototypes. By the seventh century national characteristics were well developed in Spain and France, whose easily recognisable gold tremisses reintroduced the notion of coinage to England. The burial at Sutton Hoo (c. AD 625), included a purse and thirty-seven such coins, and within two decades similar pieces, now of rather debased gold, were being struck in England.

For the next six centuries little gold was struck in Europe away from the shores of the Mediterranean. Such few as there are, such as Charlemagne's coin minted at Dorestadt or that of Offa struck in imitation of a Muslim 'Abbasid dinar, must have been made for offerings rather than commerce.

Continental silver of this period tended to name its place of mintage as well as the ruler. That struck in England more usually bore the name of a moneyer, and only gradually came to include a mint name. Many Continental series, too, remained almost unchanged over long periods – their types were 'immobilised' – whereas from the reign of Edgar (959–75) to that of Stephen (1135–54) designs on English pennies were periodically changed, testimony to the much closer control that was maintained over the coinage in England.

Gold coinage began to revive in Europe during the thirteenth century, the 'florin' of Florence being particularly influential. English gold coinage hardly began before the mid-fourteenth century, but then the profits from the wool trade and from success in the Hundred Years' War against France led to a huge output, whose stability over a long period is well attested by the Fishpool (Nottinghamshire) hoard, which also shows how Continental gold entered the country to redress a favourable trade balance. The celebrated design of the noble, showing the warlike figure of the king in a ship, was a potent symbol of a strong island power. For

57 ABOVE *(top) Silver denier of the Frankish king Charles the Bald (AD 843–77); (below) a group of English silver pennies: Alfred (AD 871–99), Edgar (AD 959–75), Stephen (AD 1135–54) and Edward I (AD 1272–1307).*

58 BELOW *a) Gold lion of Philip the Good (AD 1419–67), Duke of Burgundy, struck in Flanders; b) gold salut of Henry VI (AD 1422–61): this type of salut is an allegory of the hoped-for union between France and England under the infant king.*

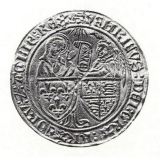

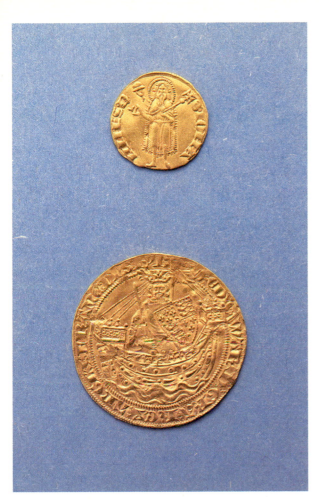

almost three centuries the kings of England had extensive lands in what is now France, and this coinage, too, is well represented in the collection. Remarkable is the design of the 'salute', in which the Angel Gabriel's salutation of the Virgin is made a symbol of the hoped-for union of England and France by the marriage of Henry V with Katherine of France.

58b

A dramatic change – though it took almost a century to accomplish – came about in European coinage after about 1470 under a triple stimulus. First was the impact of immense new supplies of precious metal, particularly of silver, from new mines in Europe and the New World. Secondly came technical developments leading to the increasing mechanisation of coin production. Third was the artistic change brought about by the influence of the Renaissance, starting in Italy and expressed in the revival of realistic portraiture and the use of Roman letters for inscriptions. These features did not of course necessarily come in together; in England, for example, a realistic portrait was normal after 1504, whereas Roman letters did not become invariable until fifty years later.

60

The financial systems of Central and Western Europe all originally stemmed from the eighth-century Carolingian pounds, shillings and pence. By the sixteenth century the same system was applied to widely differing coins in different countries; in Scotland, the pound of 1600 was worth only a twelfth of its English counterpart, the Scots shilling being the equivalent of an English penny. As the value of the unit of currency was eroded by inflation, so the use of money became

59 ABOVE *Medieval gold coins: a) florin, Florence: first issued in 1252, these coins were the basis of Western European commerce in the early fourteenth century; b) noble of Edward III (AD 1327–77): this coin was first struck in 1344 as England became rich from the wool trade and the profits of war.*

60 BELOW *Renaissance gold coinage: a) double-ducat of Louis XII of France, minted in the Duchy of Milan: a classic example of Italian Renaissance coinage; b) 30-shilling sovereign of Elizabeth I of England (AD 1558–1603), which retains many medieval characteristics.*

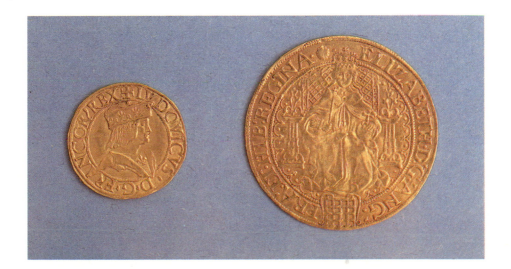

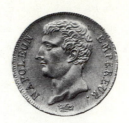

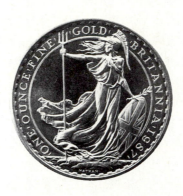

61 *Gold coins of the nineteenth and twentieth century:*
a) 20-shilling sovereign of George IV (1820–30), Great
Britain: Pistrucci's vision of St George and the dragon has
continued in use to the present; b) napoléon of Napoleon I
(AD 1804–14), France; c) Britannia, Elizabeth II (1952–),
Great Britain: a typical modern coin-like ingot, its value
expressed as a weight of fine gold rather than as a
denomination.

increasingly common until it spread to virtually all transactions. Base metal coins of very low value existed, for example, in Portugal and Sicily from the thirteenth century, but modest inflation in England meant that no copper coins existed until the seventeenth century. Until the last quarter of the century lead and copper farthings were often produced by municipalities and tradesmen. These are an important source of personal and economic information, and a very large collection, arranged by county and town or village, is kept in the Museum.

The great days of silver coinage lasted until the eighteenth century when new discoveries of gold, first in Brazil and later in North America, Australia and South Africa, made coins of that metal the dominant high value currency in the nineteenth century. However, the supremacy of gold was short-lived, as paper money was already encroaching on the traditional role of precious metal coinage. In the twentieth century the

61a,b

pressures of two world wars have eliminated all precious metal coinage from currency; it survives only as bullion and in commemorative pieces, like 'Britannia'. Modern coinage is wholly token and is confined to use in minor transactions, yet vast quantities are needed for this purpose and the mechanisation process has advanced from the seventeenth-century screw press through steam power to modern electrically powered coining machines. Now every country sees it as a matter of national pride to have its own issues and thus the variety of coins produced in the world remains as great as ever. The Museum endeavours to collect as much of this as possible, for the time will come when it will be of historical interest.

ORIENTAL COINS

The history of coinage in Asia is well documented in the Museum's holdings. If Lydia, in Western Asia, was the birth-place of the Western coinage tradition, Asia saw the origin and development of three other distinct

62 *Coins of the Chinese series: a) Bronze 'hoe' coin of the Zhou*
kings, China (c. 450 BC); b) bronze '5-grain' coin, Han
dynasty, China (c. 75 BC); c) bronze Guangxu 10-cash coin,
Qing dynasty, China (AD 1875–1908); d) brass cash, Bantam,
Java (16th century AD); e) silver 2½-bat of Rama III
(AD 1824–51), Thailand; f) gold 1-bu, Japan (AD 1601).

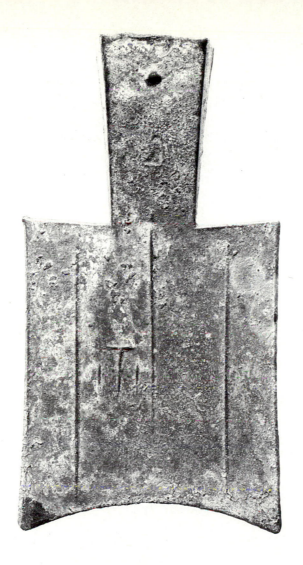

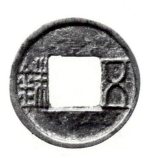

coinage traditions: Chinese, Indian and Islamic, and two lesser independent coinage systems in Japan and Thailand.

China's coinage is the oldest in the world after the Lydian. It originated independently in North China by the sixth century BC and spread during the following centuries to Central Asia, Korea, Japan, Vietnam, Indonesia, Malaysia and Thailand. During the medieval period Chinese coins even circulated as far afield as South India, Iran and East Africa.

China's first coins were cast-bronze copies of hoes, knives and cowrie shells. These objects had all previously been used by the Chinese to make payments, and the first coins standardised their use as money. By the end of the third century BC these curiously shaped coins had all been replaced by flat round coins, each with a square central hole. Coins of this shape remained in use in China until the present century. Throughout their long history Chinese coins retained three other distinctive features: the coins were cast in moulds; they

were made from base metals – bronze, brass, iron or lead; and they were decorated only with inscriptions. Chinese-style coinage was adopted by other nations in the Far East, but these distinctive features were always retained.

The Museum's Far Eastern coins cover the full range of the Chinese coinage tradition, including rare examples of the earliest phases of coinage in China, Japan and Central Asia. The collection is a valuable record of the Far East's economic and political history, and also provides an important visual account of the development of the Chinese writing system.

Together with the coins, the Department also holds an outstanding collection of the gold and silver ingots and paper money which circulated alongside the base metal coins in China and Japan. Included in the Far Eastern coin collection is an extensive series of religious charms made in the shape of Chinese coins. These represent a shared tradition from China, Japan, Korea, Vietnam and Indonesia of using coins as religious charms. The charms carry inscriptions and images relating to a broad range of Far Eastern religions.

India's coinage is almost as old as that of China, but it was not an independent invention and began as an offshoot of Greek coinage. It quickly developed characteristics of its own and spread its influence south and east to Sri Lanka, Burma, Thailand, Cambodia, Malaysia and Indonesia, and northwards in Central Asia.

63 *Coins of the Indian series: a) silver punch-marked coin of Mauryan kings of India (c. 300 BC); b) gold double stater of Kushan king Wima Kadphises (c. AD 75), N.W. India; c) gold dinara of Gupta king Samudragupta (AD c. 335–80), N. India; d) silver tangka from the kingdom of Srikshetra, Burma (c. AD 800); e) gold 5-muhar of the Mughal emperor Akbar (AD 1556–1605), India; f) gold muhar dated 1770 of the British East India Company, Bombay Presidency, India.*

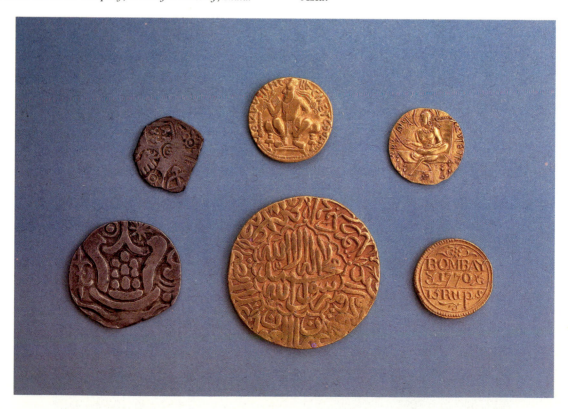

India seems to have derived the idea of coinage from the Greek world via Iran. During the fifth century BC Greek-style coins circulating as money in Iran entered the north-west corner of the South Asian subcontinent. By the end of the fourth century BC silver coins with Indian designs were in circulation throughout northern India. The Greek idea of using stamped pieces of metal as money was modified by the Indians; India's first coins were not stamped in the Greek manner on both sides, but only on one side, and the designs were applied by several punches. The early coins were rarely round like Greek coins, but were often square. The designs mostly consisted of small symbols, stylised images of the sun, moon, animals, trees and so on. The occasional use of square coins has persisted throughout the Indian coinage. Although India has always maintained a distinct coinage tradition, it is possible to trace the impact of successive cultural intrusions by Greek, Iranian, Scythian, Hunnish, Turkic, Mongol and European invaders.

The British Museum's collection of South Asian coins is probably the finest in the world. The full range of Indian coins is represented, with particularly spec-tacular holdings of Indo-Greek, Kushan, Gupta, Sultanate, Mughal and British Indian coins. Much of the chronology of Indian history has been established through a study of its coins. They also give a significant insight into the development of Indian religious thought, providing in many cases the earliest datable and identifiable representations of deities.

The third main Asian coinage tradition, Islamic, began its development in the seventh century BC. It grew directly out of the Western coinage tradition but, in response to the restraints of Islam, it soon established an identity of its own which was carried along with the Islamic faith out of the Middle East, north into Central

64 *Coins from the Islamic series: a) bronze imitation of Byzantine follis, issued in the name of Allah, from Syria, Arabs in Hims (Emesa), c. AD 680; b) gold dinar dated AH 77 (AD 696) of Umayyad caliph Abd al-Malik, Syria; c) bronze coin of Ayyubid ruler Salah al-Din (Saladin, AD 1169–93), Syria; d) gold dinar of Umayyad ruler Hisham II (AD 976–1010), Spain; e) gold kupang of Sultan Muhammad al-Sa'id, Sulawesi, Indonesia; f) silver coin of Timur (Tamerlane, AD 1390–1402), Afghanistan.*

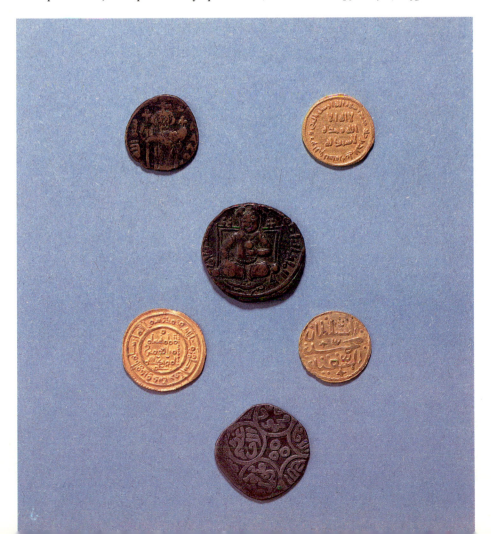

Asia, east to India and Indonesia, and out of Asia, south to East Africa and west into North Africa and Europe.

The first coins struck in the name of Allah, the God of Islam, and his prophet Muhammad were simply copies of Byzantine gold and copper and Sassanian silver coins with short added religious inscriptions, proclaiming the Islamic faith. From AD 696 these imitations were replaced by coins with purely Islamic designs. The Islamic faith was hostile to the use of pictorial representations, so the new designs were inscriptional. The new inscriptions proclaimed Islam, and referred to the denomination, date and place of issue of the coin.

Inscriptional coin designs were used wherever the followers of Muhammad carried his faith. Later additional information relating to local rulers, governors and religious leaders was included in the inscriptions. Departures from the rule against pictures were unusual and, where they occurred, tended to be on bronze coins. In India the regular Islamic coin design was retained, but modified to fit the Indian tradition, often being used on square coins and with symbols to identify the issuing mint or ruler. Remarkable examples are the zodiacal and portrait issues of the Mughals Akbar and Jahangir. Islamic coins, imported from Central Asia by Viking trade through the Baltic and Russia, played an important part in the monetary history of Northern Europe during the ninth and tenth centuries, and they even occur in British hoards.

In addition to these main Asian coinages, the Museum collection also covers two other independent minor traditions which developed in Japan and Thailand. Both these traditions were adaptations of an earlier use of precious metal ingots as money. In Thailand the ingots were bracelet-shaped and the fully developed coinage consisted of stamped bars of silver bent into a tight sphere. Japan's ingots were both gold and silver, slab- or bar-shaped; the coins were the same shape, but stamped with several punches.

In both Central and South-East Asia, where Chinese, Indian and Islamic cultures coexisted, the three main coinage traditions of Asia met and mingled, giving rise to interesting hybrid coinages, such as coins of Chinese shape with Islamic inscriptions, or Indian shape with Chinese inscriptions.

From the late fifteenth century onwards European commercial, imperial and colonial expansion into Asia had a marked effect upon the traditional coinage systems. Apart from a few residual features, Asia's coinages have lost their distinctive identities and become part of the Western coinage tradition. This process of change is particularly well documented by the Museum's collection.

62e
62f

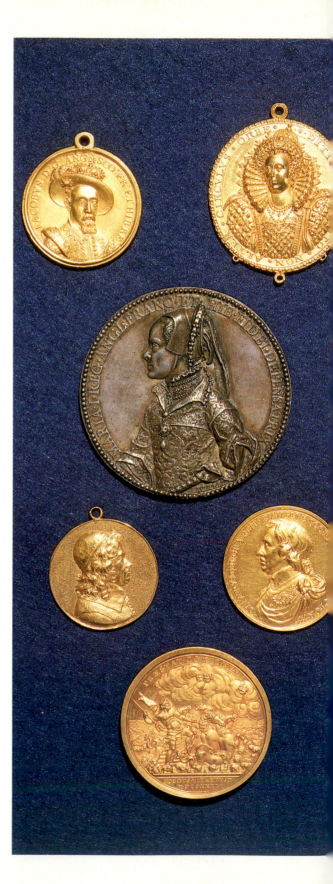

MEDALS

The art of medal-making has its origin in the Italian Renaissance, and flourished throughout Western Europe in the succeeding centuries. The British Museum's collections are drawn from every European and many non-European countries from the fifteenth century to the present day. The oldest medal in the collection, in fact the first modern medal, was struck to celebrate the capture of Padua by Francesco II da Carrara in AD 1390.

Many early medallists, such as Pisanello, produced

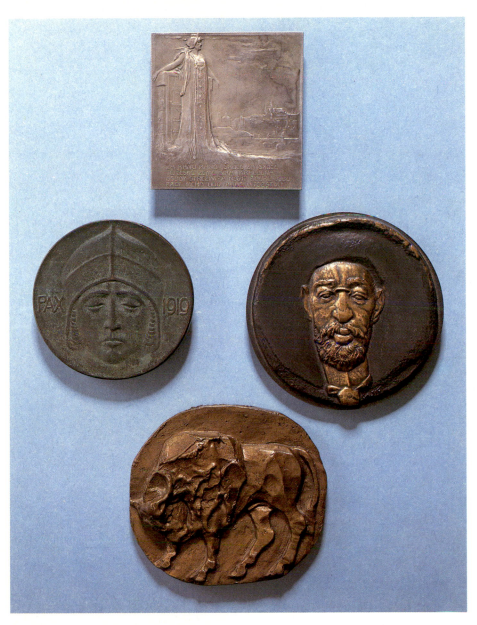

65 LEFT *Gold and silver medals of the seventeenth and eighteenth centuries: a) James I: Peace with Spain (1604), perhaps by Nicholas Hilliard; b) Elizabeth I: Dangers Averted (c. 1588), perhaps by Hilliard, executed shortly after the defeat of the Armada; c) Mary I: The Happy State of England (1555), by Jacopo da Trezzo; d) John Thurloe (c. 1653), by Abraham and Thomas Simon; e) Oliver Cromwell (1653), by Thomas Simon; f) Second Treaty of Vienna (1731), by John Croker.*

66 ABOVE *Medals of the twentieth century: a) Prague (1909), by Stanislas Sucharda; b) Pax (1919), by Erzsebet von Esseö; c) Toulouse-Lautrec (1964), by André Galtié; d) bison (1975), by Elizabeth Frink: presented to eminent British zoologists. All bronze except a), which is silver.*

67 *Bronze medal of John* VIII *Palaeologus, Byzantine emperor 1423–48, made by Pisanello in 1438.*

cast pieces far more closely related to paintings and sculpture than to coins, and have left us superb likenesses of the appearance of notable contemporaries, such as John Palaeologus, the Byzantine emperor (AD 1421–48), of whom the numismatic record is disappointing.

Between about 1500 and the end of the last century there was a tendency to assimilate the style and technique of coins and medals, but since that time the genres have once more separated, with medals losing much of their official character. Casting is again a normal technique, and there have been remarkable instances of experimentation in style and form, emphasising anew the medal as an art form rather than as a vehicle for commemoration.

The Department contains a comprehensive collection of British medals of all periods, including two versions of Nicholas Hilliard's famous 'Dangers Averted' medal of the time of the Armada, a fine series of portraits by Thomas and Abraham Simon, and a complete set of the beautiful medals engraved by John Roettiers after the Restoration. Italian Renaissance and sixteenth-century medals are well represented, as are French and Dutch, Swiss and Scandinavian seventeenth- and eighteenth-century medals. The German medals of this period, accumulated by the Hanoverians, are particularly worthy of note, as are the outstanding collection of German First World War material, the wide-ranging, if not yet entirely representative, collec-

tions of late nineteenth- and early twentieth-century European and American medals and the growing number of late twentieth-century pieces. Dies and models for medals, political and satirical badges and tokens, military medals and decorations also contribute to the unusually comprehensive nature of the Museum's medallic collection.

PAPER MONEY

Circulating paper money was first used in China in the late tenth century AD, but did not appear in Europe and the West until the seventeenth century, with issues in Scandinavia, Britain and America. Growth of trade and industry encouraged the rise of banking and the convenience of paper in the eighteenth and nineteenth centuries. Many ventures were heavily based on credit, showing more optimism than business sense, and legislation to place banks and note issue on a firmer financial footing resulted in the rationalisation and centralisation of banking services. Today the right to issue notes is almost exclusively the privilege of central banks and state treasuries.

The British Museum's collection of banknotes and related items illustrates the historical development and geographical spread of paper currency. Altogether almost two hundred countries are represented, with material dating from such early examples as notes issued by the Chinese Board of Revenue during the Ming dynasty (AD 1368–1644) and seventeenth-century issues from Sweden and Norway, to modern state issues from developing Third World countries. The collection includes not only state and privately issued banknotes, but also emergency and political issues, cheques, postal orders, printers' specimens, and artwork for note designs. Even credit cards have a place. All British paper money is well represented, with particularly good collections of notes from Scotland, the Isle of Man, and the English country banks of the nineteenth century.

The Museum's paper money is acquired by donations, loans and purchases. Several important series of notes have come from major private collections and many countries around the world help to keep the collection up to date by sending examples of their current note issues. We house on permanent loan the Chartered Institute of Bankers' collection of paper money, comprising some 10,000 British notes and 20,000 notes from the rest of the world. Combining this excellent collection with our own holdings has ensured that the British Museum contains one of the foremost collections of paper money in the world.

68 BELOW *Unissued five-pound note of the Hull Banking Co., Kingston-upon-Hull, England, 1840–49.*

69 ABOVE *Réunion, 1,000-franc note (equivalent to 20 new francs), 1958–73.*

EGYPTIAN ANTIQUITIES

T he British Museum houses one of the world's great collections from ancient Egypt. Every aspect of this civilisation over six thousand years is illustrated, from the Predynastic cultures to early Christian times. The collections of the Department of Egyptian Antiquities include all types of object in many different materials – from paintings, inscribed and written documents, metalwork, stone-carving and woodwork, to pottery, glass, jewellery and textiles. The early Christian, or Coptic collections, including inscribed gravestones, textiles and domestic objects, bring the collections up to the ninth century AD, while Islamic material from Egypt, dating from the seventh century onwards, is kept in the Department of Oriental Antiquities.

The oldest objects in the British Museum's Egyptian collections date from the fifth millennium BC. The Predynastic inhabitants of the Nile Valley were hunters who gradually settled in permanent villages and learned the skills of agriculture. Their tools are carefully worked from flint; the finest example, the Pitt-Rivers knife, has an ivory handle carved with scenes of animals and hunting. A distinctive range of fine handmade ceramics and stone vessels was produced at this early period. Some objects remain enigmatic, such as a series of slate palettes, shaped as animals, birds and fish. These may embody divine representations. Many show the stains of eye-paint and were undoubtedly used for grinding pigments – their primary purpose; others are larger and more elaborate, and carry carved scenes which may reflect events of historical importance. The Battlefield Palette, for example, which shows a lion attacking men, is probably an allegorical scene of a king slaying his enemies. A similar symbolic reference to a national struggle may be contained in the marvellous scenes on the Hunters' Palette, where men hunt lions and other wild animals.

By far the most striking element of the Museum's Egyptian collection is its large and impressive array of sculpture. Statues were produced almost entirely for religious purposes, to promote the worship of deities, to glorify the power of specific kings, to obtain benefits for private persons, or to act in a more specific funerary role, representing the person of the deceased. Some sculpture was monumental in the strictest sense of the term being part of the architectural embellishment of temples, but most pieces were conceived in private roles, to be consigned to the darkness of the tomb or to the unfrequented courts of temples.

Among the very earliest datable sculptures is an ivory figurine of a woman of the Badarian culture, from the early fourth millennium BC. This piece is crudely executed and has no recognisably Egyptian features. An exceptionally fine early sculpture is a small ivory of an unidentified king of the First or Second Dynasty (*c.*

72 *Ivory figure of a king wearing the White Crown of Upper Egypt and the cloak of the* Sed-*festival. From Abydos, Early Dynastic Period, about 2900* BC. H *8.8cm.*

71 *Carved slate palette, known as the Hunters' Palette from the scenes of hunting wild animals with which it is decorated. Late Predynastic Period, about 3100* BC. L *66.5cm.*

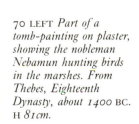

70 LEFT *Part of a tomb-painting on plaster, showing the nobleman Nebamun hunting birds in the marshes. From Thebes, Eighteenth Dynasty, about 1400* BC. H *81cm.*

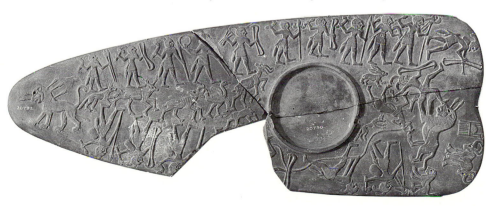

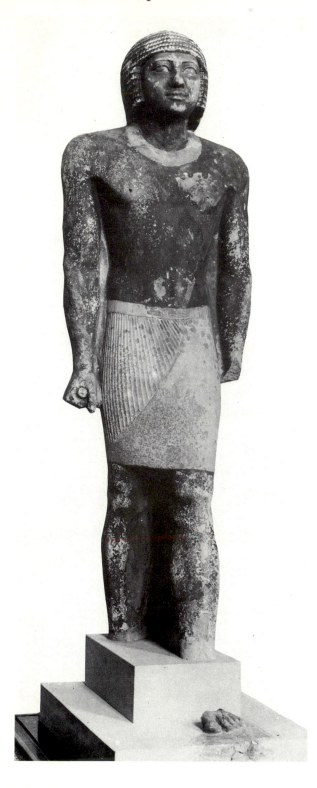

73 *Standing tomb-statue of Nenkheftka, carved in limestone and painted. From Deshasha, Fifth Dynasty, about 2400 BC.* H *1.34cm.*

2800 BC), which is delicately carved. Perhaps the most outstanding piece of Old Kingdom sculpture in the collections is a figure dating to the Fifth Dynasty (*c.* 2494–2345 BC) and representing a nobleman, Nenkheftka, in the classic pose of the Egyptian standing figure: left foot forward, arms held straight by the sides. Breaking away from this conventional pose is a wooden figure of the Sixth Dynasty (*c.* 2200 BC) of the youthful Meryrehashtef. One of the most striking and expressive of Old Kingdom sculptures, this is one of a series of figures from Meryrehashtef's tomb showing him at different stages of his life.

Statues such as these were intended to act as a residence for the soul of the deceased in his tomb, and offerings made to them could be enjoyed by the spirit of the dead. Colouring as well as pose was conventional: the flesh tones of male figures were rendered by red paint (as, for example, on the figure of Nenkheftka), female yellow. This contrast is particularly well illustrated by a tomb group of the Fourth Dynasty (*c.* 2600 BC), a painted limestone sculpture showing the seated figures of Katep and his wife Hetepheres.

During the Middle Kingdom (*c.* 2050–1786 BC) the range and style of sculpture changed quite dramatically. Royal statues show a new realism in depicting the care-worn features of the ruler, revealing him as a man rather than as a detached god-king. Three almost identical black granite statues of Sesostris III (*c.* 1878–1843 BC) from Deir el-Bahri are fine examples of the genre. The realism of Middle Kingdom royal portraiture is reflected to a lesser extent in private sculpture of the period. For the first time statues of private individuals began to appear in temples as well as in tombs, enabling the owner to partake of any offerings made to the god of the temple. Changes in usage were accompanied by changes in form, the so-called 'blockstatue' making its first appearance. The British Museum possesses one of the earliest known examples of this type, the statue of Sihathor; the figure, in its original niche, squats on the ground, his limbs covered by an all-enveloping cloak. As a form it was to become increasingly popular, since it removed the need to carve the body in detail and provided large, relatively flat surfaces which could be used for inscriptions. This was important, since it was the inscription rather than the features which gave precise identity to the statue.

The most important series of sculptures belongs to the New Kingdom, outstanding among which is a royal head in green schist, possibly depicting Queen Hatshepsut (*c.* 1503–1482 BC) or her co-regent and successor Tuthmosis III (*c.* 1504–1450 BC). There are several representations of Amenophis III, including the head and an arm from a colossal statue in red granite; its torso still lies in the precincts of the temple of Mut at Karnak. A number of statues may be attributed by their youthful features to Tutankhamun, but the inscriptions

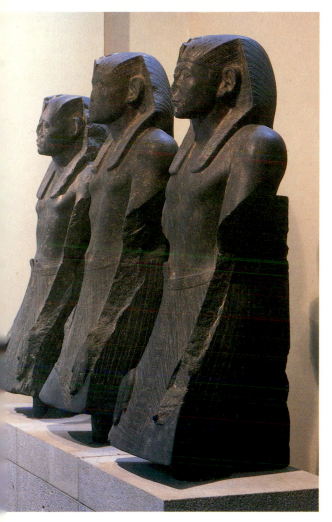

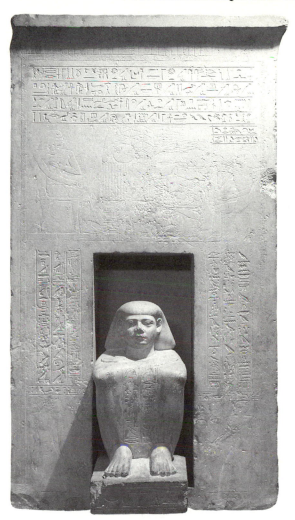

74 *Three black granite statues of King Sesostris III. From Deir el-Bahri, Twelfth Dynasty, about 1850 BC. H (average) 1.40m.*

75 *Limestone funerary stele of Sihathor, with a recess for a statue of the same material. The squatting figure of Sihathor is one of the earliest known examples of a block-statue. Twelfth Dynasty, about 1850 BC. H 1.12m.*

are of Horemheb, who usurped many of Tutankhamun's portraits.

A remarkable sculpture of the Nineteenth Dynasty, the so-called Younger Memnon, was removed from the Ramesseum at Thebes by Giovanni Battista Belzoni. This is the upper part of a colossus of King Ramesses II (*c.* 1304–1237 BC), striking for its use of two-tone granite. A standing sculpture of Ramesses II's son Khaemwese is carved from breccia, another unusual material. This very hard conglomerate stone presented enormous technical difficulties which the sculptor of this fine piece was only partially able to surmount. A fragmentary black granite sculpture of a young prince wearing the sidelock of youth may represent Ramesses II's eventual successor, Merneptah, or the future Sethos II.

The British Museum's collections are particularly rich in private sculpture of the New Kingdom on both large and small scale. Two interesting statues of the influential official Senenmut date to the reign of Queen Hatshepsut. One is a block-statue in quartz; the other, in black granite, is more unusual, and shows Senenmut with the princess Neferure on his lap. The recent acquisition of a fragmentary scribe-statue of the general Djehuty has a particular historical interest: Djehuty's capture of the city of Joppa in Palestine is recounted in a papyrus in this collection. One of the most skilful and charming pieces from this period, a little less than life size and evidently originating from the Memphite necropolis, shows an unnamed official and his wife seated hand in hand. Carved in limestone, the piece is uninscribed and is probably unfinished.

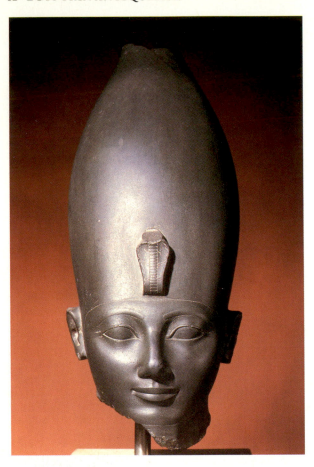

76 Head of green schist, representing either Queen Hatshepsut or her successor, Tuthmosis III. Eighteenth Dynasty, about 1480 BC. H 45.7cm.

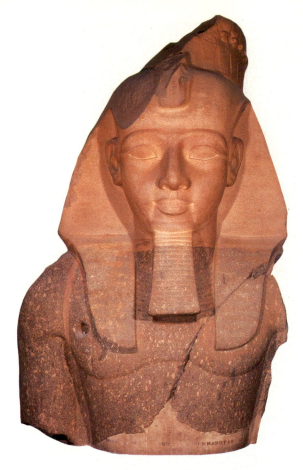

77 Upper part of a colossal granite statue of Ramesses II, known as the Younger Memnon. From Ramesses' mortuary temple at Thebes. Nineteenth Dynasty, about 1250 BC. H 2.67m.

Sculpture of animals became increasingly common during the New Kingdom, and the British Museum possesses many fine examples. On a monumental scale are two red granite lions, dating from the reign of Amenophis III (*c.* 1417–1379 BC). Both were set up as guardian figures before Amenophis' temple at Soleb in Nubia, but in the third century BC were moved south to Gebel Barkal. From early times animals were connected with the worship of deities, and many gods were represented either wholly or partially as animals. Thirty lion-headed figures of the goddess Sakhmet also date from the reign of Amenophis III: over six hundred were set up by the king in his mortuary temple and in the temple of Mut at Thebes, some of which are still in situ. The British Museum possesses the largest collection of these outside Egypt. Of the many other animal sculptures in the collections mention may be made of a life-size figure of a baboon, sacred to the god Thoth, and a fine head of a cow carved in alabaster

from a cult statue of the goddess Hathor at Deir el-Bahri.

Royal sculpture of the Late Dynastic Period is particularly well represented by two fine pieces of Nubian origin: a sphinx and a large ram incorporating an image of the king Taharqa of the Twenty-Fifth Dynasty (*c.* 690–664 BC). Much private sculpture of the period harks back to forms of the Old Kingdom. For example, a limestone statue of Tjayasetimu is based on a standing mortuary figure like that of Nenkheftka, while a head from a statue of a high official (the so-called Benson Head) from Karnak wears a wig commonly encountered in the Old Kingdom.

From the seventh century BC it became a common practice to deposit bronze figures of gods in their sanctuaries: the donor hoped thereby to partake of the beneficence of the particular deity. Most of the Department's bronze sculpture consists of votive figures of gods or sacred animals, although some depict kings and

79

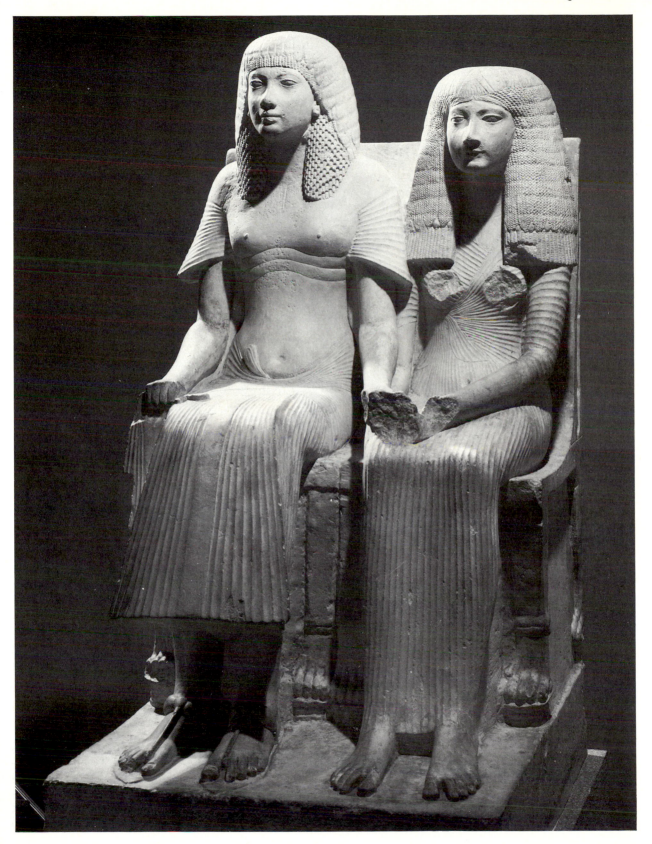

78 *Statue of an unnamed nobleman and his wife carved in limestone. Eighteenth Dynasty, about 1325* BC. H *1.3m.*

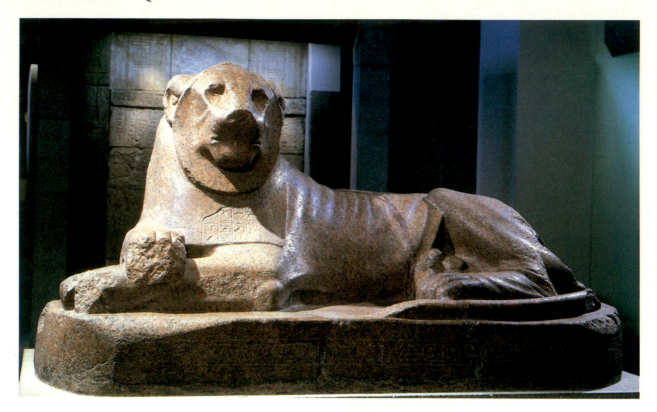

80 BELOW *Schist head of a young man. The sculpture features Greek as well as Egyptian characteristics and is finished with excellent detail. From Alexandria, Roman Period, after 30 BC. H 24.5cm.*

79 ABOVE *Statue in red granite of a recumbent lion, one of a pair originally set up at the temple of Soleb in Nubia. It has inscriptions of Tutankhamun and the much later Meroitic ruler Amanislo. Eighteenth Dynasty, about 1380 BC. H 1.17m.*

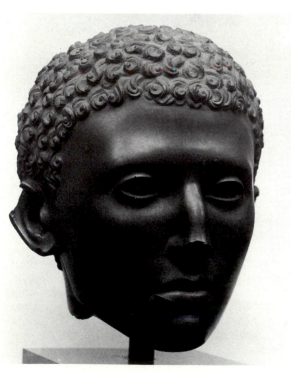

private individuals. Examples of most of the Egyptian pantheon are represented. Perhaps the finest bronze is the Gayer-Anderson Cat, incarnation of the goddess Bastet, cast hollow with ear-rings of gold and an inlaid pectoral of sheet silver. Another splendid piece, cast in silver and embellished with gold foil, depicts the god Amen-Re.

During the Graeco-Roman period a degree of realism unknown since the Middle Kingdom began to reappear in Egyptian sculpture. Though not yet able to be classed as true portraiture, the treatment of heads was less stereotyped, and statues of this period can be said to attempt a likeness of their subject. The most striking example of this type of work is a schist head of a young man from Alexandria. The face has the high finish characteristic of Egyptian sculpture of the Late Period, although the treatment of the features and the unpolished, random curls on the head betray Greek influence.

Closely related to sculpture in the round is the technique of relief carving, which was used extensively to decorate not only the walls of temples and tombs, but also funerary and dedicatory stelae, of which the De-

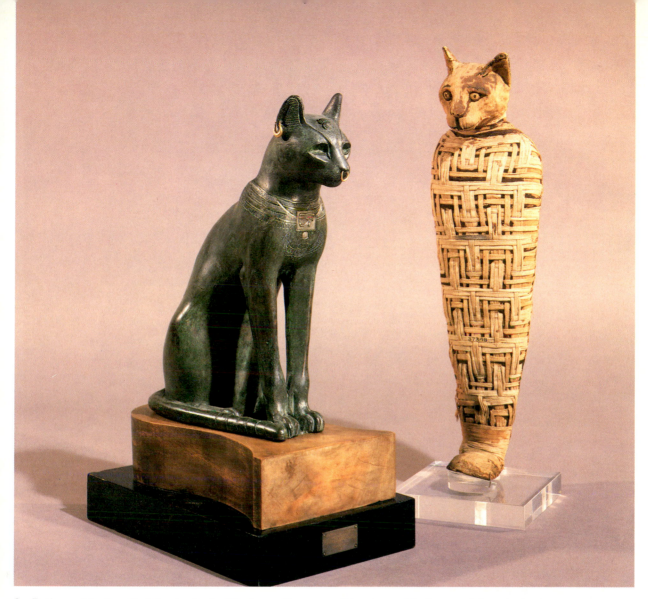

81 *Evidence of the Late Period animal cults. The bronze Gayer Anderson Cat (left) represents the goddess Bastet. A silvered pectoral bears the sacred eye of Horus. The intricately wrapped mummy of a cat (right) is from Abydos. Roman Period, after 30 BC. H (Gayer Anderson Cat) 38cm.*

partment has a large and wide-ranging collection. Two principal techniques were in use: in raised relief the background was cut away leaving the figures standing out from the surface, while in sunk relief the figures were cut into the background. Both techniques allow the figures to be modelled. On the whole the quality of sunk relief tends to be less good, although it is more effective in bright sunlight, where the sharp shadows make the decoration stand out. Some of the best-quality raised reliefs belong to the Old Kingdom, and fine examples can be seen in the stele of Rahotpe, the

false door of Kaihap, and the reliefs of Iry and Int. From the Late Period a relief of Osorkon II from the Twenty-Second Dynasty (*c.* 874–850 BC), and a slab of Nectanebo I of the Thirtieth Dynasty (380–362 BC) are good illustrations of sunk relief.

Both raised and sunk reliefs were painted, although much of the paint has now vanished. Where carved relief was not possible, the decoration could be provided in the form of wall-paintings. Although this may have been considered second best by the Egyptians themselves, the wall-paintings are perhaps the liveliest and most appealing products of Egyptian decorative art to have come down to us. The principal colours used were white, black, red, green and yellow, produced from naturally occurring minerals. While a brush was employed for larger areas, for fine detail the colour was applied with a reed chewed at one end. A wide range of Egyptian artists' equipment is to be found in the British Museum, from brushes, palettes, grinders and pig-

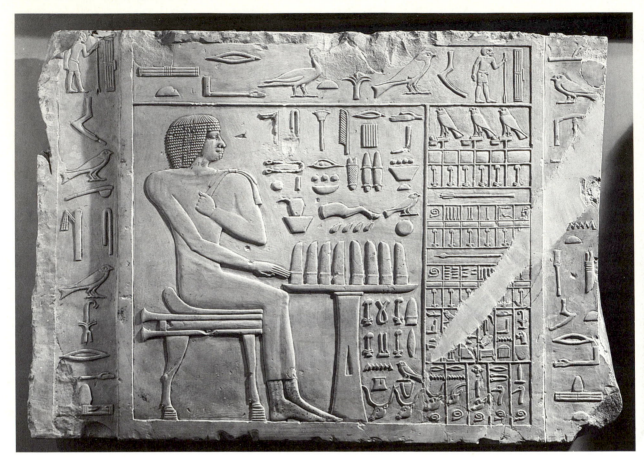

82 *Limestone stele of Rahotpe from his tomb at Maidum. It is decorated in low relief with a figure of the owner before a table of offerings. Fourth Dynasty, about 2600 BC. H 79cm.*

ment, to the lengths of paint-daubed string used for marking out a grid in preparation for the transfer of the artist's preliminary sketches onto the prepared surface of the wall. The method is well illustrated by a wooden 83 drawing board on which, within a grid, is sketched a seated figure of Tuthmosis III.

The earliest paintings in the British Museum belong to the Fourth Dynasty and come from the tomb of Nefermaat and Itet at Maidum. Although only fragments, they display a high level of skill. On the first is part of a bird-trapping scene in which one figure holds a well-observed decoy duck, while a second man pulls on the rope of a clap net. The second painting shows a man leading an antelope. The majority of tomb-paintings in the collection date from the New Kingdom and originate from the tombs of the vast Theban necropolis. A group of six paintings from the tomb of an official of Tuthmosis IV called Sobkhotpe includes a striking series of scenes representing the presentation of tribute

by foreigners (Nubians and Asiatics); another fragment from the tomb shows jewellery- and metal-workers making beads and vessels of precious metal.

An outstanding group of eleven paintings comes from a tomb which has never been identified to the complete satisfaction of Egyptologists. It belonged to an official with the titles 'scribe and counter of grain', whose name may be restored as Nebamun. The artistic quality of these paintings is of the very highest standard. Probably the best-known scene, full of life and interest, shows Nebamun and his family fowling in the marshes; the detail and precision with which the animals are portrayed are striking. Three paintings originally formed part of a banqueting scene. One fragment shows two graceful dancers accompanied by four female musicians; two of the figures are depicted full-face, contrary to normal convention. Other fragments illustrate life on the estate of Nebamun: his garden and pool; the counting of cattle and geese; the estimation of the harvest yield for taxation purposes. These scenes, too, display remarkable skill in the depiction of the animals and in their composition.

Some of the paintings in the collection are from the tombs of the necropolis workforce at Deir el-Medina; their relative stiffness demonstrates how far Theban

83 *Drawing board covered with a thin layer of plaster, marked out in red with a grid within which is drawn a seated figure of Tuthmosis* III. *Eighteenth Dynasty, about 1450 BC.* H *36.4cm.*

painting had declined since the great days of the Eighteenth Dynasty. Another series of fragments comes from the city of the heretic king Akhenaten at El-Amarna: among the most free in design, these paintings originate not in tombs but in the palaces and houses of the new capital. Scenes of animals and plants are the most popular, life in the marshes being a particularly favoured motif.

One of the strengths of the British Museum's Egyptian collection lies in its wide range of written and inscribed material. Most ancient Egyptian sculpture was inscribed with texts which play an important part in establishing the statues' function and significance. The other main sources are relief fragments, stelae, papyri and ostraca. The best-known of the British Museum's inscribed monuments is the Rosetta Stone. It was among the antiquities gathered by the *savants* of Napoleon's military expedition to Egypt and ceded to British forces in 1801. The stone is part of a monument

containing a decree dated to year 9 of Ptolemy V (196 BC), inscribed in Egyptian (in both hieroglyphic and demotic scripts) and in Greek. From the first it promised to provide the means by which the secrets of ancient Egypt might be revealed, and it provoked great interest among scholars and public alike. It was with the help of the Greek version that scholars were finally able to decipher the Egyptian scripts. The subsequent study of the Egyptian language and scripts made it possible for the many inscribed objects and written texts which have survived to be read and understood.

Another valuable historical document is the King List, recovered from the temple of Ramesses II at Abydos. Compiled under Ramesses II, it records all previous kings he thought worthy of commemoration. It is one of several such lists, the best preserved of which still exists in the temple of Sethos I at Abydos. Although damaged and incomplete – they have several important omissions, notably the kings associated with the period of 'heretical' rule introduced by Akhenaten – the King Lists have provided an invaluable source for establishing a chronological framework of ancient Egyptian history.

Other reliefs in the collections contain important religious texts. One such is found on the Shabaka

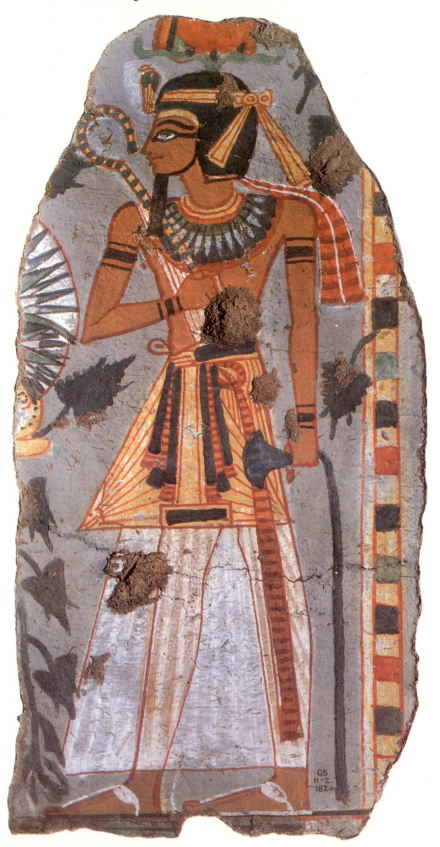

84 *Painting of King Amenophis* I *from the Ramesside tomb of Kynebu at Deir el-Medina. The king is shown in his regalia, holding a lotus flower and a sceptre. Twentieth Dynasty, about* 1140 BC. H 44cm.

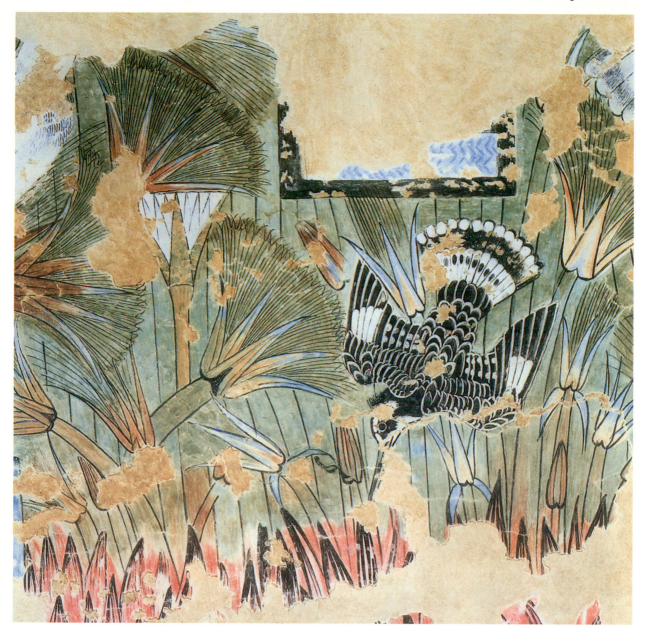

85 *Part of the rural decoration in the 'Green Room' of the Northern Palace at El-Amarna. A kingfisher swoops down through the papyrus thicket to fish in the waters below. Eighteenth Dynasty, about 1350 BC.*

Stone, a carefully carved inscription of the eighth century BC which was partially destroyed in late antiquity or medieval times when the slab carrying the text was used as a millstone. This is a treatise on the Memphite theological system in which the god of Memphis, Ptah, takes a prominent role. Another interesting religious inscription dates from an earlier period: the stele of the brothers Suty and Hor, architects in the reign of Amenophis III (*c.* 1417–1379 BC). This impressive monument includes prayers to different forms of the sun-god; one in particular is addressed to Aten, the solar disc, which later became the sole object of official worship under Akhenaten (*c.* 1379–1362 BC).

Funerary stelae such as that of Suty and Hor are a rich source of information about the ancient Egyptians. The earliest stelae were simple memorials, bearing the name and titles of the deceased, as, for example, that of the Second Dynasty king Peribsen. By the end of the First Dynasty truly funerary stelae were being pro-

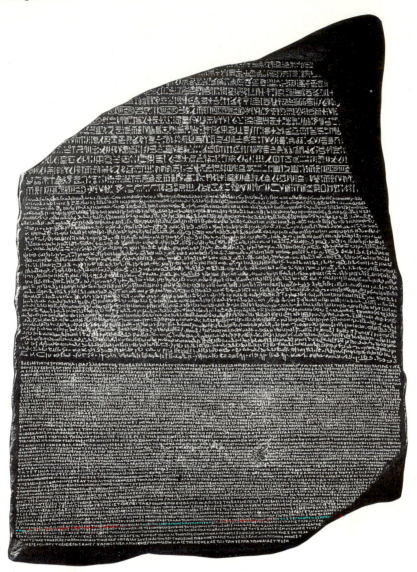

86 ABOVE *The Rosetta Stone. A slab of black basalt incised with the same priestly decree concerning Ptolemy V in three scripts (hieroglyphs, demotic and Greek) but only two languages (Egyptian and Greek). From Rosetta, 196 BC. H 1.14m.*

87 RIGHT *Part of a list of the kings of Egypt from the temple of Ramesses II at Abydos. Several lists of this kind have survived, the most complete example being in the temple of Ramesses' father, Seti I, also at Abydos. Nineteenth Dynasty, about 1250 BC. H 1.38m.*

duced; these were carved with scenes and texts directly connected with securing posthumous benefits for the deceased. From the start these scenes took a standard form: the deceased seated at an offering table upon which are loaves of bread, with simple texts enumerating the various food and drink offerings and the name and titles of the deceased.

During the Old Kingdom the predominant type is the large, false door stele, so called because it takes the form of a blind door. The false door of Kaihap is a fine example from the Fifth Dynasty; its carvings in low relief are of the highest quality. The false door was gradually superseded by a new, smaller type of funerary stele on which it was not uncommon to include an account of the career of the deceased. The niche-stele of Sihathor, for example, records that he directed the making of sixteen statues of the king to be set up near the royal pyramid; on the stele of Inyotef the owner describes his own virtues and qualities, additionally explaining his methods of dealing with superiors,

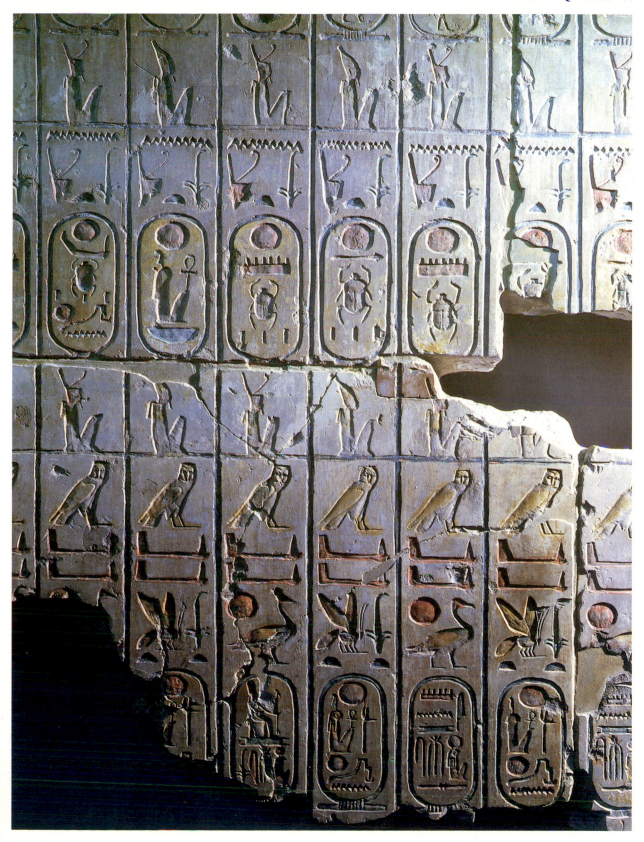

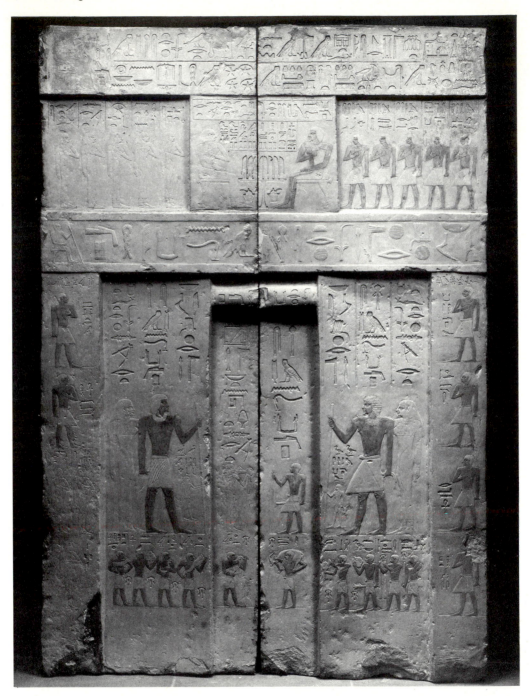

equals and inferiors in the course of his daily work. Many of the Middle Kingdom stelae, including that of Sihathor, come from Abydos, traditionally the principal burial place of the dismembered Osiris, and consequently a favoured location for cenotaphs of persons actually buried elsewhere.

Stelae of the New Kingdom frequently show the deceased worshipping gods of the Underworld, such as Osiris and Anubis; examples include the stelae of

Sobkhotpe, scribe of the wine cellar, and of Baken-amun, chief cook in the household of Queen Tiy. Each of these stelae retains its original paint. The official religion of ancient Egypt was designed to stress and enhance the relationship between the king and the gods, and its material remains offer a poor reflection of the beliefs of the average Egyptian. Personal piety is well illustrated, however, by an interesting series of stelae from the workmen's village at Deir el-Medina.

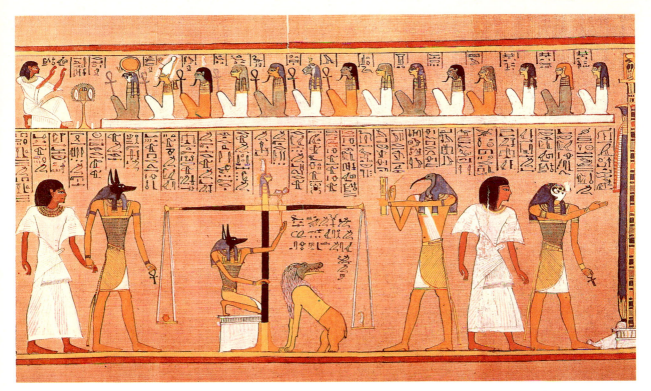

89 ABOVE *Weighing of the heart of the deceased, from an illustration in the papyrus of the royal scribe Hunefer. The weighing of the heart against the feather of Truth was a major part of the Egyptian Judgement of the Dead. Nineteenth Dynasty, about 1250 BC. H 39cm.*

88 LEFT *Limestone false-door stele of Kaihap, decorated with figures of the owner in low relief. The hieroglyphs are finely executed in both raised and sunk relief. From Saqqara, Fifth Dynasty, about 2400 BC. H 2.07m.*

Several small shrines within the settlement were available at which individuals might offer prayers, often by means of a votive stele showing the donor worshipping his chosen deity. Occasionally the design incorporates a number of ears, which were intended to ensure that the prayer be heard. The texts on these stelae, which date to the Ramesside period, sometimes take the form of a plea for mercy; afflictions of the body, such as blindness, are frequently attributed to the god as a punishment for some transgression against him – as on a stele offered to Ptah by the workman Neferabu. The custom of making funerary stelae continued through to the Graeco-Roman period. Hellenistic funerary stelae bear Greek inscriptions and often represent the deceased in Greek costume with the jackal-headed god Anubis.

By far the most extensive and important class of documentary material held by the Museum comprises the papyri written in the hieroglyphic, hieratic and demotic scripts. The best known of these are the funerary documents described as *Book of the Dead* papyri, collections of religious and magical texts which were intended to ensure a satisfactory afterlife and to enable the deceased to leave his tomb when necessary. Descended from the earlier *Pyramid Texts* and *Coffin Texts*, the earliest *Book of the Dead* papyri date from the Eighteenth Dynasty (c. 1567–1320 BC) and the finest copies are beautifully illustrated with coloured vignettes, such as those prepared for Ani, Hunefer and Anhai. In the Late New Kingdom and the Saite period the vignettes are sometimes rendered as brush and ink drawings, good examples of which include those of Nesitanebtashru (the Greenfield Papyrus) and Ankhwahibre.

Apart from magical and religious texts, the papyri in the collection cover a wide range of subject matter. Wisdom literature includes didactic works composed of maxims and precepts; *The Instruction of Ammenemes I* is a typical example, consisting of advice from the king to his son. The collections also contain one of the earliest copies of the *Maxims of Ptahhotep*, an Old Kingdom high official (c. 2380 AD) and the *Instructions of Onkhsheshonqy*, written in demotic. Another class of literature is pessimistic in character; many other papyri contain poetry, lyrics and hymns. A number of stories have also been preserved, such as *The Tale of Two*

89

Brothers, The Blinding of Truth by Falsehood, The Prince who knew his Fate, and *The Capture of Joppa.* Scientific writings include texts on mathematics (such as the Rhind Mathematical Papyri), astronomy and medicine (for example, the London Medical Papyrus and the Chester Beatty Papyrus). A fascinating glimpse into Egyptian life is offered by private letters, and business and legal documents, written at first in hieratic script and later in demotic. Particularly fascinating are the documents that chronicle the investigations into Theban tomb-robberies in the Twentieth Dynasty; these include records of the evidence given by the accused, and lists of objects found in the possession of the guilty parties.

Other forms of document include inscribed tablets of wood, frequently overlaid with gesso, and ostraca (flakes of white limestone or potsherds). The latter tend to contain texts of an ephemeral nature, such as school exercises, drafts of contracts, deeds and letters, records of attendance at work, inventories, magical texts and oracles; the British Museum has thousands of documents of this sort.

Since much of our evidence for the life of the Egyptians comes from their tombs, material relating to their funerary beliefs and customs is abundant in the collections. During the Predynastic Period (before 3100 BC) graves consisted of shallow pits in the ground; a reconstruction of such a burial in the British Museum shows the body surrounded by a typical selection of grave-goods. The body owes its preservation to the desiccating effect of the sand in which it was buried. Small coffins of basketwork or wood are from a slightly later date. The use of coffins removed the body from contact with the sand and encouraged rapid decomposition. Since the Egyptians believed it necessary for the body to be preserved for the next life, the first tentative steps towards artificial preservation were made. Evisceration of the body was practised from at least the Fourth Dynasty (c. 2600 BC), and the British Museum's collections chart the development of mummification and ancient Egyptian burial practice to Roman times.

Simple rectangular wooden coffins were used throughout the Old and Middle Kingdoms. The tendency towards increasingly elaborate decoration can be illustrated by comparing the simplicity of the Sixth Dynasty coffin of Nebhotep, decorated merely with bands of text, with that of Gua, a high official of the Twelfth Dynasty. Gua had two coffins, which fitted inside each other, both painted inside and out. On the

90 BELOW *Limestone ostracon inscribed with a hieratic text forming part of the record of an enquiry into the ownership of a tomb. Nineteenth Dynasty, about 1300 BC. H 16.3cm.*

91 RIGHT *Reconstructed shallow grave containing a naturally preserved body lying in a contracted position, with examples of grave-goods of similar age. From Gebelein, Predynastic Period, about 3250 BC. L (body) 1.63m.*

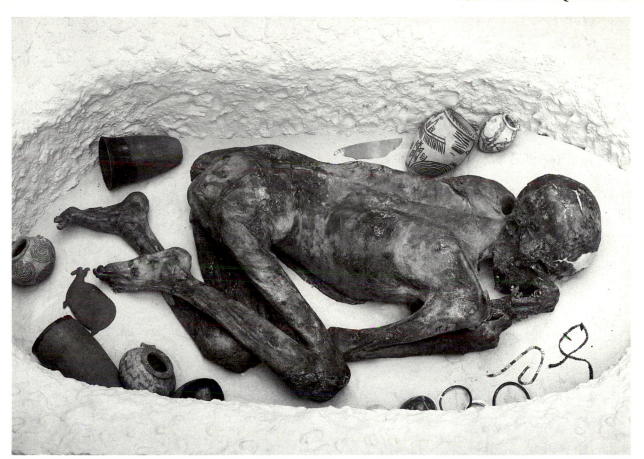

interior of the coffins are extracts from magical texts written in black ink (the so-called *Coffin Texts*) intended to safeguard the passage of the deceased through the Underworld and to ensure his eternal survival. The painted scenes show objects which were included in the funerary equipment, such as weapons and stone vessels intended for the use of the tomb-owner.

In the Twelfth Dynasty (*c.* 1991–1786 BC) masks of plaster-reinforced linen were sometimes placed over the faces of mummies, a custom which led ultimately to the appearance of coffins in human form. A particularly interesting coffin of this type is that of King Nubkheperre Inyotef, which consists of gilded wood with surface decoration in the form of feathers: this design was characteristic of the period, and was thought to represent the wings of the goddess Isis protecting the body of Osiris.

Coffins of the New Kingdom were normally made of wood or cartonnage (moulded linen and plaster). These human-form coffins are in most cases covered with religious texts and scenes inside and out. Rich burials were frequently supplied with a 'nest' of several such coffins. One of the finest examples in the British Museum belonged to Henutmehit, a priestess of Amun who probably lived during the Nineteenth Dynasty (*c.*

1290 BC). Each of her two splendid coffins was gilded and fitted with inlaid eyes. In addition, her mummy was overlaid by a cartonnage cover which fitted within the inner coffin. The painted decoration normally encountered at this period is mythological, with scenes showing the deceased praising the gods; typical examples are found on the Twenty-First Dynasty wooden coffin of Djedhoriufankh. On the floor of the coffin is painted a large figure of Amenophis I, an Eighteenth Dynasty king who by now was revered as patron of the Theban necropolis. The inner surfaces of the sides are covered with offering scenes, while the interior of the canopy bears a painting of a vulture goddess hovering protectively over the deceased.

The art of mummification reached its peak in the Twenty-First Dynasty. A finely bandaged mummy of an unnamed Theban priestess, still in her original painted wood coffin, may date from this period. Other mummies from the Twenty-Second Dynasty are preserved in their cartonnage inner coffins, which are covered wth painted scenes and funerary inscriptions. The standard of mummification declined from this point on, but in the Roman Period bandaging became more elaborate. A particularly good example from the first century AD is the mummy of a boy wrapped in

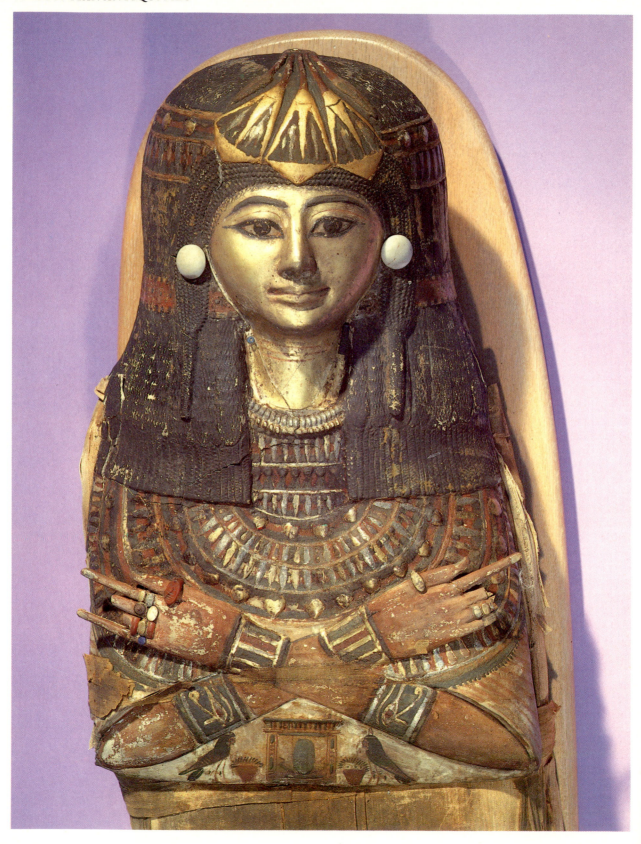

bandages which are arranged in intricate geometric patterns. The face of the mummy is covered with a portrait of the deceased in coloured wax on a wooden panel. The Museum possesses many fine portraits of this type, executed in a naturalistic if idealised style, as well as a number of three-dimensional portraits of the deceased in painted plaster.

Inner and outer coffins continued to be used until Roman times, and even in the third century AD they were still decorated with traditional Egyptian scenes, although by this date the style was increasingly debased. In the early fourth century AD the rise of Christianity led to the abandonment of mummification.

Besides human mummies, the Museum possesses many mummified animals, birds, fish and reptiles, extraordinary relics of the Late Period cults which revived the worship of ancient deities in their animal forms. The carefully wrapped bodies deposited in the great cemeteries of Saqqara, Bubastis, Abydos and elsewhere are probably to be seen as a formal acknowledgement of these deities' powers, which were invoked by visitors to their shrines.

X-ray photography of the mummies has revealed much information about the body itself, and the presence of any objects still in position beneath the wrappings. In one case, that of an unnamed man, X-ray photography has shown the presence of artificial eyes. The mummy of a Theban priestess of the Late Period, Tjentmutengebtyu, was shown to have a winged scarab amulet over her feet. Amulets of various kinds were wrapped with the mummy, the most important of which was the heart scarab, inscribed with a text from Chapter 30B of the *Book of the Dead* intended to prevent the heart from revealing any of the deceased's earthly sins. The most interesting, and one of the earliest examples in the British Museum is carved from green jasper and mounted in gold. This belonged to the Seventeenth Dynasty king Sobkemsaf and was stolen by tomb-robbers more than five hundred years later. Ordinary small scarabs are also encountered on mummies of the New Kingdom and later, engraved with divine symbols and short amuletic texts. The eye of Horus, the *djed*-pillar, the girdle of Isis, and the *wadj*-sceptre are other common funerary amulets.

A number of objects connected with the mortuary ritual have already been mentioned: tomb-paintings, stelae, funerary papyri. But the range of equipment included in the grave was wide indeed. From the earliest times the tombs of the Egyptians were provided with objects designed to satisfy the needs of the de-

92 LEFT *Gilded and painted mummy mask showing the deceased richly adorned with a wide selection of jewellery, including a number of real finger-rings. Nineteenth Dynasty, about 1250 BC. H 58cm.*

93 *Painted and modelled wooden mummy board of an unnamed Theban priestess. Late Twenty-First Dynasty, about 950 BC. H 1.62m.*

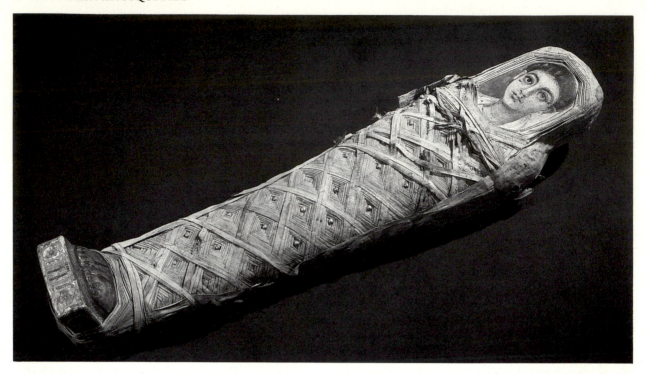

94 *Mummy of a youth wrapped in the intricate bandaging characteristic of the Roman Period. Over the face is a portrait of the deceased, executed in coloured wax. From Hawara, first century* AD. H *1.32m.*

ceased in the afterlife, including food and drink, tools, utensils, furniture, clothing and jewellery. Many of the objects in the Department which come from tombs would have originally been made for use in daily life. Other types of object were made specifically as funerary equipment and were more closely connected to the fate of the deceased in the Underworld. The internal organs removed from the body before mummification were placed in special vessels known as Canopic jars. From the Middle Kingdom sets of four jars were regularly placed in tombs, stored in wooden chests.

From this time too tomb equipment commonly included figures known as *shabtis*. They were intended to act as deputies of the deceased in the agricultural work which would be required from him in the next world as in earthly life. The earliest Middle Kingdom *shabtis* are quite simple wood, stone or wax figures, inscribed with little more than the name of the deceased owner and in the form of a mummy. In the New Kingdom glazed composition became the most common material for *shabtis*, though several fine wooden or stone examples survive, such as the *shabti* of Amenophis II, carved from serpentine. From this date most *shabtis* have tools in their hands – mattocks, hoes and one or more baskets slung over the shoulder. From the end of the New Kingdom it became customary to bury quite large

numbers of *shabtis*, and sets of as many as 401 were frequent: 1 'worker' *shabti* for each day of the year, with 36 'overseer' figures. Such large sets of *shabtis* were accommodated in special chests, such as the fine painted box of the priestess Henutmehit.

Another type of figure commonly found in burials of the Late Period is that of Ptah-Seker-Osiris, a deity embodying the characteristics of Ptah (god of creation), Seker or Sokar (god of the necropolis) and Osiris (god of the Underworld). Some of these figures were hollow and held a copy of the *Book of the Dead* inscribed for the owner. The British Museum's papyrus of Anhai, a Theban high priestess in the Twentieth Dynasty, and that of Hunefer, both sumptuously illustrated with coloured vignettes, were recovered from such statues.

Tombs of the later Old to Middle Kingdoms were frequently supplied with wooden models representing various sorts of domestic and agricultural activities and crafts. The Museum's collections include scenes of butchery, brewing, baking, ploughing and brickmaking as well as miniature granaries, boats and funerary barges. In the Middle Kingdom burials of the less affluent frequently contained pottery model houses, in the forecourts of which were represented offerings. These soul-houses, as they are known, were intended to provide sustenance and a home for the *Ka* (spirit) of the deceased.

Along with the wall-paintings and papyrus illustrations, these models supplement the evidence from objects of daily use to give an extraordinarily vivid impression of everyday life in ancient Egypt. The

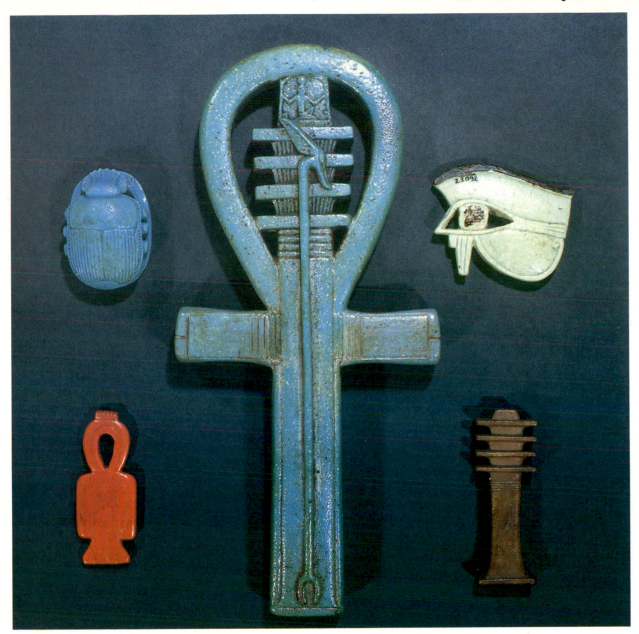

95 *A collection of popular amulets. At the top are the scarab beetle, associated with the Sun-god, and the eye of Horus, a protective device. Below are the* tyet-*symbol and the* djed-*pillar, linked to Isis and Osiris respectively. The central amulet combines the signs* ankh, djed *and* was, *meaning 'life, stability and power'.* H *(tyet-symbol) 6.5 cm.*

annual innundation of the Nile, which fertilised the valley, provided a firm and continuing basis for agricultural prosperity. The principal crops were emmer and barley, cereals used almost exclusively for making bread and beer. The Museum possesses many tools used on the land: hoes, baskets and even a plough. Diet could be supplemented by hunting and fishing: the Nile teemed with fish, and the marshy areas of the Delta and the Faiyum abounded with wild birds. Throw-sticks or boomerangs were used for fowling, while bows and arrows were needed for hunting larger animals, such as the antelope, oryx and wild bull. The bow was not just a hunting weapon, but was also important in warfare, used mainly by Nubian auxiliaries. Other weapons are also represented in the collections: the axe and shield of the native infantryman, supplemented by the dagger and spear. More advanced military equipment (including coats of mail made of small bronze plates riveted to

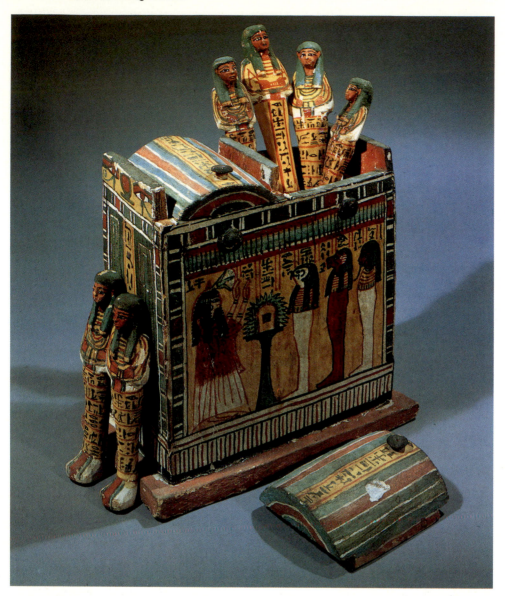

96 LEFT *Painted wooden shabtis of the Theban priestess Henutmehit, with her wooden painted shabti box on which she is depicted adoring three of the Four Sons of Horus. Nineteenth Dynasty, about 1290 BC. H 33.5cm.*

97 TOP RIGHT *Painted wooden tomb model showing a peasant ploughing with a pair of oxen. Middle Kingdom, about 1900 BC. L 43cm.*

98 BOTTOM RIGHT *Furniture including a three-legged table with splayed legs, an ornate stool and a low, wide chair inlaid with ebony and ivory. The decorated wine jar is from El-Amarna. Eighteenth Dynasty, 1400–1350 BC. H (table) 50.8cm.*

leather jerkins) and a curved scimitar-like sword with its blade and handle cast in one piece date from the warlike period of the New Kingdom, when Egypt established an empire in Syria and Palestine.

Egypt's almost total self-sufficiency in basic natural resources was a vital factor in the growth of Egyptian civilisation. The British Museum's wide-ranging collection illustrates particularly well the variety of techniques and industries developed to exploit these resources. The woven-fibre industries, such as rope- and mat-making, basketry and textile weaving, were known from earliest times. The principal materials were palm leaves, reeds, rushes, papyrus, flax and various kinds of grass. Baskets, after clay pots, were the most common form of household container, used to store fruit, seeds, linen-cloth and bronze tools. Surviving fragments of

basketwork in the collection date from as early as the Predynastic Period. Closely allied to basketry, though more advanced, is the technique of textile weaving. The woven cloth of Egypt was invariably of linen thread, the source of which was flax. The cultivation and processing of this crop are often illustrated in painted vignettes on funerary papyri, such as that of Nakht. Tools employed in the processing of flax include sharp-toothed 'hackling' combs, which were used for separating the fibres from the woody tissue, and wooden spindles in the form of slender sticks weighted towards the top with a whorl. A few fragments of woven textile remain from before 3100 BC. The vast majority of woven fabric from the Dynastic period consists of mummy wrappings and bandages, or lengths of cloth which were placed in the tomb for the use of the

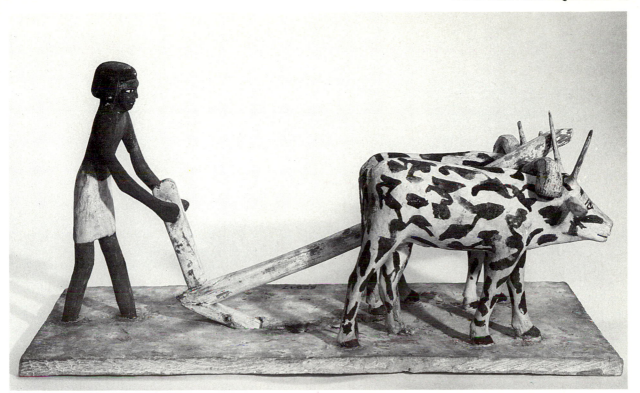

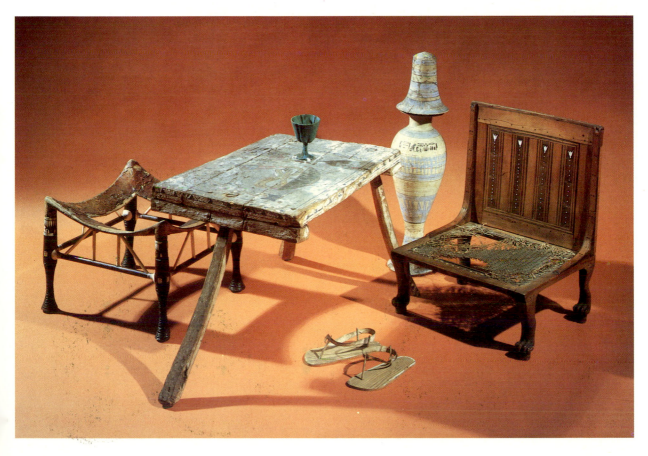

99 *A linen cloth painted with a scene in which six named ladies adore and present offerings to the goddess Hathor, portrayed as a cow emerging from the Western Desert hills. From Deir el-Bahri, Eighteenth Dynasty, about 1400 BC. L 46cm.*

deceased in the next life. Actual garments are less common and those that do survive are mostly extremely fragmentary. A fine exception is a large linen tunic or shirt which may have been worn as an undergarment.

The increasing availability of copper for tools from about the First Dynasty is thought to have greatly influenced the development of the earliest stone architecture around this time. However, the skill of the Egyptian stone-carver is evident from even earlier periods in the large quantity of beautifully worked stone vessels from Predynastic times. It was during this period that the widest range of shapes was produced in the greatest vareity of materials, including basalt, breccia, alabaster, granite, limestone, diorite, schist and serpentine. Alabaster continued to be popular into the Old Kingdom and later.

100 *Stone vessels dating from the Predynastic Period to the Eighteenth Dynasty. These examples show something of the wide range of shapes of the vessels, and of the materials used.* H *(tall marble vase) 34.2cm.*

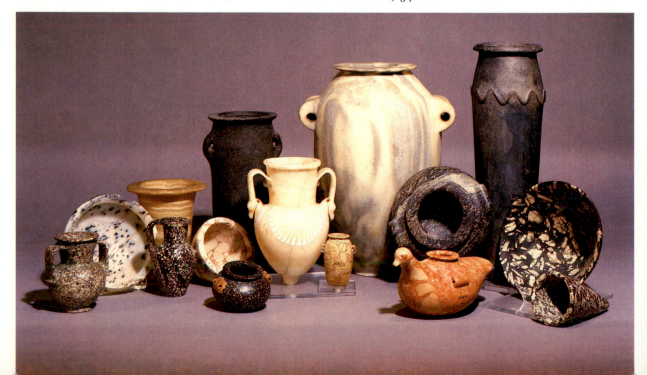

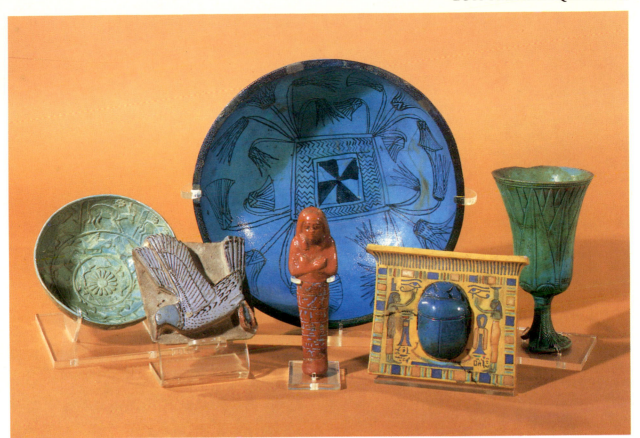

101 *Group of objects mostly of New Kingdom date made from glazed composition, including bowls and a chalice, a tile for inlaying, an amuletic pectoral and a* shabti *figure.* D *(larger) bowl) 25cm.*

The early period is also well represented in pottery; indeed, some of the most attractive Egyptian pottery is of Predynastic date. Of special interest are pots from the Naqada period in buff-coloured ware decorated in purple with boats, human figures and deities. The majority of Dynastic pottery consists of utilitarian cooking and storage vessels, and painted wares only reappear in the Eighteenth Dynasty. The most striking examples come from Malqata and El-Amarna. The jars are painted with mostly floral designs in light blue on a buff-coloured background, with details picked out in red and black. Among the finest examples in the British Museum are two wine jars inscribed for the lady Nodjmet, with hieratic dockets identifying the Delta origin of the contents.

Superior types of ware were made of Egyptian faience, more properly referred to as glazed composition. The material consisted of a core of quartz sand crushed into a fine powder. This, when heated with a colorant, fused into a glass-like material, enabling small objects to be mass-produced in moulds, usually of blue, green or greenish-blue colour, although other colours are known. Glazed composition was used for making all manner of objects, well represented in the Museum's collection: delicate vessels, jewellery, amulets, *shabtis*, figures of gods, tiles and inlays. Glass was in common use from the Eighteenth Dynasty onwards. Glass vessels are frequently decorated with patterns formed by fusing together rods of different colours; blue, yellow and white were the most frequent. The British Museum possesses one of the finest collections of Egyptian glass vessels, including an outstanding glass cosmetic vessel in the form of a fish from El-Amarna. 102

A large number of cosmetic vessels and toilet implements are preserved in the collection, reflecting the 104 concern of the ancient Egyptians with their personal appearance. Glass was only one of a variety of materials used to make these small objects, which offered the craftsman opportunities to display his artistic skills in a way denied the artist working in the strictly circumscribed field of Egyptian funerary art. During the New Kingdom this freedom resulted in a wealth of imaginative and delicate forms and designs, executed in a variety of techniques. Among the most striking are a bronze toilet implement in the form of a rider on horseback, and a wooden figure of a swimming girl

pushing before her an ointment box in the form of a duck.

One area in which Egyptian craftsmen excelled was metalworking. Copper and bronze were used in the manufacture of tools and weapons, and cast to produce sculpture, as well as utensils and all manner of ritual objects, such as censers, a sceptre, libation vessels and other containers for sacred liquids.

The precious metals of gold and silver were used in conjunction with richly coloured semi-precious stones such as cornelian, lapis lazuli, turquoise and amethyst to produce jewellery of outstanding quality. Glazed composition and glass were both used as substitutes for hardstones. The imaginative ways in which the jewellery-maker combined these disparate materials to produce such pleasing results are particularly well exemplified by the elaborate collars and necklaces of the New Kingdom. Pieces of particular interest include an openwork gold pectoral showing Ammenemes IV making offerings to the god Atum; the gold bracelet terminals of King Inyotef embellished with figures of reclining cats, and the gold inlaid bracelets of prince Nemareth, son of Sheshonq I.

Egyptian jewellery often incorporated scarabs, which are found in large quantities in all collections. The designs and inscriptions engraved on them are often commonplace and of little interest; others represent some of the finest achievements of the ancient carver in miniature. The large scarabs issued by Amenophis III to commemorate important events and royal achievements are of particular interest. The Museum possesses the only complete series of these scarabs, with subjects including a lion-hunt, a wild bull hunt, his marriage to Queen Tiy, the digging of a lake and the arrival of a foreign princess with her retinue.

103 RIGHT *Royal jewellery of gold and electrum, including an openwork plaque of Ammenemes IV, a pair of bracelet terminals of Inyotef VII, and the heart scarab of Sobkemsaf (bottom). Middle Kingdom and Second Intermediate Period, about 1885–1650 BC. W (winged scarab) 3.5cm.*

102 BELOW *Cosmetic vessel in the form of a fish, made in polychrome glass. From El-Amarna, Eighteenth Dynasty, about 1350 BC. L 14.5cm.*

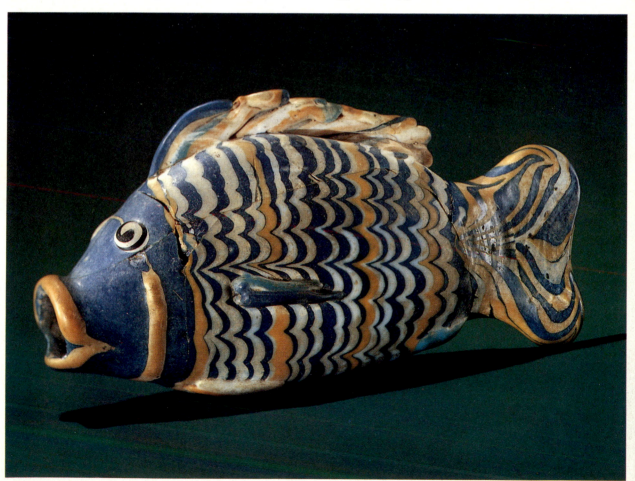

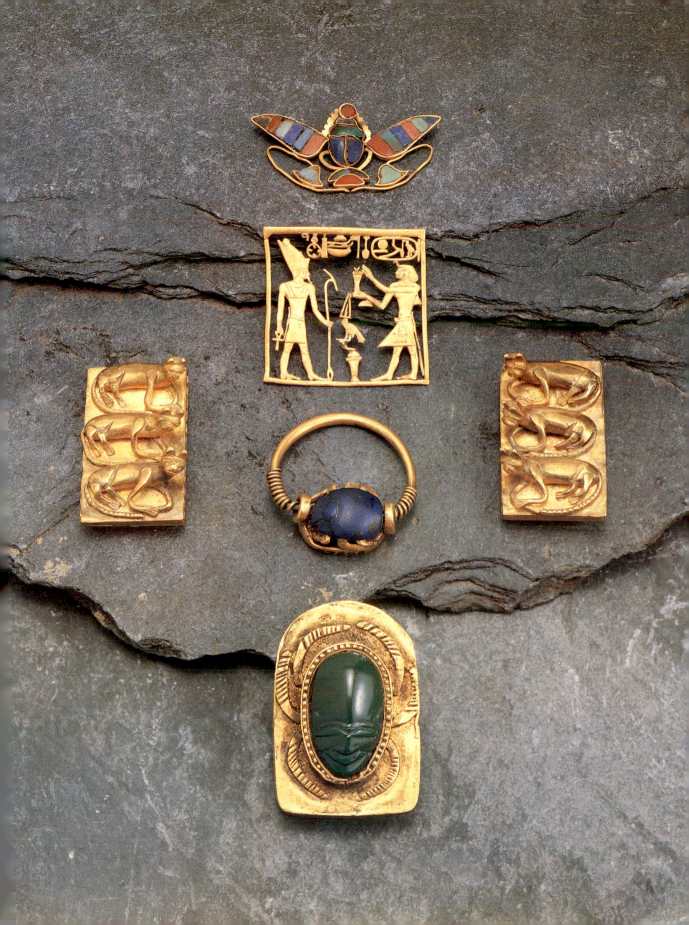

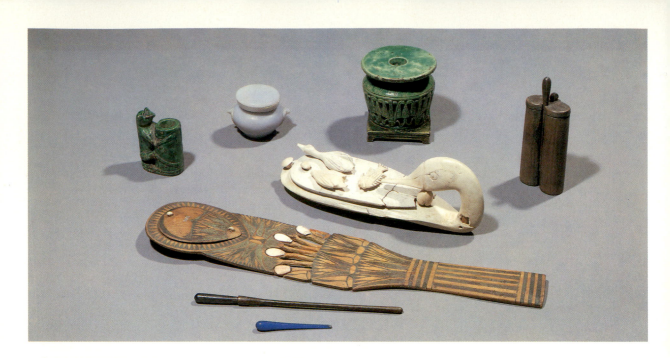

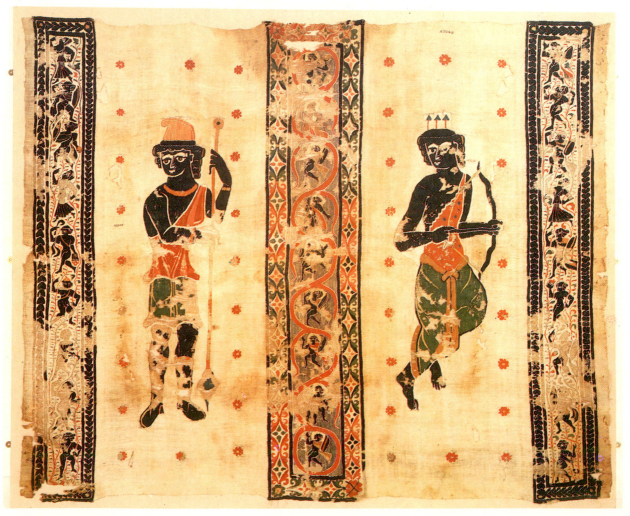

The use of scarabs as amulets in a funerary context has already been mentioned, but amuletic and magical objects were also widely employed in everyday life. Large numbers of small figures of protective deities exist, such as the hippopotamus goddess Thoeris, revered as a protectoress of women in childbirth; or Bes, a dwarf with the features of a lion who was thought to bring happiness to the home and to protect it against harmful creatures, such as snakes. Magical spells written on papyrus to protect the carrier, incantations against disease, dream books to interpret omens, oracles, and calendars of lucky and unlucky days are among the many texts in the Museum's rich collections.

Incorporation into the Roman Empire marked a vital turning point in Egypt's history, bringing this ancient civilisation into the wider sphere of eastern Mediterranean culture. A more decisive break with the Dynastic past is signalled with the abandonment of mummification in the early fourth century AD. The Egyptian collections, however, include material from early Christian and Coptic Egypt. Both pagan and Christian antiquities occur in Egypt during the third to sixth centuries AD, and it is not always easy to assign one object to one culture or the other. Gravestones of Christian origin show the typical form of the funerary inscriptions, and some have crosses in the form of the ancient Egyptian *ankh*, the hieroglyph for 'life'. Other examples of stonework from this period, fragmentary architectural pieces and reliefs, are decorated with traditional Hellenistic motifs, figures of classical divinities and foliate designs.

Hellenistic influence is also apparent in the decorated textiles which occur in the fourth century AD, of which the Museum possesses a good collection, including tapestries in wool with mythological motifs and floral designs. Subjects of a purely Christian nature do not become common until the eighth century, and they continue until the twelfth, when the textiles themselves disappear – and with them the last vestiges of pharaonic civilisation.

104 TOP LEFT *A group of cosmetic objects of New Kingdom date. At the back are containers for eye-paint applicators. The duck-shaped box and floral spoon probably contained cosmetic creams.* L *(floral spoon) 31cm.*

105 BOTTOM LEFT *Tapestry with two large divine figures between vertical bands of decoration, formed of coloured wool on a linen base. Fourth–fifth centuries* AD. H *1.8m.*

106 *Memorial stone inscribed for Pleinos, bearing a form of cross derived from the hieroglyphic* ankh, *the sign for 'life'. Seventh–eighth centuries* AD. H *61cm.*

THE ETHNOGRAPHIC COLLECTIONS

The Department of Ethnography at the Museum of Mankind near Piccadilly is the home of the anthropological collections of the British Museum. These are the finest of their kind in the world, and represent many aspects of the art and life of the indigenous peoples of Africa, Australia and the Pacific Islands, North and South America and parts of Asia and Europe. Ancient as well as recent and contemporary cultures are represented at the Museum of Mankind and much of the material is of particular interest since it was made before extensive European contact. Today the Department's main collecting focus is an emergency programme to acquire properly documented material on the life, production techniques and technologies of societies which are fast disappearing.

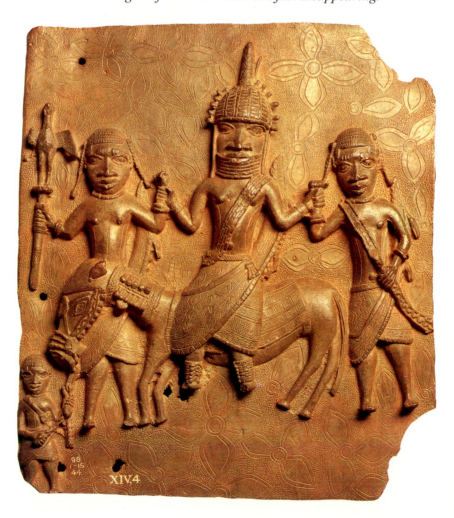

THE AMERICAS

The American collections contain artefacts from most of the major historical and cultural traditions in the New World. Those from North America derive from both the agriculturalists of eastern and south-western parts of the continent, and from the highly diversified hunters, fishermen and gatherers in the rest of the United Stated and Canada. The American collections are strongest in those areas either visited by early explorers, or affected by colonisation from the seventeenth century onwards. Most of the objects were made by often highly mobile hunters; as one would expect, they consist of clothing, always highly utilitarian but often also superbly decorated with painted and embroidered designs, and deceptively simple hunting equipment, lightweight, but often of great technical perfection. The materials from the farmers of the eastern United States are slight, although they include perhaps the earliest examples of a Cherokee basket and Cherokee gourd rattle. From the Puebloan peoples of Arizona and New Mexico come an extensive series of 108 matt painted pottery, including water jars, bowls and canteens, particularly from Zuni. The neighbouring Navajo, who became sheep farmers in the centuries after Spanish contact, are best known for their wool, wearing-blankets and rugs, of which there is a good representative collection in the Museum.

The peoples of the Northwest Coast were, and are still, fishermen occupying ancient villages in the rain-forest coast fringing the Rocky Mountains between Southeast Alaska and Northern California. Hierarchical societies developed here. Hereditary chiefs express their status by giving potlatches or feasts, at which masked dances are performed celebrating the status of the feast-giver. The Museum has important masks, 109 feast bowls and ceremonial weaponry and clothing from the period of early contact at the end of the eighteenth century. Vast poles and doorways carved with animal crests are from a later date.

The Arctic collections from Eskimoan peoples such 111 as the Canadian Inuit, like those from the Northwest

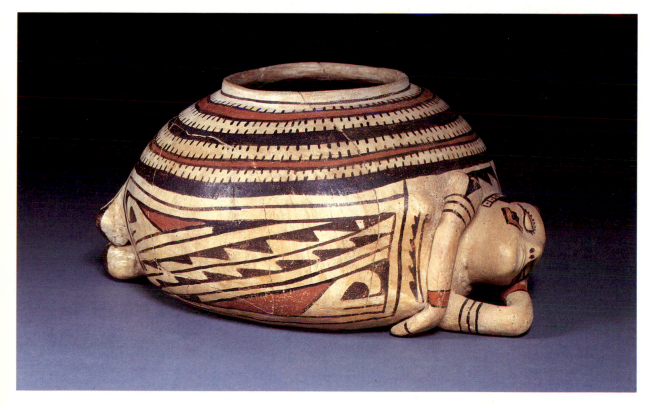

107 LEFT *Cast-brass plaque from Benin, Nigeria. The central figure on horseback is the Oba (king), probably engaged in a ritual marking his supremacy over the birds, whose cry is used in divination. Such plaques were used to cover the wooden beams supporting the palace roof. It probably dates from the mid-sixteenth to seventeenth century. H 41.5cm.*

108 ABOVE *Ceramic vessel in the form of a reclining woman, from Casas Grandes, Chihuahua, Mexico. The geometric patterns incorporate a lightning motif which may suggest that the woman represents a fertility deity. The distinctive style originated after Casas Grandes had been settled by Central Mexican peoples who represented their deities using the local style. AD 1060–1340. H 12.7cm.*

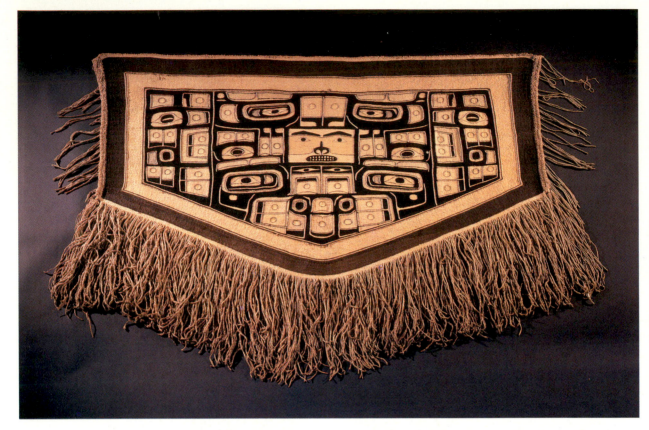

109 *Chilkat dancing blanket of twined wool and vegetable fibre from the Northwest Coast of America. It would probably have been used by a man of high rank at a feast. The design represents an animal crest belonging to the owner.* W 2.2m.

Coast, were made largely during the voyages in search of the Northwest Passage between 1818 and 1880. From northern Greenland came a now unique sled from the Polar Inuit, collected by Sir John Ross in 1818 on the first recorded occasion of contact between these people and anyone, European or Inuit, from the outside world. It is constructed entirely of whale and walrus bone and ivory, strapped together with sealskin. These people possessed little wood, and used meteoric iron for their cutting tools. Further to the west the searches for Sir John Franklin, the explorer lost in the 1840s, brought contact with Copper Inuit and the earliest collection of Inuit tools furnished with native copper blades. From Northwest Alaska large quantities of tools used in sealing, bird spearing and the hunting of bowhead whales were collected from the Inupiat Eskimo from the 1820s onwards. Many of the finest of these are of ancient mammoth ivory, a tougher substance than walrus ivory.

To the south of the Eskimoan peoples live groups of Subarctic Indians who hunt moose and caribou, fish and sell furs to southern markets. The Department possesses fifteen examples of superb caribou summer clothing from this area. The Dene clothing from the west is decorated with porcupine quillwork, while in the east the coats made by the Naskapi are delicately covered with multi-coloured stamped designs in pigments mixed with fish oil.

On the great North American Plains the aboriginal peoples were also big-game hunters. The Museum's collections from this area as elsewhere consist mostly of highly decorated skin clothing, as well as riding equipment, hunting gear, and a long series of excellent calumets, or smoking pipes; these were used in ceremonies expressing group solidarity, for instance at the time of making peace or undertaking trade. From the far west there are highly important collections from California. At the time of European contact in the eighteenth century California was an abundant wilderness teeming with big game – deer, antelope and bear. The aboriginal peoples, who all but disappeared after the gold rush of the mid-nineteenth century, were hunters and fishermen. But above all they collected acorns, from which they prepared acorn mush, a limitless source of carbohydrates. A fine group of coiled baskets dating from the eighteenth century was used in food preparation. From the Chumash of the Santa Barbara region in southern California come more baskets, as well as a unique basketry hat made in the style

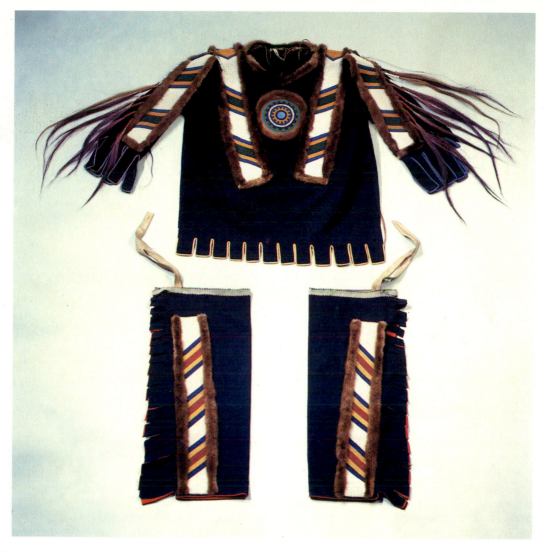

110 *A Plains Indian shirt and leggings of European cloth decorated with glass beads, hair and fur trim. This costume was presented in 1881 by its owner Osoop, a Saulteaux head man, to the Governor-General of Canada, the Marquis of Lorne, who later gave it to the Museum.* L *(coat) 88cm.*

used by Spanish priests, shell ornaments, and a series of harpoons thought to have been used in the hunting of tuna and sea-lion.

Most of the material from North American collections was collected before 1910, but since the late 1970s the Museum has extended its range, with, for example, contemporary twined basketry from the Yurok of northern California, and the coastal peoples of British Columbia. More general series of artefacts have been acquired in the Arctic and Subarctic to illustrate the maintenance of traditional skin clothing, embroidery styles and hunting technology. Other contemporary collections have been made from peoples as diverse as

the Seminole of southern Florida and the agricultural peoples of the Southwest. Contemporary prints from the Northwest Coast, Arctic and Subarctic are housed in the library.

The major cultures of ancient Middle, Central and South America are, with few exceptions, well represented in the collections. Typical of the earliest artefacts from Mexico and the other countries of Mesoamerica are the small pottery votive figurines of the pre-Classic periods (*c.* 2000–1000 BC). These usually depict nude females, sometimes with elaborate hair-styles and head-dresses.

The first major civilisation of this region was that of the Olmec (*c.* 1000–400 BC), which developed in the swampy Gulf Coast area of Mexico. As well as creating architecture and sculpture on a monumental scale, the Olmec produced some of the finest small carvings in jade and other greenstones known from the New World. Outstanding examples of this work are a cer-

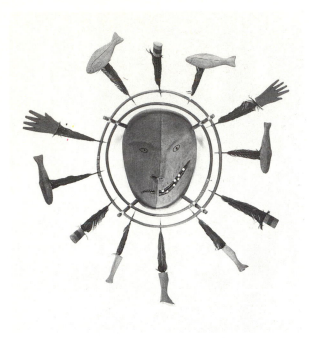

111 A Yupik Eskimo painted wood shaman's mask, representing a half-animal, half-human creature of great strength; in this form the spirit is half-fox, half-man. From Nunivak Island, Alaska, twentieth century AD. H 50cm.

112 Olmec jade pectoral from Mexico (c. 1000 BC). It is probably meant to depict an Olmec ruler or noble. Some early hieroglyph forms are incised on the panel. H 10.5cm.

emonial adze in the form of an anthropomorphised jaguar deity and a fine portrait pendant.

In the central valleys of Mexico the most important civilisation of the Classic period (*c.* AD 200–800) was centred at Teotihuacan. The builders of the massive temple-pyramids at this site were also skilled muralists, potters and stone-workers. Typical examples of their work are stone masks and an offering vessel in the form of a stylised jaguar or ocelot.

Maya civilisation developed in southern Mexico, Guatemala and parts of the adjacent countries, attaining in its Classic phase (*c.* AD 300–900) an organisational complexity and cultural sophistication unsurpassed in Mesoamerica. The great temple-pyramids characteristic of Maya sites were decorated with superb sculptures in stone and stucco-work representing rulers and deities. Massive stone stelae, usually representing rulers and with carved hieroglyphic texts, and altars were erected within the temple precincts to commemorate important events. Stone lintels from the site of Yaxchilan in Chiapas, Mexico, and the figure of a Maize God from Copan in Honduras, attest to the excellence of Maya sculptors.

As with the Olmec, jade and greenstone were highly valued by the Maya, and worked to form very elaborate beads and pendants. Their superb polychrome pottery provides much information concerning religious cer-

emony and mythology. Maya civilisation was waning by about AD 900, and there is evidence that the rise of the post-Classic civilisations which dominated central Mexico at this time contributed to this decline. New elements of style and content enter the archaeological record, with greater emphasis upon militarism and increasing interest in human sacrificial cults.

The post-Classic civilisations of Mesoamerica (*c.* AD 1000–1519) are represented by good examples of the major ceramic traditions and stone sculptures. The most notable sculptures are those of the Huastec people of Veracruz on the Gulf Coast and the Aztecs of the central valleys of Mexico. An exceptional Aztec sculpture is a highly polished representation of a coiled rattlesnake. The underside is also carved and has the original red painted decoration representing the snake's markings. Another striking sculpture is a carving of a mythological creature, the *xiucoatl* or fire-serpent.

113 Carved stone lintel from Yaxchilan, Mexico. One of the finest examples of Maya sculpture, it depicts Lady Xoc, a wife of Shield Jaguar, the ruler of the city, participating in a ritual blood-letting ceremony. The hieroglypic inscription dates the ceremony to 23 October AD 681. 130.1 × 86.3cm.

114 *Ornament of wood in the form of a serpent, with turquoise and shell mosaic decoration. Mixtec/Aztec,* AD *1400–1520.* L *43.5cm.*

114 Probably the most outstanding examples of the art of this period are the nine turquoise mosaic decorated objects of the Aztec period. The masks, sacrificial knife, helmet, small animal carvings and serpent ornament which comprise this group were probably among the earliest objects from the New World to be seen in Europe.

From the ancient cultures of the Central American countries – Nicaragua, Costa Rica and Panama – the collection contains a wealth of pottery vessels and examples of typical elaborately carved stone metates (grinding stones). There are also examples of the fine lost-wax cast-gold ornaments of these regions, and the highly polished jade celts, often decorated with zoomorphic figures.

The pre-Columbian inhabitants of the Caribbean were linguistically related to some of the lowland tribes of South America, though some aspects of the cultures of the Greater Antilles show ties with Mesoamerica. The most impressive items from this area are a small group of Taino wood-carvings. These include *duhos* (ceremonial stools) and three figures, a standing male, a bird-headed figure, possibly a deity, and a female

figure of great beauty with a canopy above the head which probably served as a tray for the inhalation of hallucinogenic snuff used in religious rites.

A few pottery vessels only represent the first of the great civilisations of ancient South America, that of Chavin de Huantar in the northern highlands of Peru (*c.* 1000–400 BC). For the subsequent Andean cultures of Peru, Colombia and Ecuador there is a wealth of pottery, textiles, stone-carvings and metalwork. There are fine examples of the characteristic red and cream painted pottery of the Moche people of Peru (*c.* AD 300–800). Representations of human and animal figures provide information concerning many aspects of Moche culture, particularly its religious and ceremonial practices. The fine polychrome pottery of the Nasca civilisation from the south coast of Peru (*c.* 200 BC–AD 600), is decorated with highly stylised depictions of deities and mythological creatures from their complex pantheon. There is also a rare example of Nazca feather-mosaic work among the textiles of this period. Among the finest textiles are those in the style of Tiahuanaco, the great kingdom which flourished in the region of Lake Titicaca (*c.* 500 BC–AD 1000).

From Colombia there are many superb examples of gold ornaments from the succession of regional chiefdoms which arose in its northern provinces from the early centuries AD to the sixteenth century. Especially notable are the gold and *tumbaga* (gold/copper alloy)

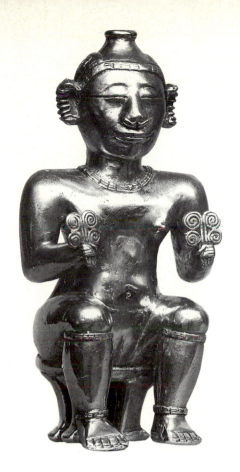

ornaments and limeflasks of the Quimbaya (*c.* AD 115
1000), and a dramatic anthropomorphic pendant in the
style of Popayan in the Upper Cauca region.

The ethnographic collections from Middle, Central
and South America began to enter the British Museum
in the nineteenth century. The most notable of these
early collections were from the tropical forest regions of 116
South America, especially Guyana, although there are
also important groups of material from Tierra del
Fuego, Paraguay and Panama. In recent years there
have been considerable efforts to enlarge this area of
the collections with a programme of Latin American
field research which has resulted in the acquisition of
a wide range of well-documented materials from
Mexico, Guatemala, Panama, Colombia, Peru, and
Bolivia. This work is still in progress.

115 LEFT *Limeflask of* tumbaga *(a gold–copper alloy),
probably from the Cauca Valley area, Colombia, Quimbaya
style.* AD *400–900.* H *14.5cm.*

116 BELOW *Mortar surmounting a double-headed animal
carved from a dark wood. The rim has a carved geometric
border, while the animal's body is decorated by scrollwork. From
Lowland South America.* L *20.3cm.*

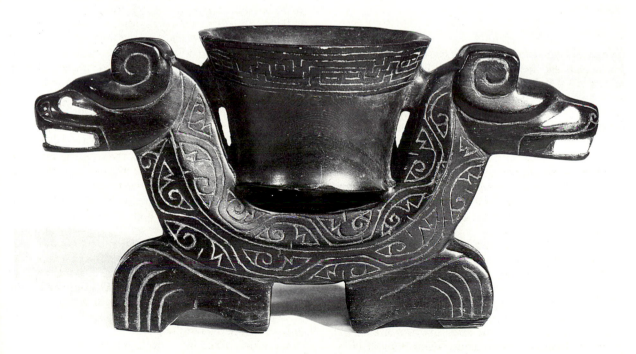

AFRICA

The collections from West and North Africa reflect the great ecological and cultural diversity of these areas. The influence of Islam in the north is shown by the lack of representational images and a wider concern with the decoration of household objects. Rich ornamentation characterises both the textiles and the metalwork of the urban Arab cultures and the mountain-dwelling Berber peoples. The African collections also contain examples of the highly distinctive decorated pottery of the Kabyle people of Algeria.

The collections from south of the Sahara come from both centralised states, especially those in the tropical rainforest zone, such as Benin (Nigeria), Asante (Ghana) and the Yoruba kingdoms of Nigeria, and the smaller, chiefless people of the Savanah and Sahel zones to the north. Many of these collections come from the areas formerly under British colonial control, but recent policy has been to complement these with major works, especially of wood sculpture, from other areas.

When Europeans first began to voyage along the African coast in the fifteenth century they found many well-established kingdoms. Early white visitors commissioned works from African craftsmen and these are important evidence for the artistic skills and sophistication of coastal societies. An Afro-Portuguese salt cellar is one of a group of similar works, including spoons, forks and horns made by African craftsmen for visitors to Benin (Nigeria) and Sherbro (Sierra Leone) at the end of the fifteenth or early sixteenth century. A number of virtually identical pieces are known – suggesting the establishment of permanent workshops, which would also have catered for a local demand. In these pieces we see African carvers struggling to interpret forms that were unfamiliar in their own tradition. For example, wood joinery seems to have been uncommon in traditional Africa, most wooden products being carved from a single piece of wood. When called upon to represent the planking of a Western ship, the carver interprets them as being fixed in the same way as the tiles on the King of Benin's palace roof – as demonstrated in later brass castings of the court made for the king.

It seems to have been as a response to the local needs of kingship that many of the ancient bronze and brass castings of West Africa were produced – indeed, copper alloys were largely a royal prerogative. The earliest documented casting tradition in the region is that of

117 *Ivory salt cellar from Benin, Nigeria. Such works were carved for European visitors in the late fifteenth to early sixteenth centuries and show a mixture of Western and African forms.* H 24cm.

Igbo-Ukwu (Nigeria). A number of sites, including the grave of a notable, have yielded evidence of a tradition of high technological and artistic ability that flourished between the ninth and eleventh centuries. Examples of these superb leaded bronze castings are in the collection.

Later casting traditions, such as those of the Yoruba kingdoms and that of Benin, are clearly related, but the precise relationship between these remains unclear. The Benin collection provides a comprehensive example of the sacral regalia of a powerful empire. The brass head is from the royal altars in the palace and dates from the sixteenth century. It would have been used to support an elephant tusk and is in the form of an Oba (king) in beaded ceremonial dress. Heads of this sort could only be made for a king and were produced under rigorous control by the guild of brass-workers.

The arts from some other parts of West Africa clearly show the effects of interaction with the West. The Kalabari screen is a commemorative image made for a trading house of the Nigerian city-state of New Calabar. Social changes brought about by the rapid generation of wealth through involvement in Atlantic trade and the absorption of large number of slave members led to shifts of power in the leadership. New images of power were produced, based upon European two-dimensional illustrations that were becoming familiar to the Kalabari in the late eighteenth to early nineteenth centuries. The Museum has eight of these carved wood screens, which were about to be destroyed early this century during a Christian movement. They were, instead, presented to a colonial administrator from whom they eventually came to the Museum.

The Yoruba people of Nigeria are among the most prolific wood-carvers of Black Africa and the collections contain many of their elaborately carved and coloured masks, as well as images used in the worship of particular deities. The special status of twins in many areas of Africa (where twin births are often far more frequent than in Europe) is shown by Yoruba *ibejis*, small carvings made after the death of a twin and subsequently carried by its mother. Other Yoruba items are associated with its kings – the elaborate crowns decorated by coloured glass beads, other items of regalia and the carved doors and roof pillars from palaces.

The great kingdom of Asante in Ghana was based, in a large part, on mining its vast gold deposits and exporting slaves. The first item to come from this area was a drum which was in Sir Hans Sloane's collection on his death in 1753. In 1817 T. E. Bowdich visited the Asante capital and collected gold castings, pottery, leatherwork and a wooden stool for the Museum. The Asante's skill in casting gold by the lost-wax method, and the use of elaborately worked gold to adorn the king and his servants is represented by many superb pieces which came to the Museum after British military intervention in Asante in 1874, 1896 and 1900.

West Africa is particularly renowned for its wood sculpture, both in the form of the human figure and in masks or other images worn on or over the head, usually in performances which also include music and dance, concerned with representing, in some way, spiritual powers. There is considerable stylistic variation between groups that produce carvings and the collections contain examples from many areas. Especially noteworthy are the masks of the Dogon of Mali and the figure sculpture of the nearby Bamana people, the helmet masks worn at female initiation among the Mende of Sierra Leone, and the carvings from the Igbo, Ibibio, Jukan and Tiv Nigerian peoples which show clearly the varying ways of representing the human form. Few wood-carvings last more than a generation or two in the climatic conditions of tropical Africa, but a hundred or so stone-carvings from the coastal areas of Sierra Leone and Western Liberia show earlier artistic forms. Some of these probably date from the fifteenth century, and some are clearly related to the ivories carved for the Portuguese around 1500.

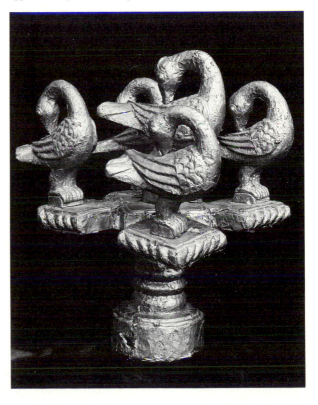

118 *Wood carving of five birds, covered in sheet gold, from Asante, central Ghana. It would have been used as the top of a ceremonial umbrella, which shaded a senior chief when he appeared in public.* H 26.5 cm.

The Department also possesses many everyday artefacts, and especially tools and utensils. The usual tool for cultivation in Africa is the hoe. One of these, from McCarthy Island in the Gambia, shows the high value of iron in this particular place: the blade is made of wood and only edged with metal.

In recent years the Museum has striven to obtain comprehensive collections from West African societies, most of which are undergoing change at an unprecedented rate. Wherever possible one artefact of each type, with full documentation, is obtained. A collection made among the Baka of Cameroon, a forest-dwelling pygmy group contained virtually all their artefacts, including a shelter made from leaves and branches. Change is also shown by the use of recycled Western manufactured items: shoes made of old lorry tyres, lamps made from burnt-out light-bulbs and musical instruments made of tin cans.

The area of West Africa that includes the modern states of Zaire and Angola is well represented in the Museum's holdings, as to a lesser extent are Gabon and the Republic of Congo. The main collection here was formed in the opening decades of this century, and ranges from masks and figure sculpture to magical devices, textiles, pottery and other domestic objects. Most of the objects came from the southern parts of the Equatorial forests amongst such peoples as the Mbala, Pende, Wongo, Lele, Songye and Tetela. The most important section documents the culture of the Kuba Kingdom in Kasai region of Zaire, an elaborate and impressive traditional state.

Three commemorative carvings represent Kuba kings. One of these depicts the founder of the ruling Kuba dynasty, Shyaam aMbul aNgoong, who ruled in the first quarter of the seventeenth century. However, although all these king figures are frequently referred to as 'portraits', it is unlikely that any were carved much before the mid-eighteenth century. Even so they rank amongst the oldest extant examples of wood sculpture from Africa. What makes them 'portraits' is not any physical resemblance between the figures and the kings with whom they are associated, but small emblems carved on the front of the plinths on which they sit. In the case of Shyaam this is a game-board, with whose introduction amongst the Kuba he is credited. In addition to objects with such royal associations the collection also includes many examples of the distinctive Kuba tradition of decorating surfaces with intricate geometric patterning. This practice can be seen on items of wood and horn, and on mats, textiles and

120

119

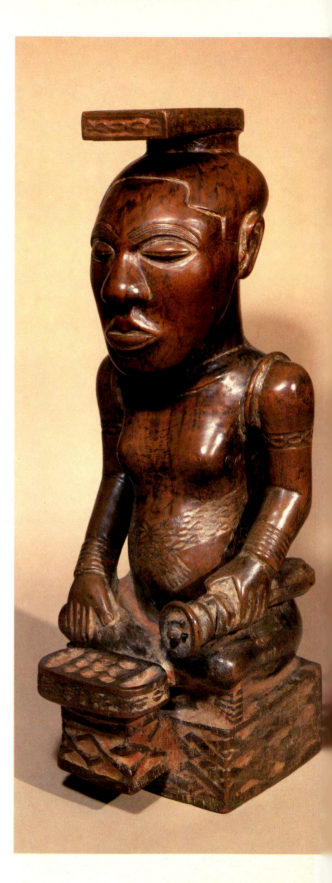

119 Dynastic statue commemorating Shyaam aMbul aNgoong, the founder of the Kuba Kingdom, Zaire. H 54cm.

beadwork. Not only is this the hallmark of the arts of the Kuba, it is also an apt reflection of the systematic and orderly operation of the state itself.

Another early collection made in the north of Zaire is also comprehensive, though within the narrower category of weaponry. Here more than anywhere else on the continent knives, both to be held in the hand and thrown, assume the greatest variety of forms. Equally, they had both practical and ceremonial functions, as most notably in the Mangbetu and the Azande kingdoms.

The way of life of the peoples of the Equatorial forests and of those in the woodlands immediately to their south is essentially that of agriculturalists. Moving to the east and south-east, however, traditional economies are much more mixed, and the keeping of cattle assumes a more significant role. Recent field collections from the Sudan and older material from elsewhere in Eastern Africa serve to document the transhumant life that is associated with purer forms of cattle pastoralism. Here more portable and robust objects are noticeable. Furniture is largely limited to light stools and head-rests that can comfortably be carried, whilst such fragile objects as pottery are relatively rare. Items made of readily available cattle-hide range from shields and sheaths to items of clothing.

120 *Polychrome mask incorporating fur horns and a raffia costume. Tetela, Zaire. L 48.3cm.*

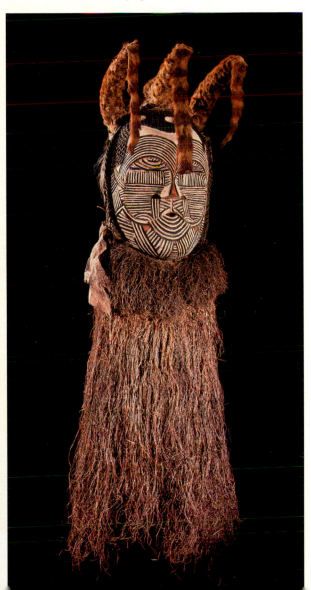

121 *Decorated calabash, or gourd, used for preparing medicines. From the Kamba people, Kenya. H 24.9cm.*

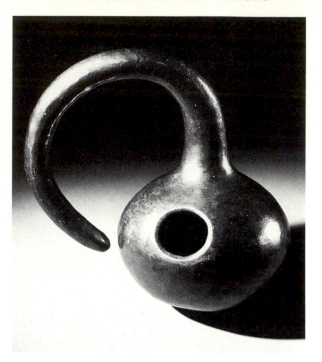

Traditions of sculpture are usually presented as being largely absent from Eastern and Southern Africa. The mask and figure sculpture of the Makonde of Mozambique and Tanzania is the major exception and is illustrated by a small but important collection of traditional examples in the Museum's holdings. Among other sculpture from Eastern and Southern Africa is a reconstructed pottery head excavated at Luzira Hill in Uganda. It remains a unique and thus far undated find. Wood sculpture from Tanzania, Kenya, Zambia and Malawi also testifies to carving traditions in these regions. Frequently the function of such figurative works is unrecorded though some appear to have been presentation and prestige objects. One large figure, for instance, seems to have been given to the Kabaka (king) of the Ganda of Uganda, but was in fact carved by a Nyamwezi sculptor in Tanzania.

However, it is the decorative arts that are most obvious from these parts of Africa and particularly in such materials as beadwork. The most prominent are the abundant examples from such peoples as the Zulu, Xhosa, and Ndebele of South Africa. Together with

122 ABOVE *Water pot with graphite glaze made in the form of a calabash ladle. Probably from the Ganda people of Uganda.* H *22cm.*

123 BELOW *Narrow-strip woven silk textile (*kente*) from the Asante people of central Ghana. Such textiles are worn by senior men on especially important occasions.*

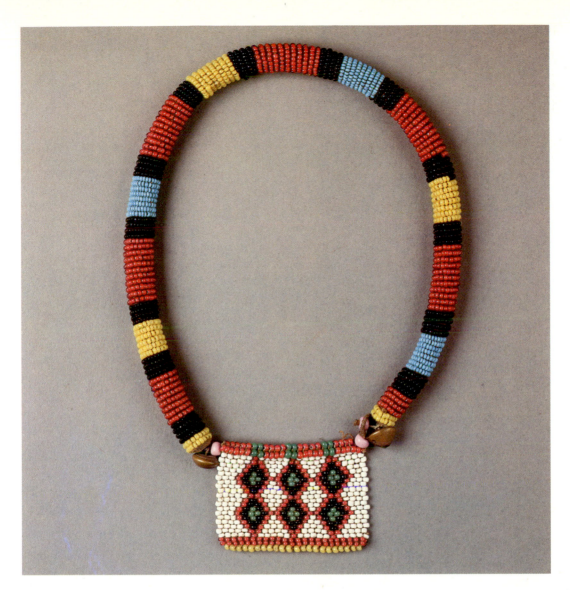

124 *Bead necklace, South-East Africa. The patterned beadwork of the peoples of southern and eastern Africa can convey messages by the use of certain colours and motifs. Young girls work beaded panels to present to their admirers.* L (central panel) 7.5cm.

weaponry, pottery, wood vessels, ivory ornaments and snuff-spoons, these are the basis of the collections from the south of the continent. Illustrative collections have also been formed amongst the Khoisan (Bushman and Hottentot) peoples of Southern Africa and the various Pygmy groups of Equatorial Africa.

The collection of textiles from Africa illustrates well the wide variety of materials used by African weavers, the extensive distribution of weaving technology across the continent, and the range of patterns and motifs that are characteristic of textiles from Islamic peoples to the north of the Sahara and throughout Black Africa. Cotton is perhaps the most widely exploited of

materials, being found everywhere but in the Congo Basin (the modern country of Zaire), where raffia is exclusively used. Silk textiles are found in West Africa and on the island of Madagascar, whilst wool is the primary material for weaving in North Africa.

Pattern is applied to cloth both in the process of weaving itself and subsequently – principally by methods of dyeing and appliqué. The collections from West Africa give perhaps the fullest impression of the colourful results achieved. A collection of weaving equipment, including working examples of looms, supports this important textile collection.

Two other, and exceptional, collections deserve mention within the African context. One is material of Ethiopic Christian origin, mostly collected in the nineteenth century. Included are processional crosses, censers, sistrums, and other liturgical items. Secondly, the island of Madagascar, off the south-east coast of the continent, is well represented in the Museum.

Older collections, mostly from mission sources, concentrate on the Merina and Betsileo areas of central Madagascar and include textiles (many of them burial shrouds), charms and jewellery. Recently formed field collections from the east and south of the island have sought to build on these historical materials. All, however, ultimately demonstrate the mixed Asian and African ancestry of the people of this large island in the Indian Ocean.

THE MIDDLE EAST

Despite the long association of the British with the Middle East as colonialists, traders and travellers, there were few objects from the area in the Department's collections before the 1960s, and it is only in the last two decades that the main collections in the Middle Eastern section have been acquired. The Department specialises particularly in material from rural cultures. The

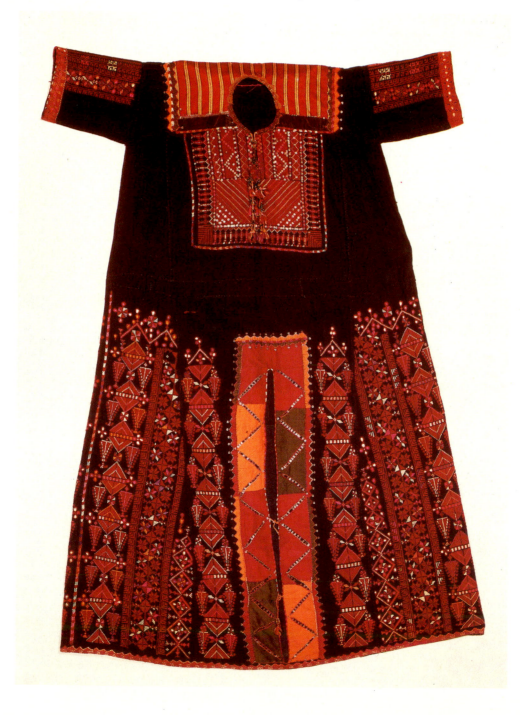

first important Middle Eastern collection was a group of fine, mainly nineteenth-century Palestinian Arab costumes. These had once been worn by the village farmers of Palestine, as distinct from the townspeople, who wore simpler costumes modelled on the fashions which prevailed among the ruling Ottoman Turks or later the British. These costumes have been complemented by subsequent acquisitions, including costume and other artefacts (such as looms) collected for the Museum during research visits to the Palestine area (Israel and Jordan) in the late 1960s and 1970s.

Until the mid-twentieth century the dresses, head-veils and head-dresses of the village women of Palestine were lavishly embroidered in predominantly red silk thread in a variety of beautiful geometric designs, and were decorated with satin and taffeta patchwork in brilliant colours. These garments have an intrinsic artistic value which can easily be appreciated by members of other cultures, and are also filled with social significance and symbolic meanings, which only research among the women who created and wore them has been able to reveal. Village costumes indicated village and regional origins within Palestine, demonstrated marital and economic status, and constituted a women's language and aesthetic which only they fully understood.

Another important group of material which has entered the Museum's collections in recent years is village pottery from South Arabia. A great variety of pots are represented, including huge water-storage vessels, cooking pots, coffee pots and delicately moulded incense-burners from the home of the ancient coffee and incense trades. These pots were made in many different centres in the former British Aden Protectorate (now the Peoples' Democratic Republic of Yemen), and were traded over a wide area of the southern Arabian peninsula.

Another collection from the sedentary peoples of South Arabia comes from a small community of farmers and traders in the Yemen Arab Republic. During the 1970s increasing financial prosperity brought about social changes in the community, and many, though not all, traditional artefacts were replaced by articles imported from the industrial world. The collection of pottery, baskets, jewellery, costume and farming implements preserves many of the objects which were rapidly going out of use and being discarded. Of particular interest is the ornate silver jewellery which was presented to the bride by the groom at marriage, the colourful baskets for displaying bread at meals and for

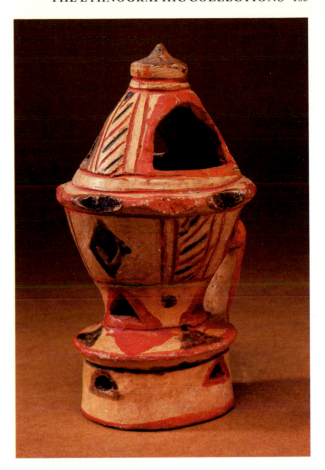

126 *Incense-burner from South Arabia. Incense is often burned when welcoming guests to the house throughout Arabia. From antiquity to recent times South Arabia was the important centre for the production and trade in incense. Mid-twentieth century* H 16.5cm.

storing clothes and incense, and cooking bowls carved from locally quarried stone.

Other important Middle Eastern collections come from various tent-dwelling nomadic peoples, who traditionally depended on livestock for their livelihood. Today most formerly nomadic peoples are integrated into national and urban economies, and pursue a variety of occupations. The collections include 'mobile homes' and their furnishings from the Türkmen of Iran and the Bedouin of Jordan. The Türkmen material includes a magnificent domed tent (*yurt*) with a wooden frame and felt covers, as well as examples of bold heavy jewellery, with beautiful designs in different metals, set with various stones. Among the Bedouin collection are a goat-hair tent and a ground loom of the type on which Bedouin weave their tent cloth, woven animal-trappings, and a wooden camel saddle. Also included is a set of utensils for making and serving coffee: an iron

125 *Dress from Beit Dajan, near Jaffa, Palestine. Richly embroidered in silk cross-stitch with taffeta and satin patchwork. Dresses such as this were embroidered by girls to be worn at their wedding ceremonies. 1920s.* H 1.4m.

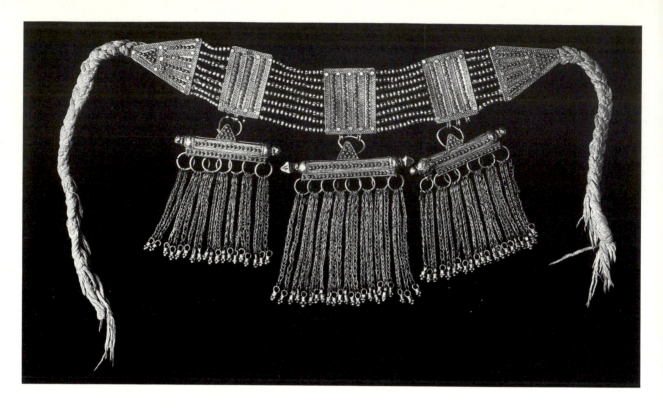

127 ABOVE *Silver necklace from Razih, North-West Yemen Arab Republic. Such jewellery is part of a woman's dowry. Mid-twentieth century* AD. L *39cm.*

128 BELOW *Silver ceremonial buckle from the Turnovo district, north-east Bulgaria. It is ornamented in repoussé with birds, a popular motif on such buckles. Late nineteenth century* AD. L *19.5cm.*

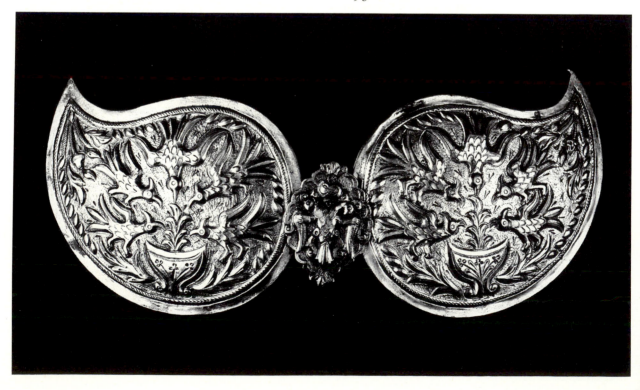

129 *Woven wool meal cloth from Baluchistan. Such cloths were used for laying out meals to serve to guests. This piece may derive from the Rakhshani or Reki tribe (Chakhansur, Afghanistan) or the Janbegi tribe (Iran).*
114 × 63cm.

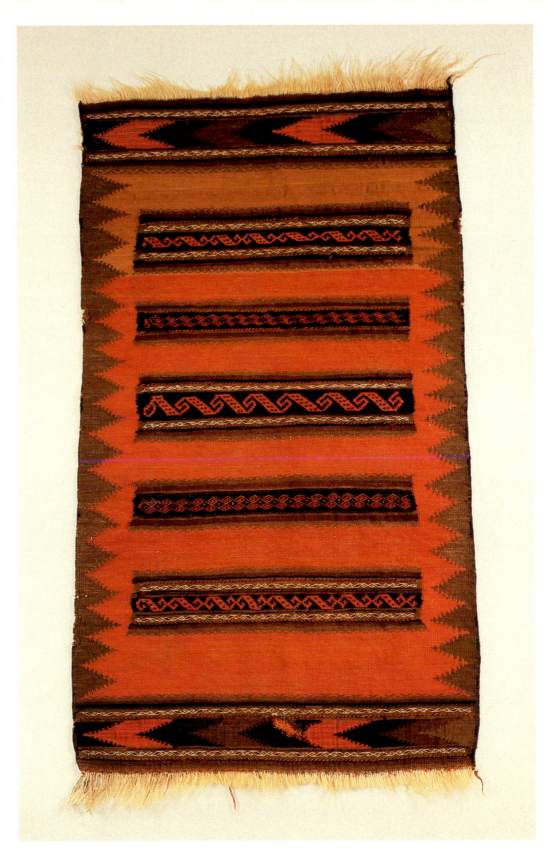

ladle for roasting the beans, a carved wooden mortar and pestle for grinding them, and a set of brass coffee pots. Offering bitter coffee flavoured with cardamon is an important expression of hospitality among the Bedouin. There are also several looms among a collection of beautiful flat-woven rugs and saddle-bags from the nomads of Baluchistan in Pakistan. These are in natural wools and dyed mainly shades of red, with geometric designs. The bags are ornamented with finely worked tassels and shells.

The Department contains little material from Europe, but worthy of note are a collection of Bulgarian costumes donated by the Bulgarian government and shadow puppets from Turkey and Greece. The costumes show the different styles of dress worn by the village people in various parts of Bulgaria, and include finely woven and embroidered dresses, jackets and blouses. The puppets were used in a popular form of street threatre which showed the farcical exploits of a comic hero.

ASIA

The Department's Asian collections reflect a great variety of natural and cultural environments. From India and China the collections are relatively sparse and uneven, although one group of material that deserves attention gives an interesting if superficial glance at mainstream rural culture. The most typical specimens are realistic models of houses, boats, mechanical devices and native figures in different occupations or social positions. These indicate not only the influence of a relatively advanced technology and division of labour (and, of course, the practical difficulty of collecting full-sized examples), but also the readiness of traditional artisans to cater to European tastes. This happened not only in India and China, for instance, but also in Java and Japan.

In contrast, the Department has more material from the tribal cultures of Asia. South Asian hunters and gatherers are represented by collections from the

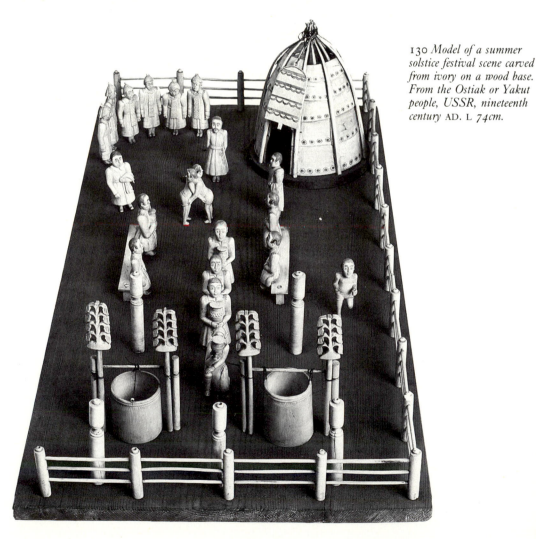

130 *Model of a summer solstice festival scene carved from ivory on a wood base. From the Ostiak or Yakut people, USSR, nineteenth century* AD. L *74cm.*

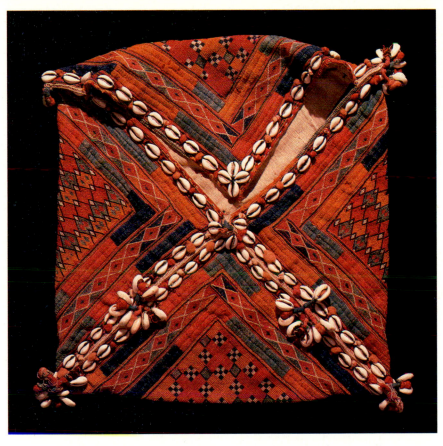

131 *Dowry bag of embroidered cotton with cowrie shells. From the Banjara people of the Deccan, India, late twentieth century* AD. H *43cm.*

Andaman and Nicobar Islands acquired around the turn of this century and in the 1920s. Between the world wars colonial officers stationed among the Nagas of north-east India compiled rich collections for the British Museum and Oxford and Cambridge Universities. Prominent among these are ivory armlets, amber necklaces, basketry hats adorned with feathers, and brass or wood heads that are related to a head-hunting tradition, and human figures which reflect the importance of ancestors.

People with a similar mode of economy and relatively egalitarian social structure, the Chhindwara Gonds of Madhya Pradesh in central India, are represented in the remarkably comprehensive collection made around 1914 by Hira Lal – a rare and particularly interesting example from the colonial period of an ethnographic collection compiled by a non-European. Even at that time the Gonds' natural environment gave them much less protection from outside influence than the Nagas enjoyed in their own hillier country further from the main concentrations of Hindu or European culture in the sub-continent.

Material from Sri Lanka documents many aspects of non-tribal Sinhalese (and, to a limited extent, Tamil) culture, and is especially rich in ritual objects, including many masks used for ritual healing. One mask represents Dala Kumara in the unique form of a human face superimposed on a woman's bosom, and is from the *Kolam* masked theatre, which is probably related to Indian traditions and is today maintained only in the south-western part of the island.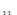

From further east on the Asiatic mainland come well-documented textiles and other tribal material from south-west China and northern Thailand, some of them received in recent years, as well as earlier collections from nomadic hunter-gatherers of the forests of the Malayan peninsula. The tribal cultures of upland Burma are also well represented, particularly by traditional costumes acquired during the colonial period.

The Department's holdings of textiles and costumes from Tibet and neighbouring territories complement other material from the same region in the Department of Oriental Antiquities, which together comprise an outstanding resource. More miscellaneous are the collections from Central Asia, although there is some notable jewellery and examples of fine, vivid

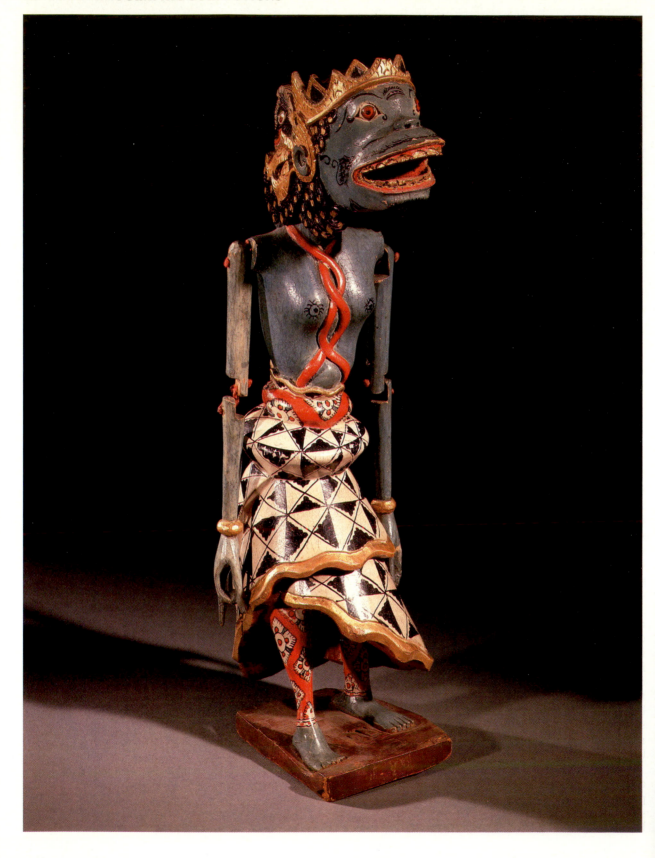

132 LEFT *Javanese painted and gilded wood puppet,* wayang klitik, *representing a mythological king. Late eighteenth century or early nineteenth century* AD. H *32cm.*

133 RIGHT *Sinhalese* Kolam *mask of painted wood depicting Dala Kumara, Lord of benevolent demons. From Sri Lanka, nineteenth century* AD. H *40cm.*

ikat-dyed textiles. The Department also holds artefacts from tribal peoples of Siberia that compare with native North American work in the resourceful use of local materials, such as birch-bark containers, fish-skin garments and delicate carvings in bone and ivory. Among these collections is a shaman's drum with a painted drum-head that was part of Sir Hans Sloane's bequest on which the British Museum was founded in 1753.

Collections from eastern Asia include important material from the tribal people of Taiwan, such as carved wooden objects and blankets of red-dyed dog-hair, and from the Ainu of Hokkaidō, the northern island of Japan. The Ainu are culturally related to certain Siberian peoples. Among the Department's finest Ainu items are outstanding barkcloth coats with bold curvilinear designs in cotton appliqué and embroidery. These people also observed a bear-cult, represented in the collection by a striking skin-covered bear's skull mounted on a post.

The collections from the South-East Asian archipelago, between Sumatra in the west, the Philippines in the north, and the tiny Kei Islands in the east, show dramatic cultural variation. This is partly due to a long history of outside influence, through immigration, trade and conquest, but it is also the result of environmental contrasts between the interior uplands, valleys and plains of the larger islands and the more restricted habitats of the smaller islands and atolls.

Steep and densely forested hills in central Borneo, for example, encouraged cultural variation as communities developed their own patterns in relative isolation from each other; elsewhere strong currents, sea-raiders, or historical differences also acted to reduce contact between separate islands. Immediate neighbours Java and Bali both practise rice cultivation and fishing, and there are similarities in their culture. Java is Islamic and Bali Hindu, but despite corresponding social and religious differences both developed aristocratic court traditions characterised by elaborate products, like superbly decorated textiles, the semi-sacred *keris,* and theatrical and musical repertoires of great finesse. The great collection acquired by Sir Stamford Raffles when he was Lieutenant Governor of Java from 1811 to 1816 probably contains the earliest datable and certainly some of the finest examples of puppets, including shadow-puppets, masks and musical instruments from Java, and also pieces from Bali and other parts of Indonesia.

132

Tribal material from insular South-East Asia includes ancestral figures from the Nias Islands off south-west Sumatra, and a wide range of traditional objects from various people of the Philippine Islands, such as figures, shields, weapons, and examples of the entire range of artefacts of a nomadic group of negrito hunter-gatherers. Of special importance is a well-documented and detailed collection from Seram of recent, everyday equipment and samples of raw materials. Many of the pieces are particularly perishable and ephemeral, and are therefore rarely found in musuem collections.

Finally, the Department has an outstanding collection of tribal material from Borneo, largely from Sarawak in the north-west of the island. Most of it derives from Charles Hose, an officer in Rajah Sir Charles Brooke's administration between 1884 and 1907. Among the most striking objects in the Hose collection are some magnificent wood sculptures – free-standing anthropomorphic figures of very varied form and expression, as well as canoe-prows and house-boards depicting stylised animals, and elaborately carved hornbill effigies to enlist the support of a deity in head-hunting raids. Hose not only collected artefacts, but could turn them to advantage in his work. A photograph in one of his books shows that before it was sent to London, he reversed the traditional function of one of the hornbill images now in the Department, to suggest supernatural approval of a peace-making ceremony he organised in 1899 between hostile communities.

134

OCEANIA

The British Museum's Oceanic collections come from that vast area stretching from New Guinea's western tip to Easter Island, and from the Hawaiian Islands in the north, to New Zealand's South Island. The great size of this area is reflected in the diversity of the societies found there. Nevertheless, three broad generalisations can be made about these societies' traditional material culture, and hence about the collections. Metalworking was not indigenous to Oceania except in the extreme west of New Guinea, where it was introduced from Indonesia. Instead, stone, shell, bone and bamboo provided the tools for felling and cutting, carving and killing. Nor is weaving a traditional Oceanic craft, save in Micronesia, on some outliers of the Solomon Islands, and locally in the Bismarck Archipelago. Other fabrics, in particular barkcloth, generally served the functions of woven fabrics elsewhere. Finally, pottery was not known in Australia, and only in prehistoric times in Polynesia.

Oceania is conventionally subdivided into Polynesia, Micronesia, Melanesia and Australia; Fiji, sometimes assimilated to Polynesia, is here treated as part of Melanesia.

Polynesia

Well-founded knowledge of Polynesia began in the West with Captain Cook's three voyages of exploration (1768–79), which were also the origin, both directly and indirectly, of many of the most important pieces in the Museum's collections. Today this great scatter of islands, of which New Zealand is much the largest, is known to have been settled by a single people, ultimately of South-East Asian origin. These proto-Polynesians

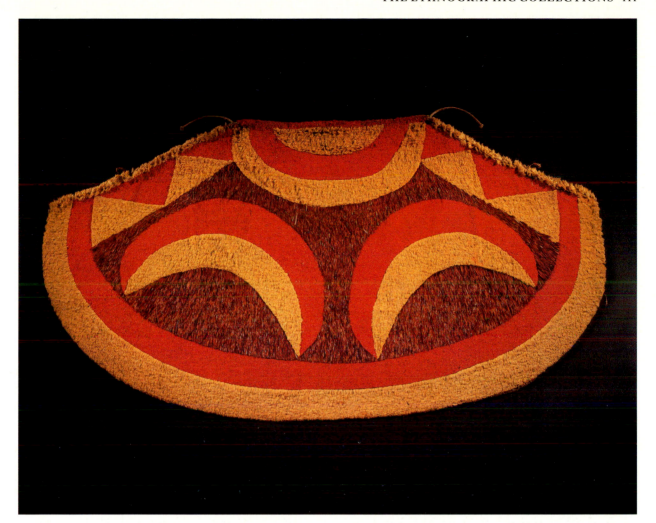

may well have brought with them the notions of rank and hierarchy, based upon genealogical proximity to chiefly lines, which Cook and other early visitors found to be expressed more or less strongly throughout the islands. These ranking systems, which were comparatively muted on the more sparsely populated Polynesian atolls, reached their fullest development on the populous volcanic islands, such as the Tahitian and Hawaiian Islands. This is reflected in their material culture. For example, in the Hawaiian Islands, from which the Museum has excellent collections, men of the chiefly class were distinguished by their feather-work regalia – capes, cloaks, helmets, which were worn on ceremonial occasions and in battle. Feathers were similarly important in Tahiti: in fact, Cook used red feathers that he had earlier obtained in Tonga to trade for food in Tahiti. However, undoubtedly the most spectacular item in the collections from Tahiti is the mourning dress presented to Cook on his second voyage. Such dresses were donned on the death of a high-ranking individual by one of his close relatives or

by a priest who, in the company of other mourners, toured the neighbourhood, terrorising the inhabitants. Further important early material from both the Hawaiian and Tahitian Islands was collected by G. C. Hewitt, the surgeon's mate on Captain Vancouver's voyage in the area at the end of the eighteenth century.

The European impact upon Polynesia was swift, marked and often catastrophic. In some island groups, such as the Australs, the combination of introduced diseases and missionary fervour devastated the indigenous culture before the full significance of such items as the representation of the god A'a from Rurutu Island could be appreciated. At the same time the introduction of metal tools often appears to have given a short-lived stimulus to local wood-carving traditions, allowing the production of artefacts that were larger (as in the case of some Hawaiian images in the collection) and more intricate (as with Mangaian adzes and Ra'iva-vaean drum bases) than before. The finer designs on Hawaiian barkcloth also seem to have been related to the acquisition of iron tools, enabling Hawaiians to

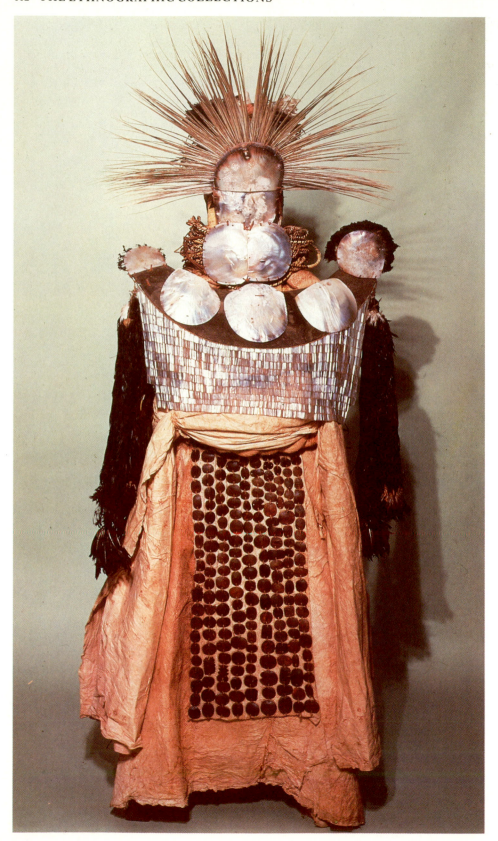

136 Tahitian mourning dress presented to Captain Cook. The dress is of barkcloth and the face-mask of pearl shell. Whole pearl shells decorate the wooden breast ornament, while the chest piece is made from pearl shell slivers. H 2.2m.

produce more intricate barkcloth-beaters and stamps.

The European intrusion into Polynesia was not the sole source of destructive change. By 1774 many of the massive stone statues for which Easter Island is so well known had been toppled by the islanders themselves, perhaps as the consequence of warfare associated with the indigenous degradation of the environment. The collections include two such statues, brought back to Britain by HMS *Topaze* after a visit to the island in 1868. However, the social significance of these statues and of the Museum's extensive collection of wood-carvings – including examples of the undeciphered *rongorongo* script – remains unclear. The combination of raids by Peruvian slavers in the early 1860s and smallpox so reduced the island's population that this cultural knowledge was lost.

Like Easter Island, New Zealand is one of the very few Polynesian islands outside the tropics. On New Zealand's South Island, in particular, the crops which are important food sources elsewhere in Polynesia did not grow, and the eighteenth-century inhabitants lived largely by hunting, gathering and fishing. Throughout New Zealand the climate also restricted cultivation of the paper mulberry, from which barkcloth is otherwise made. Instead, native flax was fashioned (using a plaiting technique known as finger-weaving) into cloaks, belts and kilts. The collections are particularly rich in cloaks and, more generally, in a host of Maori wooden artefacts carved in characteristic curvilinear style. Amongst the most elaborate carving was that done on war canoes. In New Zealand, more than elsewhere in Polynesia, the European impact – expressed in part through the sale of guns – aggravated local patterns of warfare, and was one of the factors leading to the eclipse of Maori culture in the nineteenth century.

138

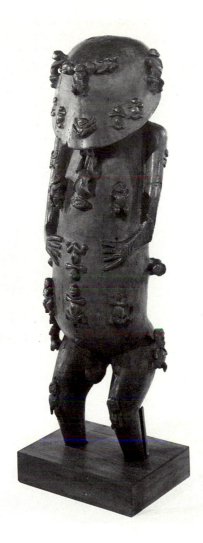

137 ABOVE *This unique figure of the god A'a from Rurutu Island in Polynesia is one of the most famous pieces in the Museum's collections. A large cavity in the figure's back once contained a number of smaller images. Probably eighteenth century* AD. H *1.17m.*

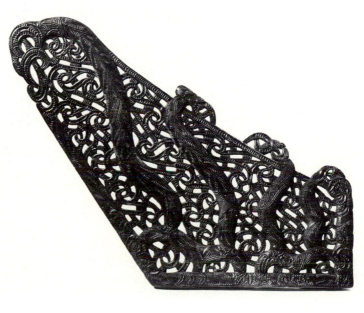

138 RIGHT *Prow of a Maori war canoe, with several* manaia, *a motif ubiquitous in Maori carving, combining elements of man, bird and lizard. Only one other prow in the northern style, such as this one, is known. Probably eighteenth or early nineteenth century* AD. H *(max.) 89cm.*

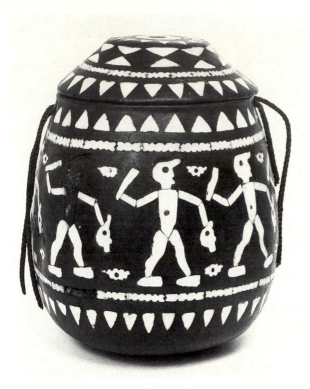

139 *Wood container with shell inlay from the Palau Islands (Republic of Belau). Such decorated containers were used traditionally for storing sweetmeats. This one is unusual in showing warriors carrying heads. Probably eighteenth century* AD. H *22cm.*

Micronesia

As in Polynesia, the four island groups of Micronesia – the Mariana, Caroline, and Marshall Islands, and Kiribati – are a combination of resource-rich volcanic islands and poorer atolls. They, too, were originally settled by immigrants (probably from the Philippines and Indonesia, and later Fiji and the New Hebrides), and their inhabitants depended both upon marine resources and horticulture. In most parts of Micronesia (the Marianas are an exception) the impact of the West was not extensively felt until the mid-nineteenth century. Thereafter introduced diseases had a similar depleting effect as in Polynesia, and the islands passed variously and successively under Spanish, German, Japanese, British and American control.

The collections include examples of characteristic Micronesian arts and crafts: wooden bowls, shell ornaments and plaited mats and baskets. Weaponry is well represented, particularly from Kiribati which, as the Gilbert Islands, was the only Micronesian island group under British control. Here the shark-tooth weapons and coconut-fibre armour are particularly notable.

The collections also include what may be the earliest documented holdings from any part of Micronesia. In August 1783 the East India Company packet *Antelope* was wrecked in the Palau Islands (now Republic of Belau). The captain and the crew forged such amicable relations with the Palauans that when they left they carried not only an impressive collection of artefacts, some of which found their way to the Museum, but also the High Chief's son who, sadly, died before he could be returned to the islands.

Melanesia

Almost all areas of Melanesia (which comprises the large island of New Guinea, the Bismarck Archipelago, Solomon Islands, New Hebrides, New Caledonia and Fiji) are substantially represented in the Museum's collections. The bias, however, is towards those parts, such as Papua and the Solomon Islands, which had closer historical links with Britain. Traditional Melane-

140 *Canoe-prow ornament, from the Solomon Islands. Such carvings, attached to the prow just above the waterline, are believed to protect the canoe and its occupants from dangers ahead.* H *22.5cm.*

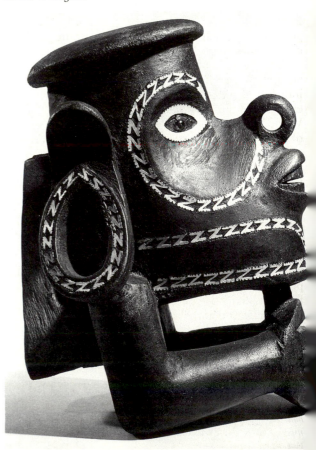

139

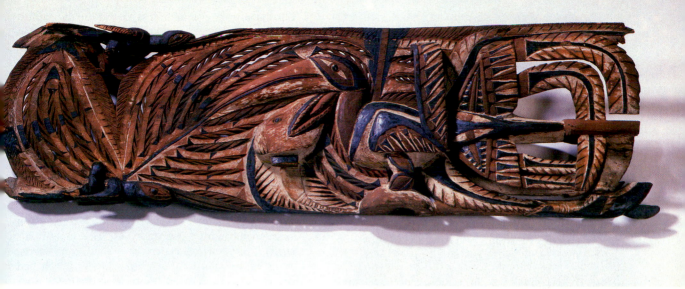

141 ABOVE Malangan *sculpture in the form of a horizontal frieze from New Ireland, Papua New Guinea.* L 1.33m.

sian political systems are typically decentralised and fairly small-scale. Their material culture does not generally reflect the hierarchical values, or the power of chiefs, apparent in Polynesia.

Social life in many parts of Melanesia revolves around the ceremonial exchange of goods between individuals and communities. The best known of such exchange systems was that studied during the First World War by Malinowski, one of the founding fathers of contemporary anthropology. Known as the *kula*, this exchange system links many of the island communities in the Massim area, off New Guinea's south-eastern tip. The Museum has excellent Massim collections (among them, Malinowski's), and includes fine examples both of the exchange items themselves, and of the intricately carved end-boards of the canoes in which those on *kula* expeditions travelled. Inter-island *kula* trips are still made today, sometimes by canoe, sometimes in modern vessels. Nineteenth-century European impact in the neighbouring Solomon Islands was far more disruptive of local societies. The large plank-built Solomon Island canoes, inlaid with pearl-shell and with striking prow carvings, are no longer made.

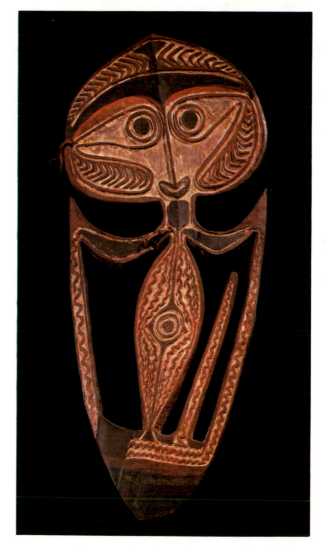

142 RIGHT *Wood rack for trophy skulls, from the Papuan Gulf, Papua New Guinea. Skull racks, together with ceremonial boards, also made of wood and similarly decorated, were kept in men's houses. Nineteenth or very early twentieth century* AD. H 1.17m.

On the New Guinea mainland the Sepik region was particularly noted for its art forms. In its diversity and expressiveness, this is perhaps the richest art-producing area in the world. The Sepik area fell into what was, until 1914, German New Guinea, and German institutions possess the finest early Sepik material. Recently, however, the Museum has added to its existing Sepik holdings, making in particular an extensive collection from the Abelam people, whose bold figurative sculpture is produced in connection with initiation ceremonies. In 1964 a comprehensive range of material from the Tifalmin people of the upper Sepik was acquired as a result of an expedition by members of the Department's staff. Field collecting by members of staff has since become a regular way of adding well-documented items to the collections.

Few artefacts survive very long in a tropical environment, but some categories of artwork are notably ephemeral. The magnificent filigree *malangan* constructions of New Ireland may be discarded and left to rot, or sold to Europeans, after having been briefly displayed in the commemorative rites for the dead for which they are made. Here the collections include in particular some fifty very early *malangan*, purchased from a single site in exchange for 'a gigantic pig', and presented to the Museum in 1884. In the Papuan Gulf, on New Guinea's southern coast, the polychrome bark-cloth masks made for a now discontinued ritual cycle were ceremonially burned at the end of festivities. Not all Papuan Gulf material culture was so transient: the skull racks and ceremonial boards in the collection would have been more enduring items.

The dense populations of the Highland areas of New Guinea were the last major Melanesian societies to be contacted by outsiders, in the 1920s and 1930s. Theirs is generally a sparser material culture, but with a particular emphasis on elaborate personal adornment worn for festivals and exchanges.

Australia

The Aboriginal peoples of Australia lived by hunting, gathering and, in some areas, fishing; for the most part by moving in small bands across vast territories, living off the land as they went. To survive they developed a subtle and deep understanding of their natural environment. Although their artefacts are generally simple, sometimes multi-functional (a shield could serve as a container and also be used in making fire), they were well adapted to a life of frequent movement. Besides the wooden shield collected at Botany Bay on one of Cook's voyages, the Museum possesses many other examples of Aboriginal tools and weapons, including various forms of boomerang, as well as baskets, fishing equipment and a double raft from the Worora people. The most substantial collections come from Western Australia, the Northern Territories and Queensland. The research expedition of the Cambridge anthropologist A. C. Haddon in 1888–9 added many items from the Torres Straits area, and two other pioneering anthropologists, Baldwin Spencer and F. J. Gillen, collected among the Aranda tribe of central Australia, whose ceremonial life they studied and recorded. The complex religious beliefs of the Aborigines are represented by several examples of sacred engraved stones, *churinga*, which record the journeys of the ancestral beings who are believed to have created important features of the landscape as they travelled.

European impact had a devastating effect on Aboriginal societies, dispossessing and destroying many, and radically affecting most of the remainder. However, recent decades have seen a revival of Aboriginal culture. Many groups in central Australia and in the Northern Territory have re-established a presence on traditional lands, a move they have partly financed from the sale of works of art. The Museum has acquired a number of collections of such contemporary Aboriginal art which, though it often employs modern materials, also refers back through the motifs it uses to the long-standing Aboriginal concern with the land.

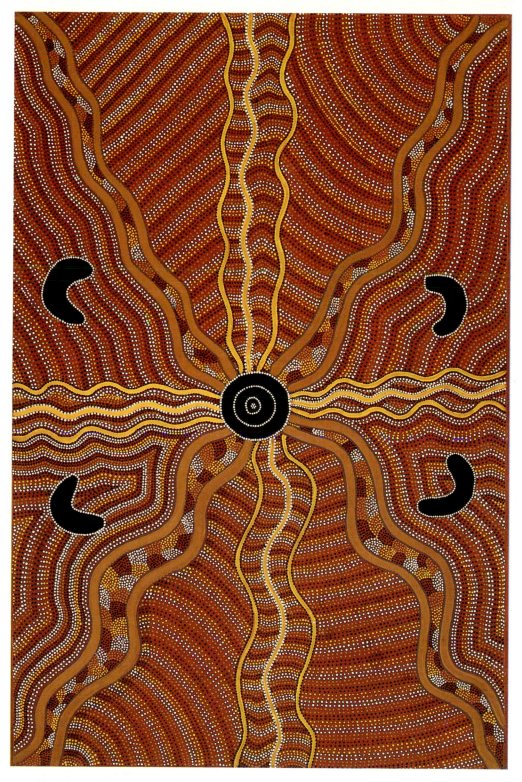

143 Bush Potato Dreaming: *acrylic paint on canvas, from Yuendumu in the Western Desert area of Australia's Northern Territory. 1986. 145 × 94cm.*

THE MEDIEVAL
AND
MODERN COLLECTIONS

The Department of Medieval and Later Antiquities contains a vast and heterogeneous collection of the post-classical art and archaeology of Europe. Other Christian and Jewish cultures of this period outside Europe are included, for instance Byzantium. The Museum does not, however, attempt to make comprehensive collections in every medium: furniture, textiles, European folk life, arms and armour, manuscripts, paintings, printed books and pamphlets and modern technology are collected by other national institutions.

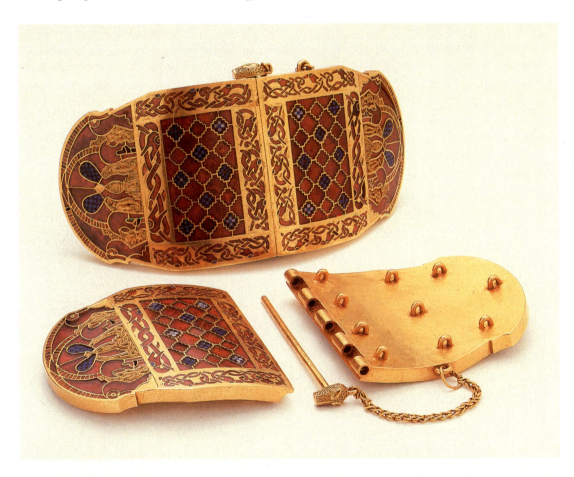

144 *Shoulder-clasps of gold, garnet and millefiore glass from the Sutton Hoo ship burial (c. AD 625–30). The clasps would have been fixed to two halves of a leather overgarment. Each is fastened on a hinge by a gold animal-headed pin. L 12.7cm.*

THE LATE ANTIQUE COLLECTIONS

The Department is responsible for those late Roman collections which date from after the Edict of Milan (AD 313) but do not come from Roman Britain. With the Edict of Milan Christians throughout the Roman Empire gained the freedom to practise their religion, and it is the emergence of a Christian art from its secular, Jewish and pagan background which gives the Department's superb late Roman collections their particular interest and importance.

Two sizeable silver treasures demonstrate the gradual development of the religion. The first, from the fourth century AD, found on the Esquiline Hill in Rome, includes two large caskets, plates and furniture fittings; a slightly later hoard unearthed at Carthage is composed predominantly of bowls and spoons with Christian symbols. The emergence of an unambiguous Christian iconography is reflected in some remarkable

145 The Projecta Casket from the Esquiline Treasure. The partly gilt silver casket is embossed with mythological and secular scenes but engraved with the inscription: 'Secundus and Projecta, may you live in Christ'. Second half of the fourth century AD. L 56cm.

ivories, among them four sides of a box carved with scenes of Christ's Passion. A substantial collection of jewellery, much of it bearing Christian symbols, includes a large number of precious and semi-precious stones engraved in intaglio with various devices; also noteworthy is a small group of gold objects executed in *opus interrasile* ('pierced work'). The collection contains some 750 magical gems, cut to magicians' 'prescriptions', mostly to cure or protect against such illnesses and misfortunes as colic, backache and shipwreck.

The collection of glass includes the unique dichromic Lycurgus Cup, carved with a mythological scene, but especially notable is the gold-glass: vessels decorated with gold foil cut to shape and sandwiched between layers of glass. Examples include pagan, Jewish and Christian designs. The Department also holds a large group of bronze and glass weights, tokens and amuletic pendants, pottery, and a wide range of everyday objects. Stone is represented by a more or less complete sarcophagus, carved with the story of Jonah, a number of architectural and sarcophagus fragments, and a few grave stelae. Few textiles survive from this early period, and then only from Egyptian soil; the Department's small collection complements textiles cared for by the Department of Egyptian Antiquities.

146

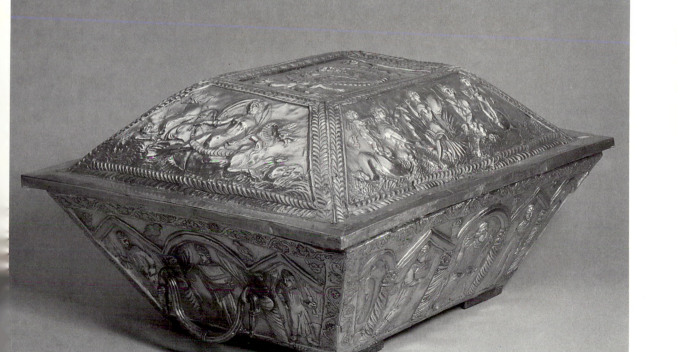

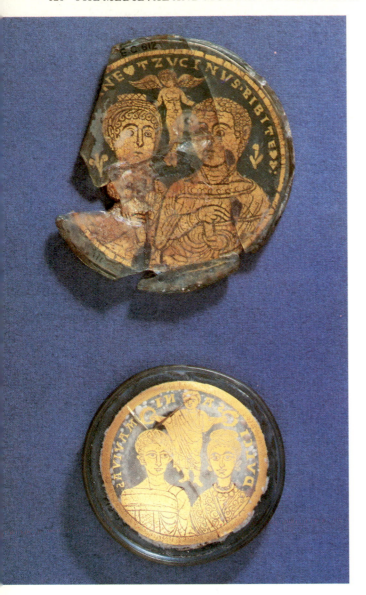

146 *Gold–glass fragments of drinking vessels, with gold foil between layers of glass. These fragments, found in the Roman catacombs, show bridal couples blessed by Cupid (top) and Christ (bottom). Fourth century* AD. D *(top) 7cm.*

Barbarian Europe

During the fourth and fifth centuries AD the power of the Roman Empire in the west crumbled, and land-hungry Germanic tribes expanded to occupy much of Western Europe. Before they were firmly converted to Christianity Germanic tribes buried objects with their dead. Thus, until the seventh century in large areas of

Western Europe, and the eleventh century in Scandinavia, significant objects from daily life are preserved in many graves. The collections are particularly rich in jewellery of the fifth to seventh centuries associated with tribes such as the Goths, Ostrogoths, Franks and Lombards, whose wealth in gold and silver, use of red garnet inlays and love of rich colour contrasts owe much to late antique traditions. Stylised animal ornament, a characteristically Germanic development, was particularly long lived in Scandinavia, where the changing styles are seen in a range of objects from Gotland of the fifth to eleventh centuries. Double-edged swords, sometimes richly decorated and skilfully smithed by Rhenish craftsmen, were marks of the powerful throughout the period; freemen carried a spear and shield, or heavy knife.

From the eighth to ninth centuries onwards new urban trading sites developed in strategic locations throughout Europe and parts of Scandinavia. From these comes extensive evidence of local industries and trading which is reflected in material, for example, from Dorestad in the Netherlands.

From the late eighth to early eleventh centuries Europe was again convulsed as Scandinavian Vikings raided widely in the west and occupied some areas for permanent settlement. A range of treasures and heavily decorated jewellery from Gotland shows the Vikings' technical skill and artistry. Objects of iron, bronze and whalebone found in Norwegian graves show more everyday aspects of their life. Roman and Byzantine gold coins of the fourth to sixth centuries, and Islamic and Anglo-Saxon silver of the ninth to eleventh centuries found in Scandinavia are evidence of the wealth derived from periods of military service, trade and piracy.

In Eastern and Central Europe from the sixth to eighth centuries the Slavs expanded to occupy lands as far as the Baltic coast, the River Elbe and the Adriatic Sea. In the east they penetrated deep into modern Russia and the Ukraine. The collections illustrate little of the complex political and economic developments in this important area of Europe. A western Slav hoard of the eleventh century contains sheet-silver beads and ear-rings with delicate use of filigree and granulation. Modest rings, worn in a woman's hair or as head-dress pendants, display regional variations, especially among the eastern Slavs. The most spectacular (called 'kolts') are of eleventh- to thirteenth-century date and are of silver, sometimes nielloed, or of gold with enamelled decoration. Kiev, the centre of the most powerful eastern Slav principality, is represented by a silver hoard of the thirteenth century, buried just before its sack by the Tartars from the east.

The Balts and Finno-Ugrians, two distinct ethnic and linguistic groups, inhabited lands bordering those of the Slavs, very broadly in the present Baltic States

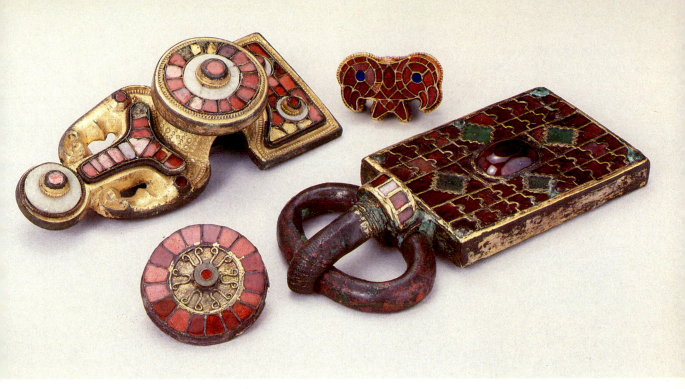

147 ABOVE *Germanic polychrome jewellery. Sixth-century female brooches and a belt buckle, from different parts of Europe. The predominant red of the cloisonné garnet inlay is highlighted by the sparing use of a second inlay and the glitter of gold or gilt.* L *(buckle) 9.8cm.*

and northern Russia respectively. Their traditional bronze jewellery during the ninth to twelfth centuries reflects very distinctive local fashions. That of the Balts is characterised by its weight of bronze and delicate decoration, while the Finno-Ugrians display a fondness for naturalistic representations of animals and birds.

Throughout the first millennium periodic invasions of peoples from the Eurasian Steppes brought upheaval to Central Europe and sometimes further west: the Huns in the late fourth and fifth centuries, the Avars in the sixth century, the Bulgars in the late seventh century, the Magyars in the later ninth and tenth centuries. Characteristic of these semi-nomadic groups are richly worked objects in organic materials, which unfortunately seldom survive. The importance of these peoples is only hinted at through the minor objects contained in the collections. Avar ear-rings, for example, and other gold ornaments, are made of melted-down coins extorted in massive amounts as tribute from the Byzantine

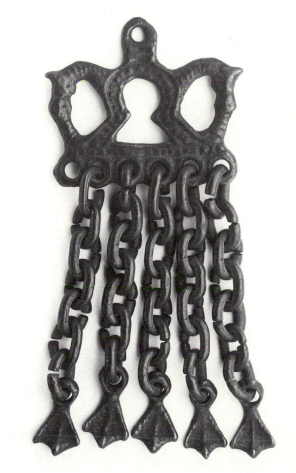

148 *Finno-Ugrian copper alloy pendant. The upper part is in the form of the head and fore-leg of two horses in profile. The chains support pendants resembling webbed feet, which would have jingled as the wearer moved.* W 5.1cm.

Empire. The vine-scroll decoration on their elaborately cast fittings from composite belts shows further Byzantine influence. Saddle-mounts and richly decorated iron horse-fittings survive, along with the rider's characteristic weapons such as the sabre.

THE ANGLO-SAXONS

In the fifth century southern and eastern areas of Britain saw the settlement of Anglo-Saxons, a blanket term for folk from a variety of tribes with homelands on the North German Plain and in southern Scandinavia. The early phases of the Anglo-Saxon settlement are represented by a range of metalwork and pottery that reveals the Continental backgrounds of the Germanic immigrants. The grave-goods of these pagan Anglo-Saxons, dating from the fifth to the seventh centuries, are exceptionally well represented in the collections, supplemented by a growing body of material from modern settlement excavations. They illustrate considerable diversity of wealth and culture, from the cremation urns and cruciform brooches of the Angles, to Saxon saucer brooches, and the lavish garnet-inlaid metalwork, prestige weapons and Continental imports characteristic of Kent, richest of the early kingdoms.

The collections also contain an unrivalled group of material from royal and princely graves. The most famous of these is the Sutton Hoo (Suffolk) ship burial,

the grave of an East Anglian king. The burial is renowned for its wealth of gold and garnet jewellery, its Byzantine silver and its weapons and armour. Lesser princely graves in the collection – notably those from Taplow (Buckinghamshire) and Broomfield (Essex) – were also lavishly equipped with gold jewellery, sets of fine drinking and storage vessels and weapons.

After the conversion of the English to Christianity the practice of burying personal possessions with the dead gradually ceased. In the collections individual finds, hoards and assemblages from rural and urban

149 The Fuller Brooch. A large silver Anglo-Saxon disc brooch, decorated in niello with scenes representing the five senses. One of the most lavish forms of late Saxon jewellery, disc brooches were worn by both men and women. D 11.4cm.

settlements replace the grave-goods of the earlier cemeteries. Although from the mid-seventh century onwards fewer objects have survived, these include a high proportion of personal possessions, such as jewellery and weapons. The role of the Church in society is reflected in memorial stones and standing crosses, liturgical metalwork, and a fine series of tenth- and eleventh-century ivory-carvings, such as the pen-case from London. Craft and technology as well as the domestic side of Anglo-Saxon life in the eighth to eleventh centuries are well represented by a range of objects including pottery and other kitchen utensils, iron knives and weaving implements. Carpenters' tools from the Hurbuck (Durham) hoard and iron fish-hooks and spade shoes, as well as metalworking equipment, give glimpses of rural life and industry otherwise known from manuscript sources.

Contemporary with the late Anglo-Saxon material is a small but rich collection of Viking objects from England, Ireland and Scotland. Through gold and silver jewellery, predominantly male, it reflects Viking wealth from loot and trade, while the significance of warfare is revealed through axes, spears, swords and their fittings. The collections include some impressive hoards of hack-silver, most famous among them that from Cuerdale (Lancashire), the largest Viking hoard outside Russia, which contained over a thousand pieces of cut-up silver bullion, as well as many thousands of coins.

The gradual development of literacy is reflected in a varied group of objects inscribed with runic inscriptions, some clearly magical. Of outstanding interest are the unique rune-inscribed box of whale's bone known

150 *Anglo-Saxon pen-case made of walrus ivory with glass inlays. It has a sliding lid and is carved in high relief with plant and animal scenes. Its shape suggests that it was used to hold quill pens. Mid-eleventh century* AD. L 23.2cm.

as the Franks Casket and two gold ninth-century rings associated by their inscriptions with the royal house of Wessex. The lighter side of Anglo-Saxon life can be seen in bone chessmen and gaming-pieces, and in a number of lyre fittings, which testify to the importance of music and poetry. Finally, the abiding pleasure that the Anglo-Saxons took in intricate decoration and fine craftsmanship is demonstrated in metalwork and sculpture covering five hundred years in which the development of the animal-based ornament brought by the earliest Germanic settlers can be traced.

THE CELTS IN BRITAIN AND IRELAND

The Museum has the most extensive collection outside Ireland of material from the early medieval phase of the western Celtic peoples. In Britain this is the period of the Anglo-Saxon settlement of lowland Britain, when the Celtic kingdoms held the highland areas of the north, modern Wales and the south-west. Fine metalwork from the kingdoms of Celtic Britain is represented primarily by the remains of more than thirty hanging-bowls, many handsomely decorated with applied enamels in characteristic scroll and spiral designs. Almost all, such as the three bowls from Sutton Hoo, have been recovered from Anglo-Saxon pagan burials.

The greater part of the Celtic collection comes from Ireland. It is rich in metalwork, particularly relating to dress. The characteristic Celtic dress fastening was the open-ring or 'penannular' brooch, well represented here, with examples from the fifth century onwards. A few come from Wales and some from the kingdom of the Picts, a major power in the early Middle Ages in northern Britain. Dress pins are also common; like them, the brooches demonstrate the variety of form and styles in the early Christian period, in particular the absorption of Anglo-Saxon and Mediterranean motifs in the eighth century, a period of brilliant crafts-manship. In the tenth and eleventh centuries Vikings in Ireland adopted new styles of brooch and pin reflecting Scandinavian taste, the most flamboyant of which are the great silver penannular brooches with thistle-shaped terminals; examples have been found in Cumbria, at Clonkeen in Co. Longford (Ireland), and elsewhere.

151 BELOW *Silver bossed penannular brooch from Co. Galway, Ireland. This is one of a small group of elaborate Irish–Viking brooches of the late ninth to early tenth centuries AD. It is decorated on the front with panels of animal interlace between the high-relief bosses.* L 39cm.

152 ABOVE *Pictish symbol stone carved with the figure of a bull, one of numerous bull carvings from the vitrified fort at Burghead, Moray Firth. The powerful bull symbol occurs only at Burghead and may indicate tribal or dynastic identity.* H 5.25cm.

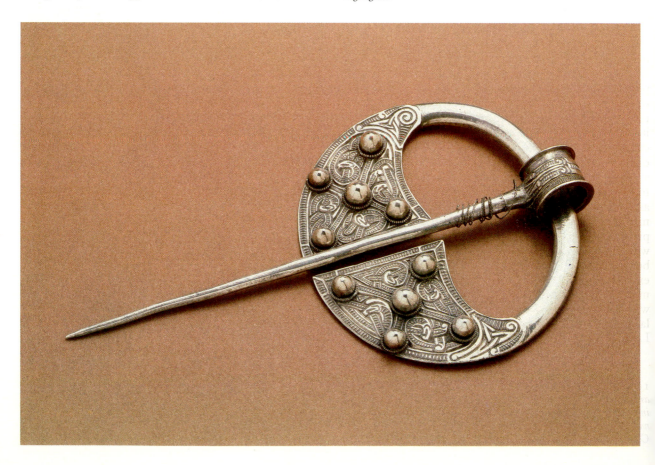

The collection also contains an important group of ecclesiastical metalwork dating from the eighth century onwards. This was a period of travel and exchange amongst the monks and clergy, when the Church was the major patron of the arts. The find-places of a few fine Irish-style pieces reflect this interchange: the gilt-bronze boss from Steeple Bumpstead (Essex), material from the Anglo-Saxon abbey at Whitby (North Yorkshire), and a Carolingian brooch from Ballycottin (Co. Cork, Ireland). The flowering of Christian culture in Ireland is also seen in an important group of early bells, some associated with holy men and enclosed later in lavish containers. The 'Kells' crozier is justly famous and the collection contains parts of other croziers, ornamental figures and plaques from other shrines.

A variety of tools, utensils and other objects illustrate domestic and rural life. Although pottery was not in common use in the Celtic kingdoms, the collections include some early imported Mediterranean sherds and later domestic ware. There are also examples of less readily portable material: among a small group of sculptured stones are a memorial stone with both Ogham and Latin script from Llywel (Powys, Wales) and a finely incised Pictish bull on a slab from Burghead (Grampian, Scotland).

BYZANTIUM

In AD 330 Constantinople (present-day Istanbul) had become the capital of the Roman Empire; the fall of Rome and the western part of the Empire to Germanic peoples during the fifth century marked the beginning of the early Byzantine period. The Roman legacy is reflected in the Department's Byzantine collections by items which preserve the classical tradition through a continuing interest in pagan motifs and yet represent a development into a fully fledged Christian art. Two silver treasures, from the sixth and seventh centuries, found near Constantinople and on the island of Cyprus, are characteristic of the period. Among the Department's collection of ivory carvings is one of the masterpieces of early Byzantine art, an ivory panel decorated with the figure of an archangel; notable also are six boxes carved with classical and Christian scenes. More extensive is the collection of jewellery, which includes medallions, buckles, crosses, rings and ear-rings, as well as an impressive gold body-chain, one of the largest pieces of Byzantine jewellery to have survived. Liturgical vessels and objects of devotion in precious

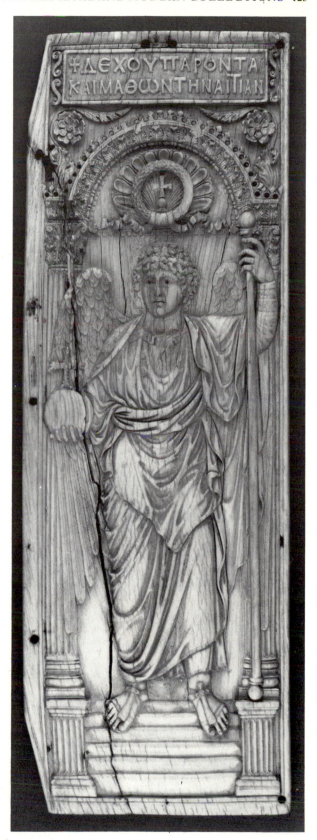

153 *Leaf of an ivory diptych, carved with the figure of an archangel: one of the great masterpieces of Byzantine art. The inscription 'Receive these, and having learnt the cause...' would have continued on the other, lost leaf. From Constantinople, sixth century* AD. H 41cm.

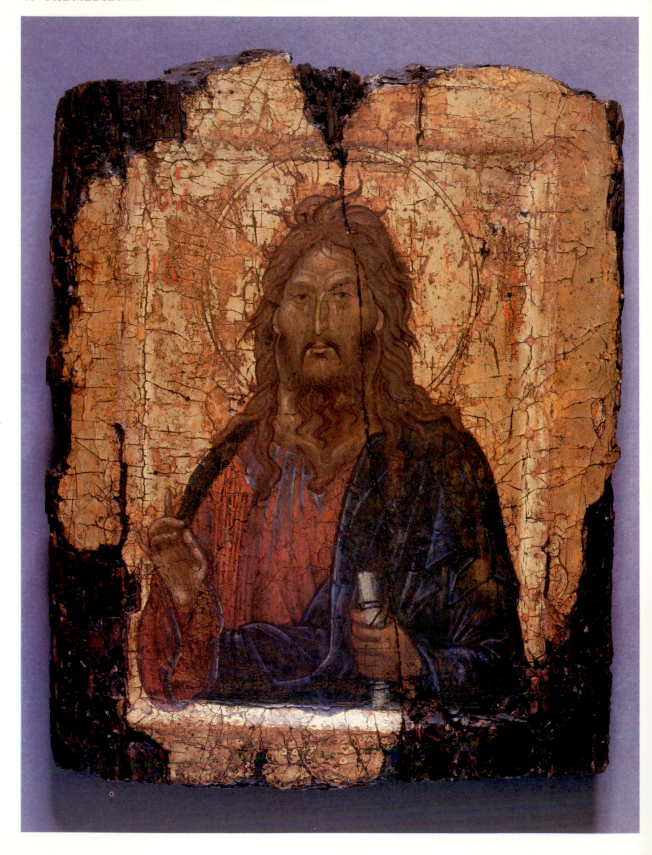

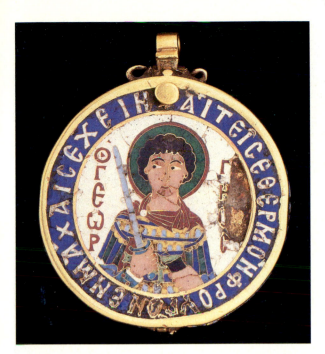

155

155 Gold cloisonné pendant reliquary with representations of St George (seen here) and St Demetrios, inscribed '[The bearer] prays that you will be his fiery defence in battle' and, round the edge, 'Anointed with your blood and myrrh'. From Salonica, thirteenth century AD. D 3.25cm.

metal, bronze, glass and pottery are numerous. These include a fine collection of pilgrims' tokens and *ampullae* (pilgrims' flasks) in pottery, and hinged bronze reliquary-crosses.

The collections from Byzantine Egypt are shared between this Department and the Department of Egyptian Antiquities, the numerous finds from the Wadi Sarga excavations (apart from the *ostraca*) being housed here.

From the middle of the seventh century onwards the Byzantine Empire contracted considerably: wealthy eastern provinces such as Syria and Egypt were lost to the Arabs, and the northern borders of the Empire were continually assailed by nomadic tribes. Because of the destruction and abandonment of many of the great cities of the eastern Mediterranean, fewer everyday objects have survived from this time onwards.

Between AD 726 and 843, with one interruption, images were officially banned in the Byzantine Empire, and their restoration marked the so-called middle

154 Icon of St John the Baptist, painted in egg-tempera on gold-leaf on a linen-faced panel. The icon was probably painted for the personal devotions of someone of high rank. From Constantinople, about AD 1300. 25 × 20cm.

Byzantine period. This 'renaissance' is mainly represented by some particularly fine ivory-carvings and a few important items of jewellery, on which the technique of cloisonné enamel, new to Byzantine craftsmen, is used to remarkable effect. Other metalwork includes bronze reliquary-crosses, belt-buckles, and seals.

155

Between 1204 and 1261 Constantinople was ruled from the west, and the resulting influences are particularly noticeable in such items as an extensive collection of glass pilgrim-tokens, steatite (soapstone) carvings and a rare 'Crusader' icon of St George, painted by a western artist in the Byzantine manner. The Department also has a small collection of pottery vessels known as sgraffito ware.

The last centuries of the Byzantine Empire, from 1261 until the fall of Constantinople to Mehmet the Conqueror in 1453, are principally represented by four superb icons; three (of St Peter, St John the Baptist, and a scene representing the end of Iconoclasm) were painted in Constantinople, and the fourth (a 'festival' icon with four New Testament scenes) either in Constantinople or Thessaloniki. These icons form the nucleus of the national icon collection, which also comprises Russian icons painted between the fourteenth and nineteenth centuries.

154

THE MIDDLE AGES

Ever since a new interest in the Middle Ages was rekindled among British antiquaries in the late seventeenth century the precious objects made for the Church and laity between about AD 800 and 1500 have been collected for their historical interest as well as their aesthetic appeal. Few of the Museum's benefactors have regarded their objects merely as works of art, rather as counterparts to the archaeology and historical documents of the period, and it is as such that they still retain a special resonance in the Museum, the 'high profile' luxury side of life, as opposed to the more day-to-day artefacts, which form the nucleus of the collections.

The Museum boasts a rich collection of precious objects of the Carolingian period, associated with the Emperor Charlemagne (crowned in AD 800) and his successors, whose literate circle in church and court sought to recreate the splendours of late antique art. These include elephant-ivory carvings and engraved rock-crystals, such as the Lothar Crystal. In the German lands during the Ottonian and Salian period small-scale carving of precious materials, particularly ivory, continued to flourish. Ottonian art reached its apogee around AD 1000 in the Rhineland and Trier, where the Townley Brooch, a remarkable gold cloisonné enamel, was probably made. From the Saxon heartland comes a small square ivory plaque from Otto the Great's Magdeburg Cathedral of the 960s.

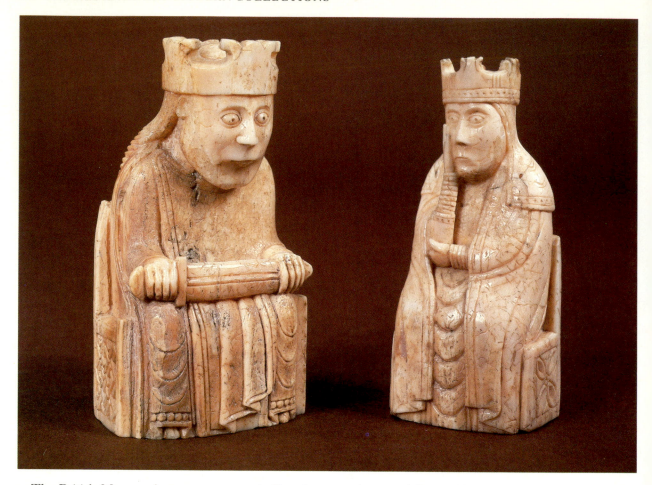

The British Museum has never systematically collected the sculpture and wall-paintings from churches, monasteries and castles, although it does possess a few important twelfth-century English capitals. On a smaller scale, too, there is a remarkable series of ivories, mostly walrus ivory. Twelfth-century gaming pieces are more richly represented here than perhaps in any museum in the world. The most famous are, of course, the eighty pieces from the hoard of chessmen found on the Isle of Lewis in the Outer Hebrides in 1831, perhaps the work of a Scandinavian artist, but the collections also contain numerous bone and ivory counters, carved with all manner of biblical and mythological scenes and exotic beasts. Other Romanesque ivories, either English or European, were commissioned by the Church, for book-covers, croziers, reliquaries, and so on. So too were many of the metalwork objects in the collections: crucifix figures, censers and reliquaries. The cult of relics inevitably led to the creation of reliquaries echoing the original form of the relic they contained: a relic of the skull of St Eustace originally owned by the Cathedral of Basle was enclosed within a carved wooden 'portrait-head' of St Eustace, itself encased in silver-gilt sheeting of about 1200.

156 *ABOVE A King and Queen from a hoard of walrus-ivory chessmen from the Isle of Lewis in the Outer Hebrides. The greatest surviving series of medieval chessmen, they date from the middle of the twelfth century* AD. *H (King) 10.6cm.*

The revival of champlevé enamel during the twelfth century finds remarkable expression in the Museum's collections. The Limoges enamels of south-west France and northern Spain are numerically by far the largest group and include some famous pieces, among them an early secular casket of about 1180 with elegantly drawn lovers, musicians, hunters and warriors. In the Meuse Valley and Middle Rhine great masterpieces of enamel were also made in the twelfth century. The collections reflect their variety: an altar cross, decorated with scenes from the Old Testament, and two plaques made for Henry of Blois, Bishop of

157 *Silver-gilt head-reliquary from the Cathedral at Basle, Switzerland. Inside a cavity in the wooden core relics were kept, including a relic of the skull of St Eustace, the hunter. About* AD *1200.* H *34cm.*

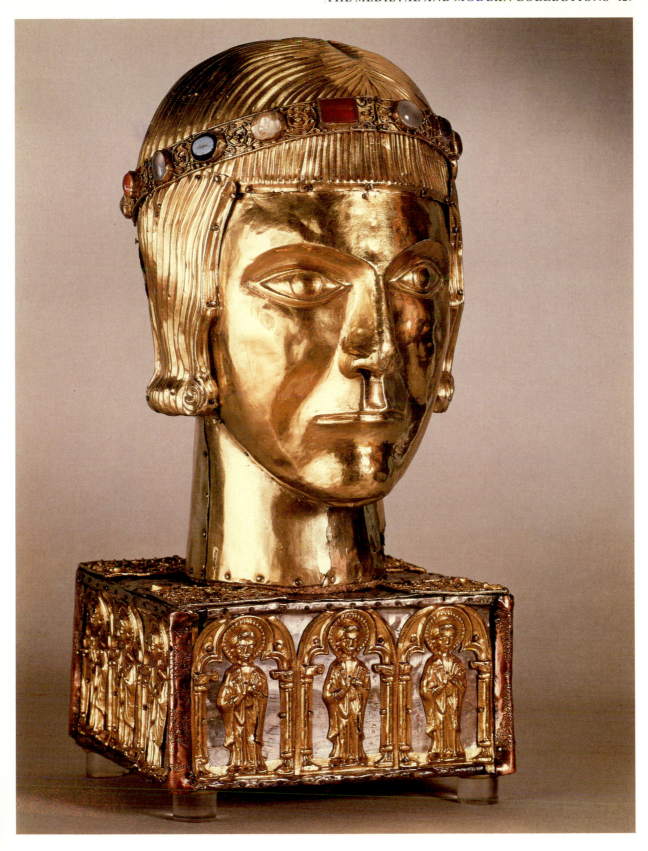

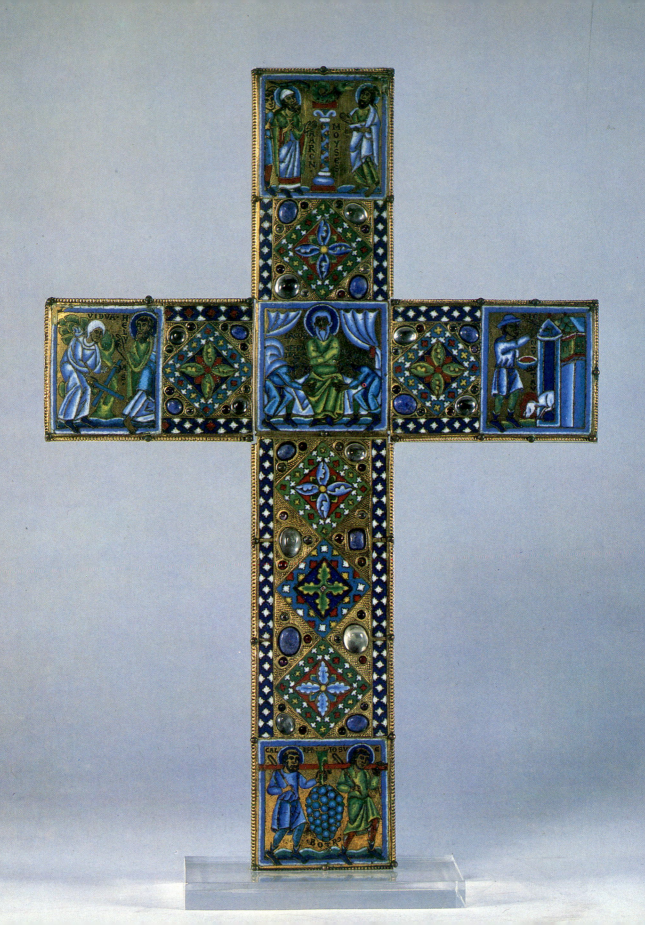

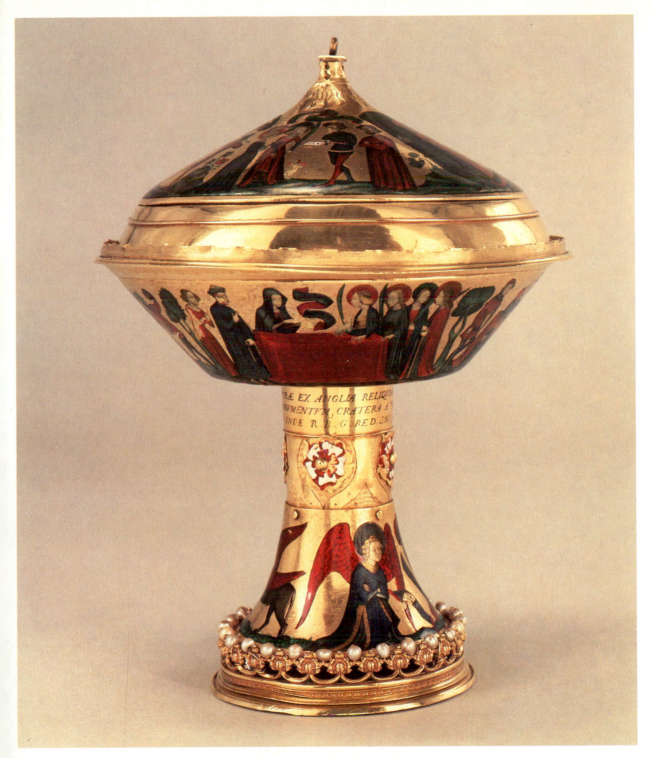

158 LEFT *Altar-cross of gilt copper and champlevé enamel, a masterpiece of Romanesque enamel. Made in the Mosan region or Middle Rhineland in the third quarter of the twelfth century* AD. *The five scenes on the cross were chosen as Old Testament prefigurations of the Crucifixion.* H *37cm.*

159 ABOVE *The Royal Gold Cup, probably made in Paris about AD 1370–80 for Charles* V *of France, and later in the royal English collections in the fifteenth and sixteenth centuries. The cup is of solid gold decorated in* basse-taille *enamel with the story of St Agnes.* H *23.5cm.*

Winchester (1129–71) by one of the greatest of the Mosan enamellers are but three examples.

From the thirteenth and fourteenth centuries comes a rich series of ecclesiastical metalwork: chalices and patens, altar crosses and other altar furniture and liturgical items. In the late thirteenth century brasses appear on monuments. The Department's English and Continental brasses include a fine fourteenth-century head of a bishop and a small group of the type known as palimpsest brasses, in which the plain reverse has been engraved with a new figure or inscription. Brass rubbings are not kept here, but in the Department of Manuscripts of the British Library.

The collections also contain a large number of Gothic ivory-carvings. Many of them were originally made in major urban centres such as Paris, where by the fourteenth century not only devotional objects but also

secular caskets, mirror-cases, cosmetic boxes, and so on, were being produced. A unique group of devotional ivories is carved with the arms of John Grandisson, Bishop of Exeter (1327–69). Among the famous enamels of the fourteenth century are a chalice signed by the two Sienese Tondino di Guerrino and Andrea Riguardi, and a small crystal-set 'bean-shaped' gold reliquary which opens like a book into enamelled leaves. A set of elaborate enamelled silver altar plate from the Hospital de Vera Cruz at Medina de Pomar

160 *Copper alloy aquamanile, used to contain water for washing hands before meals. It was filled through the helmet and emptied through the spout on the horse's forehead. Found in the River Tyne, near Hexham, Northumberland, it dates from AD 1250–1300.* H 33.7cm.

near Burgos (Spain) is of mid-fifteenth century date.

Among the most precious possessions of the Museum are the few melancholy but beautiful fragmentary wall-paintings from the royal chapel of St Stephen's within the Palace of Westminster, executed for Edward III in the 1350s. The fragments were painted in oil medium on the plastered wall, with minutely refined details and delicate brushwork.

Secular material from great households in the later Middle Ages ranges from Gothic ivories and metalwork to tooled leather items and table vessels. One of the most important surviving medieval musical instruments is an early fourteenth-century English gittern (an early form of guitar). A silver cup (on loan from Lacock, Wiltshire) was made to stand on the table of some lord or rich city merchant in the early fifteenth century, and an ivory hunting-horn, associated with the tenure of Savernake Forest (Wiltshire), has rich fourteenth-century enamel mounts. Little survives of the household jewels and plate of the fourteenth and fifteenth centuries, but an exceptional piece is the Royal Gold Cup. Of solid gold and richly decorated in red, blue, brown and green translucent enamels with scenes from the Passion of St Agnes, this was probably made for Charles V of France about 1380.

Medieval warfare is illustrated by a collection of armour and weapons, many of them now on loan to the Royal Armouries at the Tower of London. A ceremonial object, never intended for use in battle, is the tournament shield, painted in the Netherlands in the late fifteenth century, which shows a young knight kneeling before his lady, while Death in the form of a skeleton reaches out for him from behind.

In stark contrast to the brilliance of the jewels, ivories and enamels of the medieval church and nobility is the large group of material, much of it from archaeological excavations, that reflects medieval daily life in all its many facets. As well as small metal objects, the collections include a wide range of pottery vessels from storage jars to cooking pots and jugs that represent types used all over England for storing food, cooking and drinking. Some, such as those from Toynton All Saints (Lincolnshire) or Ashton (Cheshire), were discovered at the actual kiln site. The discovery and excavation of such manufacturing sites has led to the establishment of the national reference collection of medieval pottery in the British Museum; this provides a comprehensive visual collection for students of medieval pottery.

Bronze vessels, jugs, cauldrons and aquamaniles were also used both for cooking and drinking. A striking example is a ewer bearing the arms and devices of Richard II (1377–99), which was discovered in the West African kingdom of Asante in 1896. Bronze was also used for cauldrons, skillets and chafing dishes. Occasionally wooden vessels survive: mazers, shallow

161 Gold fifteenth-century brooches found in the River Meuse, decorated with stones and enamelling. The largest, with a lady holding a sapphire, shows the elaborate modelling and decoration of late medieval North European jewellery. H (largest) 3.9cm.

wooden bowls used as drinking cups, are often decorated with silver mounts. The finest example in the Museum's small collection is the bowl of Robert Pecham given to the refectory of Rochester in 1532–3.

The Department's collection of medieval jewellery consists of some important single finds, such as the white-enamelled Dunstable Swan Jewel of about 1400, but it also contains rings and brooches found with coin hoards which have come to the Museum through the operation of Treasure Trove. Such material is included in the hoards from Lark Hill (Worcestershire), Coventry, and the fifteenth-century hoard from Fishpool (Nottinghamshire). A large collection of medieval rings ranges over all the known types from signet rings, decorative rings and inscribed rings to ecclesiastical rings. Although the collection is mainly English, it also includes rings from France and Germany and an important series from Italy.

A prominent feature of medieval life was the pilgrimage. Pilgrim signs of lead or pewter were distributed at famous shrines to pilgrims to wear as proof of their journey. Examples come from important English shrines, as well as from Continental shrines, such as the scallop shell, the sign of St James, indicative of the pilgrimage to Santiago de Compostella. Among the subjects in the collection are the figures of St Thomas (Canterbury) and the Virgin and Child (Walsingham),

162 *Wall-tile decorated in sgraffito with apocryphal stories of the childhood of Christ: Jesus being hit by a schoolmaster and Jesus blessing two schoolmasters after healing two cripples. From Tring church, Hertfordshire, early fourteenth century* AD. *32.5 × 16.3cm.*

the head of St John the Baptist (Amiens), the horn of St Hubert, the Axe of St Olave, and the comb of St Blaise. The collections also contain stone moulds for casting pilgrim signs.

162 An unrivalled collection of some 14,000 medieval decorated tiles comes from the flooring of monastic and parish churches, royal palaces and manor houses. The collection was greatly enhanced by the collection formed by the Duke of Rutland, containing tiles from a wide variety of monastic sites and the late fifteenth-century pavement from the house of William Canynges at Bristol. One of the most important groups is of the thirteenth century and was found at the Benedictine Abbey of Chertsey (Surrey) in the 1850s. This series includes roundels with scenes of the romance of Tristram and Iseult, as well as a series of combat scenes including Richard and Saladin. The pavement and kiln from Clarendon Palace (Wiltshire) are evidence of royal use of tiles in the thirteenth century. Apart from the impressive quality of the finer tiles, the collection is important for understanding the geographical spread of this form of medieval craftsmanship.

166 The Department also houses the important national collection of medieval seal matrices.

FROM THE RENAISSANCE TO THE TWENTIETH CENTURY

The explosion of creative energy that we call the Renaissance is illustrated in the British Museum mainly in the 'applied arts'. The great strength of the collections from the Renaissance up to more recent times lies in ceramics, glass, precious metalwork, jewellery and small-scale sculpture. These collections were essentially accumulated in the second half of the nineteenth century and reflect the Victorian fascination with the application of art to industry. The historical and archaeological traditions of the Museum are reflected in the collection's richness in pieces of documentary or historic association.

The Department has little Renaissance sculpture, although examples include small works by Michelangelo and Giambologna and, from north of the Alps, fine wood-carvings by Tilman Riemenschneider and Conrad Meit. The great collection of Renaissance medals in the Department of Coins and Medals is complemented by an important series of single-sided metal reliefs called plaquettes, which ornamented larger objects and helped diffuse the designs of great original artists down to the other arts. The Museum holds collections among the richest in the world illustrating aspects of virtuoso Renaissance craftsmanship, particularly the painted tin-glazed Italian pottery known as 'maiolica', the elaborate drinking glasses made in sixteenth-century Venice and the painted enamels of Limoges in southern France.

Spectacular examples of goldsmiths' work, jewellery and precious *objets d'art* are to be found particularly in the Waddesdon Bequest. This collection, from Waddesdon Manor in Buckinghamshire, was bequeathed by Baron Ferdinand Rothschild in 1898 and forms the nearest equivalent to be found in Britain of the varied *Schatzkammer* (treasure chamber) of a Renaissance prince. Among the treasures of the Bequest are the enamelled gold Holy Thorn reliquary, made in France about 1405–10 for the great art patron Jean duc de Berry to contain a thorn from the Crown of Thorns; a parade shield of damascened iron by Giorgio Ghisi of Mantua (1554); and the Lyte Jewel, an English gold locket with a miniature by Hilliard of James I (1610).

England was slow to absorb the cultural revolution emanating from Renaissance Italy and the importance of immigrant craftsmen in bringing England into the mainstream of European art is illustrated by pieces like an astrolabe made for Henry VIII by the French maker Sebastian Le Seney; or the glass tankard made around 1575 in the London glass-house of a Venetian immigrant, Jacopo Verzelini, which has mounts bearing the arms of Lord Burghley, chief minister to Queen Elizabeth I. A distinguished group of pieces of English Renaissance silver plate includes the silver-gilt Wyndham Ewer (1554–5), the earliest surviving piece of English plate in the Continental Mannerist style.

The Department's splendid series of luxury objects from Tudor England and later is complemented by wide-ranging collections of more modest items illustrating social history up to the nineteenth century. The kitchen- and tableware provide dating evidence for developments in design and consumer demand. The development in cutlery design is a major indication of increased domestic sophistication, and an extraordinary range of materials and techniques were used in furnishing the handles of knives and forks. The influence of magic on the Renaissance mind is illustrated by the 'crystal ball' and astrological equipment of Dr John Dee, the astrologer favoured by Queen Elizabeth I.

163 Exotic natural history curiosities in silver-gilt mounts from the Waddesdon Bequest. Left is a nut from the Seychelles in mid-sixteenth-century German mounts; centre, a nautilus shell in Antwerp mounts of 1555–6; right, an ostrich egg in Prague mounts of the late sixteenth century. H (ostrich egg and mount) 38.7cm.

164 *One of a pair of silver-gilt vases with ivory sleeves carved by a Continental artist; the cups have the London hallmark and the maker's mark of David Willaume, a talented French Protestant craftsman who settled in London. 1711. From the Peter Wilding Bequest.* H 42.4cm.

The impact of the tobacco trade is visible in the wide range of smoking accessories, such as clay pipes and pipe-stoppers. Typical reminders of the fashion for smoking in the seventeenth and eighteenth centuries are the brass and copper tobacco boxes from Germany and Holland, many of which were imported into Britain and which were often decorated with mythological and biblical scenes. Such objects also reflect contemporary history in their decoration, and the battles and personalities of the Seven Years War (1756–63) and the career of Frederick the Great of Prussia provided popular decorative themes.

Silversmiths' work in England was heavily influenced in the late seventeenth century by the arrival of Huguenot refugees from France. The Museum possesses the superb Wilding Bequest of Huguenot silver by the leading first- and second-generation immigrant craftsmen in London between 1699 and 1723. Huguenot work was cast in solid silver, in contrast to most English ware, which was raised in hollow silver with thin walls. The French immigrants soon attracted commissions from the British aristocracy, such as the silver-gilt ewer and basin by Pierre Harache with the arms of the Duke of Devonshire (1697). London goldsmiths were forced to improve the quality of their work and adopted the French designs and techniques.

One of the most impressive items of late seventeenth-century plate is the pair of ice-pails made for the Duke of Marlborough, which were cast in pure gold. A later, even more spectacular example of work in gold is the Portland Font, commissioned by the third Duke of Portland on the birth of his grandson in 1796; designed by landscape gardener Humphrey Repton, it was executed in the London workshop of Paul Storr, and is one of the greatest monuments of English goldsmiths' work in the neo-classical style.

A more modest category of gold and silver work is found in boxes and containers of different sorts. These include Tudor and Stuart counter boxes, curiosities such as the delicately pierced cases for Goa stones (*c.* 1700), and snuff-boxes ranging from plain silver examples to the superb-quality gold and enamel boxes made by Parisian goldsmiths in the late eighteenth century. Also represented is the technique of *piqué* work, that is the inlaying of gold and silver into malleable materials, such as tortoiseshell or ivory, practised throughout Europe from the seventeenth to the nineteenth centuries.

A speciality of the Department is its collection of material illustrating the history of heraldry and seals. The department holds the main national collection of seal dies (or 'matrices') from the late Saxon period to the early twentieth century, and considerable collections of French, German and Italian seal matrices. The collection of wax seal impressions as applied to documents is in the Department of Manuscripts in the

165 ABOVE *The Portland Font. The 22-carat gold font with figures of Faith, Hope and Charity, was designed in the neo-classical style by Humphrey Repton and made in the London workshop of Paul Storr, 1797–8.* W (*pedestal*) *34.9cm.*

British Library. From the medieval period the seal matrices include seals connected with trade and administration, such as customs seals, seals for the delivery of wool and hides, wool staple seals, and seals of officials. A wide variety of seals for medieval ecclesiastical officials and institutions are joined by those of guilds and fraternities. The great seal matrices of the medieval kings do not survive, and from Tudor times

166 *The seal matrix of Richard, Duke of Gloucester (later King Richard* III*) as Admiral of England for Dorset and Somerset. The matrix is engraved with a single masted ship, the mainsail bearing the Duke's arms.* AD *1462.* D *7.55cm.*

the seals of state were often melted down and made into presentation plate, such as the sixteenth-century 'Bacon cups', one of which is in the Museum. The earliest surviving great seal of an English king here is that of William IV, dated 1831. The collection includes an extensive series of colonial seals and many personal seals, some with coats of arms. A signet ring of the sixteenth century once belonged to Mary Queen of Scots. Other highlights of the heraldic series are Tudor stall plates of the Order of the Garter made for St George's Chapel, Windsor, and a lavish set of Garter insignia made of enamelled gold and jewels, commissioned by the Earl of Northampton in 1628.

The most comprehensive area of the Department's holdings is its collection of ceramics, illustrating the history of firing, glazing and decorative techniques in Western Europe up to recent times. From medieval times earthenwares coated with lead glaze were made throughout Europe, largely for domestic use. Pieces decorated with slip (liquid clay) include posset-pots, loving cups and mugs, principally made in the London area, Wrotham (Kent), Staffordshire and Sussex. During the eighteenth century the making of pottery in Staffordshire became progressively more industrialised. This phase of production is represented by eighteenth-century green- and yellow-glazed earthenwares made by Thomas Whieldon in partnership with Josiah Wedgwood, cream-coloured earthenwares, one of Wedgwood's greatest successes, and pearlwares.

The lead-glazed wares from Continental Europe are often ornamental in character. A group of pieces with bizarre, naturalistically modelled ornament, including shells and sea creatures, decorated with coloured glazes, demonstrates the skill of France's most revered potter, Bernard Palissy. Lead glazes coloured with metal oxides were also used in sixteenth-century Germany in the manufacture of stove tiles moulded in high relief with figure scenes. The technique of scratching through a coloured slip to reveal the colour of the body beneath was frequently used by German potters in the Rhineland and elsewhere.

Coating earthenware with an opaque white glaze containing tin provided a good surface for painting. Tin-glazed earthenwares made in Spain, above all in the Valencia region (eastern Spain), in the fifteenth century inherited an Islamic tradition, and the lustred pottery of Valencia was exported all over Europe. The Museum's collection of Valencian lustreware is one of the world's richest.

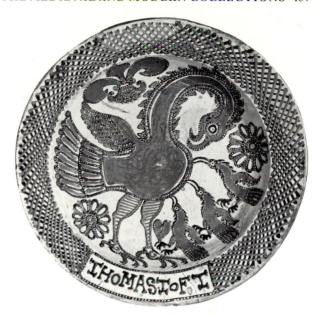

168 *Slipware dish by Thomas Toft, Staffordshire, of about 1670. The red clay dish, probably intended to stand on a dresser, is covered with white slip. The design of the Pelican in her Piety is trailed in red-brown and dark-brown slip.* D 44cm.

The pictorial potential of tin-glazed pottery was developed above all in Italy, and the brilliantly coloured maiolica dishes of centres like Faenza and Urbino were painted like pictures with overall narrative scenes, using a wealth of classical, biblical and contemporary subjects. The Museum's collection is virtually unrivalled in its series of pieces with dates and artists' signatures, key documents in the history of this art. The techniques of Italian maiolica were taken abroad in the sixteenth century by emigrant craftsmen, who helped establish native traditions of tin-glazed pottery in France, the Low Countries, England and elsewhere. Tin-glazed pottery was produced in England from the sixteenth century, and by the seventeenth century it was in common use for drug and ointment pots, bottles, dishes and mugs, many decorated in blue in the Chinese style. The tradition continued, and a large bowl inscribed *Clay got over the Primate's Coals Dublin 1753* shows that tin-glazed ware was made in Ireland too. Tin-glazed jugs and dishes from German pottery centres include skilfully painted examples by the late seventeenth-century Nuremberg artists Wolf Rössler and Johann Schaper. The collection also includes seventeenth- to nineteenth-century French, Spanish, Portuguese and East European tin-glazed wares, as well as Dutch Delftwares. The tin-glazed tradition in England and on the Continent was virtually destroyed by the new industrial wares of eighteenth-century Staffordshire.

By the fifteenth century a new type of high-fired

167 *Lustred pottery vase, made in Valencia, Spain, about 1465–75. It bears the arms of the Medici family and was probably made for Piero 'the Gouty' or his son Lorenzo the Magnificent, successive rulers of Florence.* H 57cm.

pottery, stoneware, had been developed in the Rhine-land, and fragments of fifteenth-century stoneware excavated at Savignies show that the technology also existed in France. The Department's comprehensive collection of German salt-glazed stoneware comprises more than two hundred pieces from all over Germany. Stonewares were produced in England and the Low Countries from the seventeenth century. In the 1670s John Dwight, from his Fulham pottery, was producing fine greyish or whitish stonewares, some of which were as translucent as porcelains. Amongst the examples of Dwight's superlative sculptural work are a monumental bust of Prince Rupert (1619–82) and small-scale figures of mythological subjects, such as Mars, Meleager and Flora.

In the late eighteenth century the Staffordshire potter Josiah Wedgwood produced new varieties of unglazed stoneware which enjoyed notable success, in particular his jasper ware, a fine white stoneware,

169 *Jasper ware vase and cover known as the Pegasus Vase from the figure of the flying horse on the cover. Made at Josiah Wedgwood's factory, Etruria, Staffordshire, and presented by him in 1786.* H 46cm.

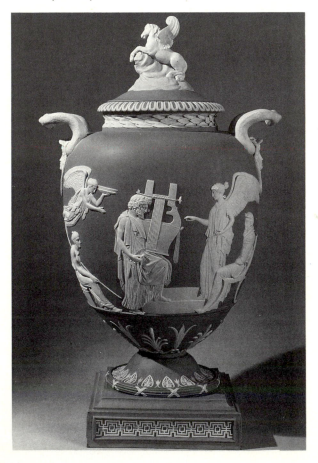

frequently tinted blue. Among the Museum's examples of jasper ware is the Pegasus Vase, presented by Wedgwood himself in 1786 and considered by him to be his finest vase, and blue and black jasper copies of the Roman cameo glass Portland Vase.

Porcelain, a hard translucent ceramic material first manufactured by the Chinese, was greatly admired by European potters, who attempted to imitate it. The earliest known examples of the so-called 'artificial' type (soft-paste) were made in Florence around 1575–87, with underglaze blue decoration directly copying Chinese porcelain. The British Museum has four examples of this very rare ware. France was next to produce porcelain, which was certainly made at St Cloud near Paris in the early eighteenth century. True porcelain containing china clay and china stone was first made at Dresden around 1710, when Friedrich Böttger discovered the secret of its manufacture. The Department has a fine series of Continental porcelain, including Meissen baroque figures and Sèvres rococo porcelains.

The collections of eighteenth-century porcelain show the development of the new material in England. From the earliest established concern at Bow, London, comes the famous monogrammed bowl, housed in a wooden box with a manuscript note, dated 1790, on the history of the factory by the china-painter Thomas Craft. A white figure of a sleeping child inscribed JUNE YE 26 1746 is the earliest known dated figure from the Chelsea factory. A group of over one hundred Chelsea 'toys' – scent-bottles, buckles and seals – includes many rarities. A magnificent pair of blue-ground porcelain vases made at the Chelsea factory during the 1760s are painted with scenes connected with the death of Cleopatra and exotic birds.

A group of late eighteenth-century unglazed Derby figures includes some, such as the 'Russian shepherd' group, which are otherwise unknown. The collection also contains several hundred pieces, both painted and transfer-printed, from the Worcester factory, as well as porcelain from almost every other eighteenth-century concern. The small group of nineteenth- and twentieth-century English porcelain is now being supplemented by acquisitions on a systematic basis.

The Museum's collection of Western European glass ranks among the best in the world. Pride of place goes to the Venetian glass of the fifteenth to eighteenth centuries, with hundreds of examples illustrating the whole range of decorative techniques. Glass from Ger-

170 RIGHT *Soft-paste porcelain vase painted with Roman soldiers attacking Cleopatra. Made at the Chelsea porcelain factory, London, about 1762. With its pair, this is the earliest piece of 'modern' ceramics to enter the Museum. Both were presented in 1763 only ten years after its foundation.* H 50cm.

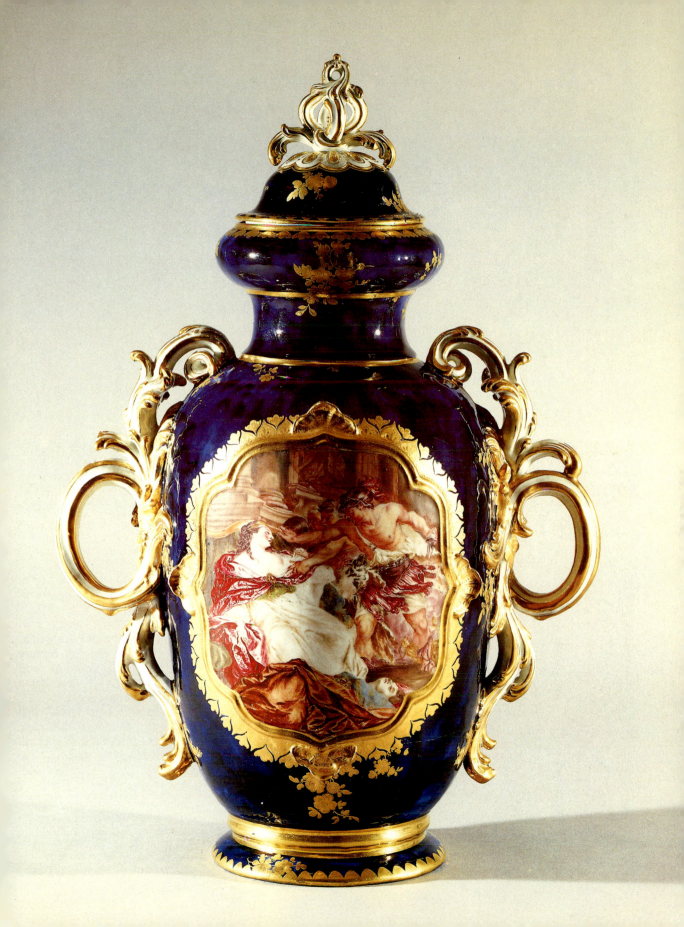

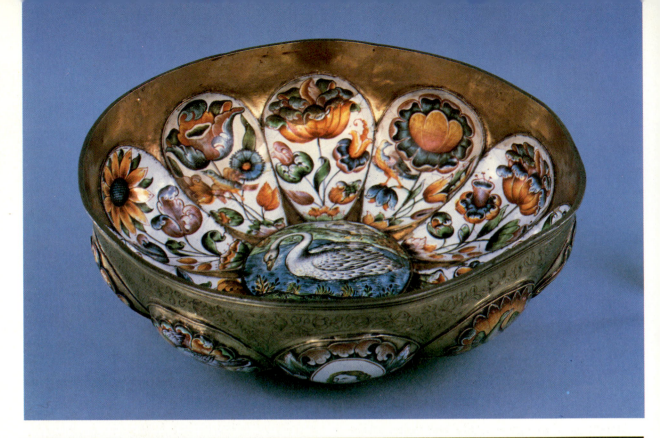

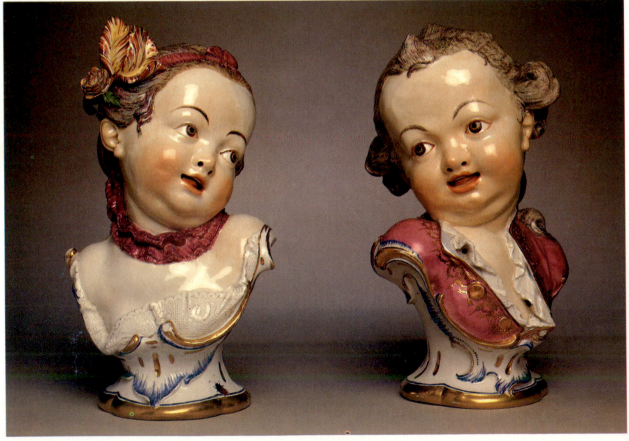

171 LEFT *Enamelled silver-gilt bowl, the central medallion painted with two swans, the sides with flowers, birds and portraits on a white ground. Made in Solvychegodsk, Northern Russia, late seventeenth century.* D 20.5cm.

many, where there were important advances in wheel-engraving and colouring of the glass itself, as well as from Spain, France, Bohemia and Holland, includes numbers of signed or dated items from the most renowned glass-houses. Two jugs in the Venetian style have London-made silver mounts and may have been made by Venetian craftsmen in London in the 1540s. A serving bottle bearing the seal used by George Ravenscroft (c. 1680) is a remarkable example of the earliest lead glass made in England.

Over two hundred hand-painted enamels of mythological and biblical subjects made in Limoges, France, in the sixteenth century represent the art of working coloured glassy substances on copper. Examples of this technique in eighteenth-century England, notably from Staffordshire and London, demonstrate its popularity. A number of enamels with printed subjects of a masonic or historical character complete the collection, famous for its signed and dated pieces.

Among the Department's huge and varied collections are smaller areas of more special interest. One such speciality is the collection of objects belonging to famous people. In addition to those already discussed are a casket made in 1769 for the actor David Garrick of wood from the mulberry tree in Shakespeare's garden, and a punch-bowl of Inverary marble made for the Scottish poet Robert Burns in 1788. Alongside such curiosities are a gold watch owned by the composer Handel, two gold rings of the poets Elizabeth Barrett Browning and Robert Browning, and a gold box bequeathed by Napoleon to Lady Holland in 1821.

The core of the Department's collection of eighteenth-century portrait sculpture is an unparalleled group of plaster and terracotta models from Roubiliac's studio purchased soon after the sculptor's death in 1759. A series of portrait busts from the eighteenth to the twentieth century represents people connected with the British Museum, such as the terracotta bust by Rysbrack of the Museum's founder, Sir Hans Sloane.

The British Museum houses the national collection of engraved gems, and the Department has over a thousand intaglios and cameos from about AD 400 to about 1900. Among the cameo carvings of the Renaissance is a remarkable Italian onyx cameo of 1520–30,

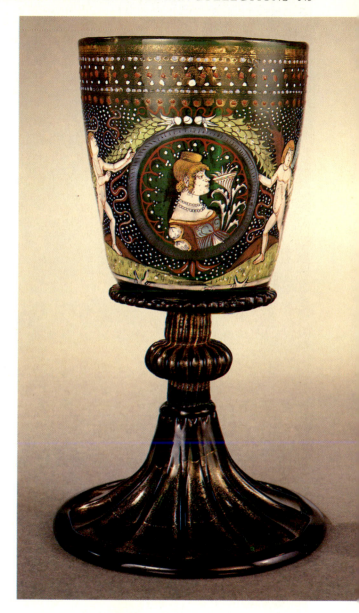

173 *Glass goblet, enamelled with the portraits of a man and a woman and the motto* AMOR. VOL. FEE *(love requires faith). Perhaps a betrothal gift. Venetian, about 1480–1500.* H 22.3cm.

carved with Hercules on one side and Omphale on the other. Engraved gems of the sixteenth and seventeenth centuries are often anonymous, unlike those of the eighteenth and nineteenth centuries, when the taste for cameos and intaglios reflected the influence of the classical world and engravers tended to sign their names after the antique. The collection is rich in works of the great European neo-classical masters – Marchant, Burch, the Pichler family, Morelli, Berini, Pistrucci, Girometti, Hecker, Lebas and the Saulini

175

172 *Pair of hard-paste porcelain busts of children modelled by Franz Anton Bustelli about 1760–1 and made at the Nymphenburg factory, Bavaria. Bustelli is considered one of the greatest porcelain modellers in the rococo style.* H 24.8cm.

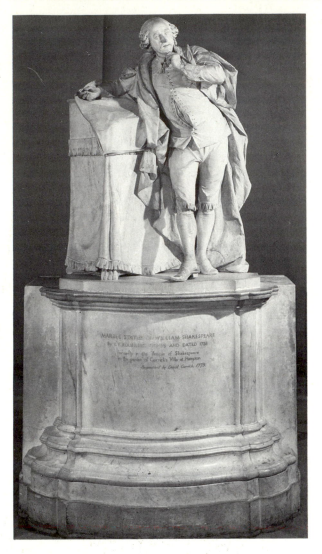

174 *Life-size marble statue of William Shakespeare by Louis-François Roubiliac; made in 1758 for the actor David Garrick (1717–79), who placed it in a Temple of Shakespeare in his garden, and left it to the Museum in his will.*

Cameos and intaglios were often set into boxes and other precious objects or mounted in jewellery.

The Hull Grundy Gift of over 1,200 pieces of jewellery, engraved gems and goldsmiths' work has extended the Department's already rich collection of post-medieval jewellery into the twentieth century, and illustrates European and American taste in jewellery, from opulent eighteenth-century diamond ornaments to Victorian naturalistic 'message jewellery' in the form of flowers and plants, each with sentimental significance. The collection is especially noted for its nineteenth-century revivalist jewellery, such as the gold and gem-set medieval-style cross designed about 1860 by the architect William Burges, or the minutely detailed gold granulation work carried out by the Castellani workshop in Rome and Naples in imitation of Etruscan jewellery. Alongside these artistic jewels are examples of mass-produced industrial jewellery made in Birmingham at the end of the nineteenth century. The curvilinear Art Nouveau style fashionable at the turn of the century is represented by pieces from the major Parisian firms designed by notable European sculptors and medallists, and some astonishingly delicate pieces by Réné Lalique with *plique-à-jour* or open-back enamelling.

The Department's collections have recently been extended into the twentieth century, to illustrate the development of the international modern movement. Nineteenth-century eclecticism can be seen in the work of two Gothic Revival architects, A. W. N. Pugin and William Burges, while the applied arts designed by Christopher Dresser look not only to the past, but to other contemporary cultures, such as Japan. The collections also encompass the many avant-garde applied arts movements of the turn of the century in Europe and America, from the Art Nouveau style of the Belgian architect Henri van de Velde to the rectilinear geometric style of the American architect Frank Lloyd Wright, whose copper vase designed for his own studio in Chicago is a rare example of his small-scale metalwork. In addition, the British Museum holds the most comprehensive collection outside Germany of German applied arts of the period 1890 to 1930, culminating in the achievements of the Bauhaus school, where Marianne Brandt's constructivist tea-pot of 1924 was made. The 1920s and 1930s elsewhere in Europe are

family. Intaglio gems, often used as sealstones, are usually carved from a stone of one colour, the subject engraved in reverse below the surface. Cameos are carved in relief, with the subject silhouetted against a ground of a different colour. The skill of the cameo engraver lies in exploiting the different layers; a spectacular example of unparalleled virtuosity is the cameo carved in 1830 by Domenico Calabresi of Rome in an agate of seven layers showing Vulcan casting his net over Mars and Venus, in which the upper layer forming the net has been undercut to reveal the scene below.

175 *Nineteenth-century gold and enamel jewellery set with hardstones or mosaics: a) Italian plasma cameo of Medusa; b) miniature glass mosaic with Greek inscription 'Bravo', made by the Castellani firm, Rome; c) agate cameo engraved in England by Benedetto Pistucci; d) onyx cameo engraved in Milan by Antonio Berini; e) hardstone mosaic or* pietra dura, *Florence. From the Hull Grundy Gift, except a (top). W (b) 5.4cm.*

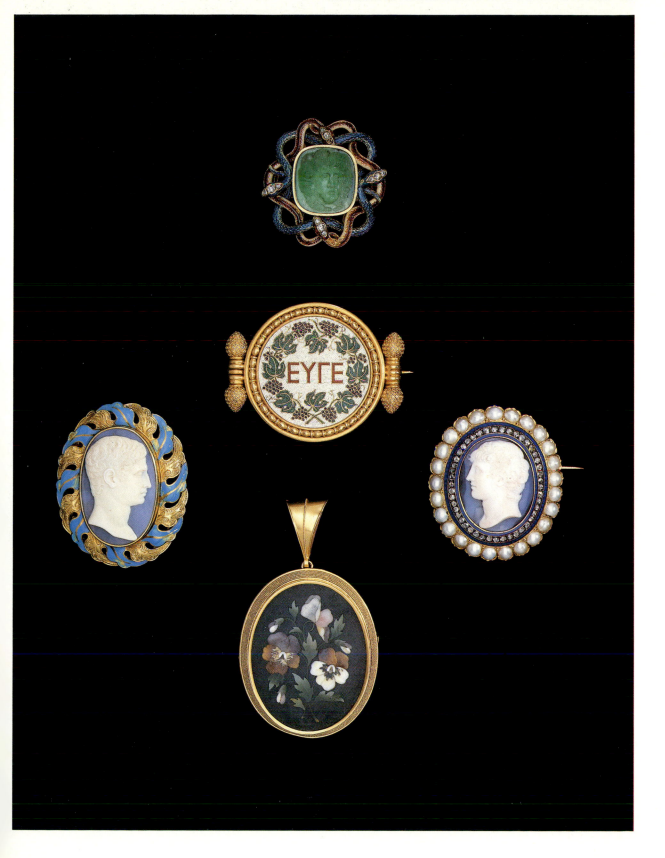

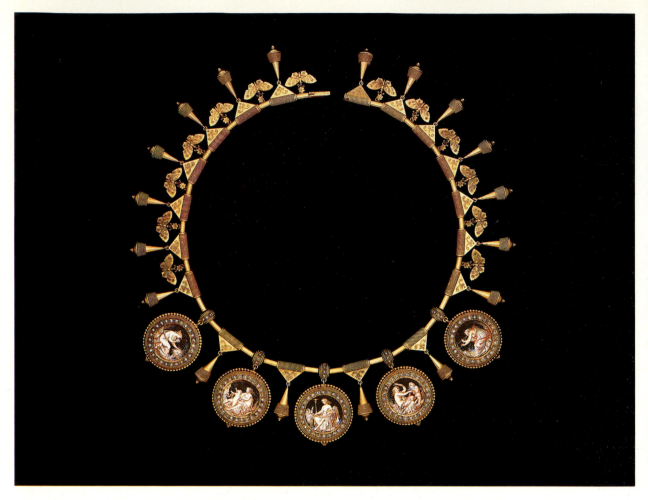

176 ABOVE *Gold and diamond necklace, made up of elements derived from jewellery of the classical world. The medallions were inspired by the Roman wall-paintings at Pompeii and painted by Eugène Richet. Made by the firm of Eugène Fontenay, Paris, about 1870. From the Hull Grundy Gift. D (central pendant) 2.95cm.*

177 BELOW *Silver tea-infuser with an ebony handle and knop. Designed in 1924 by Marianne Brandt and handmade at the Bauhaus school of design in Germany between 1924 and 1932. H 7cm.*

also represented, while notable recent acquisitions include examples of Soviet porcelain decorated in the early years of the Revolution in the style of the Suprematist movement.

Clocks, Watches and Scientific Instruments

The Museum houses what is probably the most comprehensive horological collection in the world. The earliest clocks in the Museum date from the sixteenth century. Thereafter both weight-driven and spring-driven clocks from the main European centres of clock-making are represented. While the Museum does not possess an early turret clock, the Cassiobury Park clock made about 1620 displays many of the features found in those of the fourteenth century. Particularly fine

178 Year-going table-clock with quarter repeat by Thomas Tompion, London (c. 1690). Commissioned for William III and Queen Mary in 1689, the year of the coronation, this is the earliest known spring-driven pendulum clock to go for one year at a winding. H 71 cm.

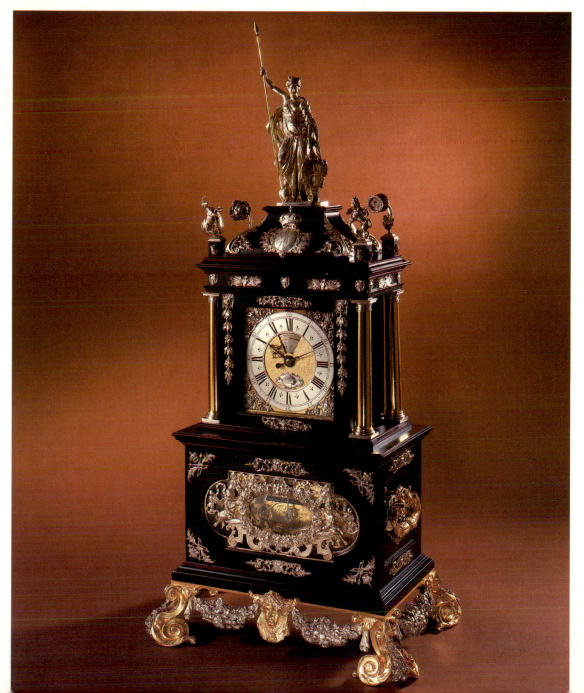

examples from the late sixteenth century are the fascinating 'nef' table clock/automaton of about 1580 made by Hans Schlottheim, and the magnificent carillon clock by Isaac Habrecht made in 1589. Standing over 1.5m in height, this domestic version of Habrecht's great astronomical clock in Strasbourg Cathedral is an impressive combination of Renaissance decoration and mechanical virtuosity. There were few clockmakers in England in the sixteenth century but Nicholas Vallin's carillon clock of 1598, which plays musical quarter chimes on 13 bells, is a fine example of their high-quality work.

Probably the most fundamental and important advance towards accurate time-keeping was the application of the pendulum to clockwork by Christiaan Huygens in 1657. Clockmakers were quick to adopt this innovation and in England the wooden cased table clock with pendulum soon became common. Of the Museum's many examples perhaps the most outstanding is the 'Mostyn' year-going table clock by Thomas

Tompion. Made for William III in about 1689, this clock is a prime example of Tompion's mechanical genius and also displays some of the finest silver and ormolu decoration of the period.

With the introduction of the pendulum in England came the beginning of a new design in clocks – the long-case clock. This basic design, introduced in the 1660s by Fromanteel and other leading London makers, was to last for almost two centuries. The Museum collections contain long-case clocks from the earliest period to the nineteenth century, including examples by Fromanteel and Knibb, the famous 'mulberry' clock by Tompion and a magnificent year-going equation clock by Daniel Quare. The Museum also possesses one of a

178

179 *Silver watches with* piqué *outer cases: (left) made shortly before 1675 by Charles Gretton, London: seconds dial on the back of the movement; (right) by Thomas Tompion, London (c. 1688): dial with subsidiary seconds.* D *(left) 5.2cm.*

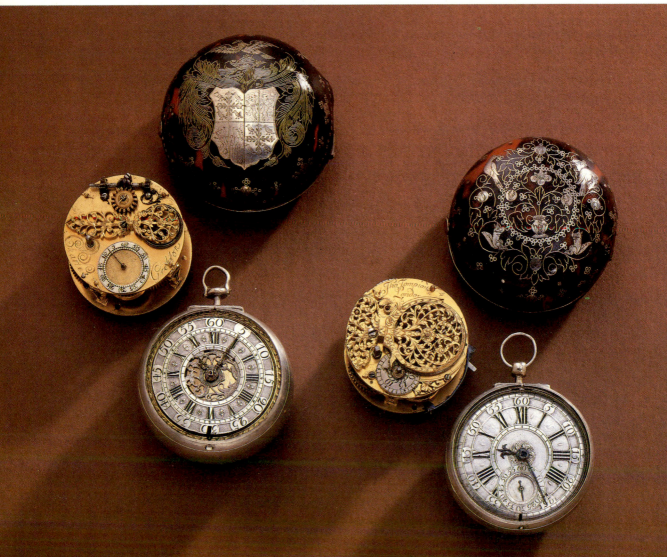

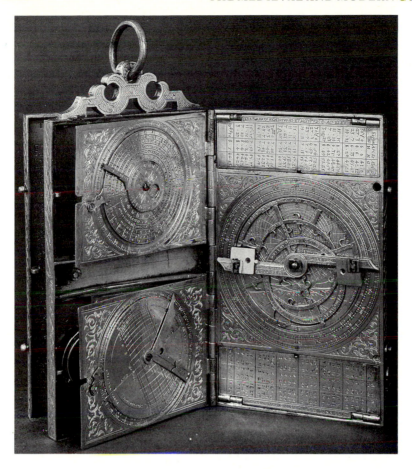

180 *Astronomical compendium by Johann Anton Londen, Heilbronn (1596), made for Christoph Leibfried of Würzburg. The compendium contains a range of instruments for astronomical, astrological and calendrical purposes.* H 12.6cm.

series of vast astronomical long-case clocks by Edward Cockey of Warminster of about 1760.

The age of precision had its origins in the late seventeenth century when the Royal Observatory, Greenwich, was built. In the Great Room of the Observatory were three regulators by Thomas Tompion, one of which, made for Sir Jonas Moore in 1676, survives in the collections. Precision 'regulators' with maintaining power and temperature compensation became an essential tool for scientists and astronomers in the eighteenth century and the Museum has a fine example by George Graham with dead-beat escapement and mercurial compensation pendulum.

The successful sea trials of John Harrison's marine time-keeper in 1761 proved that a sea-going chronometer could be used to establish longtitude at sea. Harrison's pioneering work was later improved upon by Thomas Mudge, John Arnold and Thomas Earnshaw and examples of their work as well as that of the leading

Continental makers can be found amongst the Museum's forty or so marine chronometers.

The Department's collection of over 2,500 watches comprehensively covers every aspect of the history and development of the watch as a portable time-keeper. It is probably the finest collection in the world, extending from examples of the German stackfreed watches of the mid-sixteenth century to the advent of quartz technology in the modern age. All the leading watchmakers are represented and, while the collection is perhaps oriented towards the mechanical aspects of watchmaking, it is also rich in fine examples of the casemaker's and jeweller's art.

The collection of European scientific instruments, although small, covers a wide variety of areas. It includes instruments for measuring time, such as sundials, quadrants and nocturnals from the medieval period to the twentieth century, instruments for mathematics, astronomy, surveying, and so on. Many of the well-known makers are represented in the collection, including a number of instruments by Humphrey Cole, astrolabes by Vulparia, Hartman and Volkmer and sundials by Charles Whitewell, Erasmus Habermel and Hans Tucher.

THE ORIENTAL COLLECTIONS

The Oriental collections of the British Museum are divided between the Departments of Ethnography, Japanese Antiquities and Oriental Antiquities. The Oriental Department deals with the cultures of Asia from the Neolithic period to the twentieth century, with the exception of Japan, and Iran and the Near East before the Arab conquests. Its vast geographical span thus stretches from North Africa to Korea, and includes the islands of South-East Asia. Unlike the Department of Ethnography, many of whose collections cover the same geographical area, it has tended to concentrate on urban, rather than traditional rural societies. The collections in the Department of Japanese Antiquities range in date from the third millennium BC to the present day.

181 Brass pen-box decorated with astrological figures in roundels on a ground of animal interlace, and inlaid with silver and gold. The signature of the craftsman Mahmud ibn Sunqur and the date AH 680 (AD 1281) appear beneath the clasp. L 19.7cm.

CHINA

The earliest Chinese artefacts in the British Museum date from the Neolithic period. Finds from Banpo, an important western site near Xi'an dating to about 4500 BC, belong to the Yangshao culture and illustrate the beginnings of the fine painted pottery that characterises many of the western Neolithic cultures. Early pottery from south-eastern China, whose lobed and articulated shapes influenced later bronze vessels, is not represented in the collection. However, there are fine examples of stone and jade tools, discs, and tall tubes known as *cong*, made by the peoples of the later Liang-

zhu culture (*c.* 2500 BC), which display the skill of early Chinese jade-carving. Face designs on the *cong* were the starting point for zoomorphic motifs which form such a fundamental element of bronze ornament.

Cast-bronze vessels appear in China with little metallurgical precedent. The simplest are found at Erlitou, a site after which the first major phase of

182 Bronze zun, *a container, presumably for wine. The two rams are naturalistic and thus quite different from animals on metropolitan bronzes, which are more two-dimensional and usually imaginary. It probably comes from south China. Shang dynasty (*c. 1700–1050 BC*). H 43.2cm.*

casting is named. The second phase is known as Erli-gang, the name of a site at Zhengzhou in Henan. This has been identified as one of the capitals of the Shang (c. 1700–c. 1050 BC), the first ruling house or dynasty for whose existence there is incontrovertible evidence. Unlike most other ancient bronze-workers, the Chinese used cast bronze rather than wrought metal to make vessels which were used to offer food and wine to ancestors. Ornament on these bronzes comprised monsters, animals and geometric motifs organised within units determined by casting techniques.

The last of the Shang kings was overthrown in the eleventh century BC by the Zhou peoples of north-western China. Before their conquest of the Shang, the Zhou (c. 1050–221 BC) had already adopted Shang ritual practices and their ritual vessels, and so there is no very clear distinction between late Shang and early Zhou bronzes. By the last quarter of the eleventh century, however, a Zhou style of bronze vessels had emerged, which is well illustrated by a bronze vessel in the British Museum's collection called the Kang Hou *gui*. The *gui* bears a highly important inscription re-cording the enfeoffment of the Marquis of Kang as a reward for his part played in quelling Shang insurrec-tion. Major changes in ritual practice seem to have taken place rather more than a century later, with numbers of vessel types being much reduced at that time. Decoration also changed, with sweeping wave designs dominating large vessels, as may be seen on the Museum's Shi Wang *hu*. The designs of the early Zhou period contracted into a dense geometric interlace during the Eastern Zhou. From the eighth century BC China was divided into many small states, of which the major seven were constantly engaged in warfare. One of

these states was the southern state of Chu, whose working of lacquer, silk and wood contributed new motifs and styles to bronze art. Beliefs in protective spirits is illustrated in the art of Chu by an antlered wood sculpture in the British Museum.

Qin Shihuangdi, the first Emperor of China, united the former Zhou states under one rule in 221 BC. His awesome power is reflected in his burial mound and the nearby pits containing the magnificent army of thousands of life-size terracotta warriors, which were discovered in 1974. Qin Shihuangdi's unpopularity led, however, to the overthrow of his dynasty. It was fol-lowed by the Han dynasty (206 BC–AD 220), a time of the restoration of Confucian values, military expan-sionism and the beginning of the system of recruiting officials by examination. The philosophy of Daoism was formulated at this time, with its emphasis on everlasting life and its portrayal of immortals in para-dise. The Queen Mother of the West, who ruled over the Daoist paradise, is often portrayed in art of the Han, as are Dong Fang Gong (the Lord of the East), the animals of the four directions and the sun and moon.

Chamber tombs replaced earlier simple shafts and were decorated with wall-paintings, stone friezes or moulded bricks, as if to create a dwelling-place for the person's afterlife. Burial objects changed too, with

183 The Admonitions of the Instructress to Court Ladies. *Eighth-century copy in ink and colours on silk of a handscroll attributed to Gu Kaizhi (c. AD 344–405), with illustrations to a text by Zhang Hua (AD 232–309) on correct behaviour of imperial concubines. H 25cm.*

ceramics, lacquer and silk replacing bronzes. Burial suits were made of jade, thought erroneously to preserve the body. The Museum's set of glass plaques would have had the same function.

There was also a lively portrayal of the mundane activities of everyday life in the tomb figures of the Han dynasty, which were made in low-fired lead-glazed earthenware, as opposed to the high-fired ceramics with a greenish lime-based ash glaze, which had been used for high-quality vessels from the Shang period. During the Six Dynasties period (AD 220–589) the manufacture of fine high-fired, green-glazed stoneware flourished in south-east China. Known today as Yue wares, these ceramics were made in the shapes of toads and lions, imitating small bronzes, and were also used for teabowls and tall funerary vases with small figures and houses modelled on the top.

The British Museum's most important painting is a Tang dynasty copy of a handscroll by the early figure-painter Gu Kaizhi (b. AD 345). It is called *Admonitions of the Instructress to Court Ladies* and illustrates advice on correct behaviour given to ladies in the Imperial harem by the court preceptress. The painting is in ink and colour, mainly vermilion, on silk. The fine-line drawing and the floating draperies show courtly figure painting of the time.

The division of the country into many small kingdoms, some ruled by foreigners, allowed Buddhism to be assimilated into Chinese culture. In the north large complexes of caves containing enormous Buddhist sculptures were created, particularly under the Northern Wei (AD 386–535) and Northern Qi (AD 550–77) dynasties. A number of stone sculptures and small gilt bronzes date from these periods. The massive figure of the white marble Amitābha Buddha is dated AD 585. It was produced under the Sui dynasty (AD 581–618), who unified the former small kingdoms under one ruling house.

The capital of China under the Tang dynasty (AD 618–906) was Chang'an, meaning 'long peace' (present-day Xi'an). Chang'an was the most civilised and cosmopolitan city in the world and stood at the eastern end of the Silk Route. It was a centre for trade in exotic goods from Central Asia and the Near East. The influence of Central Asia and of Sassanian Iran can be seen on Tang silver, jewellery and ceramics, many examples of which have survived in tomb deposits. 'Three-colour' ceramic lead-glazed tomb figures of camels and horses, foreigners and dancing girls, with their vivid splashed colours, served the deceased after death. Fierce guardian figures reflected Buddhist influence, which fluctuated during the Tang according to the religious inclinations of different emperors. The earliest true porcelain dates from the Tang, although it was solid and heavy, unlike European preconceptions of porcelain, derived from much later wares.

A large collection of paintings and other antiquities from sites in Chinese Central Asia was acquired for the British Museum by Aurel Stein. Stein led three expeditions to Central Asia between 1900 and 1915. The antiquities he collected mostly date from the Tang and Five Dynasties period (AD 618–960).

The paintings were found in cave 17 at Dunhuang and range from large works on silk and paper to sutra illustrations in handscrolls and books. They are valuable sources for the history of Chinese figure painting and architecture, and contain some fine examples of early landscape painting in the scenes of the life of the Buddha. Terracottas and architectural fragments show an interesting mixture of cultures, with influences from Greece, Gandhara, the Near East and China.

After the Tang dynasty the Central Asian domains came under the control of Tibet, while in northern China the Khitan tribes seized control and took the title of Liao dynasty (AD 907–1125). Under the Liao fine porcelains, similar to famous Ding wares of the Northern Song, and green-glazed low-fired wares in the style of the Tang dynasty were produced. The nomadic origins of the Khitan are reflected in the shapes of their pots, some of which were based on the leather bags which would have been slung on horse's saddles. A figure in green, brown and buff glazed ceramic from this period showing a seated Buddhist holy man is one of the British Museum's most compelling Chinese sculptures.

The classic ceramic wares of the Song dynasty are famous for their subtle glazes and elegant shapes. In the Northern Song (AD 960–1127), when the capital was at Kaifeng, stonewares and porcelains, such as Northern Celadons, Ding, Jun and Ru were produced. Many of these were offered at court as tribute for the first time. Both white Ding wares and the olive green Northern Celadons were decorated with incised and carved motifs of flowers, waves and children at play. As ceramics came to be produced in greater quantities, moulded decoration was introduced. Apart from the refined porcelains and stonewares of court taste, there was also a tradition of boldly decorated coarser stonewares for popular use, called Cizhou wares. A fine example of these wares is a pillow decorated with a dancing bear in the Museum's collection.

The Song period was a time of great achievement in painting, and court patronage played an important role in establishing the taste that dominated later generations. The Museum possesses only copies of the classic landscape painting of the Song, but it does have an important handscroll attributed to the Southern Song figure painter, Ma Hezhi (fl. *c.* AD 1130–70), entitled the *Odes of Chen*. Several fine wooden sculptures illustrate the graceful style that the Song had inherited from the Tang.

The development of appreciation of Chinese art has

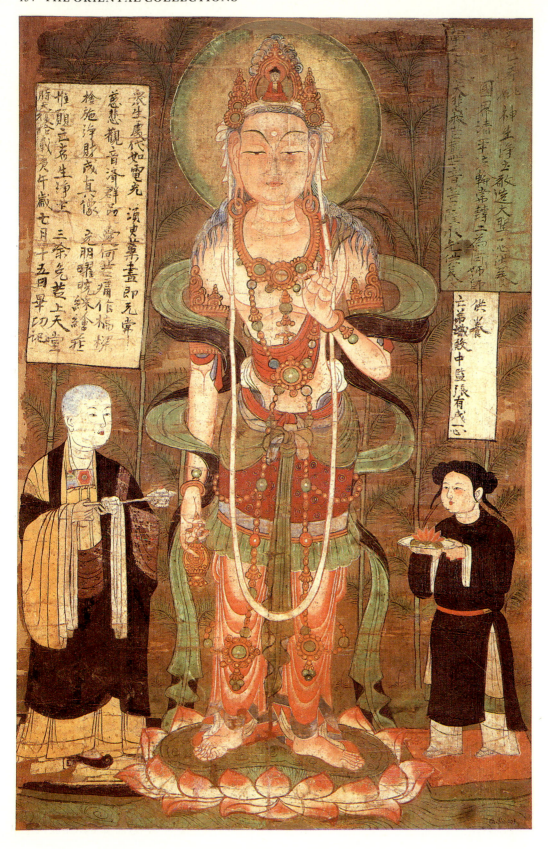

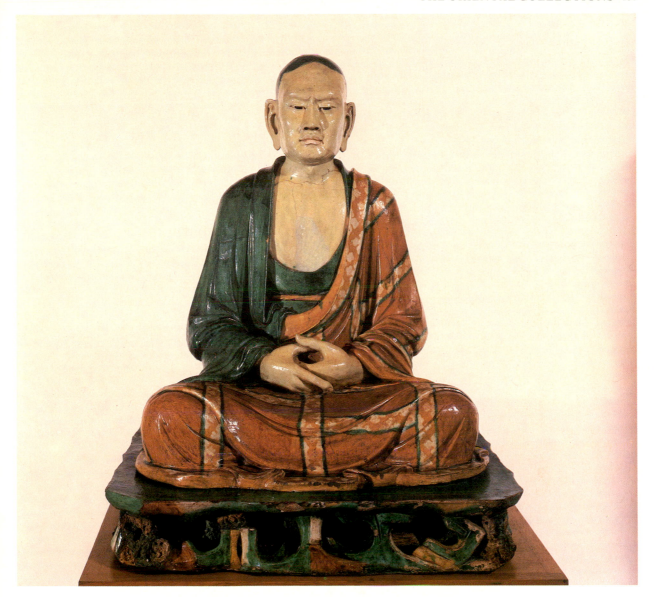

185 ABOVE *Seated Lohan of lead-glazed earthenware. From a set of sixteen or eighteen Lohans in the Yizhou caves in Hebei province, which are so individually modelled that they have been considered as portraits of individual monks. The influence of Tang 'three-colour' ware can be seen in the brilliant glazes.* H 1.03m.

184 LEFT *Avalokiteśvara. Painting in ink and colours on silk. From Dunhuang. Five Dynasties, but dated tenth year of Tianfu (the penultimate reign of Tang AD 910). 77 × 48.9cm.*

much to do with the history of collecting in China. From as early as the Han dynasty ancient bronzes were discovered by chance and accorded respect, often being interpreted as omens. Possession of such bronzes was indeed regarded as evidence of the legitimacy of a dynasty. Emperors were just as eager to obtain calligraphy of renowned masters, whose famous works were treated almost as talismans. From such origins emerged the great art collections of the Song period, whose principal components were bronzes, calligraphy and painting. The famous collector Emperor Song Huizong had a catalogue of his treasures made that can still be consulted today. Calligraphy was particularly treasured, and the southern tradition with its flowing lines and elegant brush-strokes, as practised by the master calligrapher Wang Xizhi (AD 306–65), was

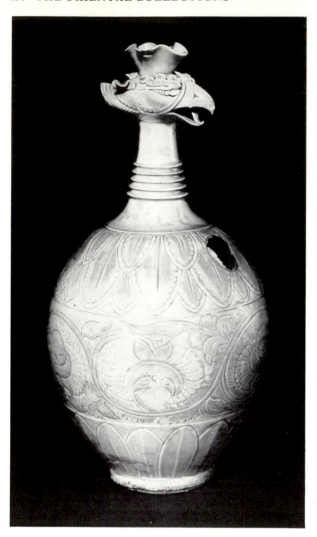

186 ABOVE *Phoenix-head ewer of white porcelain. The influence of metalwork can be seen in the rings around the neck, the punched decoration and the phoenix's head. The greenish tinge in the glaze suggests a southern origin. Eleventh century* AD. H *39.8cm.*

adopted as the classic style, as opposed to the more regular and angular northern style, which derived from stone inscriptions.

Ceramics of the Southern Song (AD 1137–1279), such as Longquan celadons with a milky-green glaze and Guan wares with their finely controlled crackle glazes, were made in the shapes of ancient bronzes, which would have been known from the catalogues of bronze shapes which scholars started to compile during this period. The tradition of archaism continued for centuries. Black teabowls of Jizhou and Jian made in the Southern Song were particularly prized in Japan and were taken home by visiting Zen monks.

In 1280 the Mongols under Khubilai Khan conquered both the Jurchen (who had succeeded the Liao) in the north and the Southern Song, setting up the capital of the Yuan dynasty (AD 1260–1368) in Peking. There was much mercantile contact with Central Asia and the Near East, which led to the development of new styles and techniques. The many Arab communities in the ports of the south-east coast stimulated the use of cobalt 'Persian blue', which was used on underglaze painted porcelain at Jingdezhen, the important ceramic centre in central south-east China. The dense and decorative style, with fish, dragons, figures and landscapes, was influenced by metalwork, textiles and

187 BELOW *Large porcelain flask with peony scrolls in underglaze cobalt blue. Peony and lotus scrolls are a favourite design on Chinese ceramics and on applied art originating in Western architectural ornament. Jingdezhn ware, Ming dynasty, Xuande period (*AD *1426–35*). H *51.2cm.*

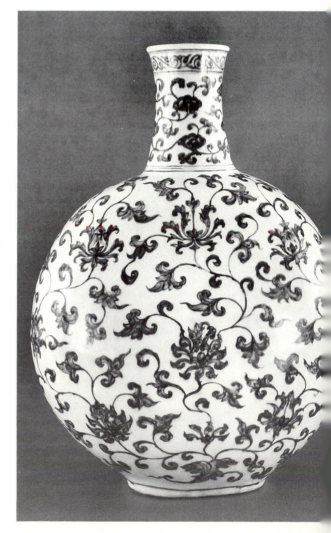

woodblock prints, elaborating the patterns used by the Song and the Jin. Cizhou stonewares continued to be made, as did Longquan celadons. Both the celadons and the underglaze blue porcelain were very popular in the Near East and South-East Asia, where they are found in great quantities.

The native Chinese Ming dynasty overthrew the Mongols in 1368. Decoration on underglaze blue porcelain reached its high point in the fifteenth century, particularly under the Xuande (AD 1426–35) and Chenghua (AD 1465–87) emperors. The elegant designs can be directly related to the academy-style bird and flower painting of the time. Some of the Museum's best Yuan and early Ming pieces come from the John Addis Bequest. Interesting copies of Islamic metalwork shapes were also made at this time. Painting in overglaze enamels was introduced in the late fifteenth century, at first in combination with underglaze blue. The reign of the Wanli emperor (AD 1573–1619) was a period of particularly vigorous designs. Many of the

later Ming wares were exported to South-East Asia, the Near East, Africa and Japan, even reaching the West. They can often be seen in Dutch still-life paintings of the period.

The Ming dynasty was also a time of development and refinement in the manufacture of lacquer and cloisonné enamels. In earlier periods lacquer had been embellished with painting or used for inlay in mother-of-pearl and gold and silver foil and wire. The Yuan had introduced the technique of carving through the many different layers of lacquer. This art was perfected in the Ming, with carved decoration of landscapes, flowers of the four seasons, dragons and lions, which was shared with that on metalwork and on porcelains of

188

188 Large cloisonné foliate dish with dragon design, dating from the Wanli period (AD 1573–1619). This shows the vigorous and lively nature of Wanli design, which can also be seen on ceramics of the same period. D 50cm.

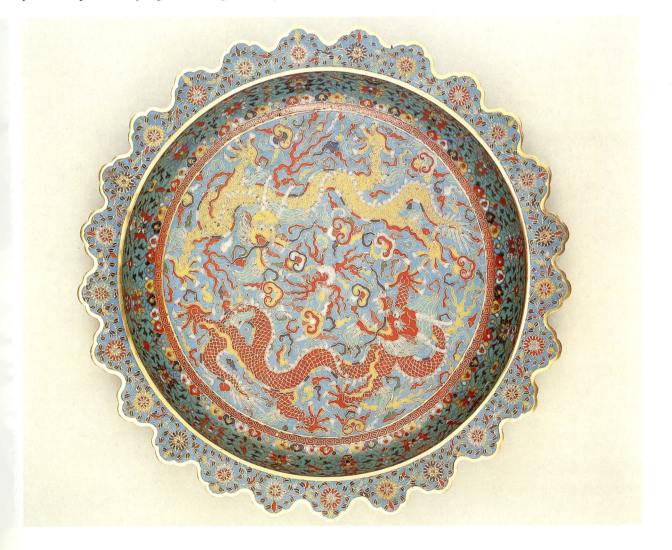

the period. In the sixteenth century polychrome carved lacquer became popular, as did inlaid lacquer and the practice of incising a design and then gilding. These methods were introduced to the Ryūkyū Islands, where they were highly developed. The art of cloisonné enamelling, used for decorating copper vessels, was introduced from the West and also reached a high point in the fifteenth century. In this technique the enamels are contained within small cells, or 'cloisons' and so prevented from running into each other. Related to these enamels are the *fahua* ceramics, which have designs painted in glazes, also separated by 'cloisons' of applied clay. Their brilliant colours on a dark-blue or turquoise ground are particularly distinctive. Buddhist sculpture of the period was influenced by Tibetan taste and several striking bronzes in this style are in the collection.

Under the foreign Mongol dynasty scholars had withdrawn into exile away from court, devoting themselves to calligraphy and painting. Zhao Mengfu alone of the great artists had continued to serve this court. By the Ming dynasty a tradition of literati painting had become established by educated men, who based their painting on the style of landscape masters from the Five Dynasties, Song and Yuan dynasties.

The Museum's collection of Ming paintings in-

cludes works by the literati painters of the *Wu* school, Wen Zhengming (AD 1470–1559) and Dong Qichang (AD 1555–1636). In parallel a group of painters from the Zhe school revitalised the style of Southern Song Academy. The Museum has fine examples of these works from the fifteenth and sixteenth centuries.

When the Manchus defeated the Ming in 1644 to set up the Qing dynasty (AD 1644–1911), certain Ming loyalists such as Kuncan (2nd half of the 17th century) developed their own style, which was based on the Ming scholar-amateur tradition. The Museum has two superb album leaves by Kuncan, which are dated 1666 and depict autumn and winter. He was one of a group of highly eccentric painters who became Buddhist monks. Zhu Da (AD 1625–c. 1705) and Daoji (AD 1641–c. 1717) were other such painters, who worked more directly from nature than many of their predecessors. Their brush-strokes were unorthodox, and Daoji stressed the importance of the 'single brush-stroke'. The more orthodox landscape style, seen in the paintings of the 'Four Wangs', was based on the writings of Dong Qichang and the celebrated Four Masters of the Yuan dynasty. The Yangzhou individualists are also represented in the Museum collections by a set of fan paintings by Gao Fenghan (AD 1683–1749) and a scroll by Luo Ping (AD 1733–99).

The reigns of the Kangxi (AD 1662–1722), Yongzheng (AD 1723–35) and Qianlong (AD 1736–95) emperors were times of particularly strong government, and the court could command high standards of workmanship. Overglaze enamels in the *famille verte* palette are characteristic of the Kangxi period, while the pink derived from colloidal gold was introduced by Jesuits at

189 Autumn. *Album leaf mounted in handscroll form, painted in ink and colours on paper by Kuncan (fl. c. AD 1650–75). Kuncan was a native of Hunan province who entered a Chan Buddhist order. He was an individualist painter, remarkable for the dryness of his brushwork. 31.4 × 64.1cm.*

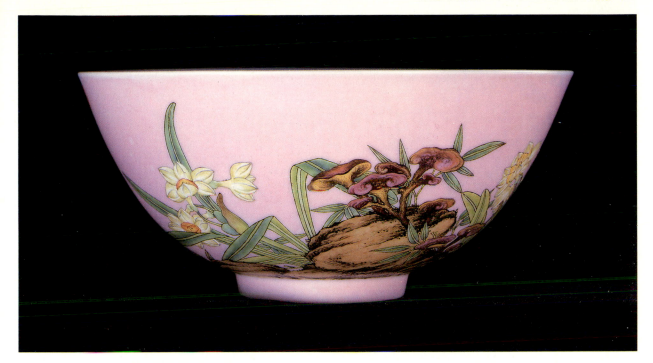

190 *Porcelain bowl decorated in* famille rose *enamels with narcissi, bamboo and fungus among rocks. The delicate overglaze painting is in Chinese taste whereas the heavier crowded decoration on some* famille rose *wares was for the Western market. Qing dynasty, Yongzheng period* (AD 1723–35). H 6.5 cm.

court to produce the *famille rose* palette under Yongzheng. The ceramic complex at Jingdezhen was managed at this time by able directors and enjoyed court patronage. Innovations in monochrome glazes such as the *sang de boeuf* red, 'teadust' green, 'robin's egg' blue and many others were products of this great period of high technical quality.

While in the West the porcelains of the Ming and Qing have been prized since the fifteenth century, in China bamboo-carving, jade and other materials employed by scholars, such as ink-stones and brushes, water droppers and table screens, have been much more highly esteemed. Jade, ivory, bamboo and rhinoceros horn were all carved with exquisite precision during the Qing. The arts of lacquer and enamels continued to flourish, as did that of glass-making and miniature arts, such as snuff-bottles. There was a continuing tradition of archaism, with bronzes, ceramics and jades all being made in ancient shapes. Copies of Song dynasty celadons were of particularly high quality. The Qianlong emperor, in particular, accumulated a large collection of the finest works of art and literature from the past. Sculpture, however, was never regarded as an art in China. Figures of popular gods, Daoist immortals and literary figures in porcelain,

ivory and wood would have adorned homes and temples for worship not for appreciation.

Much of the previously high standards of workmanship and design declined during the nineteenth century. Painting continued in the styles established in earlier centuries. The painting of the four artists known as the 'Four Rens' was a development of the work of the eighteenth-century individualists. The Museum has a set of paintings of the Four Seasons by Ren Xun (dated 1835), whose bold style and elongated compositions are found in the Shanghai school of the early twentieth century epitomised by the work of Qi Baishi (1863–1957). His work is also represented in the Museum's collection, along with a growing collection of other modern painters and printmakers and representative examples of modern ceramics.

KOREA

Korea, a peninsula off north-east China, has been greatly influenced and often dominated by China, to whom she owed Buddhism and many elements of her culture. The Koreans, however, are one of the most creative peoples of Asia and an effortless grace and vitality are apparent in their earliest work.

During the Three Kingdoms period (57 BC–AD 668) the art of the northern state of Koguryŏ showed strong influence from Han dynasty China, particularly in wall-paintings in tombs. Buddhism was introduced first to Koguryŏ and later to Paekche, the kingdom in the south-west which is well known for its high-fired pottery of great technical elegance. The third kingdom,

191 *Sutra box with clasped lid, made of lacquer and inlaid with chrysanthemum scroll decoration in mother-of-pearl and bronze wire. From Korea, Koryŏ dynasty, thirteenth century AD. L 47.2cm.*

Silla, in south-east Korea, produced gold-working of an astonishingly high standard, using thinly rolled gold foil and wire.

After the unification of Korea in the Great Silla period (AD 668–918) Buddhism provided the basis for a cultured society centred on the capital Kyŏngju. The Museum has four small gilt-bronze figures of the Buddha Amitābha dating from this period.

The ceramics of the Koryŏ dynasty (AD 918–1392) are perhaps the finest expression of Korean art. While stonewares with a celadon glaze show influence from Song dynasty China, a certain Korean innovation is the use of white and black slip inlaid into engraved designs under the glaze. Indeed, inlay dominated the taste of the later Koryŏ and can be seen in silver inlaid on bronze and in mother-of-pearl and silver inlaid on lacquer. The British Museum has a fine inlaid lacquer sutra box of the thirteenth century and a good collection of Koryŏ metalwork and celadons, as well as some of the *punch'ŏng* wares of the early Yi (or Chosŏn) dynasty (AD 1398–1910), which continued the tradition of inlaid ceramics, often having stamped designs filled

191

with slip. After the Japanese invasions in 1592–8 many of the potters moved to Japan and *punch'ŏng* wares declined, giving way to the white porcelain with its careless decoration in blue or iron-brown under the glaze, favoured by the upper classes.

One of the most important items in the Museum's Korean collection is a fine Koryŏ period manuscript of the Amitābha Sūtra, illustrated in gold and silver paint. The Museum also has a small collection of Korean paintings, including a sixteenth-century painting on silk of the white-robed Avalokiteśvara and two very large eighteenth- to nineteenth-century paintings on hemp, from a temple at Taegu, of the Buddhist guardians of the East and West.

A nineteenth-century album of scenes from everyday life after Kim Hong-do (1745–after 1814) and a set of export drawings of Korean games and pastimes by the late nineteenth-century artist Kisan give a picture of life in late Yi dynasty Korea.

THE INDIAN SUBCONTINENT

The British Museum's Indian collections are particularly strong in the rich sculptural traditions of the subcontinent, especially in the sculptures from Amaravati, the Gandhara area and medieval eastern India; the sculptures were used in the construction and decoration of temples. But the collections also include

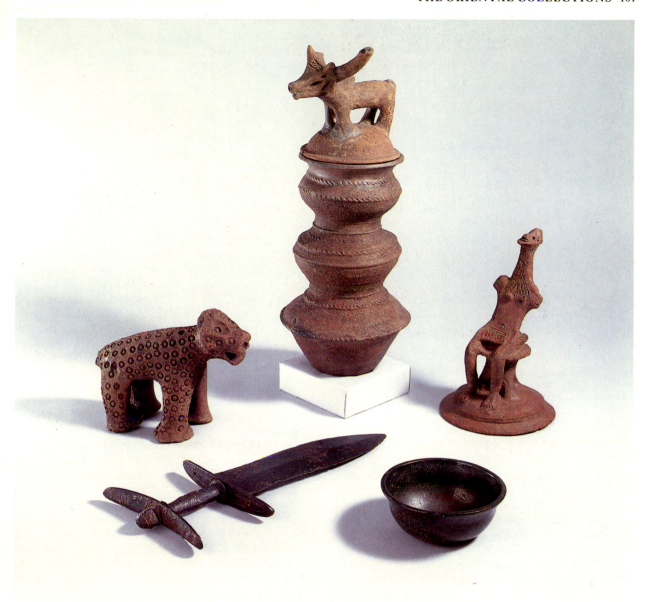

arms and armour, ritual objects, textiles, jewellery, and a large collection of Tibetan banner paintings, as well as paintings from all the major Indian schools.

The oldest objects in the collections – sherds, terracottas, stone tools, and so on – date from the Neolithic, which began in the seventh millennium BC in the subcontinent. A small group of archaeological material represents the great city culture which flourished in the Indus Valley between about 2500 and 2000 BC. The three major cities of the period were Harappa, after which this civilisation is named, Mohenjo-daro and Kalibangan. Objects from this period, mostly from Mohenjo-daro, include painted pottery, terracotta figures, copper and stone tools, as well as finely carved steatite seals. From the Ganges basin to the east of the

192 Objects from prehistoric cemeteries in the Nilgiri Hills, South India: bronze bowl, iron short sword, an earthenware funerary urn and urn lids with animal or human ornaments. About first century BC to AD 500. H (urn with lid) 43.8cm.

Indus Valley comes a group of copper implements and weapons of unusual forms. These distinctive objects are from the so-called 'Copper Hoard Culture' of the first millennium BC. A selection of iron implements is evidence of the introduction, around 1000 BC, of that metal to North India.

From about 1500 BC North India began to be populated by people entering the subcontinent from the north-west. They were speakers of an Indo-European

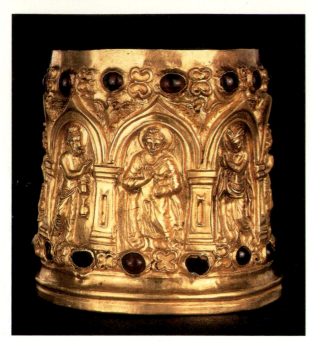

193 *The Bimaran Reliquary. Made of gold and set with garnets, this object was found inside an inscribed stone box in a stupa in Afghanistan. It depicts the Buddha, the gods Indra and Brahma and a worshipper. About first–second century* AD. H *6.7cm.*

language, the parent of Sanskrit and the modern dialects of North India. These people brought with them their religious beliefs, laid down in sacred texts known as the Vedas. In the sixth century BC two great teachers, the Buddha and Mahavira, preached the path of non-attachment to this world and the negation of all desire. The religions they founded, Buddhism and Jainism, continue to this day. The gods of the Vedas survived the growth of these religions, but were slowly superseded by the two great deities Shiva and Vishnu, and by a supreme Mother Goddess. This new complex of beliefs, Hinduism, eventually grew to become the dominant Indian religion.

In the third century North India was unified for a brief period under Ashoka (*c.* 269–232 BC), one of the greatest of all Indian rulers. He proclaimed his own conversion to Buddhism through inscriptions on rocks and polished pillars set up throughout his empire. These texts are the earliest examples of continuous writing in India. The collection contains a fragment of one of these pillars, which are usually associated with monasteries or stupas (solid domes set on a plinth and containing relics of the Buddha or some great saint). A stone bracket depicting a nature spirit embracing a tree comes from Sanchi, the important early group of stupas in North India (1st century BC–1st century AD).

After the death of Ashoka North India was invaded by the Bactrian Greeks, descendants of Alexander's colonists who in the early second century BC occupied the north-western part of the subcontinent. They are best known for their magnificent portrait coins. In about 50 BC they were followed by nomadic Scythian tribes, known as Sakas, who penetrated as far as Mathura, whence comes the famous Mathura Lion capitol inscribed with the names of the Saka kings.

Under the Kushan dynasty (1st–3rd centuries AD) two principal artistic centres flourished, one in what was then called Gandhara (the north-west of Pakistan, and Afghanistan), the other at Mathura. All aspects of the Buddhist art of Gandhara are represented in the British Museum's collection, which is one of the finest in the world. Stone friezes depict vivid scenes of the main incidents of the Buddha's life and previous existences; large and small cult images in stone and stucco portray the Buddha and the other benevolent deities (Bodhisattvas); and there are two rare, standing Buddhas in bronze. The celebrated cylindrical reliquary from a stupa at Bimaran, in eastern Afghanistan is of gold, set with garnets, and is decorated with arcaded figures of the Buddha and divine attendants. The powerful influence of the Western classical world is clear in Gandharan art.

Mathuran art, serving the Buddhist, Jain and Hindu religions, is less well represented. A group of Jain heads in characteristic mottled red sandstone (2nd–3rd centuries AD) are among the most important pieces.

From the fourth to sixth centuries AD, for the second and last time in its history, the whole of North India was controlled by a native dynasty, the Guptas, who ruled from Pataliputra, the old capital of Ashoka. There were two main schools of Gupta art, one centred on Sarnath (near Banaras), the other on Mathura. Sarnath created a refined type of Buddha image of dignified spirituality which was to become the model for future Buddhist art. Two monumental Buddha figures in the British Museum, one seated and one standing, splendidly represent this style. The Mathura style, stronger and more tense, is illustrated by an exquisite bronze figure, the 'Danesar Khera' Buddha.

The break-up of the Gupta Empire in the sixth century AD led to the rise of numerous provincial dynasties. Although the Gupta heritage was common to all, it developed in the seventh to thirteenth centuries into four parallel but distinctive regional styles: western Indian (the modern states of Gujarat and Rajasthan), central Indian (the state of Madhya Pradesh), Kashmiri and eastern Indian (the states of Bihar and Bengal, together with Bangladesh).

The Museum's earliest western Indian sculpture is a beautiful Mother and Child of the seventh century AD, one of the Mother Goddesses of Hinduism. The eighth

century is represented by a powerful seated image of the elephant-headed god Ganesha. A large pillar base carved with female figures dating from the eleventh century shows the ambitious scale of the temples of this period. Many were built of white marble, also used for a large panel of a rearing lion-headed monster.

The central Indian style retained the weight and power of the Mathura school. The most notable early sculptures here, in the sandstone characteristic of the region, are a standing Shiva and a magnificent large image of the Boar incarnation of Vishnu, both of the eighth century. An important group of Jain sculptures of the Gurjara-Pratihara style are dated to about 900. As the style developed the cutting became sharper and the detail more abundant. The Chandella dynasty, associated with the well-known group of temples at Khajuraho, controlled most of central India from the tenth century. The sculptural style is lush and detailed, as seen in a headless female torso, once the property of Sir Jacob Epstein. From Dhar in Malwa comes a famous marble Sarasvati. A magnificent three-faced figure of Brahma, also from Malwa, is dated to about AD 1000.

In the art of Kashmir and the surrounding region the Gupta style was modified by influences absorbed from the earlier Gandhara school. The collection is exceptionally rich in this field. Among the many important pieces is a group of eighth-century terracotta heads from Akhnur and Ushkur. An ivory-carving of a Bodhisattva and attendants is part of a very fine miniature shrine set in a wooden frame. Other pieces include a number of excellent Hindu and Buddhist bronzes and a rich collection of stone images. The unique Kashmir Smats wood-carvings (9th–10th century AD) and two white marble sculptures of Hindu deities represent the art of the Hindu Shahi period in the region.

The chief source of the eastern Indian style was the Gupta school of Sarnath, which continued as an artistic centre after the fall of the Empire. The main patrons were the Buddhist Pala dynasty (*c.* AD 770–1050) and the Hindu Sena dynasty (*c.* AD 1050–1220). This collection is the finest outside India and Bangladesh, and contains a wide range of Hindu and Buddhist images in basalt and an outstanding selection of bronzes. Notable in the latter group is an early image of Manasa, the snake-goddess, and a superbly inlaid and decorated Balarama of the twelfth century.

The art of the Deccan is thinly represented outside India and the British Museum's collection of Buddhist stone sculpture from this area is unique in the West. The Buddhist stupa at Amaravati on the Krishna River was the most famous monument of the Satavahana dynasty, which ruled the Deccan for the first two centuries AD. The stupa, founded in the third century BC, was extensively excavated in the nineteenth century. Most of the surviving sculptures, carved in a luxuriant

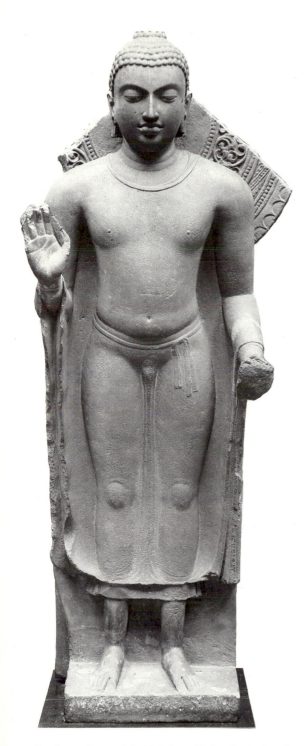

194 Sandstone figure of the Buddha, with hand raised in the sign signifying reassurance. He wears the close-fitting monastic garments typical of the Eastern Indian school of sculpture. Probably from Sarnath, fifth century AD. H 1.45m.

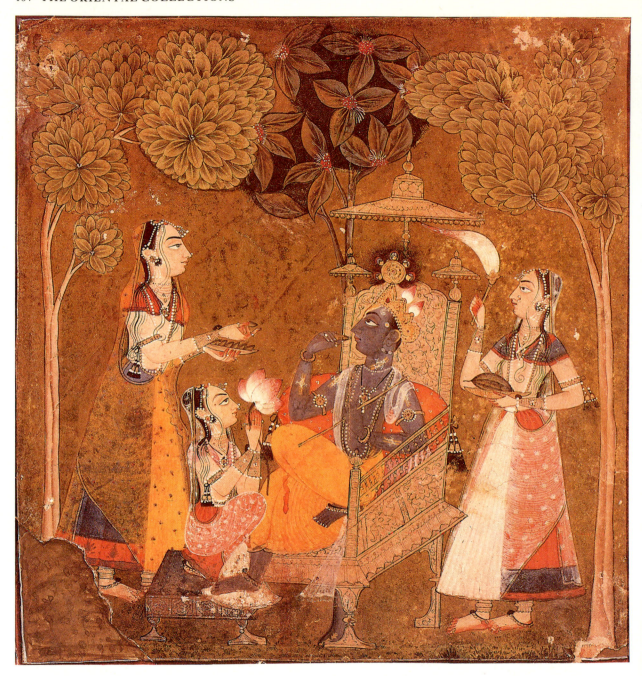

naturalistic style, are now divided between the Madras Museum and the British Museum; the latter possesses over a hundred large fragments.

Other fine examples of the art of the Deccan include a fine male head from Elephanta Island in Bombay Harbour (6th–8th century AD), and a group of Buddhist bronzes from Buddhapad (7th–11th century AD). A single stone figure of Vishnu comes from the greatest rock-cut temple in India, the Kailasanatha at Ellora, built under the Rashtrakuta dynasty (AD 753–973).

195 ABOVE Krishna and the Maidens. *A fine example of the Basohli Style of painting from the Punjab Hills, from the large and comprehensive collection of Indian paintings housed at the British Museum. About* AD *1710. 19.2 × 18cm.*

196 RIGHT *Mahakala, a powerful protector and an aspect of Shiva absorbed by Buddhism. Seen here as the 'Protector of Science' in a Tibetan banner painting or* thangka. *At his waist is a row of severed heads; all around are various deities and Buddhist notables. Nineteenth century* AD. *155 × 91.5cm.*

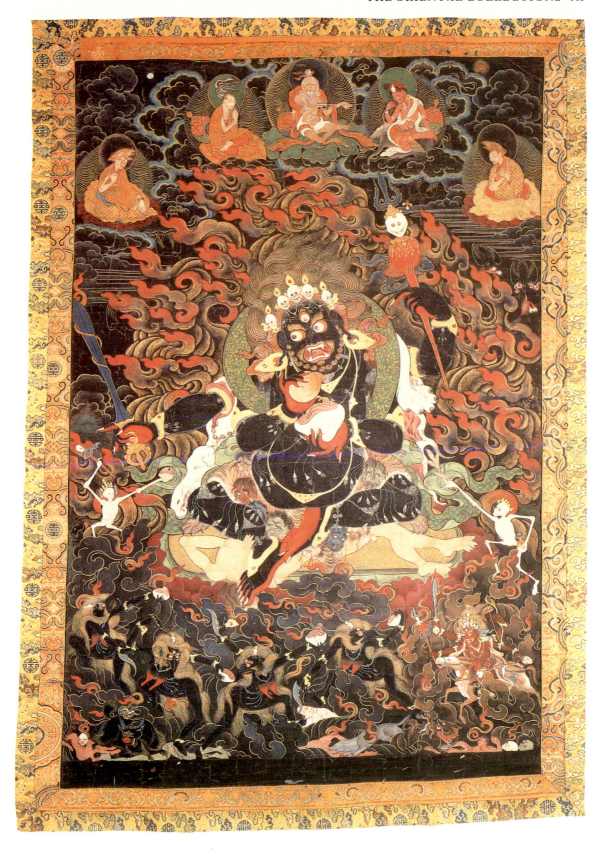

197 *Solid cast-bronze statue of Shiva as Lord of the Dance (Nataraja) performing an act of simultaneous destruction and creation in a ring of cosmic fire as he tramples the dwarf of ignorance. South India, Chola Dynasty, about* AD *1100.* H *89.5cm.*

The southern Deccan contributes much to the collections: three famous bronzes of Sarasvati, Shiva and a seated Jain figure from the Western Ganga dynasty of Mysore (8th–10th century); a small group of stone sculpture of the Nolamba dynasty; three female dancers which once adorned the pillar capitals of temples and a splendid figure of Shiva as Bhairava which date from the Hoysala dynasty (12th–13th century).

Orissa, on the east coast of India, is stylistically an integral part of the Deccan. Its three great artistic centres were the temple cities of Bhuvaneshvar and Puri, and the now-ruined coastal site of Konarak. The Museum's fine collection contains a vigorous eighth-century figure of Durga killing the buffalo demon and a later, smoother Jain Mother Goddess and child. A magnificent series of black schist sculptures of the thirteenth century illustrates the artistic splendours of the Ganga dynasty, and includes a set of Hindu planets.

In South India the first great artistic flowering took place under the Pallava dynasty (c. AD 600–900), famous for their rock-cut temples and sculpture in granite. The collection contains a magnificent Garuda

(the vehicle of Vishnu) of about AD 750: a taut and imperious figure, half bird, half man.

From the late ninth to the thirteenth century the Chola dynasty ruled from Tanjavur. Their empire extended at its height to include much of Sri Lanka. The collection is rich in Chola sculpture, including (in stone) Shiva bursting from the Lingam, and Shiva seated as teacher. In bronze, a grand Nataraja (Shiva as Lord of the Dance) is an early example of this popular type of image (c. AD 1100), while the finest bronze in the collection is a seated Shiva Vishapaharana (c. 950).

Indian painting

The Museum's collection of Indian two-dimensional art is extensive and comprehensive, the vast majority dating from the last three or four centuries. Chief among the non-Mughal paintings in the collections are those from the Deccan, the Punjab Hills and Rajasthan. From Bijapur, in the Deccan, the often published portrait of Sultan Ibrahim Adil Shah II (AD 1579–1627) and that of a contemporary standing courtier are most notable. Among the earliest and finest examples from the Punjab Hills is that of *Krishma and the Maidens*, in Basohli style (c. 1710). From Guler comes a sense of *Krishna on a Swing* (c. 1750).

Some of the finest of all Indian paintings came from the royal courts of Rajasthan, and the riches of that region are justly represented in the Museum's collection. It includes the famous Manley Ragamala (c. 1610), a bound set of miniatures depicting musical modes, possibly from Amber, and the magnificent *Krishna Supporting Mount Govardhana* by Shahadin (Bikaner school, c. 1690).

The Company school is represented by many paintings of architectural, occupational or iconographical subjects, some on mica. Nineteenth-century Calcutta is represented in a number of Kalighat paintings of Hindu deities.

NEPAL AND TIBET

Indian art had a profound influence on that of Nepal and Tibet. While the Pala style of eastern India was strongest in Nepal and southern Tibet, western Tibet followed the direction of her neighbour, Kashmir. Both countries soon expressed these influences in their own idiom, producing a fresh interpretation of the Indian model. The most creative period of Nepalese art, serving both the Buddhist and Hindu religions, lasted from the ninth to the sixteenth centuries AD. Chief among a group of early bronzes is a dignified seated Maitreya (the Buddha to come) of the tenth century. Outstanding stone sculptures include an eighth-century standing Buddha, a teaching Buddha of the ninth to tenth centuries, and a twelfth-century sculpture of Shiva and his consort.

A group of bronzes of the eleventh to thirteenth centuries show that the art of southern Tibet had already acquired a character of its own, with a marked preference for inlays of gold and silver. The collection is rich in Tibetan metal images, ritual equipment and banner paintings, or *thangkas*. An early painting, probably of the thirteenth century, perfectly preserved on a large wooden book-cover, is probably the finest Tibetan work in the collection. In the fourteenth century Tibet felt the impact of her powerful eastern neighbour, China, and Indian and Chinese influences begin to appear side by side.

By the seventeenth century the arts in Nepal and Tibet were content to repeat the old formulas. Craftsmanship, however, remained of a high order, especially in the elaborate inlaying of semi-precious stones, as seen in jewellery and musical instruments.

SRI LANKA

Both the Buddhist religion and the Sinhalese language find their origins in North India. However, the most dominant influences on the art of Sri Lanka came from

196

198 *The Bodhisattva Tara. Solid cast in gilded bronze, this image from Sri Lanka of the shakti or female essence of the Bodhisattva Avalokiteśvara is possibly the finest of all South Asian bronzes. It combines a ravishing naturalism with great spiritual dignity. Tenth century* AD. H *1.43m.*

199 *The Buddha in the earth-touching posture, symbolising his enlightenment. This gesture of the right hand is the commonest in Burmese Buddha images. This is one of the finest of the bronzes of Burma's Pagan period. Twelfth–thirteenth century* AD. H *33cm.*

the eastern Deccan (Amaravati) and South India. A small group of Buddhist bronzes belongs to the Anuradhapura period, which came to an end in the early eleventh century with the Chola invasion. The 198 greatest of all Sri Lankan works of art, an almost life-size gilt-bronze figure of the Bodhisattva Tara, dates from the flowering of Sri Lankan art in the Polonnaruwa period between the tenth and thirteenth centuries AD. The collection contains a good selection of small bronzes and ivory-carvings, including a magnificent carved casket of AD 1600.

SOUTH-EAST ASIA

During the first millennium AD Indian forms of society, religion and art were carried all over South-East Asia by sea-going traders and colonists. The collections from South-East Asia include objects from Burma, Thailand, Cambodia, Malaysia, Indonesia, Vietnam, Laos and the Philippines.

Burma
A golden age of Burmese art began with the Pagan kingdom (AD 1044–1287) on the Irrawaddy River, drawing heavily on the Buddhist art of neighbouring eastern India. The finest Pagan bronze outside Burma, 199 a seated Buddha, graces the British Museum's collection. In later Pagan style is a dignified standing wooden Buddha of about the fifteenth century. Later Burmese art is often characterised by the addition of gilt lacquer and coloured mirror glass. From the nineteenth century a figure of a kneeling monk shows genuine sensitivity in what is a very repetitive later style of art.

Thailand
The earliest kingdom in Thailand was that of the Mons (7th–11th centuries AD). The best-known early style of art is named after the capital of the Mon kingdom, Dvaravati. Influenced to a degree by the Sarnath school of Gupta India, this distinctive style is represented by a powerful stone Buddha head, and another in stucco. The legacy of Khmer domination of southern Thailand can be seen in stone sculpture from Lopburi and bronze Buddha heads from U'Tong (13th–14th centuries).

The first Thai dynasties were founded in the thirteenth century at Chiengmai and, later, Ayuthia (14th–18th centuries AD). A Thai art style, inspired by Burmese and Sri Lankan forms, developed quickly. The walking Buddha is a highly original Thai contribution to the history of the Buddha image. In the fourteenth and fifteenth centuries Thailand became famous for its ceramic production, including the celebrated Sawankhalok and Sukhothai wares, along with celadons.

Cambodia
The greatest of the Indianised kingdoms of ancient mainland South-East Asia was that of the Khmers of Cambodia. Its highly original art is sparsely represented here, but from the early period comes an exquisite eighth-century female head. The greatest complex of temple architecture of the region is at Angkor, the Khmer capital founded in the ninth century. In the Museum's collection are a tenth-century Angkor male torso, a later three-headed stone Bodhisattva of the twelfth or thirteenth century and a small collection of bronzes (11th–12th centuries).

Indonesia
A great Indianised kingdom was established in Java by the eighth century. Under the Shailendra dynasty in central Java, between AD 750 and 950, art and architecture were influenced by South India. From that period dates the greatest of all Buddhist monuments, the vast stupa at Borabudur, and the collection contains Buddha heads from that site, as well as a magnificent male torso. A rich body of Buddhist bronzes illustrates an artistic debt to eastern India. Also of this period is the famous Sambas hoard of gold and silver images from Borneo.

The Eastern Javanese period (c. 950–late 14th century), a period of excellent craftsmanship and powerful sculpture, is scarcely represented here.

Vietnam
The two principal ancient divisions of this country were the Chinese-influenced north (Annam) and Champa, the Indianised coastal south. Annam is represented mainly by a collection of porcelain, remarkable amongst which are two dated altar vases (1582) and an inscribed, pillared censer (dated 1575), both of which are decorated with raised dragons in unmistakable Annamese style. From Champa come three sculpture fragments including a lively eleventh-century rampant lion with a curly mane.

THE LANDS OF ISLAM

The Islamic religion was founded by the Prophet Muhammad, who was born at Mecca in western Arabia about AD 570. His flight to Medina in AD 622 marks the beginning of the Islamic era. Those countries in which the Islamic religion came to prevail constituted the *Dar al-Islam*, 'the World of Islam'. Its peoples were governed by Muslim rulers, and however much they differed in race and language Islam gave them a common purpose and way of life, though in the course of centuries distinctive Islamic cultures were created. The lands represented in the British Museum's Islamic collections are, in modern political terms, Egypt, Syria, Lebanon, Israel, Turkey, Iraq, Iran, Afghanistan, the Soviet Central Asian Republics, Pakistan and India.

From the earliest days Muslim patrons demanded superb craftsmanship and design in everyday objects,

and it is in the forms and decoration of pottery, glass and inlaid metalwork that Islam excelled. A decisive Arab contribution to Islamic art was the script: Kufic, an early angular style, and Naskhi, a later, more rounded hand whose remarkable dignity and flexibility were exploited in all Islamic art. Among important specimens of Arabic script in the Museum's collections are a gravestone of AD 858, a stone cenotaph of AD 991, and a building dedication of AD 1084, all inscribed in the Kufic script, reserved in the early centuries of Islam for the Quran and for monumental inscriptions. The Islamic proscription against human representation was not enforced in the case of the minor arts; only when it was intended for religious architecture (tile revetments and stucco panels) or for Koranic illumination did the decoration revolve entirely around geometric forms of the arabesque – a continuous stem with split palmette leaves, convoluted in an infinite variety of forms.

During the seventh and eighth centuries AD the Arabs conquered Egypt, Syria, North Africa, Spain, Mesopotamia, Persia, Transoxania and Sind. The caliphs of the Umayyad dynasty (AD 661–749) ruled their empire from Damascus in Syria. Early Islamic art, in its architecture as well as in the decorative arts, is heavily dependent on the cultures of the conquered peoples, the Sassanian tradition in Persia and the Graeco-Roman tradition in Syria. Thus a turquoise-glazed vase of the Umayyad period from Mesopotamia follows the style and technique of the green-glazed amphorae of the late Parthian period (2nd–3rd centuries AD).

The Umayyads were succeeded by the ᶜAbbasid caliphs (AD 749–1258), whose capital was Baghdad in

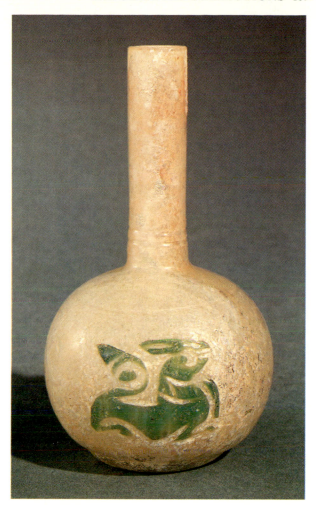

201 *Glass bottle with the silhouette of a running hare which has been carved from an overlay of green glass. The lively but abstract appearance of the hare is typical of Persian art in the tenth century AD. H 15cm.*

200 *Shallow bowl, painted in black slip with a fine Kufic inscription. The inscription reads: He who speaks his speech is silver, but silence is a ruby: With good health and prosperity. From Nishapur, Iran, later eleventh century AD. D 34.6cm.*

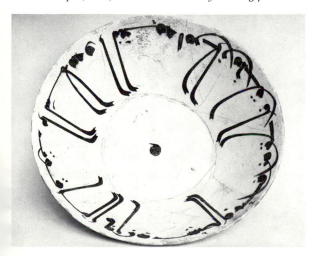

Mesopotamia. ᶜAbbasid power and the ᶜAbbasid court were greatest in the ninth century AD. Highly regarded at the ᶜAbbasid court were Tang stonewares imported from China; these greatly inspired the Arab potters. A ninth- to tenth-century Tang white ware dish with foliate rim, found at Nishapur (Iran), has an exact ᶜAbbasid parallel. Unable to manufacture stoneware, the potters achieved a cosmetic likeness by applying an opaque white tin-glaze to the surface of their earthenware vessels. Sometimes they added elegant foliate and geometric designs in blue and green. The ᶜAbbasid potters' greatest technical achievement was lustre, a technique first used in Egypt in the eighth and ninth centuries to decorate glass; metallic pigments were painted onto the tin-glazed surface of a vessel to create a lustrous sheen that may have been intended to imitate

precious metal. Early examples combine two or more colours, as on fragments of tiles from the short-lived capital of the ᶜAbbasids at Samarra. These brilliant shades, however, were abandoned in favour of a single yellow lustre, which seems to coincide with a change from organic to figural decoration.

Precious metalwork of the Umayyad and ᶜAbbasid periods is often in the Sassanian tradition; vessels are worked in repoussé and often parcel gilt with characteristic scenes of rulers engaged in courtly pastimes. Silver and gold continued to be worked until the twelfth century: an important hoard found at Nihavand in western Iran includes a complete belt of silver, parcel gilt and nielloed. Simple bronze objects were also produced in Iran and the western Islamic lands up to 1200. Early examples, particularly ewers, follow the Roman or Sassanian tradition; later objects from Iran – mortars, lamps, dishes and boxes – have fine engraved decoration. Particularly popular in the twelfth century were mirrors, often decorated on their backs with harpies and bands of Kufic calligraphy. Painting of this period is represented by illustrations from an Arabic translation of the ancient Greek pharmacopeia *Materia Medica* by Dioscorides, copied in 1224 and painted in Baghdad. A fifteenth-century page from the *Ajaᶜib al-Makhluqat* (Wonders of Creation) depicts the emblems of the four evangelists; this very popular text was much illustrated in Iraq in the fourteenth and fifteenth centuries, perpetuating the great school of painting in Baghdad under the last ᶜAbbasid caliphs.

In the ninth and tenth centuries Persian dynasties were established independently of the Umayyad caliphs of Baghdad. The Samanids in eastern Iran and Transoxania (AD 874–999), for example, ruled from their capital at Nishapur, where excavations have re-
200 vealed quantities of earthenware pottery. Painted in thickly applied slips to prevent the colours from running beneath a transparent lead glaze, the finest are boldly painted with Kufic inscriptions. Also from Nishapur are buff ware bowls, whose figural decoration continues the subject matter of Sassanian relief-worked silver.

In Persia, Mesopotamia and Egypt the Muslims
201 inherited an ancient tradition of glass-making. The most prized glasses were carved in relief; the so-called Hedwig Glass is a magnificent example. Mould-blown glass was also produced, and the ancient technique of making mosaic glass was revived by the glass-makers of Mesopotamia in the ninth century AD. Rock-crystal is singled out for praise by early chroniclers who saw the famous and opulent Cairo treasury of the Fatimid caliphs, rulers of Egypt between AD 969 and 1171. These rock-crystals range in date from the ninth to the eleventh centuries and are often carved with animals or Kufic inscriptions. Many found their way to Europe, where they were mounted in precious metal and used as

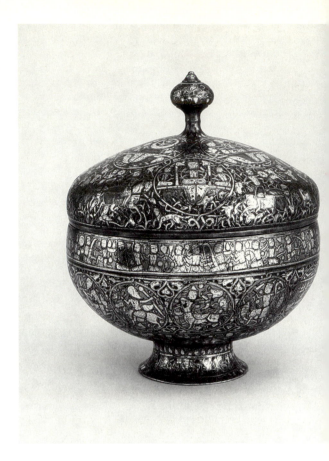

202 *The Vaso Vescovali. Bronze vessel, inlaid with silver with depictions of the planets and signs of the Zodiac, mounted warriors and a frieze of musicians. Probably from Eastern Iran or Afghanistan, about* AD 1200. H 22cm.

reliquaries. Recent research suggests that rock-crystal may also have been carved in Basra in Iraq, and a fine goblet in the collection may perhaps come from this source.

Jewellery, too, is known from the Fatimid period; several examples show the continuity of the traditions and techniques of classical and Byzantine jewellery in the use of intricate filigree-work and enamelling. But best known of the arts of the Fatimids of Egypt is their lustreware, which follows on, both technically and stylistically, from the lustrewares of Iraq. Excavations of the potters' quarters at Fustat, south of Cairo, have yielded quantities of locally produced and imported lustrewares.

In the eleventh century Persia was invaded by the Seljuk Turks, nomads from Central Asia, who established their rule over the greater part of Persia, Mesopotamia, Syria and ultimately Asia Minor. Under their patronage a style of architecture was developed, which was continued by their successors: the Atabegs in

Persia, Mesopotamia and Syria, and the Seljuk Sulans of Konya in Turkey. A major influence on pottery at this time was Chinese porcelain of the Song dynasty (AD 960–1279), which was exported into the Islamic heartlands. Islamic potters, attempting to recreate this ware, produced a new, more versatile ceramic fabric, composed of frit made from a high percentage of ground quartz and pure white clay and used in conjunction with new alkaline glazes. Iran, with its ceramic centre at Kashan, produced a whole range of ceramics in this new medium. Designs on their overglaze enamelled wares (*minai*) and lustre vessels are strongly linked to miniature-painting in manuscripts. The underglaze painted wares of Kashan were to have a tremendous impact on the Chinese for, along with Persian cobalt imported into China at this period, they created the vogue for blue and white porcelain under the Yuan and Ming dynasties.

Metalwork, too, at this time saw a revolution in form and technique. Perhaps because of a shortage of silver in the Near East from about AD 1100, craftsmen turned to brass or bronze, which they inlaid with silver and copper. The collection has fine examples of fluted brass ewers, pen-boxes and ink-wells, many of them produced in the eastern Iranian province of Khurasan. These were often decorated with the signs of the zodiac, combined with dense scrollwork and animated inscriptions. A remarkable footed bowl and lid in this style is the Vaso Vescovali, a bronze vessel inlaid with silver, dating from about 1200.

In the first quarter of the thirteenth century Persia was devastated by the Mongol invasions. A number of metalworkers may have found asylum at the court of the Atabeg Badr al-Din Lulu at Mosul in northern Iraq (AD 1218–59), where the metalworking industry reached new heights of refinement. The Museum has a number of pieces inscribed with his name and titles, and many objects are signed by craftsmen with a Mosul connection. Among the most important is a brass ewer signed by Shujaᶜ ibn Manᶜa and made in Mosul; it is inlaid with silver and copper, with intricately worked roundels containing genre scenes of life and entertainment at the Mosul court.

In Egypt the Fatimids were succeeded by the Ayyubids (AD 1171–1250), who added Syria to their domains. Syria had produced glass since antiquity, but now a new technique was developed – gilding. A fragmentary flask with gilded decoration is inscribed with the name of ᶜImad al-Din Zangi (AD 1127–46), who ruled at Mosul and Aleppo in Syria prior to the Ayyubids. In the thirteenth and fourteenth centuries enamelling was combined with gilding. A fine example is a pilgrim's flask painted with horsemen and musicians. In northern Syria at towns like Raqqa and Balis/Meskene on the Euphrates underglaze pottery, contemporary with that of Kashan in Iran, was being produced. Using the newly discovered ceramic fabric (frit), Syrian potters perfected the art of underglaze painting with geometric, arabesque or animal motifs under a brilliant turquoise glaze.

The Ayyubid period also saw the beginning of inlaid metalwork in Syria and Egypt. A superb brass astrolabe with silver and copper inlays was made in Cairo by a Cairene specialist ᶜAbd al-Karim in 1235–6. This instrument is the earliest known piece of inlaid metalwork produced in Egypt. Arab painting from Egypt is represented by rare thirteenth-century examples from Fustat. A number of objects from this period bear Christian scenes, demonstrating a wider patronage than simply the ruling Muslim élite. A handwarmer, or pomander, made in Syria for the emir Badr al-Din Baysari, bears a double-headed eagle, the blazon of the last reigning Ayyubid Sultan at Salih Ayyub.

In 1250 the Mamluks, an army of Turkish slaves built up by the Sultan Ayyub, seized power from their erstwhile masters. They made their capital at Cairo, and ruled until 1517, when they were overthrown by the Ottomans. Art flourished under Mamluk rule. Enamelled glass continued to be produced: characteristic are the mosque lamps, commissioned by sultans and emirs, of which the Museum has many fine examples. In the early fourteenth century a third wave of Chinese imports – textiles, blue and white porcelain and celadons of the Yuan period – had a dramatic effect on the decorative arts. *Chinoiserie* lotuses, peonies, phoenixes, and the blue and white colour scheme appeared on tiles and vessels. Metalwork, too, shows their influence: large basins and trays have *chinoiserie* lotuses or peonies incorporated into designs which also bear inscriptions in the large cursive script known as *thulth* often in the names of the Mamluk sultans or emirs. The Mamluks granted devices of rank to high officers of state and these are frequently depicted: a fine fourteenth-century steel mirror bears a pen-box, the emblem of a secretary of state.

In the middle of the thirteenth century Persia and Mesopotamia had been joined with Central Asia and China under the rule of the Mongol Great Khan. Political union brought close commercial relations between east and west Asia, and the exchange enriched the arts of Persia. Under the Mongol dynasty of the Ilkhans (AD 1245–c.1336) there was renewed activity in pottery and metalwork. The influx of Chinese motifs had the same effect on Persian art as it had on that of the Mamluks. Flowers and leaves were rendered more naturalistically and the lotus and phoenix now appear on ceramic wares of the 'Sultanabad' type, which are generally coarser that their Kashan predecessors.

In the fourteenth century Persia was invaded by Timur, known in the West as Tamerlane. This was only a temporary setback to Persian civilisation, however, thanks to his successors, who were enlightened patrons

204

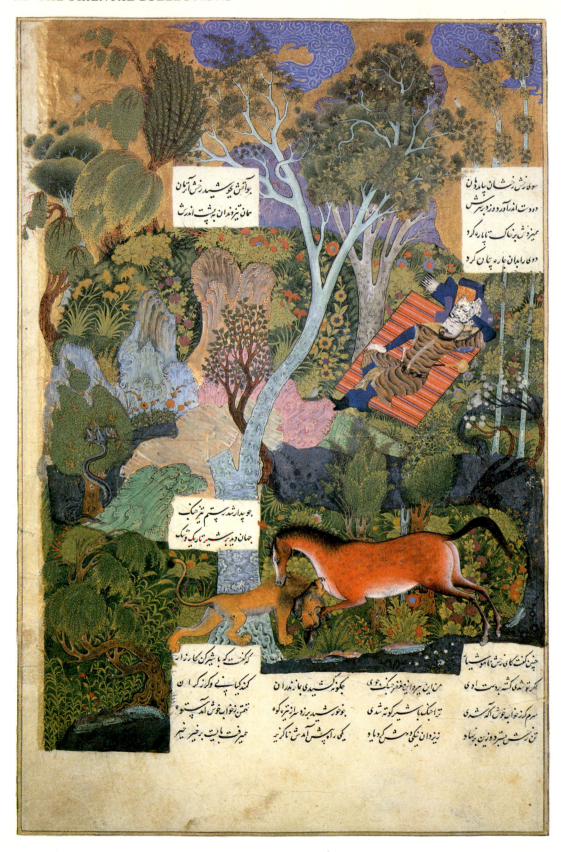

of the arts. The British Museum has three vessels of dark-green jade which may have been made at Samarqand, the seat of Timur's grandson Ulugh Beg (AD 1409–47), an enthusiastic collector of jade-carvings. One of these, a vase, subsequently passed to Jahangir, Mughal Emperor of India (AD 1605–28), who recorded his ownership in an engraved inscription.

With the collapse of the Timurid Empire and that of its Turcoman successors at the close of the fifteenth century Persia came under the rule of the Safavids (1502–1736). Safavid art continued in the Timurid tradition: the brass jugs of the early sixteenth century are close in form and style to those of the Timurid period. The armourers and swordsmiths of the Safavid period, however, were famous. A superb helmet and arm-piece of steel, carved and inlaid with gold, bear dedicatory inscriptions to the greatest ruler of the Safavid dynasty, Shah ʿAbbas I (AD 1588–1629). Two sabres, one signed by a swordsmith of Isfahan, are notable examples of the pattern-welded steel blade. The great astrolabe made in AD 1712 for the last of the Safavid rulers, Shah Sultan Husayn (AD 1694–1722), is a superb example of the high quality achieved by the Safavid instrument-makers.

Persian pottery of the seventeenth century compares in quality with that of the earlier periods. A large bowl decorated in underglaze blue and black with phoenixes and flying cranes was inspired by Chinese originals, as was a superb dish with a qilin. The turbanned head of a youth painted on a large dish is a typical invention of contemporary Safavid painting and belongs to a group associated with Kubachi in the Caucasus, where many of this type were found. A vase decorated in white slip on a soft-grey ground, and a hookah-base for a tobacco pipe painted in polychrome are examples of wares influenced by Chinese export wares from Swatow.

The political turmoil after the fall of the Safavids was ended by the Qajar dynasty (AD 1795–1924), which brought about a regeneration of Persia in the nineteenth century. Painted lacquer was popular at both the Safavid and Qajar courts, and a remarkable instrument box with the court of Solomon depicted on the lid probably belonged to an apothecary or a jeweller. A portrait of two Persian youths painted in oils on canvas employs a technique and style borrowed from Europe.

In Turkey the Byzantine Empire had succumbed to the Ottoman Turks with the fall of Constantinople to Sultan Mehmet I in 1453. By the sixteenth century Turkey was the centre of a powerful empire. The

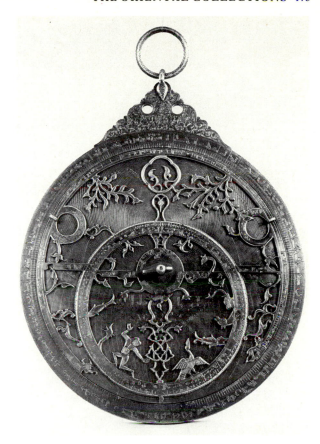

204 Brass astrolabe inlaid with silver and copper made by ʿAbd al-Karim al-Misri in Egypt and dated AH 633 (AD 1235–6). Certain of the pointers are pictorial representations of fixed stars, such as Pisces, Pegasus and Cygnus. H 39.4cm.

pointed steel helmet and breastplate are reminders of Turkey's military prowess at this time. A finely patterned steel sabre bears the name of Sultan Suleyman the Magnificent (1520–66).

The Museum has an unrivalled collection of Turkish pottery produced at Iznik from the end of the fifteenth century. Chinese taste after the capture of Chinese porcelain as booty at Tabriz in 1514 influenced the decoration of the earliest blue and white wares. Small-scale spiralling tendrils characterise the so-called Golden Horn wares, while the 'Damascus' group produced between the 1550s and the 1560s exhibit a range of colours hitherto unknown in the history of Islamic pottery. An important documentary piece is a mosque lamp dated 1549 from the Dome of the Rock in Jerusalem. The turning point for the Iznik potteries came with building of the Süleymaniye complex (inaugurated 1557) for which tiles from Iznik were ordered. This established a fashion for an underglaze bole-red used extensively on both tiles and vessels.

203 Miniature from a manuscript of the Shah-nama, *or Persian Book of Kings, probably painted in Tabriz about AD 1500. It shows Rustam sleeping in a woody landscape while his horse Rakhsh saves him from an attacking lion. 31.5 × 21cm.*

205

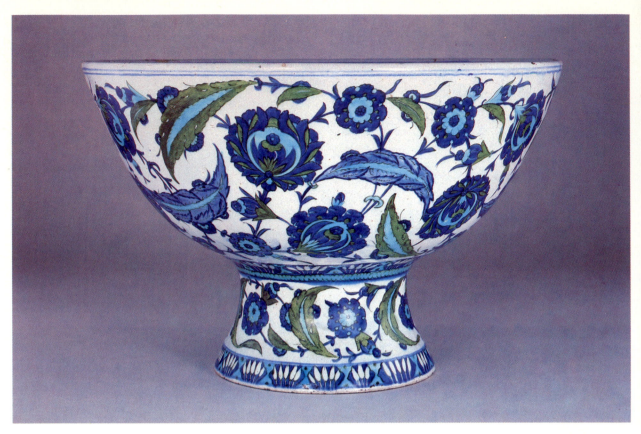

205 *Footed basin decorated with swirling leaves and fantastic flowers, with a border of tulips around the base. The colour range and fine draughtsmanship demonstrate the skill of the Iznik potters in sixteenth-century Ottoman Turkey.* H 27.3cm.

The collections also include some fine examples of Turkish miniature-painting. Of special interest are paintings of foppish European gentlemen by Levni (d. 1736). Other noteworthy items include an album of costumes and paper cuts acquired in Istanbul in 1618, a two-volume eighteenth-century album of costumes, and pages from biographies of the Shiʿi martyrs, probably executed in Baghdad in about 1600.

In India Babur (AD 1526–30), a descendant of Timur, founded the Mughal Empire; by the seventeenth century it included North India and the greater part of the Deccan. Unlike other Islamic countries, the majority of its people were not Muslim, and Mughal society shows a distinctive fusion of Muslim and Hindu cultures. Mughal craftsmen were particularly skilled in the art of carving hardstones; the emperor Jahangir (AD 1605–28) is known to have patronised jade-carvers. To his reign probably belongs a magnificent terrapin carved from a great block of jade. A beautiful jade vessel carved in the form of a split gourd bears a dedication to Jahangir's son, the emperor Shah Jahan (AD 1628–58).

A pair of huqqa bases encrusted with gold and semi-precious stones have gold ormolu mounts made specially for them in the late eighteenth century. Other hardstones were also carved: a finely sculpted tiger's head of banded agate is probably from the arm of a throne. Mughal weapons of the sixteenth to eighteenth centuries include fine daggers with blades of pattern-welded steel and handles of jade, walrus ivory, or jewel-encrusted rock-crystal. Also popular were gilded coloured glass vessels, and jewellery set with emeralds, diamonds and rubies.

The gem-set jewellery of the Mughal period, worn by the ruling élite, was frequently depicted in contemporary miniatures. The most important of the Museum's collections of miniature-paintings belong to the Mughal period, particularly those associated with the reigns of Akbar (AD 1556–1605) and Jahangir. There are portraits of courtiers; calligraphy by famous Mughal practioners; illustrations to Hindu and Persian classics; books of fables; and illustrations from a brief life of Christ composed by the Jesuits for the emperor

206 *The Prophet Khidr saving the young prince Nur al-Dhahr from drowning in the Ganges. From the* Hamza-nama, *the legendary exploits of the Amir Hamza, made for the Mughal emperor Akbar about* AD 1567–82. 67 × 50cm.

207

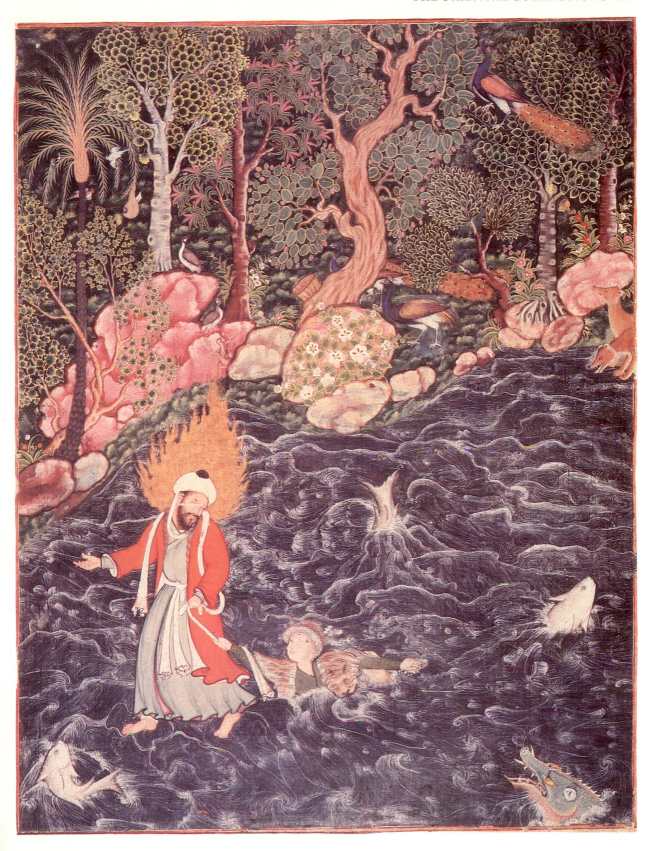

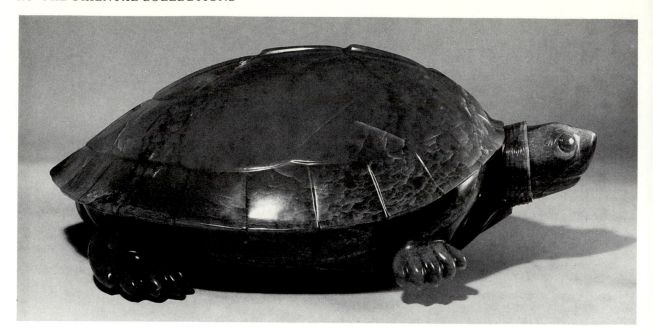

207 *Terrapin carved from one piece of jade. Found in a tank at Allahabad in Northern India. Mughal, probably commissioned by the emperor Jahangir (AD 1605–27). L 50.2cm.*

Akbar. In addition there are illustrations to the major chronicles of the reigns: *Babur-nama, Akbar-nama* and the *Tuzuk-i Jahangiri*. Among the prizes of the collection is the fragmentary *Princes of the House of Timur*, possibly painted in Kabul about 1545–50; portraits of Akbar, Jahangir and Shah Jahan were added later. Equally fine are the pages from the late sixteenth-century *Hamza-nama*, the work of Akbar's studio.

206

JAPAN

The geographical area from which the British Museum's collection comes coincides with Japan's modern political boundaries. They include the large northern island of Hokkaidō, and the Southern Prefecture of Okinawa, formerly known as the Ryūkyū Islands, both of which lay historically outside the mainstreams of Japanese culture. The Japanese collection aims to cover all aspects of material culture from the Jōmon period (beginning *c.* 10,000 BC) until the present day. It is particularly recognised as the national collection of Japanese fine arts in traditional styles or formats, but excludes international-style easel-paintings of the last 130 years, which for reasons of conservation fall within the remit of the Tate Gallery. Items of anthropological interest, especially relating to the Ainu culture of Hokkaidō, are held in the Department of Ethnography, while a group of Japanese clocks is cared for by the Department of Medieval and Later Antiquities.

Japanese culture has since the fourth century BC been characterised by its relationship with countries of East Asia; and, from the sixteenth century AD onwards, with Western nations also. In all of that period cultural change has tended to come about by following foreign example. Because of Japan's distance from the nearest Asian country (Korea) overseas influences have typically arrived in comparatively short, powerful bursts, followed by periods of greater isolation in which they have been absorbed and slowly changed into more native forms. These patterns have been broken since 1945 by the interdependence of modern international society and the speed of communications. It is too early to predict if this is a permanent change in emphasis.

The earliest culture represented in the collections is known as Jōmon after the typical cord-impressed decoration on the inventively shaped low-fired pottery. The earliest Jōmon pottery is also so far the earliest datable pottery in the world (*c.* 10,000 BC). The British Museum's collection includes only a few undocumented pieces of pottery and sherds from the later part of the period (*c.* 3,000 BC onwards), together with some stone arrowheads and other stone implements.

The first major revolution in the life-style of the Japanese people occurred in the third century BC with the change to settled rice-cultivation and the use of metals. Known as the Yayoi period (*c.* 300 BC–AD 300), this ended a period of some ten thousand years of the hunting, gathering and fishing culture of Jōmon. The development of settled agriculture is assumed to have been due to close contacts with East Asia or immigration, though there is no conclusive evidence as yet to settle the question. Other continental introductions were wheel-thrown pottery and wood vessels, the cast-

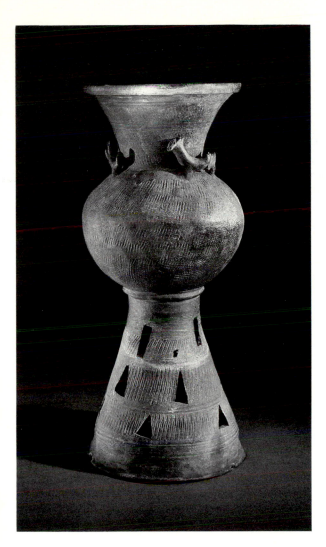

208 *Sue ware vase with applied stag, boar and bird figures.*
Such vases, found in the tumuli of the later Kofun period
(sixth–seventh centuries AD), exist in a variety of forms. They
probably contained offerings of different foods and liquids.
H *52.2cm.*

The Kofun period (*c.* AD 300–710) saw the building
of impressive tombs for the great, especially for the
ruling family of the Yamato region (modern Nara
Prefecture), which gradually established its dominance
over much of Japan. The stone chambered tombs were
protected under huge mounds of earth, the largest
reaching over 800m in length. Low-fired red pottery
figures in the form of people, animals, birds and houses
were placed round the outer slopes as guardians. The
British Museum has one such complete figure.

The contents of the tombs are close to objects from
the contemporary kingdoms of Korea, which clearly
exerted a strong influence on Japanese culture. This
included improved furnace technology, which pro-
duced a hard grey pottery known as Sue, fired at a high
temperature. The collection is rich in Sue ware; a
particularly fine example is a tall jar with moulded 208
animals around the shoulder. Some Sue ware has a
natural ash glaze resulting from the volatilisation of the
kiln wall material, an affect which was contrived in later
centuries as a major style in Japanese ceramic art. The
British Museum owes much of its collection of material
of the period to the activities of a metallurgist, Professor
William Gowland, who lived in Japan during the years
1872–88. An amateur archaeologist, he was able to visit
Kyūshū and, together with his Japanese helpers, to
excavate dolmen graves. The collection includes pot-
tery, bronze mirrors, iron swords, gilt horse-trappings,
and groups of beads and jewellery.

Buddhism was introduced in the mid-sixth century,
in the period (*c.* AD 550–710) sometimes called Asuka
after the central district of administration of the im-
perial family. Asuka was also the site of Japan's earliest
Buddhist temple. It was the Buddhist architecture
transmitted from China through Korea which was to
provide the initial setting for many of the newly im-
ported higher arts of the continent, including lacquer,
wood and metal sculpture, fine bronzes, and hand- 209
scrolls containing the Buddhist scriptures, written in
characters in their Chinese translations. All of these
arts, and many others, were to become the major forms
also used in traditional secular culture, as Buddhism
quickly spread and became in the eighth century the
state religion.

The continuity of Buddhist material culture over the
entire period until its eclipse after 1867 was neverthe-
less marked by changes of emphasis as different sects
were introduced from the continent. The earliest, in-
cluding the 'Six Sects of Nara', were monastic and
contemplative in outlook; they dominated until the end
of the Nara period (AD 710–794). Founders were
especially revered, like the monk Jion Taishi (AD 632–
682), of whom there is a fine fourteenth-century por-
trait on silk; or Prince Shōtoku (AD 574–622), the chief
establisher of Japanese Buddhism. His life was often
compared with that of the historical Buddha, as in a

ing of bronze and iron, techniques of weaving, and the
polishing of stone tools and jewellery. Settled and
stratified society gradually spread east and north. The
origins of the institutionalised Shinto religion also lie in
this period, with its distinctive shrine architecture. The
collection includes two splendid bronzes, cast from
moulds, from the middle Yayoi period, thought to have
been used in agricultural rituals. One, a *dōtaku* (bell-
shaped bronze), is decorated with abstract patterns
related to imported Chinese mirrors of the period; the
other is a halberd. There is also one fine example of a
large, wheel-thrown pottery jar, probably used for the
storage of grain.

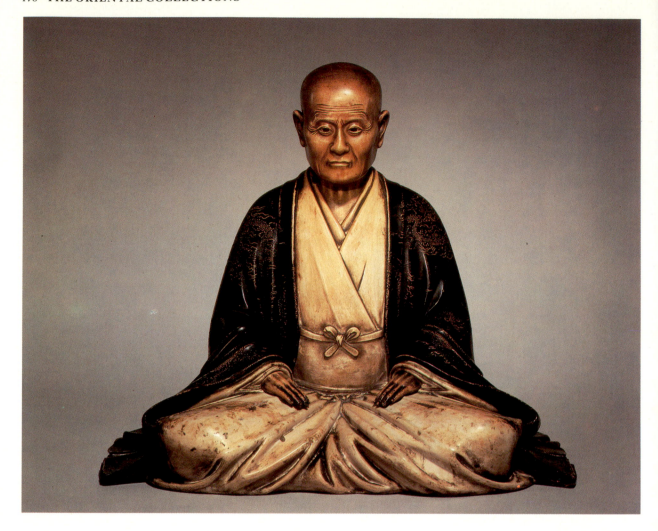

209 *Painted and lacquered wood figure of a mature man, with his head shaven in priest's style. The subject is probably the retired head of a merchant family who has taken Buddhist vows. Seventeenth century* AD. H *40.5cm.*

group of early sixteenth-century painted scenes from his life, the earliest narrative paintings in the collection. The earliest Buddhist objects, however, are eighth-century clay plaques crisply moulded with images very close to those of contemporary China; and a group of the turned-wood reliquaries called the *hyakumantō* (1,000,000 stupas) made in the years 764–770 on the orders of the Empress Kōken to hold printed *mantras*, and then distributed to major temples.

From the rare semi-secular arts of the Nara period comes a carved wooden *Gigaku* mask used in a court ritual dance-drama derived from Korea. Such masks are among the first surviving examples of the Japanese genius for sculpture. *Nō* drama masks, made from the

fifteenth century onwards, are also well represented, the greater number coming from the Edo period (AD 1600–1867).

From the Heian period (AD 794–1185) the by now well-established court aristocracy patronised newly imported forms of Buddhism with a stronger ritual element, especially the Tendai and Shingon sects. The tantric Shingon beliefs recognised virtue in the production of images of the mystical deities, and the copying of formal *mandara* (mandalas). The fourteenth-century image of the Bodhisattva Kokuzō is the earliest of many in the collection. The complex allusiveness and ritual of Heian Buddhism found its counterpart in the subtle complexities of courtly society. The life of the nobility was dominated by etiquette and dress, sexual love and the arts, especially poetry, music and painting. In this period lie the origins of the Yamatoe ('Japanese pictures') style, based on simple colour, clear outline and a high point-of-view, with a very strong preference for human subjects, especially those associated with love,

nostalgia, sadness, and with a constant reference to the passing seasons. This broad style was carried on by many schools, including the Tosa (from the fifteenth century) and the Sumiyoshi (based in Edo from the seventeenth century) and Revival Yamatoe artists of around 1800 onwards. The collection includes many hundreds of paintings of these schools in all the usual formats – hanging scrolls, handscrolls, albums, screens,

210 *Lacquer writing-box, which originally contained writing brushes, a block of ink, an ink-stone and a water dropper. The design of Futamigaura Bay is made with* makie, *lacquer sprinkled with gold dust and carved and polished into shape. Sixteenth century* AD. *24.5 × 22.2 × 5cm.*

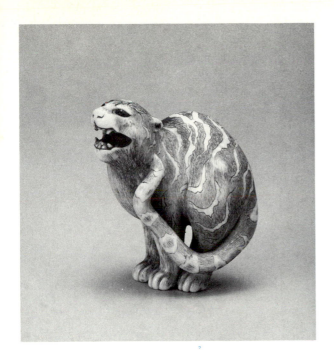

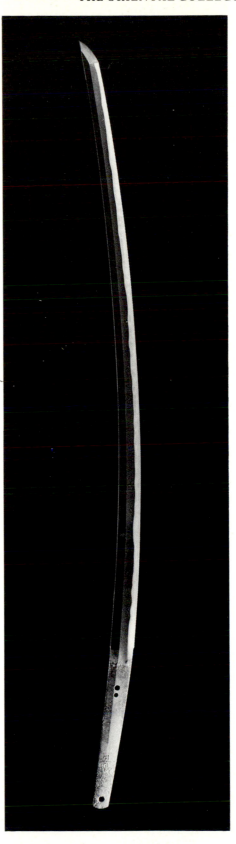

212 ABOVE *Ivory netsuke in the form of a tiger. The netsuke, or ornamental toggle, was used to fix to the sash of the kimono small pouches and containers such as* inrō *(seal or medicine boxes), which were carried suspended by cords. Nineteenth century* AD. H *4.4cm.*

211 LEFT *Portrait of Minamoto Yoritomo (AD 1147–99), who established the Bakufu samurai government at Kamakura. This hanging scroll, in colours on silk, is a late Kamakura period copy (fourteenth century* AD) *of a portrait thought to have been painted in 1173 by Fujiwara Takenobu. 145 × 88.5cm.*

213 RIGHT *Tachi-type steel sword blade, signed Kageyasu. Although the sword has had several centimetres cut from its original length, it retains the characteristic elegant shape of work of the early Kamakura period. From Bizen province, early thirteenth century* AD. L *(blade) 68.5cm.*

fans. The earliest is from the early sixteenth century, and the holdings for the Edo period (1600–1867) are particularly rich.

Another product of early Heian courtly culture was the preference for lacquered pieces for tableware, storage boxes, and personal accoutrements, which soon came generally to be decorated with sprinkled gold and silver dust and gold and silver leaf in the process known as *makie*. Mother-of-pearl was also inlaid into lacquer. The Japanese became known throughout East Asia for the fineness of these wares, which have continued to be made to the present day. The collection includes many hundreds of examples, the earliest a document-box from the thirteenth century, and the finest perhaps the

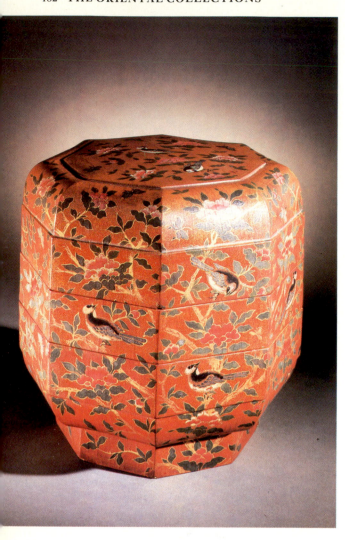

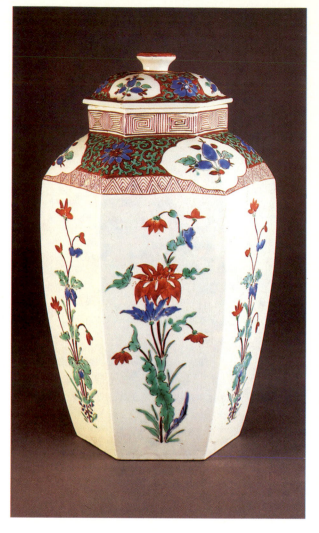

214 *Tiered hexagonal box made of red lacquered wood. Particles of gold foil scattered on the lacquer produce an 'aventurine' effect. The design of birds and camellias is painted with lithage. From Ryūkyū (present-day Okinawa), seventeenth century* AD. H *28cm.*

215 *Hexagonal porcelain lidded jar with enamelled floral decoration. The finest quality coloured enamelling is known by the name of the family of the originator, Kakiemon. This jar was made in Arita (Hizen province) for export to Europe in the second half of the seventeenth century* AD. H *27.1cm.*

sixteenth-century ink-stone box decorated with a view of Futamigaura Bay. From the later sixteenth century some lacquered pieces were made especially for export to Europe. A remarkable example is a large chest in *makie* and mother-of-pearl in export style, dating from the later seventeenth century. The most characteristic lacquer pieces of the seventeenth to nineteenth centuries are the *inrō* (seal cases), usually consisting of a series of interlocking compartments and elaborately decorated. These became items of personal adornment. In more recent times they became collectors' items in the West, and the British Museum's splendid holdings (approximately three hundred items) have been mainly given or bequeathed by major collectors such as Oscar Raphael, Collingwood Ingram and Anne Hull Grundy. Netsuke and sword furniture were acquired in the same way.

The Heian period saw the steady rise of the samurai class of warriors. From the beginning of the Kamakura period (AD 1185–1333) until 1867 the Japanese government was always controlled by the military class, and samurai virtues, skills, tastes and equipment remained major themes in Japanese culture. Of the equipment, the incomparable steel sword-blade was the most prestigious, combining sharpness, durability, elegance of shape and complex patterned surfaces into

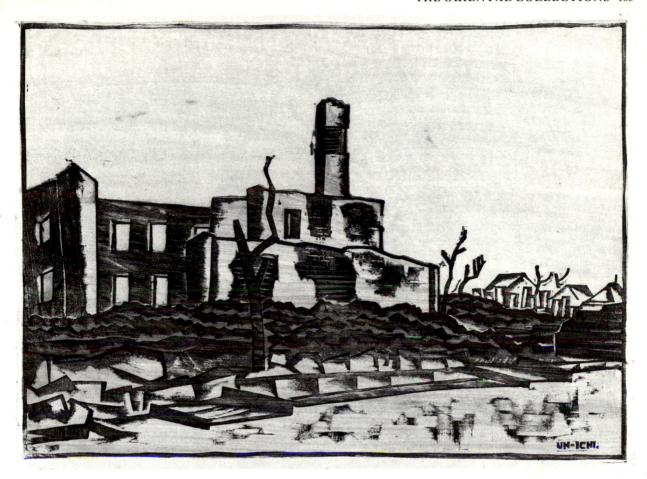

216 Tsukiji, *woodblock print from the series 'Tokyo after the Earthquake Fire', 1923. This poignant series was the earliest masterpiece by Hiratsuka Unichi (b. 1895), one of the founders of the Sōsaku Hanga (Creative Print) movement.*
26.3 × 34.5 cm.

a weapon which was also a work of art and of Shintō veneration. The British Museum's collection of over two hundred blades ranges from the thirteenth to the twentieth centuries. The decorated metal fittings were always kept separately from the blade themselves, and in the Edo period, when actual fighting almost ceased, they became the vehicle for displays of the inlayer's finest skills. The collection of *tsuba* (sword guards) of this period is particularly extensive.

During the Muromachi period (AD 1393–1573) the austerity of samurai taste encouraged the arts associated with meditative (Zen) Buddhism, including the Tea Ceremony. The hanging scroll (*kakemono*) became the prestige format for paintings, and the British Museum is very richly endowed with such paintings in ink or very restrained colour, especially those of the Kano and Nanga schools in the seventeenth, eighteenth

and nineteenth centuries. The Tea Ceremony itself led to the great development of more or less severe pottery styles, used for teabowls, tea-caddies, water jars and incense-containers, and also to hanging or standing vases for the flower arrangements which were another important element. A fine group of many hundreds of these utensils dates mainly from the seventeenth to the nineteenth centuries.

While the samurai in the Kamakura period patronised Zen, the more popular Buddhist sects from China appealed to ordinary farmers and artisans, of which the most important was the Pure Land (Jōdo) doctrine which promised salvation to those who called on the name of the merciful Buddha Amida. Much surviving Buddhist art was produced for the Jōdo sects. It typically included gilded paintings illustrating Amida, and the collection is rich in such works of all periods from the fourteenth to nineteenth centuries. The fourteenth-century wooden figure of Amida is the earliest of a large group of Pure Land sculptures, many of them in more miniature forms for private devotion.

The brilliant Momoyama period (AD 1568–1603) saw the end of a century of intermittent civil war, the growth of a large urban class, and the decline of

institutional Buddhism. Art became secular, gaudier, more middle-class. Style became bolder, notably in textiles, lacquer and the painted screens and sliding doors which had developed to suit the new castle architecture of the warlords. The expansive screen-painting style, often liberally adorned with gold leaf or gold powder, continues into the present century, and is well represented in the British Museum – perhaps the most striking example is a set of four sliding doors of geese, water, flowers and trees done by a pupil of Hasegawa Tōhaku in the early seventeenth century.

Despite Japanese isolation in the Edo period Dutch traders confined to Nagasaki carried to Europe the products of the young Japanese porcelain industry of the Arita district, prized above all for their harmoniously enamelled decoration. The Museum's large collection of seventeenth- eighteenth- and early nineteenth-century wares has been extended by recent purchases to include the fine white, celadon and underglaze painted wares made for export in the later nineteenth century. One of the great glories of the period is the growth of the Ukiyoe school of art, depicting the pleasures and entertainments of the increasingly rich city-dwellers. Beginning in the early seventeenth century with *genre* painting, Ukiyoe soon began to specialise in the subjects of the Kabuki theatre and portraits of the grand courtesans dressed in the latest fashions. From the mid-seventeenth century woodblock-printed illustrated books added to the Ukiyoe repertoire, followed by sheet prints, which by the 1750s were produced in a palette of dazzling colours. The British Museum's Ukiyoe collection is one of the greatest outside Japan, in all of its various forms, and amounts to some eight thousand items. The prints of the 'Golden Age' (*c.* 1780–1800) are of outstanding condition and quality.

The steady rise of aesthetic standards among a broad public in the Edo period resulted in many new schools of painting apart from Ukiyoe itself. The collections are most comprehensively represented in the Maruyama-Shijō school of the late eighteenth to late nineteenth centuries; with its emphasis on free brushwork and its unforced response to the natural world, it appeals strongly to Westerners, and continues to be vigorously collected.

The end of the isolation in the mid-nineteenth century brought Japan into strong contact with the Imperialistic, industrial nations. Japan rapidly modernised and industrialised, and her culture was for a while in danger of becoming swamped in wholesale Westernisation (Meiji period, 1867–1912). After a generation many traditional arts were reasserted, alongside international ones. The collection is naturally rich in the many adaptations of traditional crafts to produce exportable goods. One example was the change made by netsuke-carvers towards larger carv-

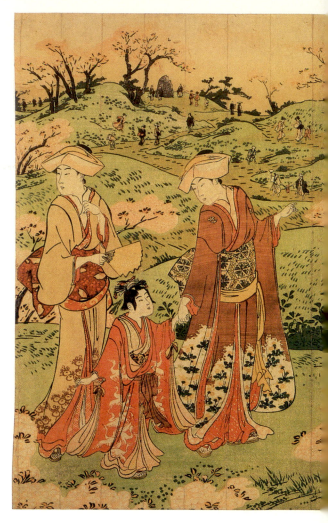

ings, usually of ivory, of 'typical' Japanese subjects for Western side-tables and mantelpieces (mostly in the period 1870–1900).

Japanese art and craft production has tended in the twentieth century to become more and more confined to self-conscious studio practitioners. The British Museum cannot keep up with all areas of activity but has successfully brought its collection of prints up to date. Indeed, its collection of graphic art in all mediums from Meiji until the present day is probably the most comprehensive in the world.

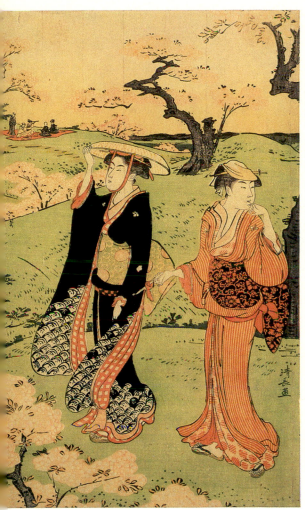
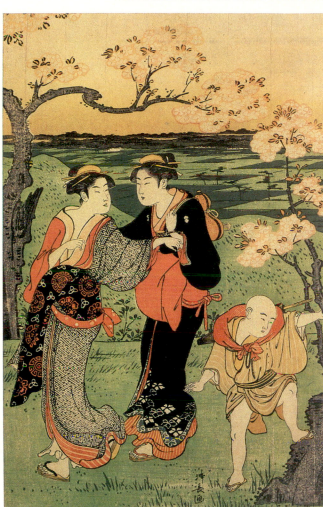

217 Asukayama at Cherry Blossom Time. *Woodblock print, signed Kiyonaga, about 1785. This is typical of the works of Tori Kiyonaga (AD 1752–1815), known for his plein-air compositions containing graceful figures which greatly vitalised Ukiyoe art at the end of the eighteenth century. Each sheet 37 × 25.5 cm.*

PREHISTORY
AND
ROMAN BRITAIN

The collections in the Department of Prehistoric and Romano-British Antiquities represent virtually the whole span of human history from man's earliest appearance more than two million years ago up to the Christian era. Geographically the collections cover the Old World for the earlier periods (Palaeolithic and Mesolithic), Europe in the later prehistoric periods (Neolithic, Bronze and Iron Ages) and Roman Britain. Prehistory is concerned with the preliterate period of man's past, which must be reconstructed by archaeologists without the help of written records. The collections also illustrate the work of the archaeologist, for all the information we have about early man is inferred entirely from material remains, whether casually collected or scientifically excavated.

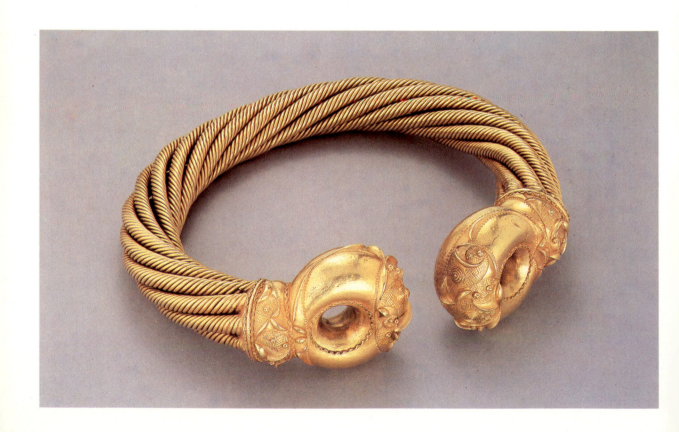

THE PALAEOLITHIC PERIOD

The oldest objects in the British Museum are those in the Quaternary Section of the Department of Prehistoric and Romano-British Antiquities. These collections consist of stone tools, bone and antler artefacts, personal ornaments and miniature art, excavated or collected in Britain, Western Europe, the Middle East, Africa, India, Australia and North America. They date from the time of the appearance of the first known tool-making humans just over two million years ago and end with the transition to agriculture about ten thousand years ago in the Old World, more recently elsewhere.

Amongst the oldest cultural remains in the world are those from the unparalleled sequence of sites excavated by Louis and Mary Leakey in Olduvai Gorge, Tanzania. The British Museum is fortunate in having a small but representative series of artefacts from these sites spanning about 1.5 million years of early human development. The choppers, spheroids and flake tools forming the 'Oldowan' tool-kits reveal that the decision-making ability and manual skills, which have been the key to human success, were already a characteristic of the early human population evolving in Africa some two million years ago. These populations lived by hunting or scavenging meat from the carcasses of animals which had died through natural causes, and by collecting plant foods – a means of subsistence which was to persist throughout the Palaeolithic period.

The collection also contains a selection of Acheulian handaxes, which first appear at Olduvai about 1.4 million years ago. There are also small collections of Oldowan and Acheulian tools from a number of other African sites, including Kalambo Falls in Zambia, Stellenbosch in South Africa and Olorgesailie in Kenya, reflecting the spread of tool-making humans throughout the African continent.

In Africa handaxes seem to have died out around 120,000 years ago as flake production became more controlled and regular. The uniformity achieved can be seen in the typical retouched points and scrapers of the Middle Stone Age from sites like Kalambo Falls in Zambia, Elmenteita in Kenya and Cape Flats in South Africa. These flake tools may have been fixed into hafts made of wood, bone or antler to form a variety of tools and weapons, such as knives or spears, but there is no evidence to prove that this technology existed south of the Sahara.

Outside Africa no artefacts can undoubtedly be dated before one million years ago. Europe is not

219 *Handaxe of flint discovered in 1690 in Gray's Inn Lane, London.* L *16.5cm.*

known to have been occupied before 700,000 years ago, and the largest part of the Quaternary Section's holdings comprise stone artefacts from Western Europe, principally Britain and France, dating from between 500,000 and 10,000 years ago. Among the older or 'Lower' Palaeolithic objects are handaxes from St Acheul and Abbeville in France. These specimens, found in ancient channels of the River Somme, are of historic interest as they formed part of the evidence which convinced late nineteenth-century scientists that human activity in Europe began far beyond 4004 BC, the estimated date of the Biblical Creation. Another early find came from Hoxne (Suffolk), and the Museum has recently acquired handaxes and flake tools excavated from the same site in the 1970s. These excavations showed that the tool-makers had established a camp in a woodland clearing by the side of a lake which had once existed there about 350,000 years ago.

The technological tradition displayed in the tool-kit from Hoxne is quite different from that derived from Clacton-on-Sea (Essex), and from the Museum's own excavations at High Lodge (Suffolk). At both of these sites the tool-makers used flint, not to make handaxes but to produce thick flakes which could then be modified to form a variety of tools. At High Lodge many flakes were found lying in clusters or 'scatters' and these have remained undisturbed since the time they were formed. By fitting the flakes back together well over 100,000 years later it is possible to see every step in the flake production.

Handaxes and flake tools from sites such as Oldbury (Kent), La Cotte de St Brelade on Jersey, and La Ferrassie, La Quina and Le Moustier in France show that very few changes occurred in tools or tool-making techniques during the Middle Palaeolithic.

Implements of the European Upper Palaeolithic dating from 35,000 to 10,000 years ago are more varied

220

218 *The Snettisham Torc. The finest surviving Celtic torc, made of eight strands of gold twisted together, each of which is in turn made of eight wires. From Snettisham, Norfolk, first century* BC. D *19.9cm.*

220 *Scrapers made on flint flakes from High Lodge, Suffolk,*
about 450,000 years ago. These tools form part of a tool-kit
used by the earliest inhabitants yet known in Britain.
H *(largest)* 11cm.

than those from the earlier periods. There is a wider range of stone tools, many of which are made on long, narrow 'blades' rather than flakes, along with a great deal of bone and antler equipment, personal ornaments such as beads and pendants, and art objects. The technological innovations and variations in tool-kit composition suggest that successive, far-reaching cultural changes were taking place within relatively short periods of just a few thousand years.

The basic sequence of these changes was established in the late nineteenth century by pioneering archaeologists such as Edouard Lartet and Henry Christy, who sought cultural evidence of progress and development to substantiate the new theories of human evolution by excavating in the caves and rock-shelters of south-west France. From these sites came a fascinating series of artefacts and works of art which were donated to the British Museum. Additional important material from other parts of western Europe came by way of the Sturge Bequest, so that the Museum now holds Upper Palaeolithic collections without rival outside France.

The earlier Perigordian, Aurignacian and Gravettian phases of the Upper Palaeolithic are represented in collections from the type-sites of Perigord, Aurignac and La Gravette (France). These include examples of the blunted or 'backed' blades, particular types of scrapers and engraving tools known as burins which typify these periods. Amongst the Aurignacian material are also examples of bone points used as spear or lance tips. The collections of Solutrean material from Solutré and Laugerie Haute show that bone- and antler-working and blade production were less significant during the period following the Aurignacian from 20,000 to 16,000 years ago. They were replaced by finely worked points shaped like laurel and willow leaves, of which the specimen from Volgu is the supreme example. Indeed, this piece is so skilfully made that it can be regarded more as a brilliant expression of craftsmanship than as a purely functional item.

A variety of bone and antler objects reappears in the final Magdalenian phase of the Upper Palaeolithic from sites such as La Madeleine, Les Eyzies, Montastruc and Corbet (France). These include barbed points made as spear or harpoon tips, spear-throwers, perforated batons of unknown function and smaller items such as needles. Many of these are decorated with abstract or geometric designs, but art was not restricted to functional items. Thin discs of bone, pieces of ivory, antler rods and plaques of stone were engraved and

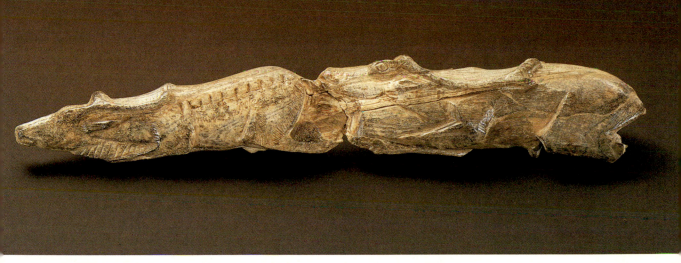

221 *Tip of a mammoth tusk carved into the shape of two reindeer swimming one behind another. From Montastruc, France, about 14,000 years old. L 20.7cm.*

sculpted, often with complex and possibly symbolic designs. The stone plaques from Montastruc, for example, are decorated with recognisable but rather stylised animals shown in twisted profile, some superimposed on others, displaying in miniature some of the features characteristic of the paintings and engravings found on cave walls. Among the decorated specimens from La Madeleine are antler batons engraved with beautifully drawn outlines of reindeer and horses which march nose to tail along the shafts, whilst the art objects from Courbet include carved heads of horses and musk ox, which originally formed parts of spear-throwers. The numerous pieces of miniature art from Montastruc include a second spear-thrower ingeniously carved as a mammoth, as well as one of the great masterpieces of the period, an ivory rod carved to the shape of two reindeer, a male following a female. The carving is detailed and naturalistic, showing the animals with their chins up and their antlers back, as if swimming. It is a work of genius in both its conception and technique, and its quality and beauty transcend the 14,000 years that have elapsed since its creation.

222 *Carving from reindeer antler of a mammoth, originally part of a spear-thrower with a wooden handle. The animal's tail provided the hook, which held the base of the spear. From Montastruc, France, about 14,000 years old. W 12.4cm.*

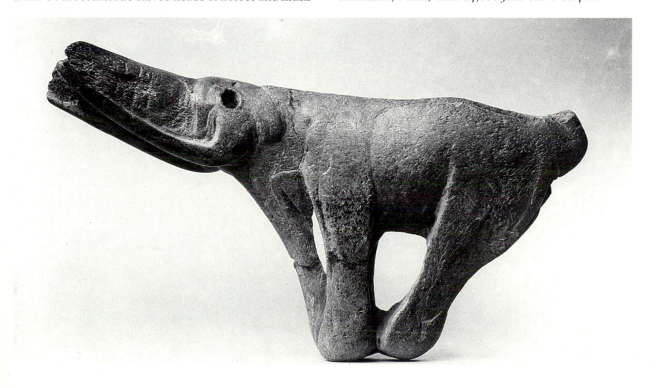

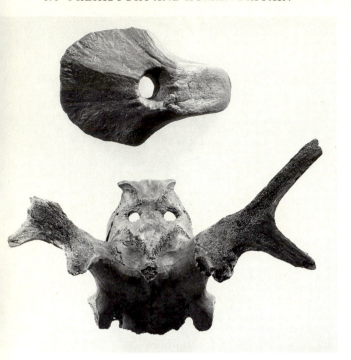

223 *Antler frontlet and mattock head from the 10,000-year-old site of Star Carr, Yorkshire. The mattock head is made of elk antler. The frontlet is part of a red deer skull with antlers and the holes drilled through it suggest that it might have been worn as a head-dress or hung as a trophy.* L (*mattock*) 20cm.

THE MESOLITHIC PERIOD

Implements dating from about 10,000 years ago exhibit considerable changes from those of the preceding Upper Palaeolithic. Some of these changes are to be seen in material from Wawcott (Berkshire) and Oakhanger (Hampshire). The tool-kits from these sites contain new, standardised tool forms made from small blades or bladelets. The most distinctive artefacts are the small neatly shaped bladelet segments known as *microliths*. These were fixed into wooden hafts to form tools and weapons, such as arrowheads and knives. Parallel-sided axes sharpened at one end by the removal of a single flake are also common and were presumably used for felling trees or wood-working. The collection from Star Carr (Yorkshire) reveals that a wide range of artefacts were also made of organic material. These include long, thin antler points with barbs along one side and perforated mattocks made from elk and red deer antlers. Most curious is part of a red deer skull which has two holes drilled through it. This skull might have been worn as a head-dress during ceremonies or as a disguise to enable hunters to get close to their prey.

223

THE NEOLITHIC PERIOD

The first domestic animals and cultivated crops appeared in the Near East some 10,000 years ago. By 5000 BC sizeable farming populations had occupied parts of Central and Western Europe and the Mediterranean area. Within the next two thousand years the knowledge of farming spread throughout Europe, save where the northern climate prevented crop growth. The production of food was to transform society: permanent settlements were established, and more stratified societies developed.

The artefacts of food production were limited but functional, and they are well represented in the collections. Axes with polished flint or stone blades were used to clear forests and were employed in increasingly sophisticated carpentry to construct timber houses. Flint-edged sickles were used for harvesting, and querns and rubbers reduced grain to flour. A range of flint tools helped to turn plants and animals into food, and their by-products into clothing, containers and bindings to satisfy the needs of everyday existence. A revolutionary new skill was the making of pottery, chiefly used for storing food, for cooking and tableware. The earliest wares were plain, but experimentation led to more complex shapes and decoration by painting and impression. The typical impressed and incised geometric decoration of, for example, Peterborough and Grooved ware in Britain during the third millennium BC strike a contrast with the simpler wares of the earlier period. In eastern Europe more ornate and varied painted styles occurred, as shown by trichrome painted pottery from the Ukraine.

Increasing economic surplus and social complexity were the impetus for developments beyond the strictly functional. The polishing of axeheads for a more efficient and durable cutting edge was widely practised, but this labour-intensive task was frequently extended to the whole surface, an action that could have no other purpose than for display. An axe of polished jadeite found near Canterbury in Kent is in pristine state and was clearly not intended for normal use. The stone from which it was made probably came from the Alpine region, and indeed jadeite deposits in northern Italy were quarried from an early date and large mirror-polished axes of this semi-precious stone were traded and exchanged far afield. A growing selectivity in raw materials becomes evident, and much effort went into quarrying and deep-mining for better-quality stone and flint, as at the Neolithic flint-mining complex at Grime's Graves (Norfolk), explored by the British Museum between 1972 and 1976.

Wood-working also became increasingly important. Little organic material has survived from this early date, although some examples have been preserved from waterlogged sites, such as the Alpine lakeside settle-

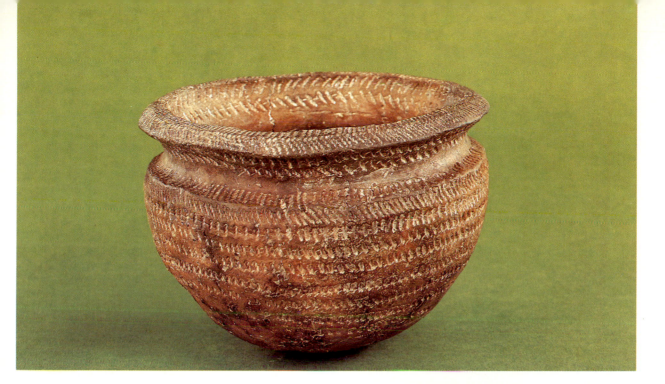

224 ABOVE *Peterborough ware bowl from Hedsor, Buckinghamshire, decorated with twisted cord impressions. Pottery decorated in this style was widely used in England and Wales in the second half of the third millennium* BC. D *17.5cm.*

ments; here the total range of domestic objects in use in the Neolithic was revealed in a remarkable series of excavations in the nineteenth century. In England the wetlands of the Somerset Levels and the East Anglian Fens have yielded up wooden implements, such as an axe-haft of ash from Etton (Cambridgeshire). A section of the Sweet Track, now in the British Museum, is a fine example of Neolithic carpentry, dating to the early fourth millennium BC; the two-kilometre track provided a dry path across the marshy Somerset Levels. Such finds offer a new perspective to a material culture otherwise known only from its less perishable components.

With these have also come objects which cast light on areas of belief otherwise unsuspected, like the remarkable god-dolly, a small wooden figure recovered from the Bell Track (Somerset). Very little naturalistic art survives from prehistoric Britain; the god-dolly, and a crude figure in chalk – the 'goddess' – from the Grime's Grave flint mines, are among the few examples. In contrast is a red-fired pottery figure from Vinča (Yugoslavia); this seated figure, with its hands on its

225 *Ground and highly polished ceremonial axehead made from jadeite from northern Italy, one of the earliest imports into Britain. From Canterbury, Kent, about 4000* BC. L *21.9cm.*

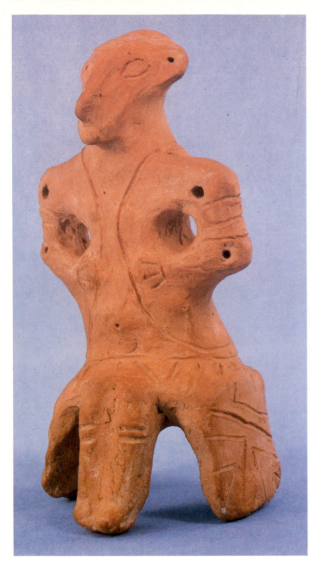

226 *Decorated fired clay cult figurine, seated on a tripod stool, from Vinča, Yugoslavia. About 4500 BC. H 17cm.*

hips, has pierced shoulders, elbows and ears and a stylised head. The aesthetic and perhaps spiritual aspirations of Neolithic society are reflected in such figurines.

THE BRONZE AGE

By the end of the third millennium BC a pattern had been established of prosperous well-adapted agricultural communities with increasing technological sophistication. Meanwhile in eastern Europe a new era had already dawned with the discovery of metallurgy. The earliest metal tools were of unalloyed copper and, although it produced a less effective cutting edge than

stone or flint, the new material held certain advantages. A damaged or broken tool could simply be melted down and recast, while the relative scarcity of copper and the mysteries of its production could confer prestige upon its owner. As copper – and tin, the other chief component of bronze – are found only in certain parts of Europe trade became a marked feature of the Bronze Age, bringing prosperity to those who controlled the sources and the routes by which the materials were dispersed. With trade came the exchange of other materials, in particular exotica such as gold and amber used for personal adornment.

The British Museum's collection traces the development of metalworking technology during the Bronze Age. Experimentation brought improvements in the quality of the metal itself and in casting techniques. The use of alloys improved the hardness and durability of the implement. Arsenical copper had such properties and its use became widespread. Around 3000 BC came the realisation that bronze – a copper-tin alloy – was superior in all respects, and this new, more durable alloy gradually replaced copper.

The development of casting technology is shown by the increasing sophistication of moulds. The early moulds are simple: shallow matrices cut into the surface of a suitable stone. A considerable improvement is represented by two-piece moulds, the separate halves being bound together and filled from one end. This form allowed the production of more complex shapes, and innovations such as sockets for hafting. In time moulds of clay and metal were added to the repertoire, providing even greater diversity in casting and an economy of labour in the production of formers. A founder's hoard from Brough-on-Humber included a two-part bronze mould complete with a socketed axe casting. The development of axe forms over this period reflects this technological improvement, from the flat axes of the Copper Age to the sophisticated socketed axes of the Late Bronze Age. Finds from Central Europe, eastern France and northern Italy particularly show technical artistry in the casting of daggers with well-crafted hilts and decorated blades.

In Western Europe the introduction of metallurgy can be linked to groups using a distinctive form of pottery, most familiar as a fine decorated drinking cup, or Beaker. The style is known from Spain to Denmark, and from Hungary to Ireland. The new Beaker pottery is very different from what went before. It is well made, thin walled and fired under controlled conditions often to give a handsome rich reddish-brown surface. The earliest carry the imprint of a fine twisted cord wound round the vessel from top to bottom or narrow horizontal zones of impressed lines made with a rectangular toothed comb stamp. On the finest vessels geometric patterns are set with great precision in evenly spaced bands around the pot.

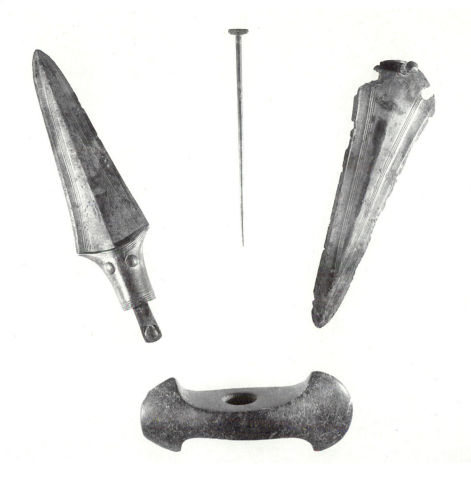

227 ABOVE *Bronze spearhead, pin and dagger, and stone battleaxe from an Early Bronze Age burial at Snowshill, Gloucestershire. The spearhead, with tang and cast socket for attachment, illustrates the improvement in casting technology during this period. About 1500 BC. L (dagger) 22.1cm.*

228 BELOW *A range of Beaker pottery (from the left) from Hemp Knoll (Wiltshire), Rudston (Humberside), Goodmanham (Humberside), Lambourn (Berkshire) and Hitchin (Hertfordshire). H (tallest) 26.7cm.*

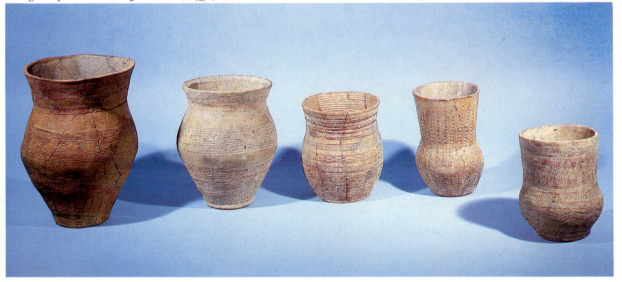

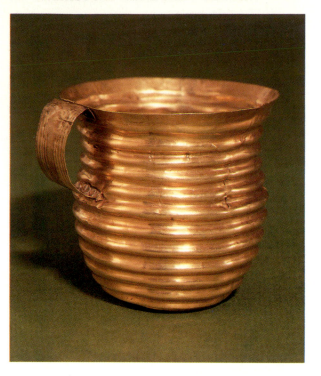

The Beaker groups were also responsible for another innovation: for the first time personal goods accompanied the deceased in the grave. In most graves the body was accompanied only by a Beaker, although some were equipped with additional objects: weaponry (a dagger, stone battle-axe, archer's equipment) and ornaments of bronze, gold, jet and amber. The Beaker itself may have contained nourishment for the deceased: analysis of the residues in a beaker from Scotland indicated a honey-sweetened drink or mead. In some areas exceptionally rich and exotic materials occasionally accompanied the dead. Among the most notable are grave finds in Wessex, southern England. Dating from the later part of the Beaker period, these graves featured prestige items such as weapons, a range of spectacular personal ornaments and beaker-shaped cups made from a variety of exotic materials, such as gold, shale and amber. Such an item is the gold cup from the Rillaton Barrow in Cornwall. This splendid piece is one of only three such found in temperate Europe, and is made of sheet gold, ribbed for reinforcement and decoration, with a remarkable ribbon-like handle.

229 ABOVE *Gold cup found in an Early Bronze Age burial at Rillaton, Cornwall. The body of the cup was beaten out from a single piece of gold; the handle, made separately, is attached by rivets. About 1700–1400 BC. H 8.3cm.*

230 BELOW *Solid chalk cylinders, ornately carved in a woodworking style, found with the skeleton of a child in a grave beneath a round barrow at Folkton, North Yorkshire. Early Bronze Age, about 2200–2000 BC. D (largest) 14.2cm.*

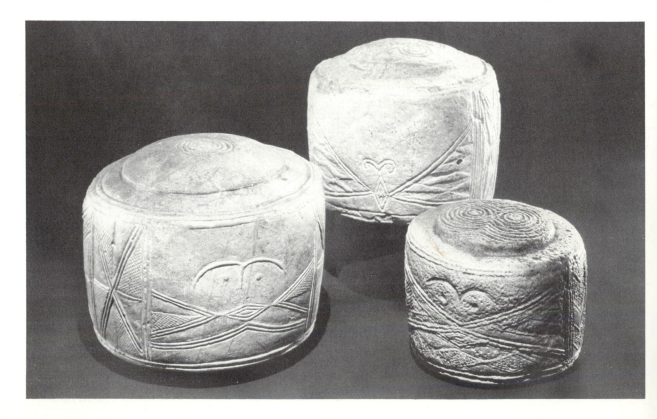

Also from the Beaker period are three of the most extraordinary objects to have survived from prehistoric Britain: the Folkton Drums. These chalk cylinders vary in diameter from 10.4 to 14.6 cm, and are carefully carved around the tops and sides. Some of the carving is reminiscent of earlier decoration on pottery, but two cylinders are carved with eyebrow and eye motifs. Although these items are unique, and their purpose is entirely unknown, they must have been highly valued, yet they were placed with the body of a child in one of a number of simple graves beneath an unremarkable mound.

One of the richest and most important discoveries from Bronze Age Britain was the group of burials in a barrow at Barnack in Cambridgeshire, excavated between 1974 and 1976. The barrow had been used for a number of burials over several centuries. The initial burial at the base of the great central grave is now reconstructed in the British Museum. At the foot of the body of an adult male stood an exceptionally large

and fine Beaker, a copper or bronze dagger, an ivory pendant and a polished greenstone wristguard.

Evidence for ritual is sparce. Votive deposits, often consigned to river or bog, became increasingly common. Hoards of metalwork were frequently buried during the Bronze Age and many of these seem to have been for ritual or ceremonial purposes. In Britain, for example, a group of four bronze axes were buried at Willerby Wold (North Yorkshire), in association with a contemporary burial mound – clearly a sacred site. These axes are in pristine condition, three of them with punched ornament. Although sites such as the monumental stone circles and henges yield little in the way of precise information about the nature of the

231 *Bronze shield found in a bog at Moel Siabod, near Capel Curig, Wales. The raised decoration was beaten out from the back. The type is British, differing considerably from Continental forms. Late Bronze Age, about 800 BC. D 64.4cm.*

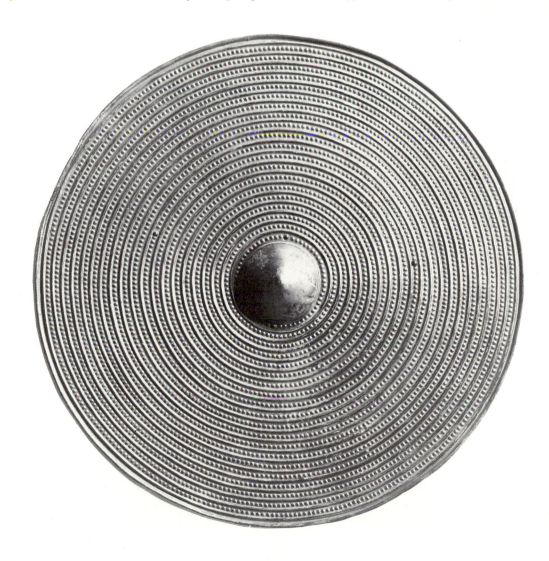

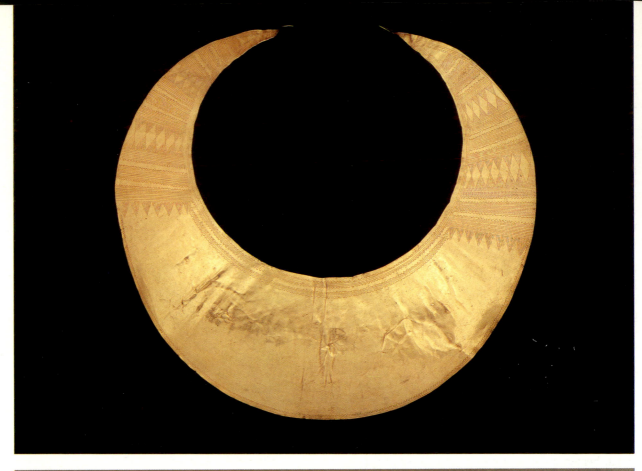

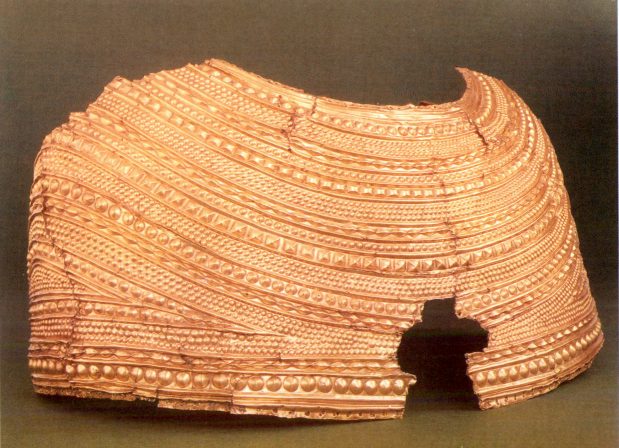

232 LEFT *Gold lunula from Ireland of 'classical' type, one of a group distinguished by their thinness, by their width and by the precision of their ornamentation. Early Bronze Age, about 2000–1500 BC. W 23.7cm.*

rituals enacted, they emphasise the preoccupation with power and prestige constantly in evidence. Hoards of the later Bronze Age make the same point: they reveal a considerable expenditure of effort on the elaboration of weaponry, especially swords and spears, together with the appearance of spectacular shields and bronze body-armour.

Western European craftsmen showed an early interest in the decorative possibilities of sheet gold. In Ireland Beaker ceramic motifs were transferred to crescent-shaped neck ornaments or *lunulae*. The zoned geometric designs often achieved a fine degree of intricate detail. Elsewhere this crescent form was re-produced in bead necklaces, the desired shape being maintained by complex bored spacer plates in amber and jet. The jet necklace from Melfort (Strathclyde), is a typical example and a characteristic find from Scotland at this period. The acme of sheet goldwork in the West European Bronze Age tradition, dating to about 1200 BC, is the great gold cape found in a grave at Mold (Clwyd, Wales). Made from a continuous piece of metal, beaten out over a rock to obtain the shape, its surface is decorated with bosses and ribs in a pattern that may imitate the folds of cloth. The cape was presumably for ceremonial use, since the wearer could not have moved his arms once the cape was in place.

If the techniques of sheet-gold working reached their peak with the Mold gold cape, casting and the manipulation of wire offered new possibilities. The improvement in casting technology, involving the use of increasingly complex moulds, encouraged the elabora-tion of shape. Wire became prominent in such items as the fibula, or safety-pin brooch, a long-lived form invented at this period. Irish goldsmiths in particular produced fine goldwork, culminating in the develop-ment of the twisted bar torc: torcs continued to be manufactured for at least a millennium.

Most of the surviving evidence for the Bronze Age comes from either graves or hoards of metalwork. These enable us to study the widening range of tools and weapons in use and to gain some insight into the technological achievements of the age. A founder's hoard from Minster in Kent, for example, contained a quantity of raw metal and casting waste and bronze

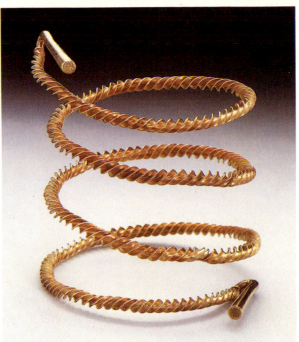

234 *A gold torc from Wales made from a twisted bar and wound into 3½ coils. It is an example of a type found in Britain, Ireland and northern France. Middle Bronze Age, about 1200–900 BC. L 11.6cm.*

implements, some of which were scrap, ready for re-casting. Hoards from southern Britain also reveal par-ticular local fashions; a hoard of bronzes from Brighton contained three coiled finger-rings, a torc and a pal-stave, as well as four 'Sussex loops', a type of coiled arm-ring known only from hoards in Sussex.

Recent archaeological work has concentrated on ex-cavating settlement sites. The rich yield of informa-tion from well-preserved sites such as Runnymede Bridge (Berkshire), now being explored by a team from the British Museum, is set to transform our under-standing of prehistoric Britain and so allow us to place the hoards and graves within the social systems which once existed. Here enormous quantities of finds as varied as pottery, metalwork, bone objects and flints have been recovered. Such sites can also yield valuable information on the trading patterns which provided the real motive-force of Bronze Age society and economy. Whereas hoards and grave groups are by definition selective, the loss or discarding of material which char-acterises all settlement sites provides a more accurate reflection of what was available and in current use. Trade was clearly highly organised, as shown by the retrieval of lost cargoes of bronzes from the estuary of the Huelva and off the modern port of Dover, the latter preserved in the British Museum.

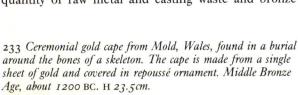

233 *Ceremonial gold cape from Mold, Wales, found in a burial around the bones of a skeleton. The cape is made from a single sheet of gold and covered in repoussé ornament. Middle Bronze Age, about 1200 BC. H 23.5cm.*

Developments towards the end of the Bronze Age prefigured those of the succeeding Iron Age, when new technologies began to alter the long-standing social systems. The central position held by metal resources and their control is emphasised by a determination to maintain the pre-eminence of bronze. Iron implements have been found in later Bronze Age contexts, sufficient to show that the technology was available and understood, but the introduction of ironworking beyond south-east Europe was long delayed and, it must be assumed, long resisted.

THE IRON AGE

The European Iron Age is divided into two phases, Hallstatt (*c.* 700–450 BC) and La Tène (*c.* 450 BC to the Roman Conquest), named after type-sites where large collections of artefacts were excavated in the nineteenth century. At Hallstatt, in Upper Austria, almost 1,000 burials were excavated by J. G. Ramsauer between 1845 and 1863, and later in the 1860s more were unearthed by two British archaeologists, Sir John Evans and Sir John Lubbock. La Tène, on the edge of Lake Neuchâtel in Switzerland, seems to have been the site of a water-cult, where artefacts were deposited as votive offerings. Engineering works and subsequent archaeological excavations during 1880–85 and 1907–17 produced more than three thousand swords and scabbards, spearheads, brooches, tools, coins and wooden objects. Hallstatt and La Tène are representative of the kinds of site from which the British Museum collections draw their strength. There is a little from La Tène itself, rather more from Hallstatt (including most of the finds from the Evans/Lubbock excavations), but from other burial sites and votive deposits come many of the finest objects known from the period.

Many of the Iron Age peoples of Europe (mainly Celts) buried their dead with great ceremony, accompanied by objects worn or used during life. Nowhere provides a better example of these rituals than Champagne, where the most spectacular finds are from a series of chariot-burials. The corpse was buried with a complete chariot surrounded by harness and other grave-goods. The majority of graves are less elaborate, but it was customary to bury women with their jewellery – a torc round the neck and often a couple of bracelets and one or two brooches – whilst warriors had an array of weapons. Both men and women were accompanied by pottery, and animal bones suggest that food was included to sustain the dead. In the second half of the nineteenth century many thousands of La Tène graves were excavated in Champagne, and one of the largest collections amassed by Léon Morel, of Rheims, was acquired by the British Museum in 1901. It includes one of the most spectacular chariot-burials, from Somme-Bionne (Marne), whose grave-goods included

235 *One of a pair of bronze flagons, decorated with inlays of coral and red enamel. This is one of the outstanding examples of early Celtic art of the La Tène period. From Basse-Yutz, France, about 400 BC. H 39.6cm.*

a Greek pottery cup and an Etruscan bronze flagon.

In Britain Iron Age burials are well represented in only two areas; eastern Yorkshire, where inhumation was practised from the fourth century BC; and south-eastern England, where cremation was the rule, but only in the century immediately before the Roman Conquest. The Yorkshire burials are less impressive than their Continental counterparts; most skeletons are without grave-goods, but some have the occasional brooch, bracelet, pot or sword. Finds from excavations by nineteenth-century antiquaries have now been supplemented by material from a modern excavation at Burton Fleming. Two chariot-burials have recently

235

been excavated by the British Museum at Garton-on-the-Wolds and Kirkburn. In both the vehicle had been dismantled, the T-shaped chariot frame, a crouched skeleton and pieces of harness being distributed on the floor. Chain-mail had been placed over one of the bodies, the earliest occurrence so far found in Britain.

The cremation burials of south-eastern England belong to the 'Aylesford Culture', which takes its name from a cemetery in Kent excavated at the end of the last century. Again, the Department's old acquisitions (including material from Aylesford itself) have been supplemented by recent finds, noticeably from a huge cemetery of 471 burials found just outside the walls of Verulamium in 1966. Many of those burials comprised only a collection of cremated bone in an urn, but others were more elaborate, with up to ten pots in a grave and several were accompanied by brooches. None of the Verulamium burials was as rich as that found at Welwyn Garden City in 1965. Here the cremated bones were in a heap on the floor of the grave and included bear-claws from the fur-wrapping round the corpse. No fewer than thirty pots were ranged on the floor of the grave, and the five Roman amphorae leaning against the wall would have held about 100 litres of imported wine.

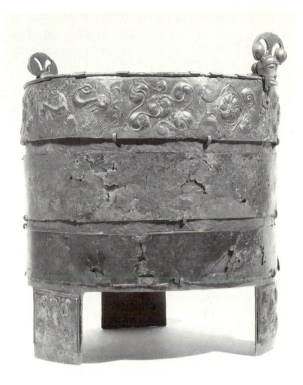

236 BELOW *A complete set of twenty-four glass game-pieces from a burial at Welwyn Garden City, Hertfordshire. First century* BC. H *2–2.2cm.*

237 ABOVE *Reconstruction of a bucket with bronze fittings found in a burial at Aylesford, Kent. The repoussé decoration on the upper band includes pairs of stylised horses. First century* BC. H *(excluding handle mounts) 30cm.*

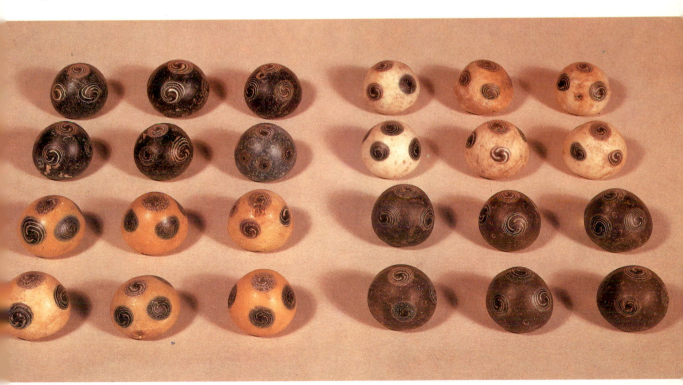

236 The most spectacular item in the Welwyn Garden City grave, however, was a unique set of glass game-pieces; divided by colour into four sets of six pieces, which seem to have been used for a race-game perhaps like ludo. Discoveries such as Welwyn Garden City show how Britons living in south-east England were 238 open to influences from Roman Gaul. They appear to have relished Italian wine, and imported the tableware to go with it, including silver cups. In return, according to Strabo, the Britons exported corn, cattle, gold, silver, hides, slaves and hunting dogs. Such trade gradually paved the way for the Roman Conquest.

Food and drink for the dead, and vehicles for transport to another world, suggest that the Celts anticipated an afterlife, but beyond such vague generalisations little can be said of the beliefs of people who left no written documents. The importance of some kind of water-cult is obvious, for some of the finest surviving artefacts come from lakes, rivers and bogs. In England the River Thames has pride of place, for this has produced some of the very finest decorated metalwork. The great shield 239 from Battersea, two shield-bosses from Wandsworth, and a magnificent horned helmet from near Waterloo Bridge are only the most outstanding of the finds

recovered from dredging in the nineteenth century, while even today the supply of treasures continues. In 1985 a unique bronze shield was discovered in a former water-course at Chertsey (Surrey). Smaller collections have come from the River Witham, near Lincoln (including the magnificent Witham Shield), the River Nene (swords and scabbards found between 1980 and 1984) and the River Bann, in Northern Ireland (a superb decorated scabbard-plate).

A further example of this water-ritual is the now-famous Lindow Man – the upper half of a human body whose skin has been perfectly preserved by the acids of the peat-bog. Found in 1984 by a peat-cutting machine (which destroyed his lower half) at Lindow Moss (Cheshire), Lindow Man had met his death perhaps two thousand years ago. First stunned by a couple of blows on the top of the head, he was then garrotted with a fine length of animal sinew, which strangled him and broke his neck. The killers then cut his throat before dropping their victim face-down in the bog. A ritual killing is suggested by this elaborate sequence of death, concluding with the flowing of blood and deposition in water, and it is known from classical sources that the Celts did not shrink from human sacrifice.

Impressive collections of metalwork, especially harness and vehicle fittings, were deposited at Stanwick (North Yorkshire), Polden Hills (Somerset) and Westhall (Suffolk) in the years shortly before and after the Roman Conquest. They convey a good idea of the range and decoration of such equipment, but leave no

238 Group of fine pottery of the early first century AD imported into southern England from north-eastern Gaul before the Roman invasion of AD 43. Found at St Albans, Hertfordshire, and Colchester, Essex. H (tallest) 19cm.

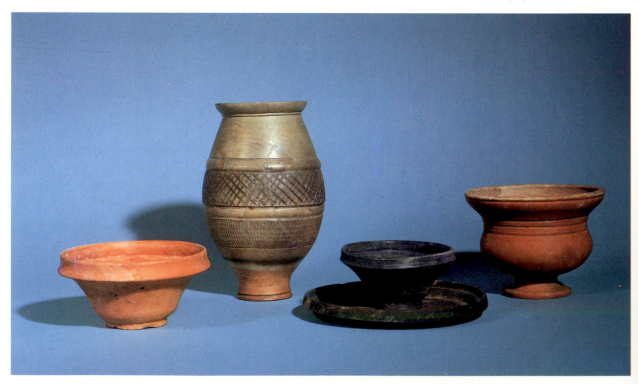

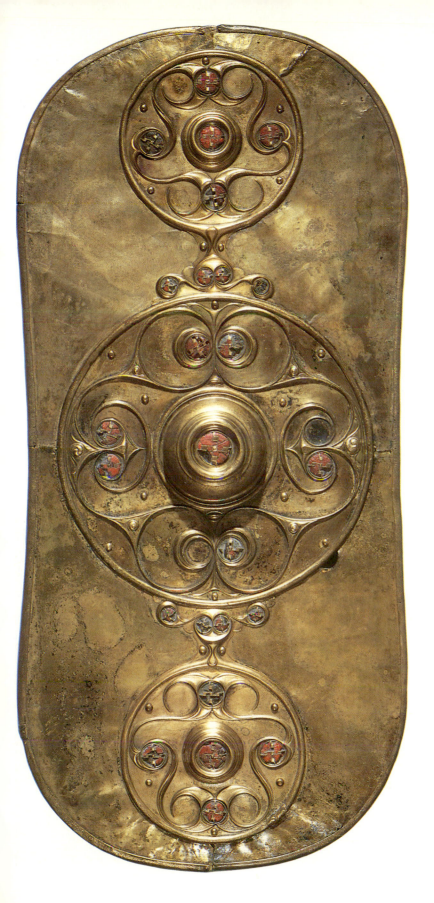

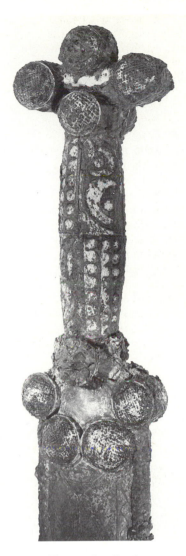

240 ABOVE *The iron handle of a sword, decorated with red enamel. From Kirkburn, North Humberside, second century* BC. L *(handle) 13.7cm.*

239 *The Battersea Shield: the bronze facing from a wooden shield, the flowing palmette and scroll ornament enhanced with red enamel. Found in the River Thames at Battersea, London, first century* BC. H *77cm.*

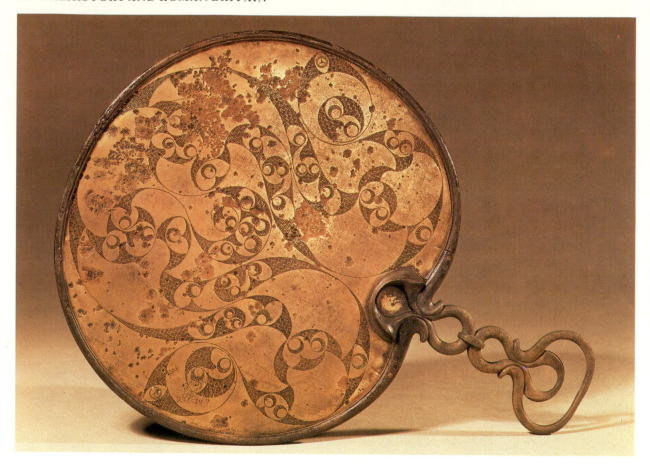

241 *Bronze mirror from Desborough, Northamptonshire. One of the finest surviving Celtic mirrors, it is decorated on the back with an elaborate symmetrical design. First century* BC. L *35cm.*

clue as to why these deposits were buried. Again, there seems every likelihood that they served some ritual purpose, but there is no way in which the ceremonies and beliefs associated with their deposition can be reconstructed. With another type of hoard, the gold torcs found especially in East Anglia, it seems reasonable to suppose that wealth was being buried for safe keeping in time of danger. At Snettisham, Norfolk, five separate hoards were uncovered in one field in 1948 and 1950. One included the magnificent Snettisham Torc, but in all fragments of at least 61 torcs were found in the hoards, together with 158 coins. It may well be that the entire collection was deposited on one occasion some time during the second half of the first century BC, buried in separate locations for greater security. In 1968 five complete gold torcs were found on a building site at Ipswich; another was later discovered nearby.

The bulk of the artefacts mentioned convey something of death and ritual in the Iron Age and throw light on such matters as fashion in jewellery and aspects of

218

warfare. Much, too, can be learnt about the technology needed to manufacture these objects, but what of life itself in the Iron Age? The most impressive settlements are the hillforts, whose often massive earthwork defences remain spectacular even today. Some were in permanent occupation, whilst others seem to have served as refuges. Far more common than hillforts would have been the lowland settlements, especially farmsteads, many hundreds of which are now known from air photography. Most of the population would have lived in these, occupying circular wooden huts with thatched roofs, and earning their living on the land, growing grain to be stored in pits or in the wooden

242 TOP RIGHT *Roman weapons of the first century* AD. *The javelin-heads and the dagger and sheath are from Hod Hill, Dorset, while the sword and its highly decorated scabbard were found in the Thames at Fulham, London.* L *(sword blade) 57cm.*

243 BOTTOM RIGHT *The body of a man preserved in a peat-bog at Lindow Moss, Cheshire. First century* AD.

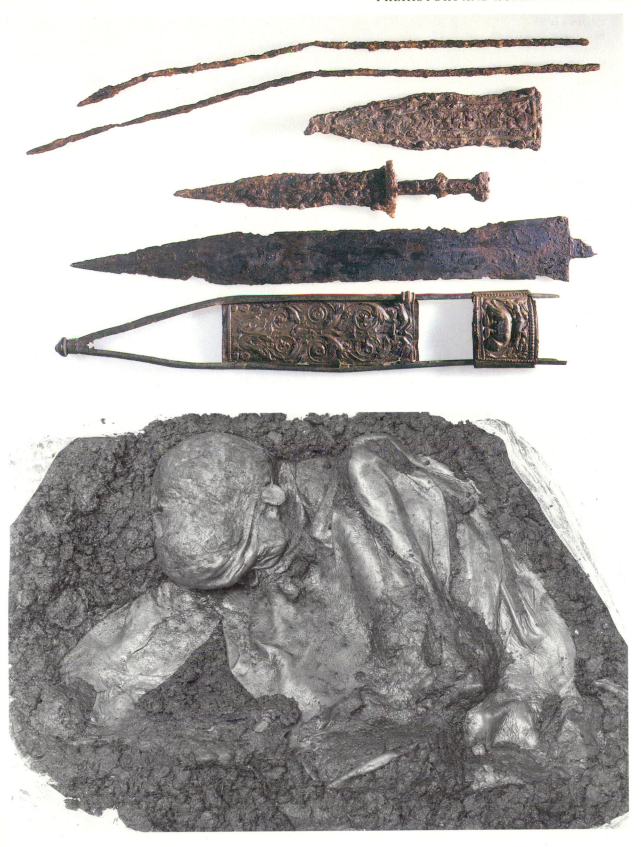

granaries whose ground-plan of four post-holes is such a distinctive feature of Iron Age settlements. Such communities were largely self-sufficient, rearing also cattle, sheep and pigs. The most common finds to come from these settlements, apart from animal bones, are sherds of pottery, whilst metal and bone artefacts are relatively rare. Occasionally we are offered a glimpse of other things. A pit on the settlement at Gussage All Saints (Dorset), had been used to dump the debris from a bronze-smith's workshop. This yielded more than 7,000 fragments of clay moulds, used for casting bronze by the lost-wax process, as well as some bone tools used in modelling the wax. The collection includes a type series of finds from a number of sites as well as the entire collection from excavations at Staple Howe, a small palisaded farmstead in Yorkshire, and the Hod Hill hillfort in Dorset.

Hod Hill, excavated by a team from the Museum between 1951 and 1958, was one of the hillforts attacked by the Roman Second Legion under the command of the future emperor Vespasian. The Britons there had no time to complete their defences, and were no match for the organisation of the Roman army. They had to suffer an attack that accurately concentrated its fire of ballista-bolts on the chieftain's hut, and in defeat saw their defences slighted. But Hod Hill marks the arrival of Rome in a still more obvious way. The conquerors expelled the defenders and built their own distinctive military fort within a corner of the Iron Age defences.

242

ROMAN BRITAIN

When Britain became a province of the Roman Empire in AD 43 profound changes were to take place, not only in social organisation, but in administration, law, language and religion. The very appearance of the country was transformed by forts, roads, towns and buildings of brick and stone, while the lives of the inhabitants were enriched by a vastly increased choice of material goods. Celtic culture continued, certainly, but was now to become inextricably woven with the traditions of the classical world.

With the Conquest Britain also makes its appearance on the stage of written history, and though the greater part of our knowledge of the period is derived from archaeological rather than historical sources there are rare instances where the two combine. One such is the tombstone of Julius Classicianus, the procurator (senior fiscal administrator) of the province immediately after the unsuccessful rebellion led by the British Queen Boudica in AD 60–1. The Roman historian Tacitus relates how wisely Classicianus dealt with the aftermath of the revolt, overruling the desire for retaliation and revenge evinced by the Roman military leadership.

244

244 *Restored tombstone of Julius Classicianus, erected by his widow, Julia Pacata. The fragments were found in London, so although the date of his death is unknown, we may infer that Classicianus died in office.* L 2.3m.

Evidence for the presence of the army is abundant, and the collections contain a wide range of armour and weaponry. They range from fragments of armour and an array of iron spears and javelin-heads from Hod Hill (Dorset), to exceptional objects, like the highly decorated cavalry parade-helmet found at Ribchester (Lancashire), in the late eighteenth century. One of the most remarkable finds of recent years is the collection of wooden writing-tablets from Vindolanda (Chesterholm), near Hadrian's Wall. These tablets are a striking illustration of the fact that the most interesting and important objects are not necessarily beautiful or intrinsically valuable, being simply paper-thin slivers of wood, with faint traces of writing in ink, hardly seeming to merit a second glance. Yet these are the earliest written documents from Britain, and afford a unique glimpse into the everyday affairs of a garrison in a remote frontier post of the Empire.

The dividends paid by careful study of often unspectacular material have long been known in the case of pottery. Detailed research on the huge quantity of ceramics from Roman sites has enabled scholars to build up a framework for dating, and to gain insights into the organisation of manufacturing industries and trading activities. Pottery was used for the majority of cooking utensils and tableware, and was manufactured throughout the country. Many existing pre-Roman industries simply developed and expanded under the new regime. Pottery was also imported from other provinces: the mass-produced red tableware known as *samian* was manufactured in Gaul and traded all over the western Empire in the first and second centuries AD. It can be very closely dated, sometimes to within

245 *A Roman cavalry helmet in bronze and iron, from Witcham Gravel, Ely, Cambridgeshire.* H 30cm.

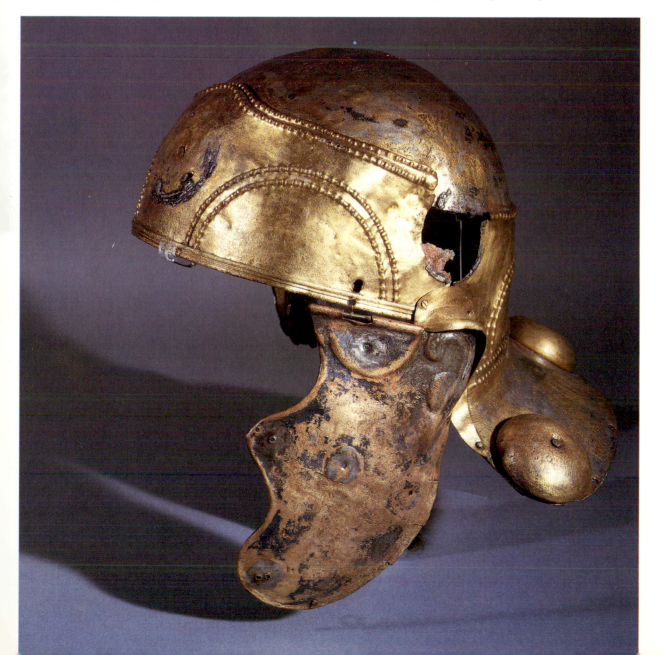

246 ABOVE *One of several hundred documents found at the Roman fort of Vindolanda. They were written on thin tablets of wood, and include official and personal correspondence.* L *17cm.*

247 BELOW *Group of pottery from Stonea, Cambridgeshire.* D *(central bowl) 31.6cm.*

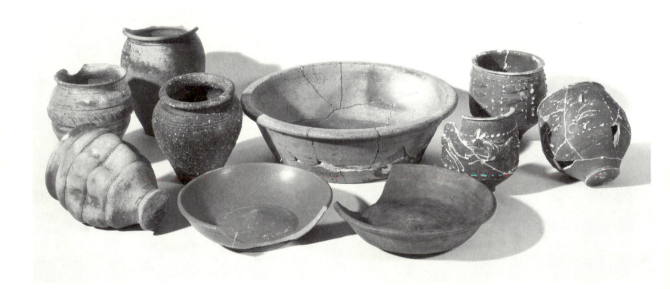

twenty years or so, and the styles of individual potters and workshops, whose name-stamps appear on many of the vessels, can be recognised.

Stonea (Cambridgeshire) was excavated by the British Museum between 1980 and 1984 as part of a planned programme of research into a specific area of the Roman landscape. It was evidently an administrative centre, perhaps overseeing the development of agriculture and stock-raising in the Fenland during the earlier part of the Roman occupation. Finds from sites like Stonea and from the small rural settlements in the same area help to build up a picture of the life-style of

the inhabitants and the way in which Roman policy decisions impinged upon them.

Glass vessels, which first appear in Britain just before the Roman Conquest, must be classed as luxury goods. Because glass is fragile and reusable, settlement sites seldom yield complete vessels, but undamaged examples are sometimes found in graves. The collection includes some of the finest pieces known from Roman Britain, such as the perfect mould-blown beaker with a chariot-racing scene from Colchester, the elegant cut-glass cup from Barnwell (Cambridgeshire) and a superb flagon from Bayford (Kent). Window-

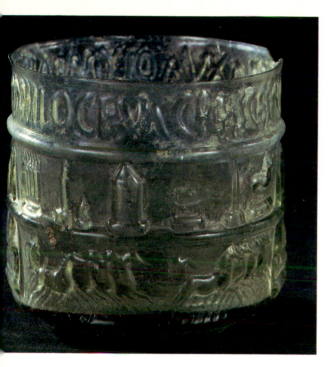

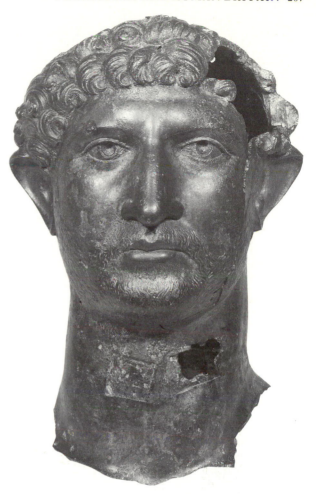

248 ABOVE *Mould-blown glass beaker of the first century* AD *from Colchester, Essex. It is decorated with a scene of chariot-racing and the names of charioteers.* H *8.3cm.*

249 RIGHT *Bronze head of the emperor Hadrian from the Thames at London Bridge. It is from a statue of well over life size.* H *43cm.*

glass is known, too, from many buildings, and a complete pane has survived from a villa at Garden Hill (Sussex).

Large-scale sculpture in bronze and stone was also new to Britain, and statues of the emperor, life size or even larger, would have featured in towns and public buildings. The fine bronze head of Hadrian (ruled AD 117–138) is from such a statue, which might well have adorned a square or government building in London. One of the most important pieces of Romano-British sculpture was found as recently as 1979, during the excavation of a temple to the god Mercury at Uley (Gloucestershire). It is the head from the cult-statue of the god, larger than life size, and carved from Cotswold limestone. Though surely the work of an outstanding local sculptor who was familiar with the distinctive properties of the stone, the graceful proportions and serene expression of the head place it in a tradition which has its origins in the work of the great artists of classical Greece.

The Uley temple site produced many other finds, including the bones of sacrificed animals and a large series of lead tablets with curses scratched upon them. Unlike the Vindolanda letters, these tend to be written to a formula, but even so, those which have been translated give a vivid picture of rural Gloucestershire at the time, with complainants seeking divine help from Mercury against thieves who had deprived them of such indispensable valuables as lengths of cloth and draught oxen. Gifts to the deity at this and other pagan temple sites comprise money, statuettes and other valuables, especially jewellery.

Certain types of personal adornment, whether made of precious metal or copper alloys, had been established well before the Roman period. The functional fibula, or safety-pin brooch, is the prime example. Brooches were made in a variety of imaginative and decorative forms, and were often embellished with enamel, a Celtic speciality which reached its fullest development under Roman rule. Other types of jewellery were purely

250

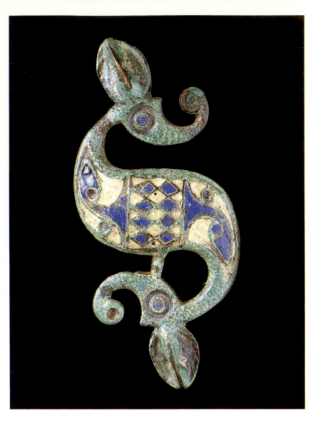

classical, and appear for the first time in Britain after the Conquest, though in due course they too came to be manufactured here. Examples include finger-rings set with engraved gems, and bracelets and rings in the form of snakes. A small pot full of coins and silver jewellery found at Snettisham (Norfolk) in 1985 is part of the stock of a local second-century jeweller and gem-cutter, and includes amongst other things over 40 snake-rings and 110 engraved cornelians ready for setting into the standard type of early Roman ring. Gold, silver, copper and other metals had long been skilfully worked in Britain: the Roman development of these crafts was built on an ancient and sound foundation.

Silver and bronze were also used for the most luxurious tableware. As already noted, Roman silver drinking cups were among items already imported by wealthy wine-drinking Celtic rulers before the Conquest. A group of silver wine cups from Hockwold (Norfolk) belong to the early Roman period, but it is from the fourth century that a truly impressive quantity of silver has come down to us, most of it found in hoards buried for safe-keeping.

The most spectacular of these treasures was ploughed up in 1942 at Mildenhall (Suffolk). The

250 ABOVE *A 'dragonesque' brooch in enamelled bronze, a typically Romano-British ornament. The pin is missing.* L *6.2cm.*

251 BELOW *A selection of items from the hoard of Christian silver found at Water Newton, Cambridgeshire. The Sacred Monogram, the Greek letters* chi *and* rho, *can be seen on the three triangular plaques.* H *(central vase) 20.3cm.*

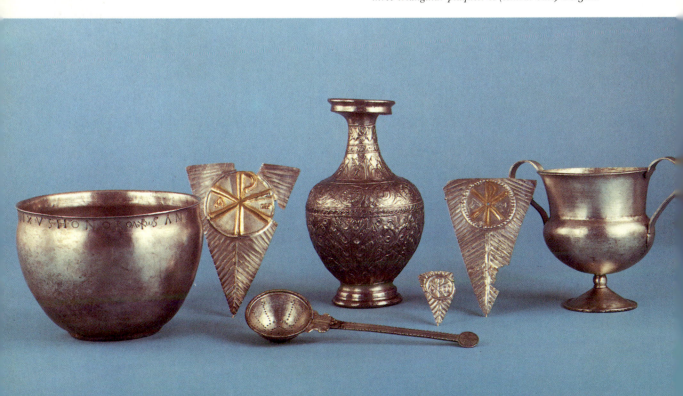

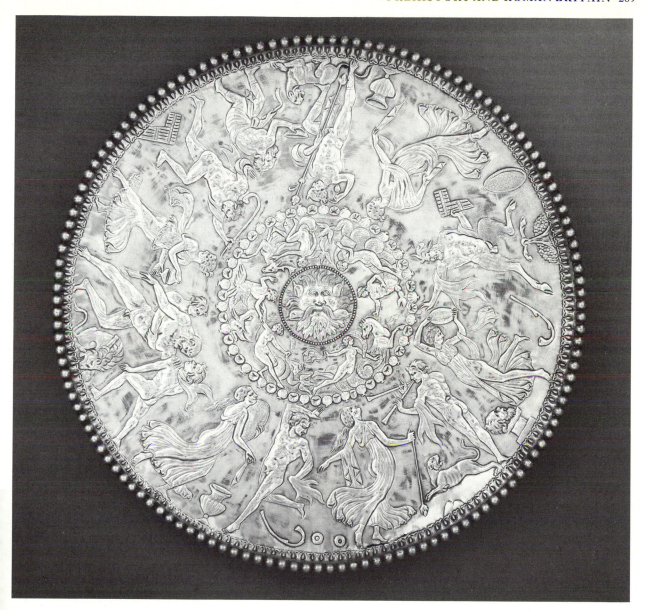

252 *The Great Dish from the Mildenhall Treasure, one of the finest examples of silverware surviving from antiquity.* D 60.5cm.

technical and aesthetic quality of some of the objects in this group remains unrivalled anywhere in the late Roman Empire. The largest piece is a shallow dish over 60 cm in diameter and weighing over 8 kilogrammes, entirely covered with figured decoration in low relief. In the centre is the head of a sea-god, surrounded by a circular frieze of sea creatures and nymphs; the main zone of decoration depicts the wine-god Bacchus and his unruly entourage, drinking, dancing and making music. The traditional pagan decoration of this magnificent work of art is reflected in most of the other decorated vessels in the treasure, but three spoons are engraved with unequivocally Christian symbols: the *chi-rho* monogram and the Greek letters alpha and omega. This combination of pagan and Christian icon-

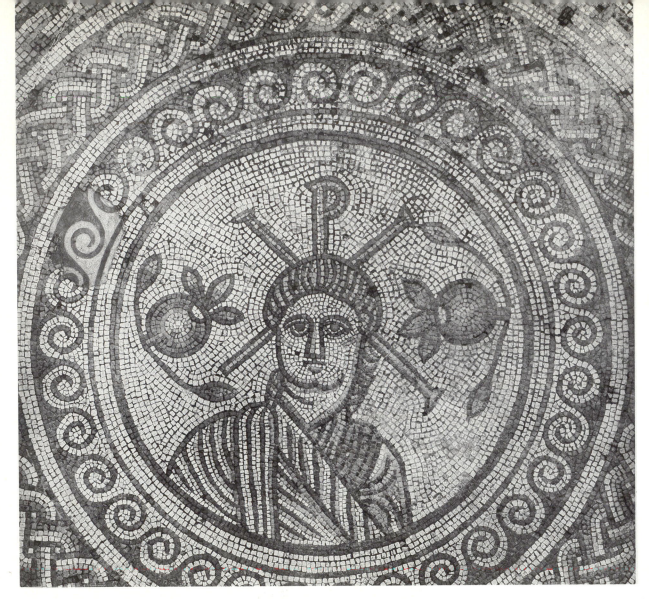

253 *The central portrait roundel of the mosaic floor from the late Roman villa at Hinton St Mary, Dorset. The* chi-rho *monogram appears behind the head, which probably represents Christ.* D *(inner circle) 87.5 cm.*

ography is characteristic of the unsettled fourth century, when the struggle between the old pagan values and the newly approved cult of Christianity became acute. The collections are particularly rich in objects which illustrate this religious crisis.

Foremost is another silver treasure, found at Water Newton (Cambridgeshire) in 1975. The objects in it comprise the earliest set of Christian liturgical silver yet discovered. Inscriptions on the vessels establish beyond doubt that they were in use in a Christian church, and record the names of one man and three women who must have belonged to the congregation: Publianus, Innocentia, Viventia and Amcilla. In addition to the bowls, jugs and a chalice-like cup, are numerous triangular plaques made of thin sheet silver, intended as votive offerings to be displayed in the place of worship. Such plaques are well known from pagan temples, bearing dedications to deities such as Mars, Minerva and Jupiter, but the plaques from Water Newton are the first to demonstrate the practice within a Christian congregation.

Buildings, whether public or domestic, were fundamentally transformed by the influence of classical standards, and by the later Roman period decoratively painted walls and mosaic floors were commonplace in all but very humble dwellings. The subjects chosen for these forms of interior decoration were generally taken from the wide repertoire of Graeco-Roman religion and mythology, but they also provided a medium for expressing the spread of Christianity in the fourth century. At the Lullingstone Roman villa in Kent the painted walls in one room reveal it as a Christian chapel;

the decoration includes large *chi-rho* monograms and a frieze of figures standing with hands upraised in the ancient attitude of prayer. Equally evocative of Romano-British Christianity is the largest mosaic floor in the collections, excavated at Hinton St Mary (Dorset) in 1964. The design of the pavement is conventional, with hunting scenes and corner figures surrounding a circular panel containing a portrait head. A central portrait of this kind is usually the image of a pagan god or goddess. Here it depicts a young, beardless man, flanked by pomegranates (symbols of immortality), with the Christian monogram behind his head: almost certainly a picture of Christ. The Hinton pavement therefore stands at the beginning of the tradition of Byzantine Christian mosaics which are one of the glories of early medieval art.

The collections contain many other major relics of Christianity, but two small objects perhaps deserve special mention, gold finger-rings from Suffolk and Brentwood (Essex), bearing the Christian monogram engraved on their bezels. Finger-rings traditionally carried some religious device, such as the figure of a god or goddess, or an attribute of a deity. Here again can be seen early Christians adopting pagan customs to their own beliefs.

Even in the late fourth century AD, when Britain's days as a province of Rome were numbered, paganism continued to fight for existence against the increasing power of the new faith. An astounding illustration of this was found in late 1979 at Thetford (Norfolk). The Thetford Treasure consists of an assemblage of flamboyantly beautiful gold jewellery, including no fewer than twenty-two finger-rings, a set of thirty-three silver spoons and three strainers. Spoons with Christian inscriptions became increasingly common throughout the fourth century, and undoubtedly had a religious use. The Thetford spoons also have religious inscriptions engraved on them, but they are all to a pagan god, to the obscure Italian nature-deity Faunus, who by this time was probably perceived as part of the cult of Bacchus. Even more remarkable, the name of Faunus is combined in true Roman provincial fashion with by-names of unmistakably Celtic form, so there is no question of these spoons being some inexplicable import from the Mediterranean.

The wealthy Romano-British pagans who dedicated these precious things to the use of Faunus in fourth-century East Anglia must have seen themselves as the heirs and upholders of a precious tradition, a truly combined classical and Celtic tradition in the inexorably changing world of late antiquity. The treasure was probably concealed for safety in response to the Imperial decrees forbidding pagan practices in the early 390s. There is a poignancy in the ostentatious richness of the Thetford Treasure, for within a generation of its burial all that it represents, the ancient civilisation of one of the world's great empires, had already begun to vanish from Britain.

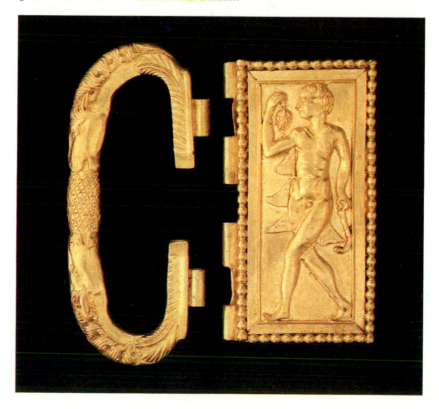

254 *The gold buckle from the Thetford Treasure, decorated with a dancing satyr.* H 5.9cm.

PRINTS
AND DRAWINGS

◆

*T*he Department of Prints and Drawings houses the national collection of Western graphic
art. It possesses one of the great collections of prints, documenting the history of printmaking
from its beginnings in the fifteenth century down to modern times. The collection of
drawings, though relatively small by comparison with some of the great Continental
accumulations, such as those in Paris and Florence, is one of the best balanced and most
representative in the world, for in it most of the greatest masters of the
major schools are represented.

255 CHARLES RENNIE MACKINTOSH (1868–1928). Port Vendres (*c.* 1926–7)
*Watercolour over pencil. One of a series of large Mediterranean watercolours he painted between 1923 and 1927. The
views of Port Vendres were executed out of doors and would often take two or three weeks to complete. 28 × 37.8cm.*

DRAWINGS OF THE ITALIAN SCHOOL

The Early and High Renaissance in Italy are particularly well represented. Among outstanding drawings of the fifteenth century in Florence is *The Prisoner before a Judge* by Antonio Pollaiuolo, exemplifying the Florentine tradition that conceived the fundamental language of artistic expression in terms of the nude figure in action. This tradition was continued in the vigorous black-chalk nude studies by Pollaiuolo's younger contemporary and pupil Luca Signorelli, and was carried to its fullest pitch of expression by Michelangelo. The complementary aspect of Florentine art is the linear graceful style of Sandro Botticelli, whose drawing of *Abundance* or *Autumn* is one of the most beautiful Renaissance drawings to have come down to us. A drawing by Andrea Verrocchio depicts the magnificent head of a woman. The emphasis on the complexity of the *coiffure* anticipates the work of his pupil Leonardo da Vinci, twenty-one of whose drawings are in the collection.

In north Italy during the *quattrocento* the chief artistic centres were Venice, Padua and Verona. Nine drawings are kept under the name of Giovanni Bellini, the greatest Venetian artist of the period, but some of these are possibly by his brother-in-law, the Paduan Andrea Mantegna. Drawings by Mantegna are very rare, and the Museum's group, which numbers at least six and possibly as many as nine, is unrivalled both in quantity and quality. It includes the carefully finished and coloured *Mars, Venus and Diana* – a drawing as beautiful in its own way as the Botticelli *Abundance*. By Giovanni Bellini's elder brother Gentile, who visited Constantinople in about 1470, we have the drawings of a *Turkish Lady* and a *Janissary*; and by their father, Jacopo Bellini, the so-called 'sketchbook' of some hundred leaves, with black-chalk drawings of a great variety of subjects, religious, allegorical, mythological, architectural.

Fine drawings by Andrea del Sarto and Fra Bartolommeo illustrate the High Renaissance style in Florence; but in the early sixteenth century the artistic initiative had begun to shift from Florence to Rome,

256 RAFFAELLO SANTI, CALLED RAPHAEL (1483–1520). Head of a bearded man (*c.* 1519–20)
Black chalk over pounced-through underdrawing. An auxiliary cartoon for a foreground figure, usually identified as St Andrew, in Raphael's altarpiece The Transfiguration *in the Vatican Gallery. 39.9 × 35cm.*

257 ABOVE MICHELANGELO BUONARROTI (1475–1564).
Study for the *Bathers* (*c.* 1504–5)
*Pen and brown and greyish-brown ink and wash, heightened
with white. The* Bathers *formed part of the design for the*
Battle of Cascina, *a painting intended for the Palazzo Vecchio
in Florence but never completed. 42.1 × 28.7cm.*

258 RIGHT SANDRO BOTTICELLI (1444/5–1510).
Abundance
*Pen and brown ink and brown wash over black chalk
heightened with white bodycolour, on pink prepared paper. One
of the most beautiful drawings of the Italian quattrocento, this
may have been executed a few years after Botticelli's* Primavera
in the Uffizi of about 1478. 31.7 × 25.5cm.

259 GIOVANNI BATTISTA PIRANESI (1720–78). View of the
Capitol, Rome
*Pen and brown ink with red and black chalk. A study for the
etching in Piranesi's famous series of prints, the 'Vedute di
Roma', on which he worked from the late 1740s to his death.
40.3 × 70.1 cm.*

where the Florentine-trained Michelangelo executed
many of his greatest works, and the Umbrian Raphael
all of his. Both artists are magnificently represented in
the Museum. Raphael's thirty-nine drawings include
an early self-portrait, done at the age of sixteen or
seventeen, and studies for some of his greatest works –
the *Parnassus* and the *Disputa* in the Vatican, the *Sibyls*
256 in Sta Maria della Pace, Rome, and the Vatican *Trans-
figuration*. The group of over eighty Michelangelo
drawings, the largest outside Italy, illustrates almost
every phase of his long career: especially noteworthy
are the study for a figure in the early cartoon of the
257 *Bathers*, the sketch of the first, discarded scheme for the
decoration of the Sistine Ceiling, the series of designs
for the tombs in the Medici Chapel in S. Lorenzo in
Florence, the group of very late *Crucifixion* drawings
and his only surviving complete cartoon, the large-scale
Epifania.

Michelangelo, essentially a solitary genius, had no
pupils, but there are five drawings by his most import-
ant follower, Sebastiano del Piombo. Raphael, in con-
trast, headed a flourishing school, and the Museum

possesses a very good representative collection of draw-
ings by his pupils and/or associates: Giulio Romano,
Perino del Vaga, Baldassare Peruzzi and Polidoro da
Caravaggio. Towards the end of his life Raphael was
developing in the direction of the graceful, decorative
style which is usually called Mannerism, and after his
premature death in 1520 the tendency was carried
forward by his younger associates. The same develop-
ment away from the ideals of the High Renaissance
was formulated independently in Florence by Rosso
and Pontormo. It was continued there by Bronzino,
Francesco Salviati and Vasari, and in Rome by Daniele
da Volterra, Taddeo and Federico Zuccaro, Pellegrino
Tibaldi and Raffaellino da Reggio.

Although Rome was the most important theatre for
the evolution of the High Renaissance style, Parma and
Venice contributed their own local variants. Seventeen
drawings are by the Parmese Correggio, and nearly one
hundred by his more prolific compatriot and follower,
Parmigianino. Only one drawing is certainly by the
greatest Venetian painter of the sixteenth century,
Titian, a small study in black chalk for an Apostle in
the altarpiece of the *Assumption* in Sta Maria dei Frari,
Venice; but his younger contemporaries Jacopo Tin-
toretto and Paolo Veronese are well represented, and
there is an important group of about ninety composi-
tion-sketches in oil on paper by the younger Tintoretto,
Domenico.

The beginning of the seventeenth century in Italy is
marked by a naturalistic reaction. No drawings by

260 Giandomenico Tiepolo (1727–1804).
The Arrest of Christ
Pen and brown ink with brown wash over black chalk. From a series of eighty-two biblical subjects, this drawing reveals the artist's powerful imagination in his interpretation of religious themes.
47.5 × 37cm.

Michelangelo da Caravaggio, the exponent of a highly realistic style, are known; but Annibale Carracci, whose idealised naturalism was of seminal influence upon the development of both the classical and the Baroque style of the 1620s, returned to the High Renaissance example of Raphael and Michelangelo in making numerous preparatory studies for his paintings. The large group of some twenty-four drawings by him include, besides several landscape drawings in pen and ink, the cartoon of a helmsman for the fresco *Ulysses and the Sirens* in the *camerino* of the Palazzo Farnese in Rome.

As the influence of the followers of Caravaggio and Annibale Carracci waned, the true Baroque style developed in Rome. This is typified in the grandiose decorative works of Pietro da Cortona. Bernini, who was primarily a sculptor and architect, was another brilliant protagonist of the Baroque, and the Museum possesses several examples of his work as a draughtsman. Towards the end of the seventeenth century Roman painting came to be dominated by Maratta's High Baroque classicism. The essentially academic basis of his art is shown by the fact that most of the Museum's seventeen drawings by him are studies from the model.

In the eighteenth century it was above all in Venice that the great tradition of Italian painting continued. The lively rococo figure style of Giovanni Battista Tiepolo and his son Giandomenico parallels contemporary developments in France. The two great view-painters, Francesco Guardi and Antonio Canaletto, specialised in townscapes, particularly of Venice, but the collection also includes a number of Canaletto's views in England. Another mainly topographical draughtsman well represented in the collection is Giovanni Battista Piranesi; though a Venetian by birth he spent his working life largely in Rome, the city which is the subject of most of his etchings and drawings.

Drawings of the German, Dutch and Flemish schools

In Germany the Renaissance flowered briefly but intensely, and it is fortunate that the Department's holdings of this school are mainly concentrated in that period. Its collection of drawings by the greatest of all German artists, Albrecht Dürer, is the largest in the world, and is particularly strong in watercolour landscapes and portrait drawings. By the other great German artist of the early sixteenth century, Hans Holbein the Younger, who is best known as a portrait draughts-

261 ALBRECHT DÜRER (1471–1528). View of the castle at Trent
Pen and black ink with watercolour. The castle at Trent was reconstructed in 1468 and remains comparatively little altered. Dürer probably made the drawing in 1495 en route *from Italy to Nuremberg. 19.6 × 25cm.*

man, is a large group of designs for jewellery and metalwork, but only two drawings, both of ladies, one traditionally identified as Sir Thomas More's daughter, Margaret Roper, the other as Queen Anne Boleyn.

A small but choice group covers the rest of the German school (with which may be linked the Swiss) from the fifteenth century to the end of the seventeenth. Outstanding among drawings by the followers of Dürer in Nuremberg are those of Hans von Kulmbach and Hans Schäufelein, while those by Hans Holbein the Elder and Hans Burgkmair at Augsburg illustrate the rise of the Renaissance in southern Germany. Among the seventeenth-century drawings may be particularly

noted the group of technically accomplished land-scapes in bodycolour that are traditionally attributed to Adam Elsheimer.

The late nineteenth and twentieth centuries are represented by a growing number of works by some of the most important figures: Paula Modersohn-Becker, Kirchner, Heckel, Grosz, Beckmann and, most recently of all, Anselm Kiefer and Gerhard Richter.

The Netherlandish school is subdivided into 'Dutch' and 'Flemish' because of the break-up, in the later sixteenth century, of the Low Countries into the Protestant north and the Catholic south. The collection starts at the beginning of the fifteenth century, with a group of portraits in silverpoint by or attributed to Jan van Eyck and Rogier van der Weyden. Subsequent developments can be studied in detail here, and include fine examples from all the important artistic centres, Bruges, Ghent and Antwerp, as well as the only known brush drawing by Hieronymus Bosch, *The Entombment*.

The two most important treasures of the sixteenth century are the unrivalled group of twelve drawings by the precocious genius, Lucas van Leyden, and the

262 HANS HOLBEIN THE YOUNGER (1497/8–1543).
Portrait of an English woman
Black and red chalk and brush and black ink, heightened with white bodycolour, on pink prepared paper. This was drawn during Holbein's second stay in England from 1532 to 1543. 27.6 × 19.1cm.

group of landscape drawings by Pieter Bruegel the Elder, together with his only known drawing of an allegorical subject, *The Calumny of Apelles*. The leading draughtsmen of the next generation, Hendrick Goltzius and Jacob de Gheyn II, are well represented, together with many of their lesser contemporaries.

From the beginning of the seventeenth century in the Catholic south (Flanders) the artistic world was dominated by Peter Paul Rubens. All periods of his career and most aspects of his interests are illustrated. There are five studies after the model – perhaps the most impressive, both in the skill displayed and in the feeling expressed, is that of *Christ on the Cross* – and preparatory studies for compositions, for instance, a *Lioness* for *Daniel in the Lion's Den*. Rubens closely studied the work of his predecessors, and the collection is rich in copies after Michelangelo, Raphael and others. His antiquarian and collecting interests are reflected in sketches after the antique as well as the numerous drawings by earlier masters that he improved by retouching. A small but important group of landscapes

266

includes his *Sunset*, while among the portraits is one of the most outstanding, that of his first wife, *Isabella Brant*. His designs for title-pages and preparatory drawings for engravings after his paintings are also included.

The British Museum's collection of drawings by Rubens' brilliant assistant, Anthonie van Dyck, is without rival. There are several early pen studies, which are sometimes difficult to distinguish from those of Rubens. The 'Italian Sketchbook' contains drawings made during his travels in Italy between 1621 and 1627. After his return from Italy he was principally interested in portraiture. Four preparatory drawings for engravings in his *Iconography* are executed in black chalk on white paper with the occasional use of brown wash, and admirably illustrate his portrait style before he settled in England in 1632. Studies for portraits he painted in England are in black chalk on blue paper, perhaps inspired by the sixteenth-century Venetian school. The Museum's collection of drawings of this type is without parallel, including many studies for famous paintings.

263 ABOVE ERNST LUDWIG KIRCHNER (1880–1938).
A nude woman standing in her bath (1914)
Pastel. Kirchner produced some of his most striking compositions in pastel between 1913 and 1914 while he was living in Berlin. 67.3 × 51.2cm.

264 TOP RIGHT HIERONYMUS BOSCH (c. 1450–1516).
The Entombment
Brush drawing in grey over traces of an underdrawing in black chalk. The drawing was first discovered and identified as by Bosch in 1952. The high quality of the brush work and unusual iconography seem characteristic, and no convincing alternative attribution has been proposed. 25.3 × 30.4cm.

265 BOTTOM RIGHT ANTHONIE VAN DYCK (1599–1641).
Study of trees
Pen and brown ink and watercolours. The drawing was almost certainly made in England in the 1630s, and was used by van Dyck in the background of the Equestrian Portrait of Charles I *in the National Gallery, London. 19.5 × 23.6cm.*

266 LEFT
PETER PAUL RUBENS
(1577–1640).
A lioness
*Black and yellow chalk,
with grey wash,
heightened with white
bodycolour. A
preliminary sketch for a
painting of* Daniel in
the Lions' Den *now
in the National Gallery
of Art, Washington.
The drawing was
probably made in or
before 1618, when
Rubens offered the
painting to the British
ambassador to The
Hague. 39.6 × 23.5cm.*

267 RIGHT
REMBRANDT VAN RIJN
(1606–69).
A sleeping girl
*Brush drawing in
brown wash. Drawn in
the mid-1650s. The
model was probably
Hendrickje Stoffels, who
had entered
Rembrandt's household
as a servant ten years
before. 24.5 × 20.3cm.*

An impressive group of his charming landscape drawings seem to date from his final years in England.

The only other Flemish artist of that period of any real importance is Jacob Jordaens. He was essentially a decorative artist, and this aspect is given full scope in his tapestry designs.

The collection of drawings by Rembrandt, though relatively small, is one of the most representative. Rembrandt was an extraordinarily versatile draughtsman, and his use of a kind of pen-and-ink shorthand to capture the mood of the moment makes the study of his drawings one of enormous fascination. In his maturity his disregard for conventional technique led to the brilliant economy of brushwork in the *Sleeping girl*, for example, and the virtuosity with the reed pen in *A girl seated* (both possibly studies of Hendrickje Stoffels).

In addition to those undeniably by Rembrandt, a large group of drawings are by his pupils, some of whom aped his style so well that it is often difficult to distinguish their drawings from the master's; but his most important followers or associates, such as Jan Lievens and Gerard Dou, have quite distinctive styles.

The particular strengths of the rest of the seventeenth-century Dutch school are also represented: landscape by fine examples of Jan van Goyen, Jacob van Ruisdael, Anthonie Waterloo and Aelbert Cuyp; marine painting by Renier Zeeman and Ludolf van Backhuizen; and *genre* by Adriaen van Ostade.

Towards the end of the seventeenth century in both the Dutch and Flemish Schools we find an increasing use of watercolour and a growing dependence on French culture. These tendencies became even more evident in the eighteenth century. Dutch art of this period is well represented, but after the glories of the previous century its effect is inevitably one of anticlimax. Subsequent developments are sparsely illustrated, but there is a magnificent pen-and-ink landscape, *Le Crau from Montmajour*, by Vincent van Gogh, a sketchbook page by Piet Mondrian (*c.* 1911) and a gouache of 1958 by the COBRA artist, Karel Appel.

DRAWINGS OF THE FRENCH SCHOOL

In France a high level of excellence was achieved in portrait drawing in the early sixteenth century at the court of François I in the work of Jean and François Clouet; the Museum's large group of drawings by the Clouets and their successors provides a primary source for the study of this school. In the tradition of manuscript illumination are the fifty watercolours by the sixteenth-century Huguenot artist, Jacques Le Moyne de Morgues. His surviving work consists almost entirely of plant drawings and miniatures of great refinement and surprising naturalism. The 122 vellum sheets of French chateaux by Jacques Androuet Ducerceau are perhaps the most notable of such sixteenth-century French drawings extant.

The development in Lorraine in the early seventeenth century of a native Mannerist school produced two remarkable draughtsmen and etchers, Jacques Callot and Jacques Bellange. By the former there is a quite large group of drawings of landscape, small figure compositions and studies of horses, some of them

268 JACQUES LE MOYNE DE MORGUES (c. 1533–88). Primrose and fly
Watercolour and bodycolour. Le Moyne was born in Dieppe, but little is known of his early life. In 1564 he accompanied an expedition to Florida to make a graphic record of the native Indians and the flora. A Huguenot, he eventually settled in London about 1580. This is from a series of more than eighty studies of flowers and fruit painted around 1585. 20.7 × 14.1 cm.

269 CLAUDE LORRAIN (1600–82). Landscape with the abandoned Psyche at the palace of Cupid
Pen and brown ink and brown wash, heightened with white bodycolour, over black chalk on blue paper. From the celebrated Liber Veritatis, *the drawing corresponds to a painting known as* The Enchanted Castle. *19.6 × 26.3cm.*

connected with etchings. Bellange is represented by five drawings, including a remarkable study of a girl in pen and blue wash.

There are only a few authentic drawings by Nicolas Poussin, the greatest and most influential of the French 'classical' masters of the seventeenth century, or by the other artists working in the same tradition: Simon Vouet, Eustache Le Sueur, Laurent de la Hyre and Charles le Brun. On the other hand, the collection of some 500 drawings by Claude Lorrain, who, like Poussin, spent his working life in Rome and who as a landscape painter and draughtsman overshadows all his contemporaries, is the largest in existence. Most of them are sketches of an astonishing freedom and poetry made directly from nature in the Roman Campagna;

distinct from these, and in their own way no less beautiful, are the 205 drawings in the *Liber Veritatis*. These were made by the artist, whose works were extensively forged and imitated even in his own lifetime, as a record of his work and a protection against forgery. 269

The classicism of Poussin and his followers survived into the eighteenth century, but the emphasis was shifting to the men and manners of the new age. Antoine Watteau was largely instrumental in bringing about this change. The Museum's sixty or so drawings by him cover every phase of his brief career from the elongated forms and timid handling of his maturity. By use of the technique *à trois crayons* – a combination of 270 black, red and white chalk – he achieved an unequalled effect of mingled richness and precision. One of the outstanding drawings by him is a design for a fan-leaf, the only one of its kind known.

The other leading masters of the eighteenth century, François Boucher and Jean-Honoré Fragonard, the two most characteristic personalities of the *rococo* period, and Hubert Robert and Gabriel de Saint-Aubin are represented, though less well, while there is a small

270 Jean-Antoine Watteau (1684–1721). Four studies
of the head of a young woman
*Two shades of red chalk, and black and white chalk. Although
Watteau made few formal portraits, there are a number of
highly expressive and convincing drawings of heads of his
friends. This is a particularly fine example. 33.1 × 23.8cm.*

but interesting group of drawings of the neo-classical
movement of the end of the century.

The collection contains relatively little from the
nineteenth century, although there are some drawings
in pencil, pen, watercolour and pastel by Eugène De-
lacroix; *Studies of a seated Arab* is a masterpiece of
delicate and perceptive portraiture. His pupil Théo-
dore Géricault has some effective drawings to his name,
most of them from his English period, notably *The Coal
Waggon.* Jean-August-Dominique Ingres, the upholder
of a rigid classicism and the outstanding draughtsman
of his age, can be studied in a group of preparatory and
finished drawings including two remarkable portraits,
Sir John Hay and his Sister and *M. Charles Hayard and his*

Daughter, as well as studies for the *Golden Age* and *Apotheosis of Homer*. From the Barbizon school of landscape are drawings by Théodore Rousseau, Jean-François Millet and Charles-François Daubigny. By Jean-Baptist-Camille Corot there is little in the way of landscape, but there are two excellent portraits in pencil. The few examples of the work of the Impressionists and the artists associated with them include a nude study by August Renoir; a group of drawings by Edgar Degas; several characteristic examples of the work of Camille Pissaro; two watercolours by Berthe Morisot; and five portraits and figure studies by Toulouse-Lautrec. Cézanne is represented by two works in pencil and a watercolour of 1878–80, *The*

271 PIERRE BONNARD (1867–1949). *La salle à manger, Villa le Bosquet, le Cannet*
Watercolour, bodycolour and pencil. Bonnard made numerous depictions of the little house just above Cannes which he acquired in 1926. In 1942 on one of the occasions when he was painting the dining room he commented: 'I'm trying to do what I have never *done: give the impression one has on entering a room: one sees everything and at the same time nothing'. 46.5 × 48.7cm.*

272 HENRI MATISSE (1869–1954). A seated woman wearing a taffeta dress (1938)
Charcoal. 66.3 × 50.5 cm.

Apotheosis of Delacroix. Georges Seurat, the exponent of neo-Impressionism, can be studied in six drawings, including two studies for *La Grand Jatte*.

 Of the major figures and movements of the twentieth century, from the Cubists onwards, there is only a small body of work, including a fine watercolour by Bonnard, dated about 1930, and a substantial drawing of 1938 by Matisse.

271

272

DRAWINGS OF THE SPANISH SCHOOL

The main strength of the small collection of the Spanish school lies in its drawings by some of the major seventeenth-century masters. There are seven drawings by Jusepe Ribera, who though a leading member of the Neapolitan school always insisted on his Spanish nationality; at least twenty by Bartolomé Esteban Murillo, and a few by other leading masters, including the only drawing generally accepted as being by Fran-

273 FRANCISCO GOYA Y LUCIENTES (1746–1828).
Por linage de ebreos (For being of Jewish ancestry)
Brush and grey and brown wash. One of a series of drawings made between about 1814 and 1823 during the period of repression under Ferdinand VII. The subjects are victims of the Inquisition. 20.3 × 14.2 cm.

cisco Zurbaran, a powerful study in black chalk of the head of a monk.

The greatest master of the Madrid school, Diego Velasquez, is virtually an unknown quantity as a draughtsman; but the black-chalk study of a man on a horse, attributed to him when in the collection of Mariette, the great French connoisseur of the eighteenth century, has been accepted by some authorities. Other examples of the Madrid school are by Vicente Carducho, Antonio Pereda, Juan Carreno and Claudio Coello.

The coverage of eighteenth-century works by Spanish masters is by comparison thin and of lower quality: designs for church decoration by Mosen Domingo Saura and Teodoro Ardemans are still in the seventeenth-century Baroque tradition, and there are two interesting and accomplished portraits, one by Luis Paret of Maria Luisa de Borbon, the other of Elizabeth Farnese by Miguel Jacinto Menendez.

273 By Francisco Goya, one of the greatest Spanish painters and unquestionably the greatest Spanish draughtsman, there are seven drawings. The earliest, *The Garotted Man*, dates from the 1780s and derives in technique, though not in subject matter or mood, from G. B. Tiepolo. The others include the red-chalk sketch of the Duke of Wellington, done from life in 1812 after the Battle of Salamanca, which served as basis for all Goya's painted portraits of him, and a brush drawing of a group of victims of the Inquisition, *For being of Jewish ancestry*, which can be dated after 1814. Goya's influence is all-pervading in the small group of drawings by his follower, Eugenio Lucas. Another nineteenth-century artist whose influence was felt within and outside Spain was Mariano Fortuny; the Department possesses eighteen characteristic drawings by him, mostly in watercolour.

DRAWINGS OF THE BRITISH SCHOOL

The Department's collection of drawings by British artists, or by artists from abroad who made their careers in England, is inevitably larger than that of any other school. It ranges from the mid-sixteenth century until the present day and includes, as well as drawings in chalk, black lead, ink, and pencil, a comprehensive selection from the English watercolour school from its origins in the seventeenth-century 'stained drawing'.

English drawings of the sixteenth century have survived in very small numbers, but the Department possesses one rare design in pen and ink by the miniaturist Nicholas Hilliard for the Irish Great Seal of Queen Elizabeth, and the earliest and finest set of ethnographical watercolours in John White's drawings of the Algonquin Indians and the flora and fauna of Sir Walter Raleigh's original colony of Virginia. Of English seventeenth-century draughtsmen, the most important are Inigo Jones, a number of whose architectural drawings in the collection include some for Whitehall Palace, and Francis Barlow, whose work as an illustrator is well represented, especially by the designs for the *Aesop's Fables with his Life*, 1666. There are also series of drawings by the York topographer, Francis Place, and by several of the Continental artists who worked in England at the period; in particular Wenceslas Hollar, Willem van de Velde the Elder, and Sir Peter Lely, by whom the Department possesses sixteen studies of figures in the Garter Procession at Windsor. There are

274 WENCESLAUS HOLLAR (1607–77). View of Westminster and the Thames from Lambeth House
Pen and brown ink over black lead. Born in Prague, Hollar settled in London in the late 1630s. His detailed views of the city are an unparalleled source of topographical information on its appearance before the Great Fire of 1666. Here we are looking north and down river, the Tower visible in the distance. 15.1 × 40.1 cm.

examples of the portrait studies of Lely's German successor, Sir Godfrey Kneller, and of the Swedish portrait painter, Michael Dahl. The tradition of pastel portraiture in England is illustrated by the drawings of Edward Lutterell, Edmund Ashfield, John Greenhill and others, as well as a group of plumbago (lead pencil) miniatures by Thomas Forster, David Loggan and Robert White.

In the eighteenth century English artists became self-consciously concerned with founding a national school to vie with those of the Continent. Sir James Thornhill painted grandiose decorative schemes on the model of those by the Italians Verrio and Ricci and the Frenchman Laguerre, and the Department's book of sketches by him for schemes of this sort is one of the most important surviving documents of the English Baroque period. His son-in-law, William Hogarth, was even more influential in achieving a new status for the artist in England. An extensive group of his drawings include all the surviving designs for the series *Industry and Idleness*, and examples of his skill as a portrait draughtsman. An underrated contemporary of Hogarth's was Francis Hayman, also well represented by a series of illustrations to Smollett's translation of *Don Quixote* (1755).

275 THOMAS GAINSBOROUGH (1727–88). Study of a woman
Black chalk and stump, heightened with white bodycolour on buff paper. Dating from the mid-1780s, this study is one of a series Gainsborough probably made in connection with a projected painting, The Richmond Water Walk.
49.5 × 31.4cm.

276
J. M. W. Turner
(1775–1851).
The Vale of
Ashburnham
Watercolour; signed:
J. M. W. Turner
RA 1816. *One of a
series of views in
Sussex commissioned
from Turner by John
Fuller in 1815;
Beachy Head is visible
in the centre distance.
It is closely based on a
pencil drawing of the
view in the artist's*
Vale of Heathfield
*sketchbook. Together
with others in the
series, this was
engraved in 1817.
37.9 × 56.3 cm.*

Sir Joshua Reynolds, the great portrait painter, did not practise drawing to any great extent, but the collection includes a large proportion of his studies, in addition to a self-portrait dated 1750 and two of the notebooks that he used in Italy in 1752. Reynolds's great rival, Gainsborough, can be seen both as portrait draughtsman and landscape artist, with several full-length figure studies and over eighty sketches of trees and plants and imaginary landscape compositions. Downman, Hoppner and Lawrence also figure, and Romney's romantic figure subjects are well represented by several dramatic wash studies. These, together with Fuseli's Roman sketchbook of the 1770s (one of the principal documents of the early Romantic and neo-classical movements) and the excellent group of drawings by Stothard and Flaxman, form a background to the Blake collection, which, apart from the illuminated books, includes the complete series of watercolours for Young's *Night Thoughts* and a number of the subjects from the late illustrations to Dante.

The humorous figure draughtsmen of this period are also present, with many good examples of Thomas Rowlandson's lively watercolours, preparatory studies

275

by James Gillray for his savage political cartoons of the French Revolutionary and Napoleonic periods, and drawings of comic social observation by John Nixon, Henry Bunbury and Nathaniel Dance. These provide a general view of the social background of the period, as do the charming watercolours of Paul and Thomas Sandby and the minute rural scenes by Thomas Bewick, which he himself engraved on wood as vignettes in his classic *History of British Birds*. There is also a very large collection of sketches by George Cruikshank, who continued the tradition of comic and satirical draughtsmanship down to the middle of the nineteenth century.

The Romantic movement manifested itself as much by an interest in nature as by concern for the more passionate aspects of human behaviour. It was above all in landscape that colour came to be seen as an integral expressive part of a finished drawing, and the landscape watercolour is the most important British contribution to European art since the Middle Ages. The mood of Romanticism, already foreshadowed in the first half of the eighteenth century in the drawings of William Taverner and Jonathan Skelton, appears even more obviously in the views which William Pars made in Greece and Switzerland in the 1760s and 1770s, imbued as these are with the enthusiasm for ruins and mountain scenery that was to become widespread in the next generation. All Pars's finest drawings of these subjects are in the British Museum, along with numerous examples by his associates in the 1780s, Francis Towne and John 'Warwick' Smith. Two other artists of an earlier generation who were also inspired by Italy, but who did not work in watercolour, were Richard

277 RICHARD DADD (1817–86). The Halt in the Desert *Watercolour and bodycolour. This rare and important example of Dadd's early work was thought to have been lost since 1857 until its recent discovery. It was developed from sketches made in 1842 while on tour with his patron Sir Thomas Phillips. Here the travellers are bivouacked by the Dead Sea; Dadd himself is at the far right of the camp fire. 37 × 70.7cm.*

278 HENRY MOORE (1898–1986). Crowd looking at a
tied-up object (1942)
*Watercolour over coloured chalks. This is one of Henry Moore's
most famous compositions, probably influenced by a reproduction
he knew of Nupe tribesmen in Nigeria standing around two
immense, draped cult figures. 40 × 55cm.*

Wilson and Alexander Cozens. The Department pos-
sesses a large number of studies of landscape and
details of landscape by Wilson in his characteristic
medium of black and white chalk on grey paper, and
several of Cozens's ideal 'blot' landscapes in brown
wash together with a group of pen-and-ink sketches
made in Rome when he was a young man. John Robert
Cozens, his son and arguably the finest English water-
colourist before the generation of Turner and Girtin, is
also represented. Both Wilson and John Robert Cozens
exercised a fundamental influence on the early de-
velopment of J. M. W. Turner. The Henderson, Salt-
ing and Lloyd Bequests of finished watercolours give a
superb picture of this, the greatest, most versatile and
prolific of British painters. An unrivalled collection of
watercolours and drawings by Turner's contemporary

Thomas Girtin includes five well-preserved sections of
the preliminary design in watercolour for the *Panorama
of London*, which together constitute the artist's master-
piece.

The collection of drawings by John Constable,
though smaller than that in the Victoria & Albert
Museum, is well balanced, and includes a sketchbook
of 1819, and a fuller representation of the artist's figure
drawings than exists elsewhere. Watercolours by mem-
bers of the Norwich school include a very large number
by John Sell Cotman, among them several of the
well-known 'Greta' subjects of 1805 and the famous
Dismasted Brig. A large view of Lincoln is the most
impressive of a small group of watercolours by Peter de
Wint; David Cox, on the other hand, is represented by a
comprehensive collection of works from all periods of
his life. The drawings by Richard Parkes Bonington are
mostly pencil studies, many of them made in the
Louvre, but there are a few watercolours, including the
lively *Château de Berri* and a striking self-portrait.

Two of Samuel Palmer's sketchbooks are in the
department, and one of the finest watercolours from his
Shoreham period, of *A Cornfield by Moonlight with the
Evening Star* (c. 1830). Another highly individual figure,

277 Richard Dadd, who was committed to Bethlem Hospital for the murder of his father in 1843, is represented by one of his most important watercolours, *The Halt in the Desert* (c. 1845)

From the second half of the nineteenth century there are good holdings of such artists as Edward Lear, William Müller and John Frederick Lewis, and a small but representative group of Pre-Raphaelite drawings, including fine examples by Rossetti and Millais, and a substantial quantity by Burne-Jones. The latter include two important sketchbooks, one a volume of pencil studies dating from the 1870s, including designs for the *Days of Creation*, the other containing a series of circular designs in watercolour suggested by the names of flowers and known as the 'Flower book'. There are also examples of the draughtsmanship of Lord Leighton, Alma-Tadema and Charles Ricketts; Ricketts's notebook of jewellery designs is a particularly telling record

279 PERCY WYNDHAM LEWIS (1882–1957). Woman with a sash (1920)
Pen and ink, crayon and watercolour. The sitter is Iris Barry (1895–1969), the writer and film critic who lived with Wyndham Lewis from 1918 to 1921; she was the subject of Praxitella *(1920–1), one of his most striking portraits in oil, now in the Leeds City Art Gallery. 38.1 × 39.1 cm.*

of his delicacy of invention and technical refinement. Many of the great book illustrators of the period also feature in the collection: Beardsley, du Maurier, Charles Keene, Kate Greenaway, Edmund Dulac and Beatrix Potter among them – the last represented by the complete set of watercolours illustrating *The Tale of the Flopsy Bunnies*.

All the major figures in British art from the 1880s onwards are represented, with particularly strong concentrations of the work of W. R. Sickert, one of the main links between Continental Post-Impressionism and England, Muirhead Bone, Charles Rennie Mackintosh, Wyndham Lewis, David Bomberg, Ceri Richards, Graham Sutherland, Henry Moore and the St Ives artists among many others. A number of interesting sketchbooks and albums include Henry Moore's *Shelter* sketchbook 1940–1. The collection also embraces work by contemporary British artists

280 DAVID SMITH (1906–65). Untitled (1951)
Oil and gouache. David Smith's artistic reputation has rested largely upon his sculpture, yet painting and drawing also played a vital role throughout his career. The drawings were conceived more as a parallel means of exploring certain ideas rather than being direct preparatory studies for sculpture. 66.5 × 50.4cm.

such as Frank Auerbach, Lucian Freud and Howard Hodgkin.

A small group of drawings by American artists are mainly of the late-nineteenth and twentieth centuries. The most notable examples are an *Amsterdam Nocturne* (1883–4) by J. A. M. Whistler, a fine selection of J. S. Sargent watercolours and more recent works of the post-Second World War period by David Smith, Hans Hofmann, Franz Kline, Jim Dine and Sol LeWitt.

280

PRINTS

The multiplication of visual images began in Europe, in south Germany and Italy, in the first half of the fifteenth century, rather before the earliest dissemination of the written word by movable type. Prints have been used for many purposes: not only as original works of art and as reproductions of works of art, but also for book illustration, for religious or political propaganda, for the recording of historical events and the appearance of famous people and as patterns for decoration – to name only a few of their innumerable uses. Until the invention of photography in the mid-nineteenth century images could only be multiplied by means of the traditional hand-crafted techniques of the printmaker. The new photographically based technologies produced a further category of photomechanical print; prints of this type have in general not been acquired by the Museum. But before this point the most important distinction is between the 'original' print, in which the artist exploits the resources of the medium in order to produce a work of art, and the reproductive print, in which he reproduces a design by another. The Department possesses one of the finest and most complete collections of original prints in the world. Over and above these there is a vast mass of prints that are of interest primarily for the information of one kind or another that they convey.

Prints can also be categorised by technique. With intaglio prints (engravings, etchings, drypoints) the design is incised in a metal plate which, after being inked, is wiped clean and printed under pressure so that the ink remaining in the incised lines is forced out on to the paper. In the relief-printing process (woodcuts, wood-engravings and metal-cuts) the white areas are cut away on the block, leaving the lines that print standing in relief. In surface prints (lithographs and screenprints) the printing surface is neither raised nor lowered. In addition, there are the 'tone processes': stipple and aquatint (varieties of etching and almost always used in conjunction with the etched line) and mezzotint. In the latter the plate is first roughened so that if inked it would print dead black, and the lighter areas are then burnished down.

The earliest techniques were woodcut and engraving on metal. Relief printing from woodblocks was first used for the decoration of textiles and in the manufacture of playing-cards, and for the crudely executed representations of religious or devotional subjects made as souvenirs for pilgrims. The wider use of the process coincided with the invention of printing, for since text and block can be printed together it was ideally suited to book illustration. The history of woodcut in the fifteenth and sixteenth centuries is thus closely involved with that of the printed book, and the Department possesses, in addition to cuts either issued separately or extracted from books, a considerable

281 ANONYMOUS GERMAN. Christ before Herod (early 15th century AD)
Woodcut. One of the finest woodcuts surviving from the earliest period of the use of the medium in Europe. It is known in only two impressions, both found pasted inside the cover of a single book. 39.5 × 28.5cm.

collection of books with woodcut illustrations, chiefly German. The culmination comes at the beginning of the sixteenth century with Dürer, to whom about 150 woodcuts are attributed (some of the original woodblocks are in the collection), and with the woodcuts produced in Venice in the circle of Titian, many after his designs. An earlier Venetian masterpiece is the great bird's-eye view of Venice, dated 1500, by Jacopo de' Barbari.

Though the process was used throughout the sixteenth century, it gradually gave way to metal engraving; but a significant new development was the introduction of the 'chiaroscuro' woodcut, printed in colours from two or more blocks in imitation of a wash drawing. Of these the Department has a good collection, from Ugo da Carpi in the early sixteenth century to the English amateur John Skippe at the end of the eighteenth. Woodcut later came to be used mainly as a cheap method of illustrating chapbooks and broad-

282 ATTRIBUTED TO ESAIAS VAN DE VELDE
(*c.* 1590/1–1630). Arcadian landscape (*c.* 1615)
Woodcut with two tone blocks in shades of green. Only recently
attributed to van de Velde, this remarkable landscape shows the
method of 'chiaroscuro' colour woodcut printing invented in
Germany and Italy in the early sixteenth century.
18 × 24.8cm.

sides, but towards the end of the eighteenth century there was a revival of the process when it was discovered that a block of very hard wood, such as box, cut across the grain, could be worked with engravers' tools. The wood-engraving thus differs fundamentally from the woodcut, which is made with a knife on a block of softish wood cut along the grain, and its effect depends largely on the use of white line on black. Wood-engravings are usually small in scale, but some of the most beautiful work ever done on wood was produced in the early nineteenth century by Thomas Bewick, William Blake (in the illustrations to Thornton's *Virgil*) and, under Blake's inspiration, Edward Calvert. (The blocks of Blake's *Virgil* and of Calvert's five wood-engravings are in the Department). In the middle years of the nineteenth century wood-engraving was much

used as a reproductive process for book illustration, and its practitioners displayed astonishing skill in translating the pen-and-ink drawings made by the artist on the block. The Department owns a large collection of proofs from the workshop of the most famous of these engravers, the Dalziel brothers.

Towards the end of the nineteenth century the revival of fine printing, associated above all with William Morris and Charles Ricketts, brought with it a revival of woodcut illustration that was at first consciously inspired by fifteenth-century northern and Italian examples. The revival continued until well into the following century, mainly on traditional lines; but of particularly original work in this medium should be mentioned the woodcuts of William Nicholson and Paul Nash, and the semi-abstract experiments of Edward Wadsworth. In Germany the revival of the woodcut took a quite different direction, and it became the favoured technique of the Expressionists, mostly notably the members of the artists' group *Die Brücke* (The Bridge) founded in Dresden in 1905 (Ernst Ludwig Kirchner, Erich Heckel and Karl Schmidt-Rottluff).

A process which involved the use of metal plates but

283 KARL SCHMIDT-ROTTLUFF (1884–1976).
House behind trees (1911)
Woodcut. Schmidt-Rottluff was one of the four founding
members of the Dresden group Die Brücke *(The Bridge), which*
played a pioneering role in the development of German
Expressionism. 20.4 × 26.2cm.

which is essentially analogous to woodcut rather than to
metal engraving was the method of 'relief etching'
invented by William Blake for the production of his
illustrated books. The design was drawn with the 're-
sist' so that the areas to be left white were bitten away,
and the plate was printed in same way as a woodblock.
The Department has a very good collection of Blake's
illustrated books.

Printing from engraved metal plates originated, like
woodcut, in south Germany and Italy in the early
fifteenth century, and developed from the goldsmiths'
practice of taking impressions from ornamental engrav-
ing on their works. This origin is reflected in the timid
technique of the earliest German engravings and in
those Florentine ones classified as the 'Fine Manner'.
(Closely related in style to these is the volume of
drawings in the Department known as the 'Florentine
Picture Chronicle'.) Another group of Florentine en-
gravings is classified as the 'Broad Manner', and to that
tradition belongs not only the one indisputable master-
piece of the Florentine school, Antonio Pollaiuolo's
Battle of Naked Men, but also the engravings of the
Mantuan master, Andrea Mantegna. The seven plates
now accepted as being from Mantegna's hand repro-
duce the effect of his vigorous style of drawing in pen

and ink. As an original creative process, line-engraving
reached its height in the late fifteenth and early six-
teenth centuries with Mantegna, Dürer and the Ger-
man 'Little Masters' (Beham, Pencz, Aldegrever and
others, so-called because of the small scale of their
plates), Marcantonio Raimondi in Italy, and Lucas van
Leyden in Holland. Dürer and Lucas van Leyden were
wholly original engravers, responsible for the design
and the execution of their plates. Marcantonio's early
original plates are of little interest, but those after
Raphael, with whom he worked in close collaboration,
are among the greatest and most influential reproduc-
tive engravings. The last major exponent of original
engraving, at the beginning of the seventeenth century,
was the Dutch Mannerist Hendrick Goltzius; tech-
nically brilliant though he was, with him virtuosity
seems to have become an end in itself. From the early
seventeenth century onwards line-engraving was more
and more confined to reproduction; and though an
ever-increasing degree of technical skill was developed,
engraving as a medium of original creative expression
gave way to the altogether freer and more rapid process
of etching.

In an engraving the line has to be laboriously incised
into the metal, whereas in etching the plate is coated

284 WILLIAM BLAKE (1757–1827). God creating the
Universe (1794)
Relief etching. This plate was originally made as the frontispiece
to Europe, a Prophecy, *written and illustrated by Blake in*
1794, using a method of relief etching of copper plates that he
had invented himself. 23.3 × 16.8cm.

In his hand he took the Golden Compasses, prepared
In Gods eternal store, to circumscribe
This Universe, and all created things.
One foot he center'd, and the other turn'd
Round through the vast profundity obscure,
And said, thus far extend, thus far thy bounds
This be thy just circumference, O World!

Milton

with an acid-resisting substance, either wax or resin (the 'resist'), through which the design is scratched with an etching needle and then bitten by immersion in acid. The potentialities of the medium for free and direct expression were not all at once recognised. Dürer, for example, experimented with it but the results do not differ fundamentally in treatment from his engravings, and it is broadly true to say that in the sixteenth century the process was mainly used either in combination with line-engraving or as a short cut to achieving the same effect. There are a few exceptions, notably Parmigianino, who has the distinction of being the first 'painter-etcher', and from whose hand seventeen etchings are known, characterised by the same graceful elegance as his drawings, and Federico Barocci. But it was not until the first half of the seventeenth century, in Holland, that the process was first properly exploited, by Hercules Segers and, even more, by Rembrandt.

Segers's landscape etchings, often printed in coloured ink on tinted paper or even cloth, display an extraordinary degree of freedom and fantasy. They are extremely rare, but the Department possesses twenty-four – a number exceeded only by the considerably larger group in the Amsterdam Printroom. Rembrandt's output was far greater and his range far wider. The three hundred or so etchings that are generally accepted as his represent landscapes, portraits, biblical subjects and *genre* scenes. Many, particularly the later ones, use much drypoint (direct incision into the plate with a sharp point) in addition to etching, and most plates are known in several 'states' (a term denoting any alteration to a plate). In the vast majority of prints differences of state, when they exist, are of trivial importance; but Rembrandt's show him developing his ideas as he went along, and by preserving his successive changes of mind they provide a unique insight into the creative process.

288 Francisco Goya (1746–1828). A caza de dientes (Hunting for teeth)
Etching and aquatint. Plate 12 of Los Caprichos *(1799). This set of eighty plates satirises the vices and follies of his time. The teeth of a hanged man were regarded as aphrodisiacs. 21.5 × 15cm.*

289 PABLO PICASSO (1881–1973). Minotaur and sleeping girl (1933)
Drypoint. One of the so-called Vollard Suite, *a collection of a hundred of Picasso's finest plates of the 1930s published together by Ambrose Vollard. 30 × 37cm.*

Original etching was widely practised in Holland in the seventeenth century by many besides Rembrandt and his followers. The work of all these artists is very fully represented in the Department. But in his range of subject matter and profundity of treatment, as well as in his technical mastery of the medium, Rembrandt stands alone in his own period and overshadows all but one or two of his successors. There were others working in the early seventeenth century for whom etching was the primary means of expression: Jacques Callot, a native of Nancy who worked in Florence, and Stefano della Bella, a Florentine by birth, both of whom etched more than 1,000 plates; and Wenceslas Hollar, a native of Bohemia who worked in England, and who produced as many as 2,700. The etchings of all three are of very varied subject matter and tend to be small in scale. In the eighteenth century the most outstanding original etcher was Giovanni Battista Piranesi, who worked on a large scale and specialised in architectural fantasies and in views, equally touched with fantasy, of ancient and modern Rome.

Two technical innovations were introduced in the course of the eighteenth century: soft-ground etching, which reproduces the effect of a chalk drawing, and aquatint, in which an area of tone is achieved by biting the plate through a partly porous granular resist. These were mainly used in reproductive engraving, though Gainsborough etched a number of soft-ground landscapes and in many of Goya's etchings aquatint is used to great effect in combination with the etched line. Francisco Goya is the only etcher unquestionably in the same rank as Rembrandt. The series that he produced, *Los Caprichos* (a series of satirical prints on the vices of his times), *The Disasters of Wars* (on the atrocities of the Napoleonic invasion of Spain and the reaction after the

288

290 WILLIAM DOUGHTY (1757–82) Dr Samuel Johnson
(1779)
After Sir Joshua Reynolds (1723–92)
*Mezzotint. Doughty was apprenticed as a painter to Reynolds
and married one of his servants. This is one of six prints after
Reynolds' paintings that Doughty made in 1779–80 before
leaving England to seek his fortune in Bengal. 45.4 × 32.9cm.*

restoration of the royal family) and the mysterious
Disparates (Follies), are unique in their powerful and
unforgettable combination of satirical bitterness, fan-
tastic imagination, brutality and compassion. The other
late eighteenth- and early nineteenth-century etchers,
in Germany, France and Britain, were mainly inspired
by Dutch seventeenth-century masters. What has been
called the 'etching revival' began in the middle of the
nineteenth century in France, with the painters of the
Barbizon school – Rousseau, Daubigny, Millet and the
rest – Charles Meryon (who was exclusively an etcher),
and James McNeill Whistler, equally well known as a
painter. Many of Whistler's best etchings (e.g. the
'Thames Set') were produced in England, and his
technique owes much to his years in France and to the
example of Meryon. In his artistic aims he differs so
completely from Rembrandt and Goya that comparison
is hardly possible, but he certainly approaches them in
technical mastery. Other nineteenth-century etchers
include Seymour Haden, whose landscape etchings are
strongly influenced by Whistler, his brother-in-law,
and the more isolated figure of Samuel Palmer, best
remembered for his early visionary landscape drawings

of the 1820s, who etched a few plates that are among
the best work of his later years. Of succeeding gener-
ations, the Department has excellent collections of
the work of almost all the leading figures in Britain,
from the Scotsmen Cameron, Bone and McBey to the
Englishmen Augustus John and Sickert. The greatest
etcher of the twentieth century is Picasso, and by him
the Department has a small but reasonably representa-
tive collection of prints.

Mezzotint, invented in the middle of the seventeenth
century by Ludwig von Siegen, is a tone process,
differing essentially from all others in that the artist
works from dark to light. Although its earliest masters
such as Prince Rupert and Vaillant worked on the
Continent, the process soon came to be associated with
England, where in the eighteenth century mezzotint
engravers attained an extraordinary degree of technical
skill in the reproduction of portraits by Reynolds,
Gainsborough and their followers. In the early
nineteenth century mezzotint on steel was used to great
effect by John Martin and J. M. W. Turner, im-
pressions of whose very rare *Little Liber Studiorum* are
in the Department. Stipple was another process that
came to be an English speciality, and its most famous
practitioner, Francesco Bartolozzi, made over a
thousand plates while resident in London.

Lithography was invented at the very end of the
eighteenth century by the German Alois Senefelder. It
involves the use of a particular kind of limestone and the
chemical fact that grease repels water. The design is
drawn in a greasy ink-absorbent chalk or ink either
directly on the stone or on lithographic transfer-paper
from which it is transferred to the stone, which is then
wetted, inked, and printed. The essence of printmaking
as a creative art lies in the skill with which the artist
adapts his conception to the technical limitations of the
process. This element of conflict hardly exists in
lithography, which provides an exact facsimile of a
free-hand drawing, and the process was in fact mainly
used as a cheap and convenient means of reproduction.
There were, however, a number of 'artist lithographers'
who produced original work in this medium; the most
successful were the chalk lithographs which took
advantage of the grained surface of the stone and the
possibilities of scratching down the surface to create
highlights to produce uniquely beautiful effects: Goya
(the first major artist to experiment with the process); in
France, Géricault, Delacroix, Daumier, Manet,
Toulouse-Lautrec, and the symbolist Odilon Redon; in
England above all Whistler and C. R. W. Nevinson.

Since the Second World War lithography has be-
come perhaps the most popular medium of printmak-
ing, partly because it can easily be adapted for colour
printing. In France the major figures were Picasso and
Dubuffet; in America a number of specialist workshops
devoted to lithography opened around 1960, and pro-

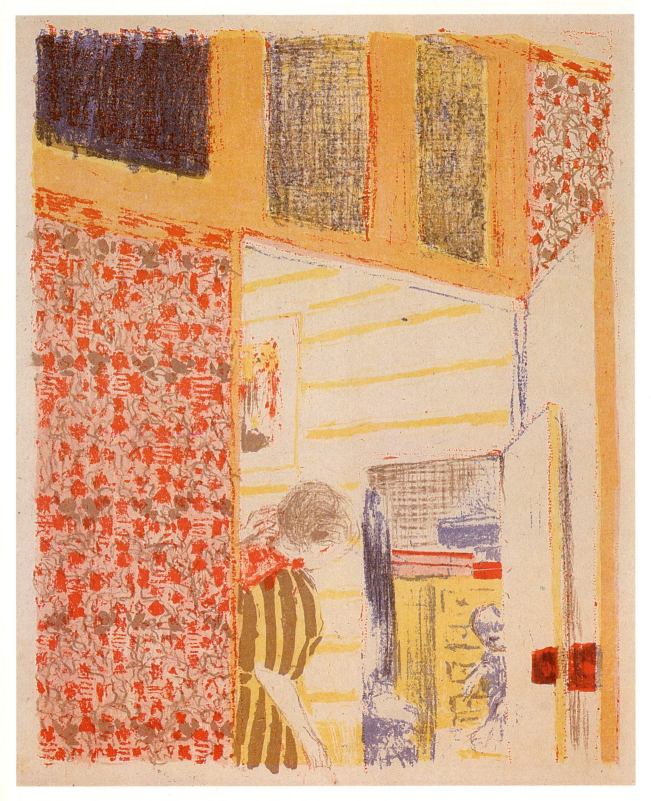

291 EDOUARD VUILLARD (1868–1940). Interior with red wallpaper (1899)
Colour lithograph. From a series of twelve colour lithographs Paysages et Intérieurs *(Landscapes and Interiors) commissioned by the publisher Ambrose Vollard.34 × 27cm.*

292 VASILY KANDINSKY (1866–1944). The Mirror (1907)
Linocut printed in five colours from two blocks. An example of Kandinsky's early style, made in Munich in the years shortly before his development of abstract art. Later in the 1920s Kandinsky taught at the Bauhaus in Weimar and Dessau. 32 × 15.8cm.

vided facilities for Jasper Johns, Robert Rauschenberg and their numerous successors. The Department has a few representative works by all those artists, but, in keeping with the historical nature of the collection, makes no attempt to buy contemporary works as they are published, leaving this to the Tate Gallery and Victoria & Albert Museum.

293 RIGHT ROBERT GWATHMEY (b. 1903). Hitch-hiker (1943)
Screenprint in colours. Screenprinting, a variety of stencil printing, was originally developed for commercial purposes in advertising and packaging. It was first adopted by artists for printmaking in the United States during the Depression of the 1930s. 42.7 × 33.2cm.

Screenprinting (or silkscreen or serigraphy as it is often called) is the youngest of the printmaking processes to be applied to fine art. It is in essence a stencil process by which parts of a silk or nylon mesh are stopped out with a paper stencil or with a brushed-on liquid, and ink forced through with a squeegee to the paper on the other side. Screenprinting was originally developed for commercial purposes in the early years of this century, and first used to make artists' prints in America in the 1930s. Its use spread to Europe in the 1950s, and a number of specialist firms established (the most famous in England is Kelpra, in Germany Domberger). It has been particularly liked by 'Pop' artists, who relished the intense colours that can be produced by thick layers of pigment, and the Superrealists who could build up their images with layer after layer of colour using no line at all. Examples of the main figures and types of screenprint may be seen in the Department.

The collection is not confined to original prints. Notable features of the reference collection are: reproductive engravings, classified by designers; reproductions of drawings, including the Gernsheim *Corpus Photographicum* of more than 120,000 photographs (still in progress); portrait engravings, classified by sitter; prints illustrating British and foreign history, classified by date; topographical prints and drawings, especially of London (these include the Crace collection of nearly six thousand London drawings and prints, the twenty-two volumes of the Potter collection of material relating to North London and seventeen portfolios of water-colour views of London made in the 1840s and 1850s by J. W. Archer); satirical prints, both political and personal, especially British from the seventeenth to the early nineteenth century; the three thousand photographs of the National Photographic Record made by Sir Benjamin Stone about 1900; the Banks and Heal collections of trade cards; Lady Charlotte Schreiber's collections of playing-cards, fans and fan-leaves; and the Franks, Rosenheim and Viner collections of book-plates.

WESTERN ASIATIC ANTIQUITIES

*T*he collections of the Department of Western Asiatic Antiquities include objects from many different areas and civilisations. Their geographical range covers virtually all those lands east of Egypt, south of the USSR, and west of Afghanistan and Pakistan. Greek and Roman remains from Western Asia itself are excluded, but the range extends westwards to include Phoenician colonies throughout the Mediterranean. The earliest items in the collections date from about 6000 BC, the latest are from the time of the first Muslim conquests in the seventh century AD.

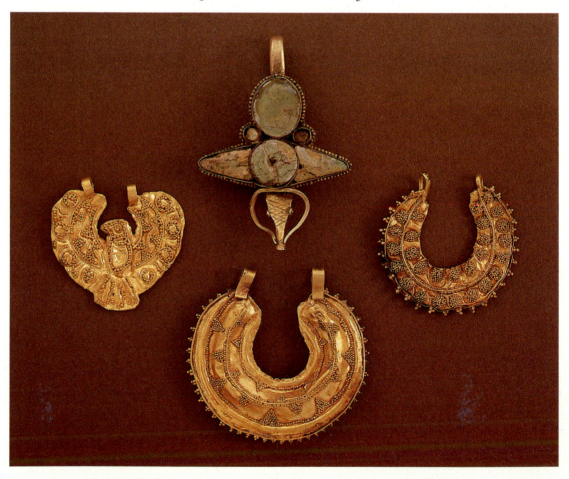

294 *Gold jewellery from Tell el-'Ajjul, southern Palestine. This was a prosperous city in the Middle and Late Bronze Ages. The jewellery, from the sixteenth century BC, well displays the artistry and skill of the Canaanite craftsmen.* W *(bottom pendant)* 4.57cm.

THE PREHISTORIC PERIODS

The earliest peoples represented in the collections had a way of life comparable with that of the unwesternised cultures which still exist here and there across the world. Material in the Museum of Mankind indicates the extraordinary richness and variety of surviving pre-industrial cultures, not only in material goods but also in social conventions and imaginative thought. The articles in daily use among them, however, are often made of perishable materials, such as wood, textiles, or skin. The same was evidently true of the primitive cultures of ancient Western Asia, and the things which are preserved in the earth for the archaeologist to discover give an unavoidably distorted picture of what life was then like.

The prehistoric collections of the Department consist largely of pottery, which has been found in large quantities on settlement sites, as well as a variety of stone and bone tools, terracottas and stone figures, beads and amulets. Such finds allow us to reconstruct something of the economic basis of prehistoric communities, and see that similar evolutionary pressures led time and again to similar solutions in widely separated areas.

The people relied basically on their own local resources, mainly as settled farmers or as migrant herdsmen or hunters. The smallest groups may have contained only a few families, but circumstances sometimes favoured the growth and survival of larger groups, where several thousand people were associated in interdependent units, or in single towns and tribes. Some groups lived in areas with local resources that were more than adequate for their own needs: resources like obsidian, a volcanic glass with a fine cutting edge; volcanic lava, which makes excellent grinding stones for grain; natural bitumen, for glueing and water-proofing; metals and metal ores; decorative coloured stones such as lapis lazuli; cowrie shells, and so on. Some items were exchanged over hundreds or even thousands of miles, perhaps accompanied by travelling merchants or craftsmen. At the same time there had to be occasional contact and competition between previously unrelated groups of people. Factors such as these ensured that widely separated areas shared, in some respects, a common culture.

Evidence of crafts is offered by bone and stone awls and needles from Mesopotamia of the Halaf period (*c.* 4500–4000 BC); these were used in leather-working. Spindle-whorls of clay indicate spinning. Other finds show that by about 3500 BC metalworking was estab-

295 Handmade pottery jar and bowl, each with a design of geometric ornament shown in black paint. From Tell al-'Ubaid, fifth millennium BC. H (jar) 5 cm.

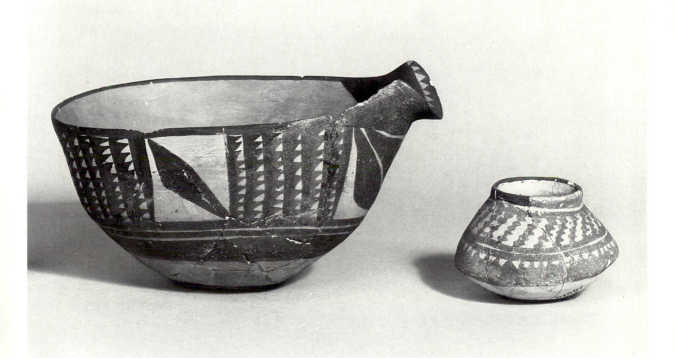

lished over a wide area of Western Asia. If excavation of sites yields information about the living conditions, a tiny steatite amulet in the shape of a hut from Arpachiyeh gives a more immediate picture, with its pitched roof. A terracotta model of a hut dated about 3300 BC from Azor in Palestine also has a pitched roof and overhanging eaves. This was a receptacle for the bones of the dead, and other similar ossuaries show further architectural details, such as windows, thatched roofs and pillars.

The pottery found at prehistoric sites provides an invaluable aid to the archaeologist in distinguishing one period from another. In Mesopotamia, for instance, incised wares of the Hassuna period (6th millennium BC) could never be confused with the fine painted wares of the Halaf period. There are many more such distinctions, seldom so conspicuous, which can even enable us to date an ancient site by an examination of the pottery fragments found on its surface. Studies of pottery also help to trace cultural influences across wide areas. For example, design motifs in the painted decoration of Halaf period pottery are found as far afield as north Syria and southern Anatolia.

Most of the prehistoric pottery was made on a slow wheel rotated by hand. Before being fired the smaller vessels were often painted with patterns which are sometimes reminiscent of basketwork. Pictures of

295

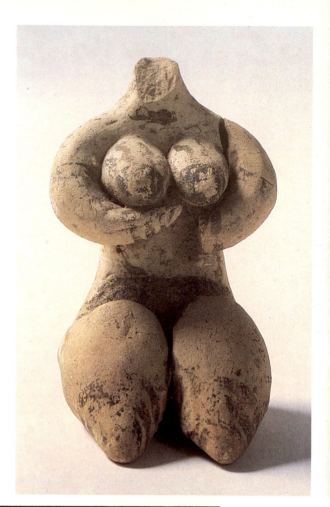

296 RIGHT *Pottery figurine showing a woman with prominent breasts, perhaps a goddess of fertility. From Chagar Bazar, Syria. Halaf period, about 5000 BC.* H *8cm.*

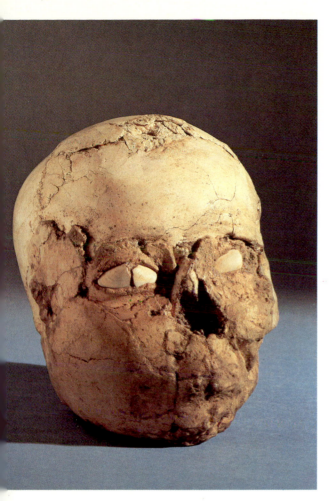

several found in an early level (6000 BC or earlier) at Jericho in Palestine. There is evidence that the head represented a dead relative and had been preserved in a family shrine.

Fortifications and religious buildings on a monumental scale were already being built in the pre-historic period. A reconstruction in the Museum using original materials shows part of a half-columned façade from a temple at Uruk in southern Mesopotamia dated about 2900 BC: geometric patterns were created by pressing coloured cones into wet plaster.

The same kind of mosaic decoration was used as far away as Brak in Syria. Fragments of the embellishment of the Eye Temple at Tell Brak, also dated about 2900 BC, include part of a frieze from the altar made from gold, limestone and shale; a rosette of marble, shale and pink limestone was one of several decorating the façade of the temple. Excavations at the Brak temple produced thousands of small amulets and 'eye-idols', probably offerings made to win the god's favour. An elegantly stylised human head also comes from this temple. The architecture of the temple and the artefacts found there have no identifiable local characteristics, and are further evidence of the strong cultural influence exerted by Mesopotamia.

THE INVENTION OF WRITING

The invention of writing and the keeping of permanent records allow us a much fuller glimpse of ancient society. The collections of the Department well illustrate the history of writing in the ancient Near East. A preliminary step towards the invention of writing was taken with the manufacture of stone seal stamps. The oldest date from before 6000 BC, but some of the finest in the collection are from the late prehistoric period, about 3500–2800 BC. They were used in much the same way as seals and signatures are today. To prove, for instance, that he was responsible for a delivery of oil, a particular person applied his personal seal to wet clay covering the stopper of the oil-jar; no-one could then open it without breaking the seal.

The first written records seem to have been receipts, sealed lumps of clay on which rows of circular impressions, representing numbers, were written; such receipts have been found from Syria to central Iran and may date back to 3500 BC. The British Museum's collection begins slightly later, when the impressed numbers were accompanied by simple pictures (pictograms). The head of an ox, for example, was used to indicate that the number of dots referred to the number of oxen. As it was not easy to incise curved lines on clay, the scribes simplified the characters to forms made up of straight lines. These were made by pressing one end of a wooden or reed stylus into clay; as the end of the stylus struck the clay first, it made a wider mark than the

297 LEFT *Group of stone amulets from the Tell Brak temple, Syria. The amulets, representing a pig, a ram and a fox, have the form of stamp-seals, with patterns on the base, but were apparently left in the temple as offerings. Jamdat Nasr period, about 3000 BC.* L *(ram) 4.5cm.*

298 ABOVE *Plastered skull from Jericho. Several such skulls, dating to the seventh millennium BC, were found at Jericho, and are thought to have been connected with some form of ancestor cult.* L *20.3cm.*

people and animals are relatively scarce, and they are drawn, when they do appear, in a schematic form which exaggerates some physical characteristics and omits others. The attitude to living subjects can also be seen in prehistoric figures. Some of these, notably two from Chagar Bazar in Syria which seem to show women offering the breast, emphasise the importance of fertility beliefs in many early farming communities. The nature of the subject is tolerably obvious, but there is no attempt at realism. Another aspect of prehistoric religion is represented by a plastered human skull, one of

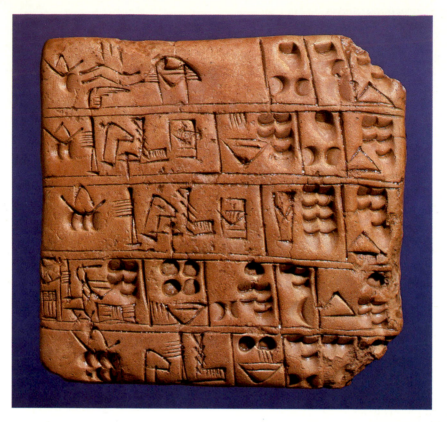

299 ABOVE *Clay tablet of the Jamdat Nasr period, about 3000 BC, with an administrative text. Although the pictographic origin of the script is still clear, individual signs are beginning to evolve into a truly cuneiform script. 7.8 × 7.8cm.*

301 BELOW *Akkadian cylinder-seal of lapis lazuli with gold mounts. The seal is carved with scenes of combat between heroes and animals, and there are traces of the owner's name. From Ur, Iraq, about 2100 BC. H 4.3cm.*

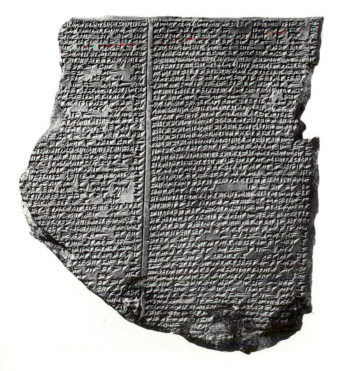

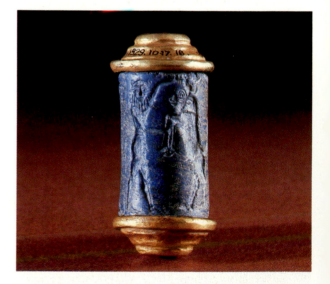

300 LEFT *Clay tablet from Nineveh with the Babylonian account of the Flood, from the Epic of Gilgamesh. At the instruction of the god Ea the hero Utnapishtim successfully builds a boat. Seventh century BC. 13.5 × 15,3cm.*

shaft, so that the impression formed was characteristically wedge-shaped. The pictograms were increasingly stylised until in time the characters were no longer recognisable as pictures of objects. The signs or characters included word signs (logograms) and phonetic signs (phonograms) representing syllables which could be used to spell out words.

This script is now known as cuneiform ('wedge shape'), and was eventually used to write records of many kinds in several different languages. The material on which it was written remained, most commonly, damp clay; this was available everywhere, retained its shape when dry, and could always be baked if a permanent record was required. The British Museum possesses a vast collection of cuneiform tablets, representing a wide range of literature, from economic and administrative records, legal documents and letters, magical, astrological and mathematical texts, to historical records, and myths and legends.

Cuneiform tablets, like prehistoric receipts, were often authenticated by means of seals in stamp form in the early period, about 3000 BC. These were generally cylindrical in shape, and were rolled over the surface of the clay. The carvings on these seals, though miniature in size, are among the finest products of ancient Mesopotamian art.

There are many different styles, but the best of all are perhaps those produced in the Akkad period (c. 2370–2100 BC). One has to look at them very closely to appreciate the quality of the workmanship and the concentrated vitality of the figures. The subject matter ranges from offering scenes to contests between men and animals and depictions of deities.

The development of cuneiform for use in complex documents was a gradual process, but it had been completed by about 2500 BC, when it was in use in the Sumerian cities of southern Mesopotamia.

THE HISTORICAL PERIODS

The Sumerians appear to have been the heirs of the prehistoric culture of Mesopotamia, whose influence was widely felt throughout the Near East: certainly their civilisation was strongly influenced by what had gone before. A gypsum trough, which shows sheep returning to the fold where their lambs are waiting, is the Museum's finest example of Mesopotamian art about 3000 BC. This may have come from Uruk, where a magnificent temple complex continued to flourish in the Early Dynastic Period (c. 2800–2370 BC).

The inlaid decoration from the façade of a temple at al-'Ubaid (c. 2600 BC) included another series of pastoral scenes. Still more imposing, and of great technical interest for the history of metallurgy, are the copper heads and plaques representing lions, cattle, and deer. The columns of this same temple façade were found fallen in a heap, together with the rest of the decoration, but have been restored on reliable evidence. They were originally made of palm-tree trunks coated with bitumen, and their surface was then covered with shaped pieces of pink limestone and mother-of-pearl.

The temples of Sumer owed their great wealth to the theocratic system of government which existed in many Sumerian sities. The priests and controllers of the temple bureaucracies established themselves in power, and spent the surplus wealth of the community not only on the temples but also on themselves. The results of this policy are seen most dramatically in the Royal Tombs of Ur.

The city of Ur lay close to the Euphrates. Archaeologists were first attracted by its 'ziggurat', a massive brick tower which once had a temple on top, but excavations in the 1920s also uncovered a cemetery which had remained in use for centuries. The excavator, Sir Leonard Woolley, was working on behalf of the British Museum and the University Museum, Philadelphia, and these two institutions were each awarded a quarter of what the expedition found; the other half remained in Baghdad. Even the British Museum's share, however, amply demonstrates the lavish way in which the tombs were furnished, and the extraordinary skill which Woolley brought to the task of excavating them. The finest articles in the collection are

302 Sumerian stone trough showing lambs emerging from a reed hut to meet a flock of sheep. This trough, from Uruk, Iraq, probably comes from a temple of Inanna, goddess of fertility. About 3500–3000 BC. L 96.5cm.

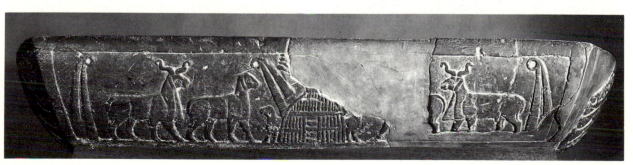

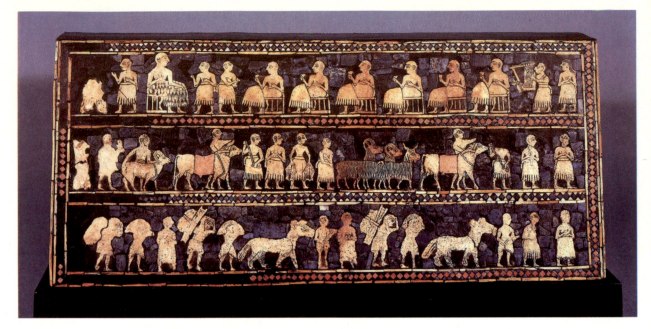

303 *The Standard of Ur: a wooden box inlaid with stones and shells. This side shows the king celebrating at a banquet (top row), while servants bring animals and other goods below. From the Royal Cemetery at Ur, about 2500 BC. L 49.5cm.*

thought to have belonged to the ruling family at a time, about 2500 BC, when Ur was the most powerful city in Mesopotamia. Sometimes the dead man or woman had been accompanied to the grave by as many as sixty attendants, who brought with them everything necessary to ensure that their master continued to live, after death, in the style to which he had been accustomed. Woolley's discovery of these 'death-pits' aroused extensive controversy among scholars at the time, as Mesopotamian literature is singularly devoid of reference to any such macabre ceremonies.

We can still see the skulls of a helmeted soldier and of a female attendant wearing a jewelled headband, as they were found crushed in the ground. Some of the finest objects, however, have been restored to their original shapes. The goat with his forelegs resting on a tree – often called the Ram in the Thicket because of a fancied connection with the story of Abraham and Isaac – is one of a pair. The two probably supported a small table on which delicate vessels of gold and silver, or the Sumerian equivalent of a chess-set may once have stood. This highly ornamental goat was made on a simple wooden core; the surface consists of carved stones, shell and sheet metal, with bitumen as glue. Musical instruments were constructed in the same way: the British Museum has one silver lyre, and another pair of inlaid instruments, a harp and a lyre, which have been restored in wood. The sounding-boxes of the lyres represent bulls, and a text tells us that the music was imagined as coming out of the animals' mouths.

A lyre of the same kind is shown in a scene on the so-called Standard of Ur, a lectern-shaped box with mosaic panels all round. One of the two main sides shows people bringing gifts and tribute; the lyre-player is entertaining the king and his high officials at a banquet in the top row. The other side shows a different aspect of Sumerian civilisation, with chariots charging, and warriors bringing captives into the royal presence. The chariots are pulled not by horses but by a kind of ass native to Mesopotamia; one of these animals is represented on an electrum rein-ring which was part of the harness attached to a queen's ox-drawn sledge. The collections also include a large quantity of jewellery, such as the queen's attendants wore. It is worth noting that all the metals used, together with the cornelian and lapis lazuli, must have been imported.

Life-size Sumerian sculpture is represented by the statue of a slightly later ruler, about 2100 BC, almost certainly Gudea of the state of Lagash. This statue would have been set up in a temple, to encourage the god to look after the ruler's interests. Most Mesopotamian statues are far smaller than this, as the blocks of stone had to be brought from outside the Tigris-Euphrates plain, and the problems of moving them must have been considerable.

In the early part of the second millennium BC Baby-

304 *Ram feeding at a bush. This figure is decorated with gold, copper, shell, lapis lazuli and other stones. It comes from one of the Royal Tombs at Ur, Iraq, and may once have been part of a stand. About 2500 BC. H 46cm.*

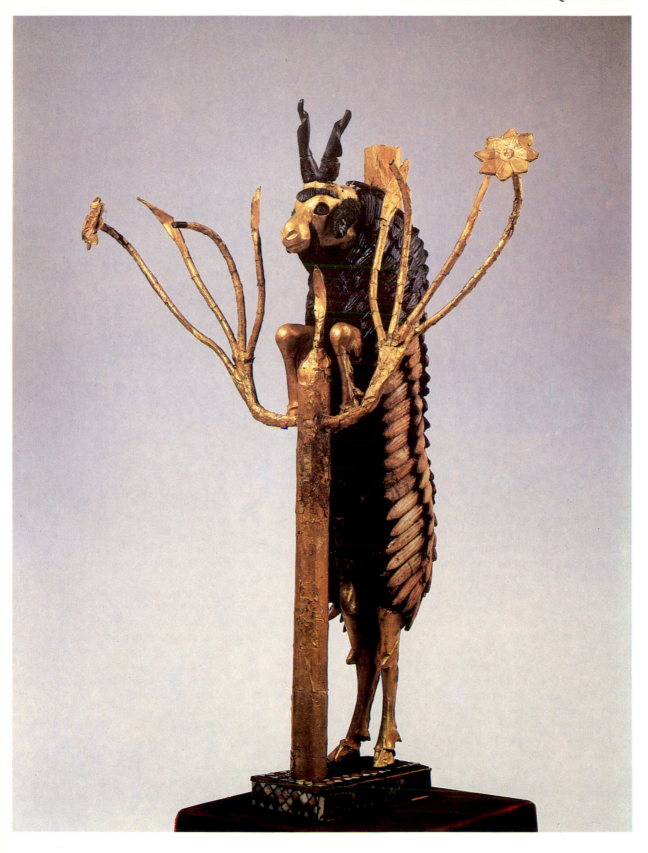

305 *Assyrian and Babylonian stone weights in the shape of ducks. Mesopotamian rulers took great trouble to ensure that traders used correct weights. Their* mina *weighed about half a kilogram. From Iraq, about 2000–500 BC. L (largest) 14cm.*

305

Ionia achieved supremacy in Mesopotamia under its most famous king, Hammurapi (1792–1750 BC), whose capital was at Babylon. The Old Babylonian levels at the site have scarcely been excavated, but the collections contain much material of the same date from other sites in Mesopotamia. Particularly interesting are the series of terracotta plaques showing scenes of daily life, female fertility figures and erotic pleasures. The collections also contain vast numbers of cuneiform tablets from the site of Sippar, including economic and legal texts. Perhaps the most interesting item is an inscribed model of a sheep's liver, used by diviners to interpret omens.

Syrian civilisation shared the same prehistoric background as Mesopotamia on the one hand and Palestine on the other. During the third millennium BC, however, a distinctive culture flourished in the central and northern parts of the country which was distinctively Syrian. Characterised by wonderfully fine, almost metallically hard pottery, this culture became known as 'calciform', on account of the ubiquitous cup- or goblet-shaped vessels present in the repertoire. Excavations at major sites such as Hama, Qatna and Ebla have revealed a level of cultural sophistication and architectural refinement to rival that of Mesopotamia. Terracotta figurines

were produced in great quantity, and the collections contain many examples of the distinctive types found in the Euphrates area, which have pillar bases in place of legs, exaggerated facial features and elaborate hairstyles.

During the second millennium BC the city-states of Syria exerted considerable political influence. One of the most important was Alalakh, and the collections contain many of the finds recovered during excavations between 1937 and 1949. Perhaps the most impressive of these is the statue of one of the city's rulers, King Idrimi (c. 1550 BC), carved in a somewhat austere and simplistic style, quite unlike contemporary sculptures in Mesopotamia.

Palestine, during the third millennium, was an active commercial centre. An economy based on productive agriculture and trade led to the development of sophisticated urban centres, with well-planned houses, palaces, temples and, in many cases, substantial fortifications. Tombs of the period were often large, and contained multiple successive burials. The Museum has objects from such tombs excavated at Lachish in the 1930s. The elegant pottery vessels, many covered with a bright red slip and highly burnished, testify to the skill and artistry of the Early Bronze Age potters. The collections also contain many of the impressive copper weapons (daggers and javelins) and bead necklaces recovered from these tombs.

Towards the end of the third millennium Palestine's main trading partner, Egypt, failed, with the collapse of the Old Kingdom. Objects from this period reflect the

Canaanites soon established a firm reputation as skilled artists and craftsmen. Examples of rarely preserved carpentry can be seen in the furniture excavated from tombs at Jericho near the Dead Sea. The Museum has reconstructed one of these tombs, which in addition to the furniture, includes pottery vessels, wooden boxes and platters, and baskets. Jewellery of this period shows highly developed techniques of granulation and repoussée. The fine collection from Tell el-'Ajjul well illustrates these features, and also includes pendants bearing highly stylised representations of the goddess Astarte.

Canaanite Palestine, open to sea-faring traders of the eastern Mediterranean became a cosmopolitan centre. Cypriot and Myceanaean objects were imported, and these were skilfully imitated by local craftsment. One of the most characteristic imported Cyptiot juglets was modelled in the form of a poppy-head. Known as 'bil-bils', these vessels are thought to have been used to transport opium. The 'bil-bil' was copied by the Canaanite potters and became a popular and elegant tableware.

During the second half of the second millennium Palestine (and part of Syria) formed part of Egypt's New Kingdom empire, and the diplomatic correspondence between the pharoahs and their subject Canaanite princes has been preserved in the fascinating documents known as the Amarna letters. Found at Amarna in Egypt, they include appeals for help from attacks of the 'Hapiru', identified by some as the biblical 'Hebrews'.

The Amarna letters were written in Akkadian cuneiform, as indeed was most of the formal diplomatic correspondence at this time. It was the Canaanites who, during the second millennium BC, developed a new and much simpler writing system, which was to have a major and lasting impact upon later civilisations. In its earliest stages, as illustrated by the Sinai Inscriptions, this system used pictograms to represent the initial consonantal value of the word depicted. By selecting and standardising a set of these pictograms every sound in the language could be represented by a single symbol. This was the basis of the alphabet, and because it relied upon single consonants (plus signs to stand for the vowels) rather than syllables, only twenty-five or so signs were needed, unlike the cumbersome Akkadian system which required over six hundred.

The alphabet system spread among the Phoenicians and other Semitic-speaking peoples of the eastern coast of the Mediterranean. The inhabitants of Ugarit, modern Ras Shamra near Lattakia, and subsequently the Achaemenid kings, used alphabets written in types of cuneiform. Both were eventually replaced by alphabets drived from the Phoenician, which could be written at greater speed on materials like paper.

The Semitic alphabet developed in several direc-

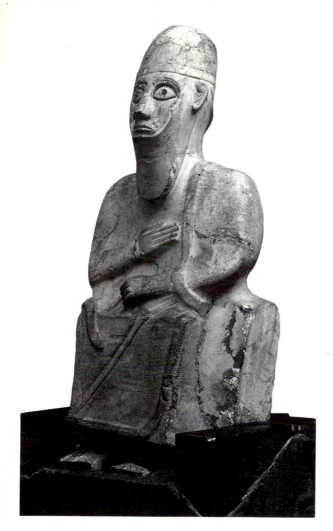

306 *Statue of Idrimi, King of Alalakh, Syria, in the sixteenth century* BC. *The statue would almost certainly have been painted, and the eyes and eyebrows were inlaid with black stone.* H *1.1m.*

recession that followed in Palestine: tools and weapons become heavier, pottery becomes simpler and more functional. Examples of the pottery and metalwork of this interesting period are illustrated by the finds from Tiwal esh-Sharqi in Jordan. Dating to about 2300 BC, the objects placed in the deep shaft-tombs as funerary offerings include fine handmade pottery jars, copper daggers and javelins, necklaces of cornelian beads and distinctive four-spouted pottery lamps.

In the second millennium BC the re-establishment of trade routes led to a return to city life in Palestine. The population, which is now referred to as 'Canaanite', generally chose to re-occupy sites which had been abandoned during the period of recession, creating high mounds (or *tells*), which they then fortified with smooth plastered slopes and massive ramparts. The

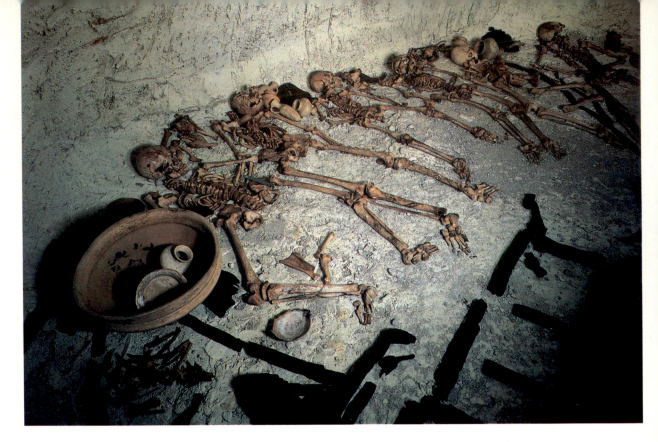

307 ABOVE *Reconstructed tomb from Jericho. In the Middle
Bronze Age (c. 1750–1650 BC) first one, then subsequently six
other individuals were interred in this tomb. It contained
pottery, as well as wooden furniture, rarely preserved elsewhere
in Palestine.*

tions. Hebrew, as written on the tomb of Shebnaiah at
Jerusalem, eventually became the square Hebrew script
still used today. The Aramaic script, used through
much of Western Asia for centuries, had several
descendants, including Armenian. The Arabic script
is again derived from the early Semitic alphabet.
The Greeks borrowed their own alphabet from the
Phoenicians, and the Russians took theirs from the
Greek. Most Western European languages now use
the Latin alphabet, which derived from the same source.

The end of the second millennium was, in the
Levant, one of the most confused and turbulent phases
of its history, with the historically documented incur-
sions of new peoples such as the Sea Peoples (including
the Philistines), the Aramaeans and the Israelites.
Amidst the confusion the Egyptians struggled to main-
tain control of their dwindling empire, establishing
garrisons at key strategic sites, such as Beth Shan in the

308 *Carved limestone stele with a Punic inscription in the
alphabetic Phoenician script of the western Mediterranean,
which records its dedication to the goddess Tinnit and the god
Ba'al Hammon. Third to second century* BC. H 26.7cm.

north and Gaza in the south. Excavations at Tell es-Sa'idiyeh in Jordan have brilliantly illuminated this final phase of Egyptian control. The site, which is identified as biblical Zarathan, was a major Egyptian outpost on the eastern side of the River Jordan, and excavations have revealed a part of the governor's residency. A rich and extensive cemetery has also been excavated, and the finds, many of which are now in the Museum's collections, reflect not only the prosperity of the city, but also the unusual and mixed nature of its population. For many of the objects show influences from Egypt, Anatolia, Cyprus and the Aegean, suggesting perhaps that the Egyptians had in their employ, in addition to local Canaanites, many other peoples of foreign origin. One of the most interesting objects is a beautiful ivory cosmetic box in the form of a fish. This piece, which is almost certainly of Egyptian manufacture, was found inside a bronze bowl which covered the genitals of the deceased.

In prehistoric times some of the earliest towns had developed on the Anatolian plateau, in what is now Turkey, but urban civilisation did not expand there as rapidly as in Mesopotamia. In the third millennium BC Anatolia was probably an important source of copper, and fine examples of metalwork have been found in tombs at Alaça Hüyük, about 2300 BC. A silver bull with high horns probably derives from this group. In the Yortan area, to the south of Troy, an undistinguished type of black burnished pottery was used, but those who could afford it possessed metal vessels, such as an elegant two-handled silver cup.

In the second millennium Hittites, who spoke an Indo-European language, built an empire in Anatolia, which extended into Syria and shared a border with the Egyptians. A cuneiform tablet in the Hittite and Luvian languages is one of thousands of tablets found in the royal archives at the Hittite capital of Hattusa (Bogazköy). The Museum's most remarkable example of Hittite workmanship is a series of miniature figures made of gold, lapis lazuli and stealite which represent Hittite gods and dignitaries. These were found in a grave at Carchemish on the Euphrates, a town which retained some aspects of Hittite culture long after the empire had collapsed around 1200 BC. Also from Carchemish is a series of sculptural slabs with texts in the language of Carchemish, which was related to Hittite but written in a heiroglyphic script. The style of the sculptures themselves is clearly reminiscent of Assyrian art; most of were in fact made in the ninth and eighth centuries BC, when Carchemish was an important trading centre under Assyrian protection. Other articles from Carchemish indicate the cosmopolitan character of what is sometimes called 'Syro-Hittite' art.

Despite the upheavals at the close of the second millennium BC, the Canaanite legacy of artistry and craftsmanship was preserved in a small area of the

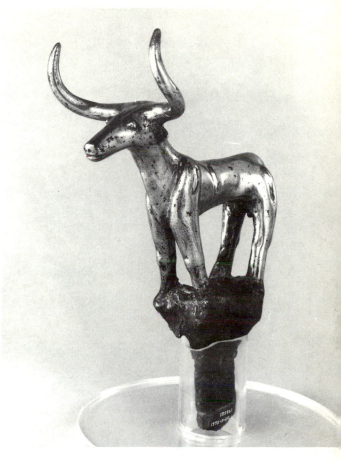

309 *Silver bull, probably the decorative terminal of a pole or staff, with gold inlay and standing on a base of copper. It is thought to have come from one of the rich graves at Alaça Hüyük, and dates to about 2300 BC. H 24cm.*

Levantine coast, which became known as Phoenicia. The Phoenicians, during the first millennium BC, refined and developed the already sophisticated eclectic style of the Canaanites, and their products, and at times the craftsmen themselves, were in great demand throughout the Near East.

The biggest contributor to their distinctive style was undoubtedly Egypt, and this influence can be clearly seen in the sphinxes and decorative motifs on a series of bronze bowls found in the Assyrian capital city of Nimrud; these must have been made between 900 and 700 BC. In addition to fine metalwork, the Phoenicians were renowned for their manufacture of jewellery, glass and, of course, the famous purple dye. However, it is perhaps in the field of ivory-carving that their artistic excellence can best be illustrated and judged.

The Museum possesses a fine collection of Phoenician ivories. Most were excavated in Assyrian palaces,

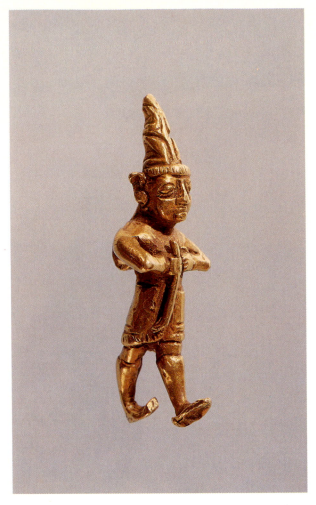

310 *Gold Hittite figure, probably representing a king. The collections contain a series of such miniature figures in gold, lapis lazuli and steatite. Fourteenth century* BC. H 3.94cm.

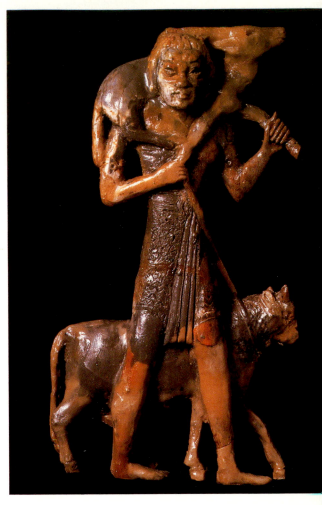

311 *Ivory figurine from Nimrud, depicting a kilted male figure carrying a gazelle on his shoulders and leading a bull or calf. The ivory has been discoloured by burning. About eighth century* BC. H 11cm.

where they had been taken as booty. Many are panels which would have been used as furniture decoration; some have alphabetic marks on the back, which indicated to the carpenter where to fix them. Some pieces came from toilet boxes, and others were fan- or whisk-handles. Occasionally a larger object, such as a chair, might be made entirely of ivory members: one piece in the collection is apparently a furniture-leg.

Some of the items are blackened by fire, but others retain the brilliant whiteness of fresh ivory. This can be misleading, as ivories were sometimes stained in different colours, and the richer pieces were covered with gold-leaf. Colour was also provided by red and blue inlays; these were normally made of glass, but we occasionally encounter cornelian and lapis lazuli too,

for instance on a plaque which shows a lioness holding an African by the neck. The delicate carving of this small panel is among the finest examples of Phoenician workmanship. It must be dated between 900 and 700 BC, a period during which large quantities of ivory furniture were transported to Assyria as war booty or as tribute.

The Phoenician ivories were often inspired by Egyptian models, so much so that some of them at first sight might seem to be Egyptian work. Towns in inland Syria, including probably Damascus and Hama, had their own schools of ivory craftsmen; ivories were also carved in Urartu, Babylonia, and in Assyria itself. Notable motifs on the Syrian and Phoenician ivories include the sphinx, the griffin, the grazing deer, the cow

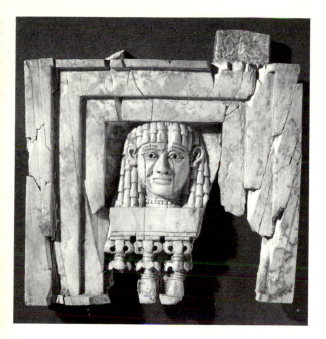

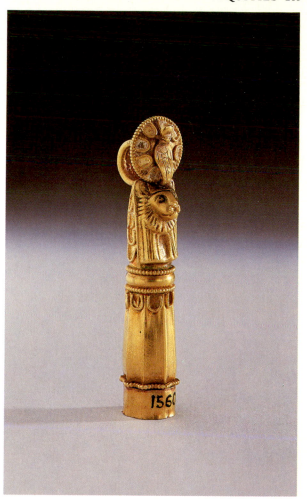

312 ABOVE *Ivory panel from Nimrud, originally part of a piece of furniture. The female head wearing an Egyptian-style wig and looking out of a window is thought to be an acolyte of the goddess Ashtarte. About eighth century* BC. H 10.7cm.

313 RIGHT *Gold amulet-case, probably from Tharros, Sardinia. The lion's head surmounted by a disc and uraeus indicates the Egyptian goddess Sakhmet. The hollow lower section once held an amulet. Sixth to fifth century* BC. L 4.5cm.

turning to lick her suckling calf, and the 'woman at the window', believed to be a picture of one of the Phoenician goddesses of reproduction and fertility. Although the ivories were mass-produced, each one seems to have some individual felicity of carving. We can see that the Phoenician reputation for ingenuity, mentioned by the early Greeks, was thoroughly well deserved.

With almost no effective hinterland to support an agricultural economy, Phoenicia turned to the sea in order to secure its prosperity. During the first millennium colonies were established throughout the Mediterranean, and expeditions were undertaken to places beyond. Cyprus was among the islands colonised from Phoenicia; an elaborate silver bowl, showing both Egyptian and Assyrian influence, comes from a grave at Amathus. A Phoenician cemetery has also been discovered as far west as Tharros in Sardinia. A large collection of material from the Tharros cemeteries is preserved in the Museum and includes fine pottery and much jewellery of high quality. The most famous of all Phoenician settlements, however, was the city of Carthage in what is now Tunisia; the Carthaginian

empire was at one time a serious rival of Rome. There are a number of stelae inscribed in the Phoenician (Punic) script; some were erected over the graves of children who had probably been sacrificed to the local god, a practice noted by several Greek and Roman authors.

Politically, the first millennium BC was dominated by the military campaigns of the Assyrians. Based in the valley of the River Tigris, Assyrian culture was distinctive, with its own dialect, and its own arts and institutions. The military expeditions of the neo-Assyrian kings, between the ninth and seventh centuries BC, extended their power from Egypt to the Persian Gulf, and deep into what are now Iran and Turkey. Their exploits were commemorated on carved stone slabs which lined the palace walls in the successive capital cities of Nimrud (ancient Kalhu), Khorsabad (Dur-Sharrukin), and Nineveh. The subject matter of these narrative carvings include military expeditions – sieges and battles, victories, and processions of tribute-bearers – as well of scenes of hunting and banqueting. These carvings offer an extraordinarily detailed picture

316

314

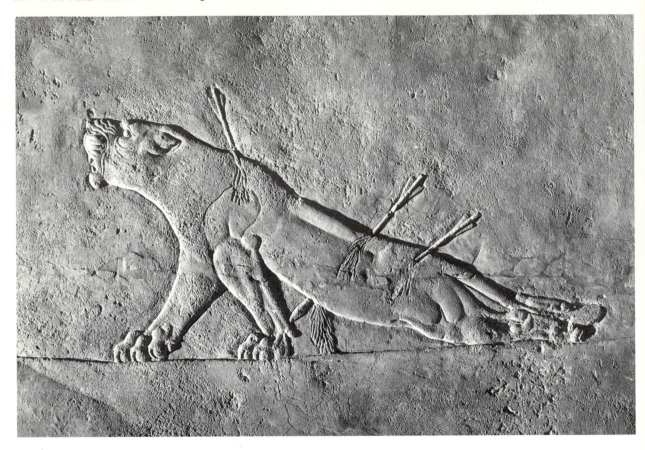

314 *Dying lioness: gypsum carving from the palace of Ashurbanipal at Nineveh. Hunting lions was a favourite sport of Assyrian kings. Such wild animals symbolised the forces of evil against which the king, as the champion of civilisation, was obliged to struggle. About 645 BC.*

of the Assyrian world as seen through contemporary eyes. The palaces which contained them were eventually destroyed in 612 BC by a combined army of Iranians and Babylonians.

The slabs in the British Museum were excavated between 1845 and 1855 principally by two men, Layard and Rassam. At that time Great Britain was a valued ally of the Ottoman Empire, and the excavators were allowed to remove the lion's share of what they found. Their discoveries, together with some already made by a Frenchman, Botta, first opened European eyes to the high achievements of Mesopotamian civilisation. The collection of sculptures brought back by them to England is still much the finest in the world. The British Museum is the only place where one can see so many sequences of magnificently preserved slabs, re-erected in their original order.

In addition to the sculptured slabs, the collections contain a number of free-standing sculptures, such as the imposing statue of Ashurbanipal II (883–859 BC). There is no pretence of naturalism: the king's features are no portrait, but simply an ideal of static dignity.

Assyrian obelisks, like Egyptian ones, were probably set up outside temple doors. Only two have ever been found complete and both are now in the British Museum. The better preserved, the Black Obelisk, made for Shalmaneser III (858–824 BC), shows people from the extreme ends of the Assyrian Empire bringing tribute before the king. He himself appears twice, once as a conqueror with bow and arrow, and a second time carrying a cup. The tributaries, and the nature of the tribute, are described in captions above the rows of carving. We see among them elephants, monkeys and other exotic animals. One group of tribute is provided by Jehu, King of Israel.

Perhaps the most impressive monuments of Assyrian art are the two magnificent winged bulls, each weighing some 16 tons. Colossal animals such as these frequently flanked magnificent doorways: these are from the palace of Sargon II at Khorsabad. From Balawat near Nimrud, came two massive pairs of gates. Made of wood, the gates were decorated with strips of worked bronze illustrating the full range of Assyrian narrative art: battles, sieges and tribute-bearers. The larger pair of gates, dating from the reign of Shalmaneser III

(858–824 BC) illustrate the king's expeditions to Turkey.

As well as these large items, the collections include many small articles made in Assyria or under Assyrian influence. Arms and armour are well represented: the Assyrians generally used iron weapons, but their protective armour was sometimes bronze. An iron saw-blade was probably used for cutting slabs of stone, such as those on which the sculptures were carved.

A silver cup with gold foil round its rim, which was buried before the sack of Nimrud and crushed by the weight of earth above it, is one of the few Assyrian articles in precious metal to have survived. Weights were often made of bronze: one complete set, in the shape of lions, was found in a palace at Nimrud. A much larger bronze object is the hip-bath from Ur. This had been used as a coffin when it was found, but the delicate incisions on its sides are typically Assyrian in style.

Most of the earlier excavations concentrated on the major royal sites, and consequently the Museum's collections reflect the opulent taste of the Assyrian court. A more balanced perspective has recently been added by a series of excavations of late Assyrian and post-Assyrian sites in the Eski Mosul region of northern Iraq. The results and finds shed interesting light on the material culture of smaller settlements.

One of the most interesting sequences of sculptural slabs from the final royal capital, Nineveh, vividly portrays the Assyrian king Sennacherib's siege and capture of the city of Lachish in southern Palestine in 701 BC. It was not, however, the Assyrians who finally destroyed this great city, but the inheritors of the Empire, the Babylonians. In 587 BC, shortly before the fall of Jerusalem brought an end to the southern kingdom of Judah, Nebuchadnezzar attacked Lachish. The last few days before the fall of the city are poignantly documented by a group of ostraca, letters written on potsherds in black ink, which were found amidst the burned debris of the gateway at Lachish. Written in ancient Hebrew, they represent the correspondence sent to the military commander of the city from an outlying watch-post where the Babylonian advance was being monitored.

To the north-east the kingdom of Urartu (*c.* 850–600 BC) included the eastern provinces of modern Turkey, Russian Armenia, and part of Iran. It, too, was strongly influenced by Assyrian civilisation, as can be seen in the fine collection of Urartian bronzes from Toprak Kale near Van. The collection contains several

305

316

315 *The Black Obelisk. This black stone monument from Nimrud, Iraq, displays the achievements of Shalmaneser* III, *King of Assyria 858–824* BC. *The carved panels show people bringing tribute, and the inscription describes his many campaigns. About 825* BC. H *1.98m.*

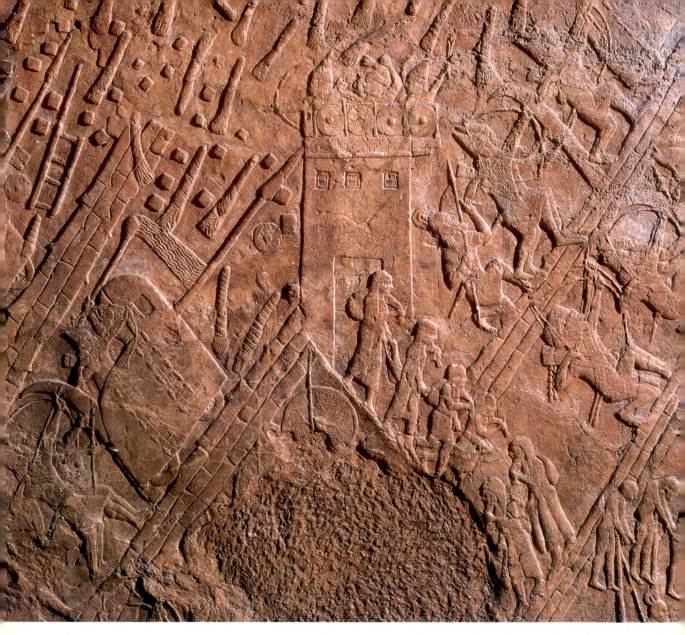

316 *The capture of Lachish: gypsum panel from the palace of Sennacherib, King of Assyria, at Nineveh, Iraq. A siege-engine attacks from the left, and prisoners stream out of the gate below. Lachish was a town in the biblical kingdom of Judah, captured by Sennacherib in 701 BC. About 700 BC.*

318 fragments of bronze furniture, which may have belonged to a throne of the national god Haldi. A winged figure with a female head probably derives from the rim of a cauldron; this shape was widely imitated in Greek and Etruscan art. Other bronzes include an Utartian model castle, and arms and armour; one round bronze shield is elaborately decorated with processions of animals. Some examples of Urartian texts are written in a version of the cuneiform script.

During this period the cultures of Iran were also highly developed, showing rich and varied artistic traditions, especially in the fields of metalworking and pottery manufacture. Mesopotamian influence can still be recognised in many silver and bronze objects from Iran during the second millennium, but the bronze horse harness and dress pins from Luristan are distinctive in style. It is unfortunate, if not tragic, that the majority of the quite exceptional objects that have

317 *Glazed tile, probably showing the Assyrian king Ashurnasirpal II (883–859 BC). He stands under a canopy with bodyguards behind him, and takes a cup of wine from a servant. From Nimrud, Iraq, ninth century BC. H 30cm.*

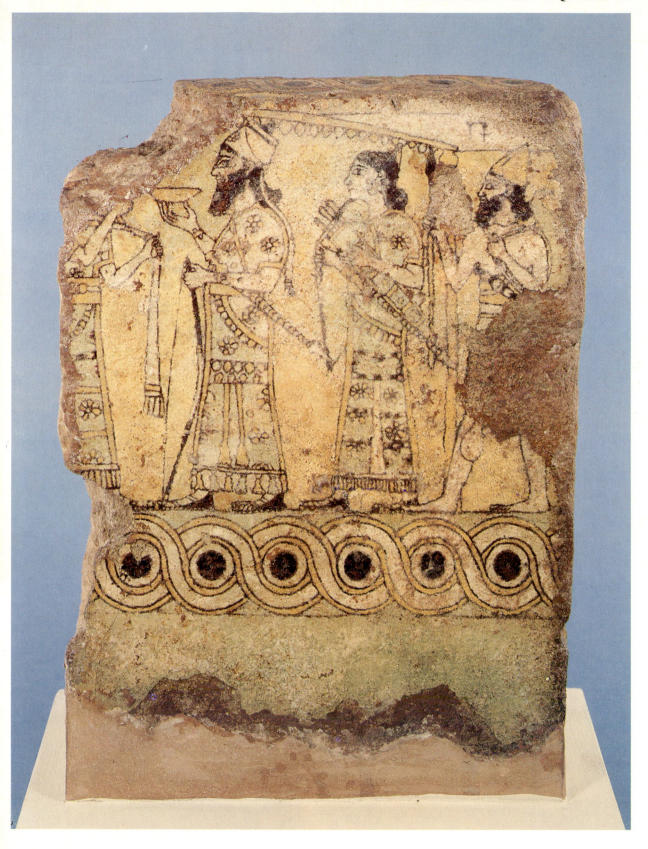

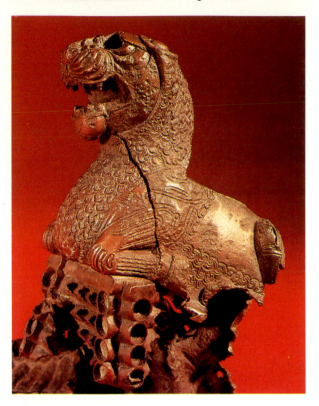

The rich cross-fertilisation of techniques and motifs between the cultures of ancient Western Asia is nowhere more apparent than in the Oxus Treasure. This impressive hoard of gold and silver objects probably belonged to a temple where offerings had accumulated for several centuries. It was buried, perhaps about 200 BC, and rediscovered in 1877 by a group of merchants who carried it to India. There it was sold to a British officer and most of it eventually came to the British Museum as part of the Franks Bequest.

The Oxus Treasure provides ample confirmation of the wealth and sophistication of the Achaemenid court. The style of the ornament is typical of the Achaemenian Persians; as in much Iranian art great use is made of animal forms, both real and mythical, sometimes naturalistically rendered, but more often subordinated to the total design. While the main treasure is Achaemenian, it contains some earlier, perhaps Median pieces, and since it had a chequered history after its discovery

319 BELOW *Silver sword hilt from Luristan. The handle and split pommel are elaborately decorated with embossed lions. Eighth to seventh century* BC. H *16.8cm.*

318 ABOVE *Urartian bronze furniture-fitting, in the form of a bar surmounted by a snarling lion. This piece was twisted out of shape in antiquity. From Toprak Kale, eighth to seventh century* BC. H *30cm.*

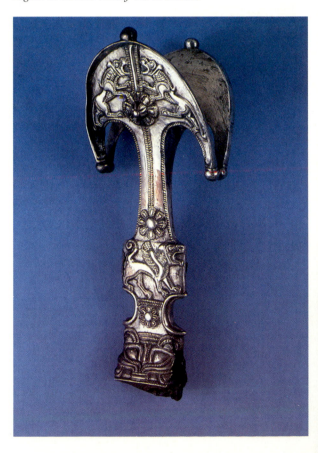

survived come from looted tombs and lack, therefore, any archaeological context.

The most famous site in Iran is undoubtedly Persepolis, capital of the Achaemenid Persian Empire. The Empire was established through the capture of Babylon by Cyrus in 539 BC. A cylinder seal in the British Museum records the event, asserting that the Persian conquest liberated the people from their oppressors. The Museum is singularly fortunate in its collection of Achaemenid work. The Susa archer is a large-scale example in glazed brick. Among smaller works of art one of the finest is a silver and partly gilded rhyton with a griffin's head. This was a drinking vessel, the liquid being poured into the mouth through a hole in the griffin's chest.

Fragments of wall-carvings, which once adorned the walls of palaces and public buildings in Persepolis, are also in the collections. These slabs are carved in a distinctive, highly finished style, characteristic of the art of the Persian Empire which, extending from Egypt to Turkestan, borrowed freely from all the ancient cultures it superseded.

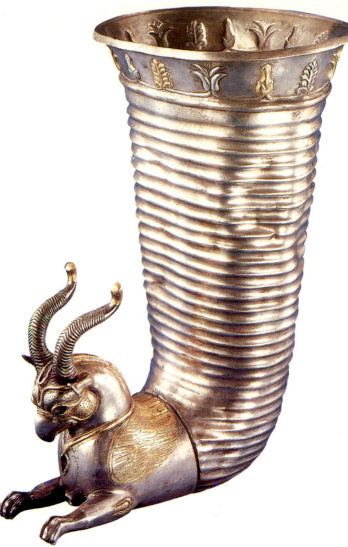

321 ABOVE *Silver-gilt drinking horn: the base is in the form of a griffin, a fabulous bird-headed creature with horns and wings. From Erzincan, Turkey, Achaemenid period, fifth–fourth century* BC. H *25cm.*

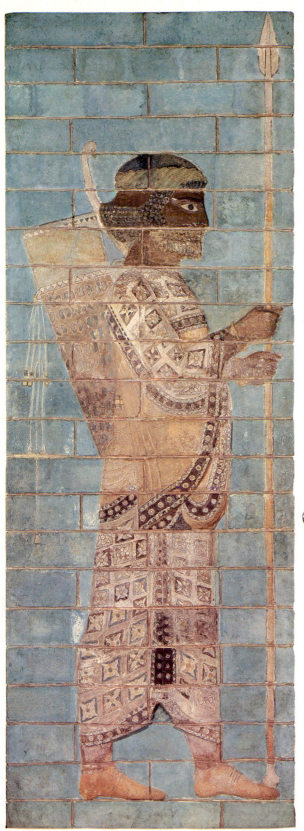

320 *Relief of polychrome glazed bricks from the palace of Darius the Great (521–486* BC) *at Susa. This panel is part of a frieze showing a parade of the king's bodyguard, special troops known as the 'Immortals'. On loan from the Louvre.* H *1.47m.*

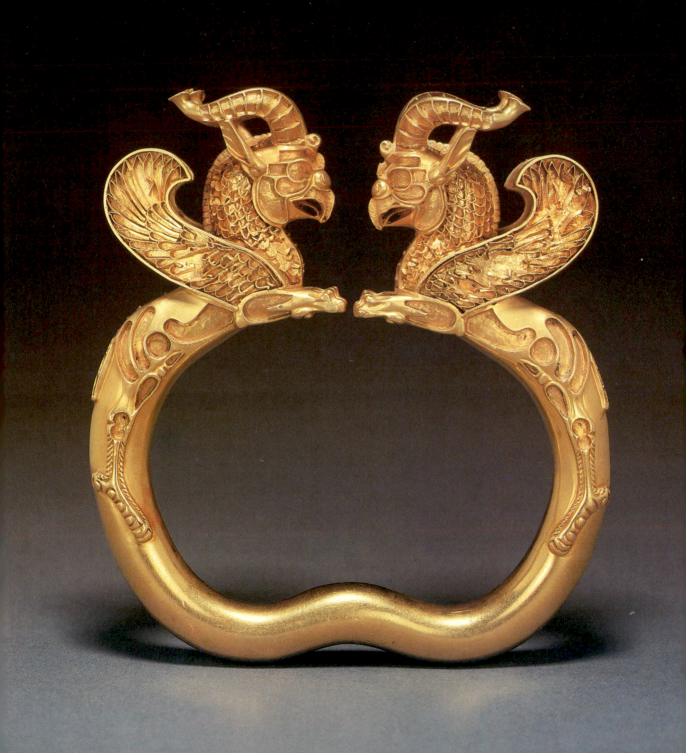

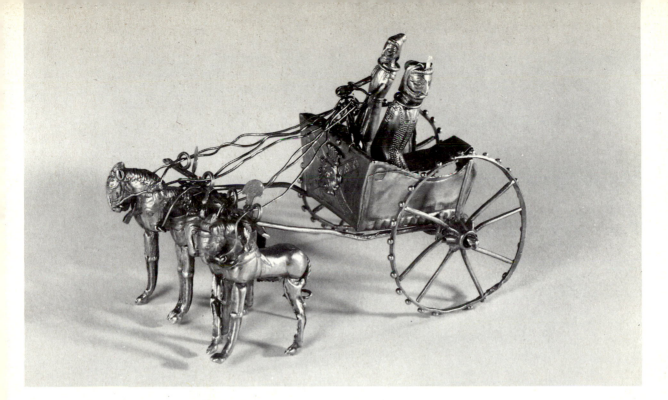

some later pieces have become associated with it which do not strictly belong.

One item of particular interest is the model chariot drawn by four small ponies. Others worth noting include the pair of armlets decorated with griffins' heads and once inlaid with glass or semi-precious stones, and the large gold fish, really a bottle, with an aperture at its mouth. A simpler form of art is represented on a series of gold plaques for sewing on clothes, while an elaborate scabbard, with scenes of lion-hunts, recalls some of the Assyrian sculptures. The 1500 or so gold and silver coins which were sold with the Treasure may not have been part of the hoard. These are now housed in the Department of Coins and Medals.

The conquests of Alexander the Great destroyed the Persian Empire, but from about 250 BC his Greek successors were gradually replaced by a local dynasty, the Parthians, who had their early capital at Hecatompylos in north-eastern Iran. Work produced in the

323 ABOVE *Gold model of a chariot pulled by four horses, from the Oxus Treasure. The charioteer stands holding the reins while his passenger, represented at a larger size and probably a person of high rank, is seated. Achaemenid, fifth to fourth century BC. L 18.8cm.*

322 LEFT *Gold armlet from the Oxus Treasure, its terminals in the form of fabulous bird-headed creatures with horns and wings. The armlet was originally inlaid with precious stones. One of a pair, the other belonging to the Victoria and Albert Museum. Achaemenid, fifth to fourth century BC. H 12.3cm.*

324 RIGHT *Gold face-mask from a tomb of the Parthain period at Nineveh. Gold masks were sometimes used to cover the faces of corpses, thereby concealing the decay of organs such as the eyes, nose and mouth that would be needed in the afterlife. First century AD. H 16.5cm.*

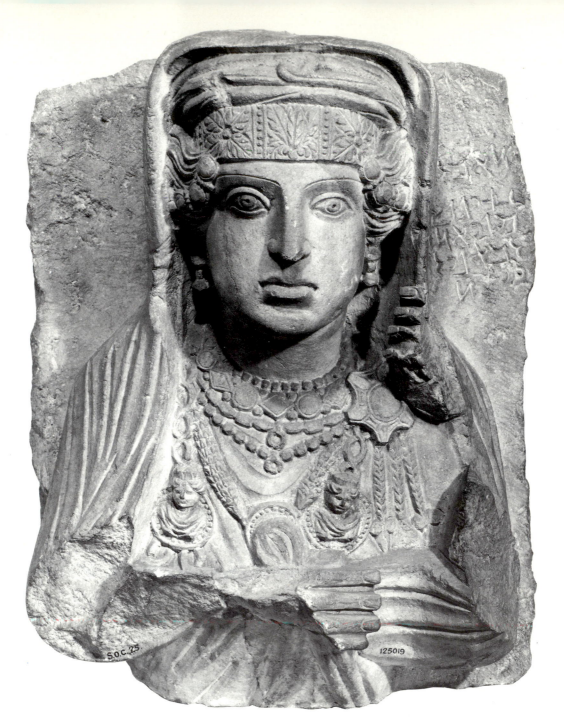

S.O.C. 25.

125019

Parthian period (*c.* 150 BC–AD 224) is often based on Greek models, but older Iranian themes tend to intrude. The gold masks from Nineveh were originally 324 placed in graves, over the faces of the dead. The blue-glazed coffin from Uruk is decorated with figures of armed men, made by pressing a mould into the damp clay.

The period of the Parthian Empire witnessed in the west the rapid expansion of the Roman Empire, which reached eastwards to incorporate Anatolia, Mesopo-tamia, Palestine, Syria and Arabia. Syria was a frontier province, and the desert city of Palmyra, or Tadmor, retained a considerable degree of freedom. It was situated on an oasis dominating the most direct trade-route between the Syrian coast and the important Mesopotamian territories of the Parthian and, later Sassanian empires. Its control of the transit trade greatly enriched the city, especially in the second and third centuries AD, and the principal families built themselves imposing tombs in the suburbs. Each grave

was provided with a stone portrait of the deceased, and their style is a strange amalgam of eastern and western influences. They are worth comparing with some of the painted portraits from Roman Egypt in the Department of Egyptian Antiquities.

Other late objects from Syria, including stone statuary from the Hauran, are variable in style, but the glassware shows great originality; indeed, the blowing of glass was probably invented in Syria. Some pottery bowls, with Aramaic incantations written across them, were originally buried for magical purposes.

Although later a Roman province, Palestine in the first century BC was independent, under Roman protection, and the centre of the expanding Jewish religion. It seems to have been prosperous, and it possessed its own characteristic culture. The British Museum has two elegantly carved ossuaries or stone chests which were designed to contain the bones of the dead; one belonged to the family of a man who had presented a new set of gates to the temple at Jerusalem. These chests date from about the time of Christ, and this is also approximately the period of the Dead Sea scrolls.

A frequently overlooked, but very important area of the ancient Near East represented in the Department is South Arabia. Most South Arabian antiquities have come from what are now the territories of Yemen and South Yemen, the home of the legendary Queen of Sheba. The ancient history of this area is virtually unknown, but it was famous for the production of aromatic spices and incense; its reputed wealth attracted invaders from Roma, Iran and Ethiopia. One of the more delicate objects is, appropriately, a bronze incense-burner; its handle represents an oryx, or antelope with highly exaggerated horns.

The South Arabians had their own alphabetic script, which appears on several monuments, and a distinctive style of primitive sculpture, sometimes reminiscent of modern work. A great bronze altar with projecting bulls' heads and massive rows of sphinxes, recalls the art of Western Asia before the Greeks. Two fine heads, however, in bronze and translucent stone, are obviously influenced by Graeco-Roman standards of portraiture.

In Iran the Parthian Empire was overthrown in AD 224 by Ardashir I, founder of the Sassanian dynasty. The Sassanians regarded themselves as the heirs of the Achaemenids, and retained a religious centre at Istakhr, a city in the neighbourhood of Persepolis.

325 LEFT Bust of a woman from Palmyra. During the Greek and Roman periods Palmyra was a major commercial centre in the Syrian desert. The wealthy citizens buried their dead in tomb towers or hypogea, with plaques bearing portrait busts. The inscription records that this lady was a certain 'Herta, daughter of Ogilu'. H 53cm.

326 BELOW Limestone ossuary, originally decorated with red paint, with a Greek inscription indicating that it contained the bones of Nicanor, a wealthy Jew of Alexandria. First century AD. H 38cm.

327 ABOVE *Silver-gilt dish, showing a Sassanian king, probably Shapur II (AD 309–79) hunting stags. The king sits astride one stag while another (perhaps the same animal) lies fatally wounded beneath. D 18cm.*

328 BELOW *Sassanian iron swords, with gold and silver hilts and scabbards. The gold scabbard is decorated with an embossed scallop pattern, and the silver with applied wire spirals. Sixth to seventh century AD. L (max.) 108cm.*

329 *Silver-gilt Sassanian vase. The decoration, which includes birds and foxes between vines, is based on the Roman cult of Bacchus. This scene shows two naked boys picking grapes. From Mazanderan, Iran, sixth to seventh century* AD. H *18.5cm.*

28 Their goldsmiths and silversmiths showed great skill in the use of embossing, chasing, engraving and gilding, and other craftsmen continued ancient Near Eastern traditions of fine workmanship. One silver dish shows 27 Shapur II hunting stags; on another Bahram V is shown hunting lions, and a partially gilded silver vase is deco- 29 rated with vineyard scenes framed in stylised grape vines. Contacts with the classical world are shown by seals depicting Leda and the swan, and Romulus and Remus suckled by a wolf.

At the height of their power the Sassanians ruled an area extending from the Euphrates in the west to the Indus in the east, and in the north to Armenia and Soviet Central Asia. They were, therefore, the heirs to all the great civilisations of ancient Western Asia. However, in the early seventh century AD Arab invaders swept through the Near East and carried all before them. The defeat in AD 642 of the Sassanian forces marks the end of the Persian empires and the coming of Islam.

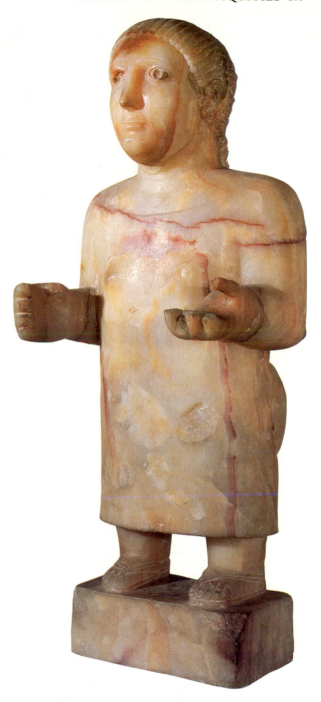

330 *Calcite statue of a woman from South Arabia. She may well have held an offering in her outstretched hands. About first century* BC *to first century* AD. H *74.5cm.*

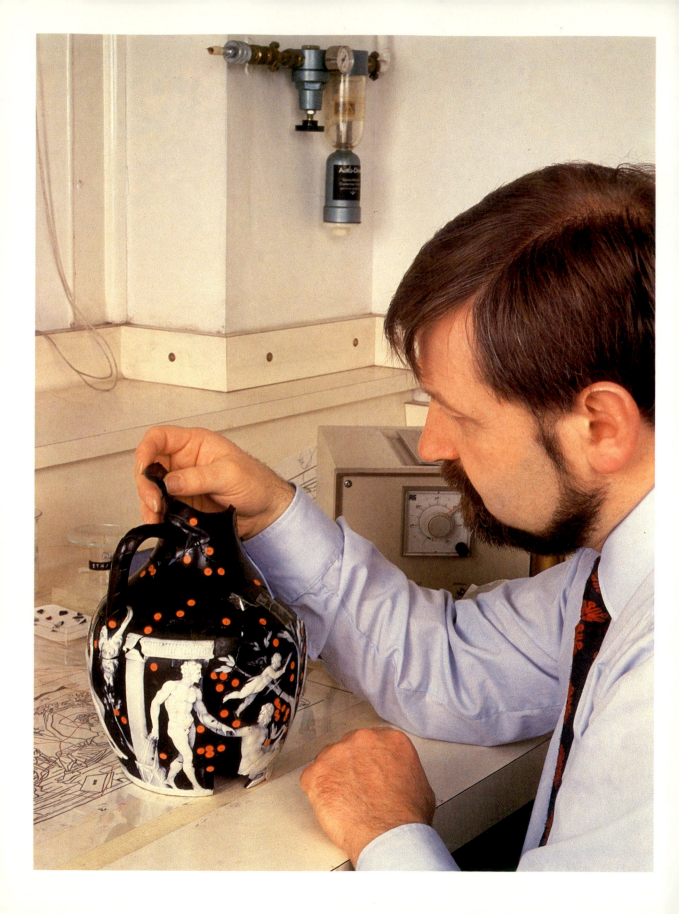

CONSERVATION
AND
SCIENTIFIC RESEARCH

Conservation

Conservation in the British Museum has its origins in the work of craftsmen who were employed to clean and restore objects from the earliest days of the Museum. Since 1924, however, the Museum has had its own permanent conservation research facility staffed by fully trained scientists, and these scientists have worked alongside a growing number of conservators to improve the methods and materials of conservation. The Department of Conservation now employs nearly sixty conservators working in six specialised sections: ceramics and glass; metals; organic materials (wood, leaves, fur, feather, leather, bone and ivory) and textiles; stone, wall-paintings and mosaics; Eastern pictorial art; and Western pictorial art. In addition there are the Conservation Research Section manned by scientists, and a small team of craftsmen who make replicas of museum objects for other institutions.

The work of a conservator today is highly specialised, demanding both manual dexterity and some knowledge of science, particularly chemistry. Within any of the categories listed above the work can be very varied, so that a ceramic conservator may be working on Greek vases one month, eighteenth-century porcelain the next, and crude prehistoric pottery a few weeks later. The overriding principle is to preserve whatever remains of an object for the future. Usually conservation begins with cleaning and stabilisation (that is the counteracting of any active decay mechanisms), followed by any necessary restoration. Finally, the object may be mounted to safeguard it in storage or on display.

Needless to say, these four processes vary enormously from object to object and from one type of object to another. For instance, cleaning porcelain may involve

331 *The Portland Vase undergoing conservation in 1988/9. Because the adhesive used in the previous restoration, during late 1940s, was deteriorating, the vase was dismantled into its two hundred or so separate pieces and reassembled using the most modern adhesives. See title page.*

simple washing to remove dust and finger grease, or it may involve the use of chemicals to remove more stubborn stains. In many cases conservation will involve the undoing of previous restoration, using water or organic solvents to dissolve adhesives, and physical or chemical treatments to soften and remove restored areas. The cleaning of excavated metal objects presents special problems, as they are often covered in layers of corrosion which may obscure decoration. The conservator must decide how much of these to remove and radiography is a useful aid for revealing what lies below the surface. In modern conservation a combination of manual treatments and the local application of small quantities of chemicals enables the process to be totally controlled.

Organic objects, textiles and works of art on paper are often very fragile, but in many cases either washing in water or 'dry cleaning' can be used, although only if any pigments or dyes which may be present are not fugitive. Cleaning, however, must never remove evidence of the use to which an object was put. Hence evidence of libations, food remains on the inside of a vessel, or smoke marks on the outside must be left in place.

Stabilisation is important where, as a result of burial or storage in a hostile environment, an object is undergoing spontaneous decay. Atmospheric pollutants, for example, may attack limestone and many plant and animal products (including paper); the movements of soluble salts (absorbed during burial) caused by daily or seasonal changes in the humidity of the surrounding air may have a deleterious effect on porous objects. The presence of chemicals absorbed from the soil may also promote corrosion on bronze or iron objects. Sometimes stabilisation will seek to remove the agent of decay – for example, washing pottery can remove soluble chloride – but in other cases this may be impossible, and the conservator must control the humidity and pollution in the atmosphere to prevent further deterioration.

Once an object is clean and stable the conservator can proceed to carry out any necessary restoration. Here he or she is guided by a very strict ethic – the

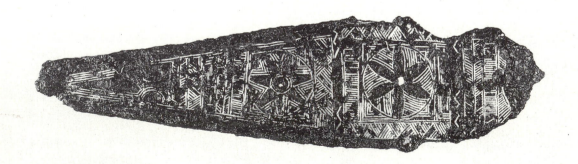

extent of the restoration should be fully recorded and (usually) visible to the naked eye on close inspection. This means, again taking pottery as an example, that any gap-filling should be clearly visible on close inspection, although it may go unnoticed by the casual museum visitor who strolls past the display. The same is true of scupture, although here the tendency is not to restore missing parts, as we can never know exactly how they looked. Indeed, in recent years conservators have been removing restorations from sculpture carried out by earlier generations. For works of art on paper, however, surface blemishes may be camouflaged and areas where pigment has been lost discreetly restored.

Finally, the mounting of an object ensures its safe handling, storage and exhibition in the future. Sculpture and other heavy objects are often fixed permanently to a base in such a way as to ensure that no undue strain is put on the object. Works of art on paper are usually mounted between sheets of acid-free cardboard, with an aperture cut in the front to the size of the picture. Small three-dimensional objects are usually only mounted for display purposes, unless they are very fragile, in which case a mount will be specially designed to double as a splint. A good example is the collection of early medieval swords, which are stored on specially made plastic mounts moulded to the contours of the corroded blades. These give excellent support when the swords are handled.

332 LEFT *Roman dagger sheath plate made of iron, from Hod Hill in Dorset: (top) before cleaning; (centre) an x-radiograph revealed extensive decoration hidden below the layers of corrosion; (bottom) cleaning by hand revealed the decoration formed of silver wires inlaid into the iron.*

333 BELOW *The conservation of an Egyptian papyrus document dating from about 1100 BC. The use of a frosted glass table top with a light below facilitates the examination of the papyrus fibre structure and assists in the repositioning of the fragments.*

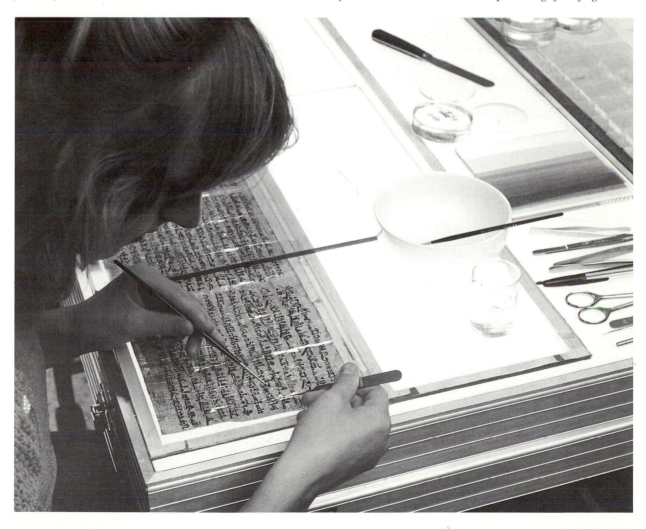

334 *Sarcophagus lid from Clazomenae, near Izmir, Turkey, which was damaged by a bomb on the night of 10 May 1941. It dates from about 500 BC and weighs 900 kg. The view below shows it on display (Room 3) after cleaning and repair.*

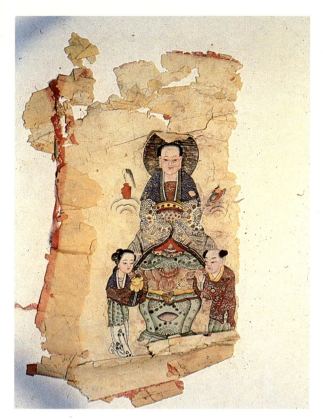

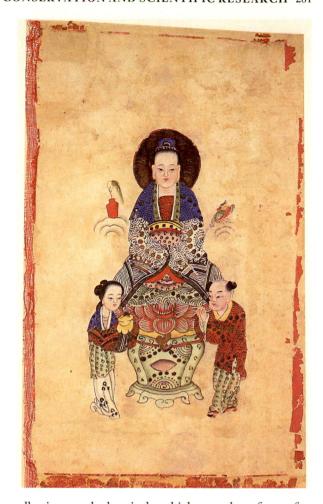

335 *Nineteenth-century Chinese painting from Canton which has been adversely affected by damp and mould growth (above). Conservation included the removal of the disintegrating backing paper and relining with modern high quality Japanese paper.*

Much of the conservation done in the British Museum is common to many museums with similar collections throughout the world, but there are also three specialist studios, each devoted to one type of object: mosaics, cuneiform tablets and scroll-paintings from the Far East. In the latter case the studio has been designed and built to a traditional Japanese format, and the tools and techniques in use are those which have been developed in Japan by traditional craftsmen over several centuries. For the mosaic pavements and cuneiform tablets, however, the workshops are of the most modern design and the techniques of conservation in use have been developed by scientists within the British Museum.

In order that conservation in the British Museum stays at the forefront of the subject, the conservators are backed up by a team of scientists who research into the mechanisms by which objects decay. Once the decay mechanism is understood, ways of arresting the decay can be developed. The corrosion of metals, the flaking of stone, discoloration of paper, the fading of dyes and pigments are just a few of the topics being investigated. In addition, there is a continuous programme of testing

adhesives and chemicals which may be of use for conservation, and of the materials used to make or line show-cases and storage cupboards (wood, glues, textiles, plastics and so on) to ensure that these materials are not slowly giving off chemicals which may react with the antiquities. For instance, it has long been known that vapours emitted by certain types of wood will corrode lead; recently it has been discovered that many textiles will cause silver to tarnish. In fact, it is only relatively recently that the scale of the problem of air pollution has been recognised, and methods are now being researched for eliminating the harmful gases from inside show-cases.

Conservators are intimately involved in the planning and setting up of exhibitions, so new scientific developments will ensure that the objects on display will not be harmed by excessive light, the degree of humidity, air pollution or rapid changes in temperature. Such advice is also given when loans are made to other institutions and the objects are carefully inspected for any signs of physical weakness, so that essential conservation can be carried out and the correct environment specified.

Practical conservation work is not confined to the

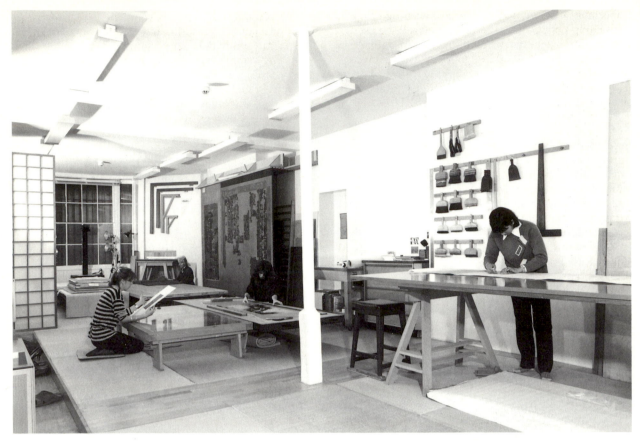

336 *The Eastern Pictorial Art conservation studio, where the Japanese tradition is followed of conservators working in a kneeling position at low work-benches on a floor covered in tatami matting. Traditional tools and drying boards are visible on the walls.*

Museum's premises; conservators frequently work on site at excavations, both in Britain and abroad. This is a natural extension of the process of conservation to the moment when the object is discovered. The Department of Conservation also plays a significant role in the training of future generations of conservators by taking students into the workshops and studios as interns, and by providing lectures and demonstrations for various conservation courses in Britain.

The work of the Department of Conservation has an enormous and visible impact on the display of the Museum's collections, although this may not be evident to the majority of visitors. Reflection for a moment, however, on problems of deterioration at home – yellowing of newspapers left in the sun, breaking of pots, corrosion of car bodies, tearing of clothes – will give some idea of the damage from the past that conservators have to deal with every day.

THE RESEARCH LABORATORY

The Research Laboratory is responsible for the scientific examination of the collections of the British Museum. It essentially provides important information on when, how and where objects were made and what materials they were made of. It commands a wide range of scientific equipment to assist in its investigations, as well as computer systems for handling scientific data, for statistical analysis, and for the documentation of the Museum's collections.

For determining when an object was made two main methods are available to the scientist. Radiocarbon dates can be provided for organic materials, such as charcoal, wood, bone and antler. The radioactive isotope carbon-14 is present as a fixed proportion of the total carbon in all living substances but decays at a known rate when a substance ceases to live. By measuring the amount of carbon-14 in a given sample, the date at which an artefact was made can be calculated. Samples up to a few thousand years old can be dated typically to within about fifty years, but the inaccuracy increases with the age of the sample: the upper limit is about 40,000 years. Another problem with radiocarbon dating is that the quantity of material required using the conventional equipment available in the Research

Laboratory is about 10g of charcoal or 150g of bone. This equipment cannot, therefore, normally be used to date museum objects, since the extent of damage in obtaining a sample would be unacceptable. However, recent developments in other laboratories involving the use of a particle accelerator have reduced the sample size required to a few milligrams, making it possible to obtain radiocarbon dates for museum objects.

The other scientific dating technique – thermoluminescence – is used on materials such as pottery, burnt flint, calcite and sediments from archaeological excavations. The method involves measuring the light emitted when samples from such materials are heated. This light is the result of radioactive impurities present within the samples themselves and in their burial environment. For pottery or burnt flint the amount of light emitted is proportional to the length of time elapsed since its last heating; for calcite, since its formation; and for sediments, since their last exposure to sunlight. A particularly important application of this method has been the provision of dates for Palaeolithic sites which

were occupied at times beyond the range of radiocarbon dating. In addition to dating archaeological sites, the method is now routinely used to establish whether ceramics on offer to the Museum for purchase are genuine or forgeries. It has also been applied to objects which were acquired before the advent of thermoluminescence and which curatorial staff now regard as suspect on stylistic grounds.

The Research Laboratory is also concerned with the study of ancient technology, researching into the raw materials and production methods used in antiquity, as well as investigating the more fundamental question of why particular materials and methods were used. A

337 *The synthesis rig in the Research Laboratory: it is used to convert pretreated samples to benzene for radiocarbon dating. Using a method known as liquid scintillation counting, the decay of the radiocarbon atoms can be detected and the age of the sample evaluated.*

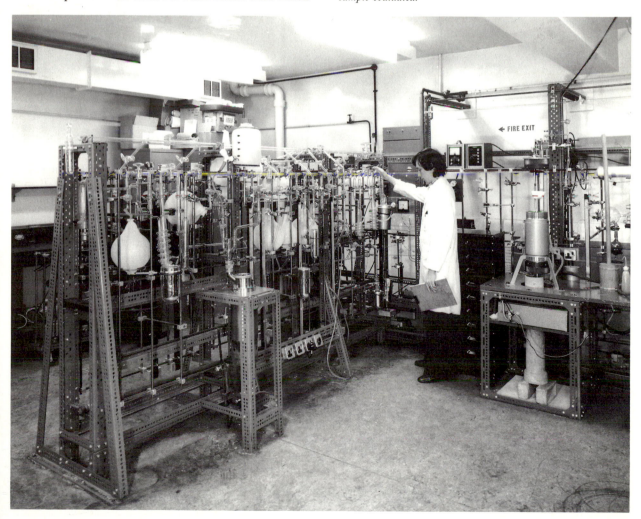

338 ABOVE *X-ray fluorescence spectrometer, used to analyse a Chinese Ming dynasty brass figure. When x-rays from a high-voltage tube strike the area to be analysed fluorescent x-rays are emitted which are characteristic of the elements present.*

wide range of analytical techniques are employed, including atomic absorption spectrometry, x-ray fluorescence spectrometry, and x-ray diffraction, together with x-ray radiography and both optical and electron microscopy.

The study of the microstructure of ancient ceramics with an electron microscope can reveal particle size and shape, degree of interconnection and porosity. This allows scientists to trace the development from low-fired, coarse undecorated pottery, through the Greek and Roman fine wares with their characteristic high-gloss surface finish, to high-fired glazed stonewares and porcelains, which were first made in China and ultimately imitated in Europe. In such investigations the aim is to determine what type of clay and what firing temperature were employed to make the bodies and what methods were used to produce the different types of surface decoration. Similarly, in the case of glass, a major interest is the identification of the colorants and opacifiers used.

The development of metalworking has also been the subject of close scientific scrutiny. The method of manufacturing iron sword blades, for example, is of particular interest. Modern analytical techniques have allowed scientists to examine their very structure. From their first use iron sword blades were made up of several strips of iron welded together. We can see that Roman

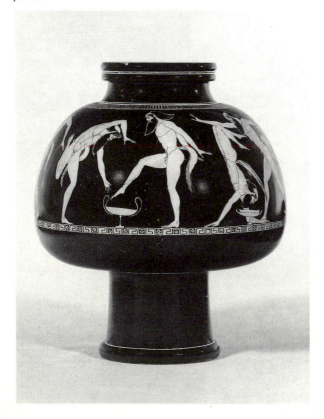

339 *Attic Greek vase of the fifth century* BC, *with the characteristic high-gloss finish of its black surface. Great skill was required to retain the black reduced surface coat while firing the body to a red-oxidised colour. This was achieved by preparing a very fine-grained clay for the surface coat, as shown by the photomicrograph (below), so that it was highly impermeable as compared to the porous body.*
Scale of micrograph: bar = 10μm

340 *Sword blade from the Sutton Hoo ship burial. An* x-*radiograph (slightly enlarged) of this totally corroded blade reveals the complex structure of the iron still preserved in the corrosion. Rods of iron have been repeatedly welded, twisted and beaten out to form the intricate pattern shown (pattern welding).*

technology achieved considerable improvements in quality, and in the Dark Ages the blades were made from large numbers of rods welded together to produce a very complex structure referred to as pattern welding, which both strengthens the sword and produces a decorative pattern on the blade. The development in techniques such as gilding, silvering and tinning used to decorate metals has also been investigated. For

example, it has been shown that prior to the Hellenistic period (*c.* 325–27 BC) metals were gilded by the application of gold-leaf to their surfaces, but subsequently mercury or fire-gilding became common. This technique involves applying a gold-mercury amalgam to the surface of an object; when heated the mercury evaporates, leaving a layer of gold on the surface.

The historical development of the composition of metal alloys, from copper, through arsenical copper to

341 *A bronze arm from a life-size Roman statue found in Gaul, providing an example of leaf-gilding. Squares of gold-leaf were burnished in place; in this case the outline of the leaf can still be seen.*

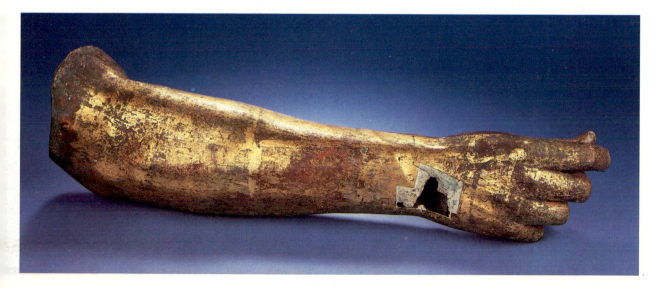

342 *Excavation of furnaces at Zawar, Rajasthan, India, used in the fifteenth century AD to produce metallic zinc by distillation. The retorts, filled with ore and charcoal, were placed in the furnace with the necks protruding through the perforations in the floor into the cool-chamber below, where the zinc was collected.*

tin-bronze and ultimately brass (a copper-zinc alloy) has also been examined. Coinage offers some useful data, as coins provide comparatively well-dated series from which the chronology for the introduction of a specific metal alloy can be inferred. Thus the analysis of a large number of Hellenistic coins from the eastern Mediterranean has revealed that the use of brass occurred as early as the beginning of the first century BC.

The analysis of metals is also of special importance to numismatic studies, since it provides crucial data on the debasement of coinage. For example, during the seventh century AD the gold content in Merovingian gold coinage fell from more than 95 per cent to as low as 20 per cent, probably as a result of the breakdown of supplies of the precious metal from the Byzantine Empire. It has been possible, using these data and by analysing the compositions of the coins found in the

Anglo-Saxon ship burial at Sutton Hoo, Suffolk, to suggest a date of about AD 625 for the burial.

For a fuller understanding of how metal objects were made, it is important, as well as examining the finished artefacts, also to investigate the complete production process, from mining the ore through to the extraction and purification of the metal. The Research Laboratory has, therefore, collaborated in the excavation of ancient metal-production sites and has acquired for the Museum representative groups of smelting debris, such as furnace fragments, crucibles and, of course, slags from these sites. At Zawar in India the earliest known furnaces used to produce metallic zinc (15th century AD) have been excavated. The major obstacle to the production of metallic zinc in antiquity was that it volatilises at about 900°C and would have been lost in any normal smelting process. At Zawar a distillation process analogous to that used in the production of alcohol was evolved in which zinc vapour was condensed under reducing conditions.

Another important area of the Laboratory's work is its contribution to provenance studies: ascertaining where an object was made. Here the aim is to determine whether artefacts found on an archaeological site were manufactured locally or whether they were imported, and if so from where. Provenance studies involve

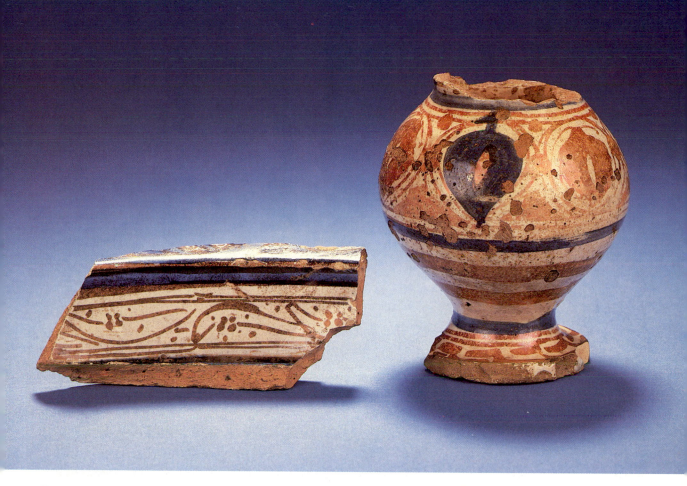

343 *Fragments of Hispano-Moresque lustreware. Neutron activation analysis has been used to identify the production centres. The dish fragment (left), found in Bristol, was made in Valencia, and the vase fragment (right) from London, was made in the Malaga region.*

finding some fingerprint for distinguishing different sources of raw materials and thus identifying production centres. One approach is the analysis, using for example neutron activation, of minor and trace element impurities, since their patterns of concentration can characterise a particular raw material source. Where the raw material has been chemically altered by man during manufacture, as in the case of metals, great difficulties have been encountered. However, with stone and pottery which has undergone only slight or no chemical change it has proved successful. For example, comparison of the minor and trace element concentrations in flint artefacts and in the possible sources has enabled the identification of the areas in southern Britain which provided the material for Neolithic polished flint axes. Similarly, it has been possible to establish whether fragments of Hispano-Moresque lustre pottery dating from the thirteenth to fifteenth centuries AD, found on urban excavations in southern

Britain, were produced at the Malaga or Valencia pottery production centres in Spain.

In the case of pottery and stone artefacts a complementary technique involves the careful preparation of thin cross-sections of the material. These sections – which may be only a few hundredths of a millimetre thick – are translucent, and under the microscope the type of geological deposit from which the clay and stone were obtained may be recognised. In some cases the restricted occurrence or juxtaposition of specific rock types even allows a geographical origin to be identified.

With marble a different approach is necessary. Marble is a form of calcium carbonate, and here the ratios of the stable isotopes of carbon and oxygen provide the key. These ratios are affected by the conditions under which the marble is formed, so that different quarry areas have different isotope signatures which can be measured by mass spectrometry. In principle, therefore, the quarry exploited for marble for specific statues or carvings can be determined. This technique has been used to analyse various elements from the Mausoleum at Halicarnassus (4th century BC). It has shown that marble was imported from widely distributed sources, such as the Greek mainland for the statues (Pentelic marble) and nearby Asia Minor for the architectural components.

Scientific examination is invaluable in the authentication of an object. Artefacts from the Museum's own collections, or on offer for purchase, are routinely sent to the Research Laboratory for investigation. Usually the questions are not simply whether the object is fake or genuine, but how much it has been restored, whether new parts have been added or whether it has been assembled from otherwise genuine but unrelated components.

The research of the Laboratory into ancient technology provides the basic control data for establishing whether the materials and techniques used to make any object are appropriate to the age and place of origin ascribed to it. Further, if the object is ceramic, or of cast metal with a clay core present, then thermoluminescence can establish whether it is ancient or modern. The patination of a metal is also a useful guide it is antiquity. Patina which has been forming on the metal in the ground over thousands of years will be firmly attached.

If, however, it has been only recently applied in the form of a pigment, then normally it can be easily removed mechanically or by using an appropriate solvent.

The work of the Research Laboratory remains largely unseen by the Museum's visitors, but it is of immense importance. It provides the curators with basic information which is vital to the understanding both of individual objects and of the Museum's collections as a whole. A long-term project of documentation and inventory is now under way to compile computerised records containing such information as object type, material, provenance, period and donor for all of the Museum's collections. Not only will this assist the curators, but in due course it will be possible to provide academic and public enquirers with on-line or printed listings of, for example, all the objects of a particular type and provenance held by the Museum, offering a degree of access to the Museum's vast collections possible only in the computer age.

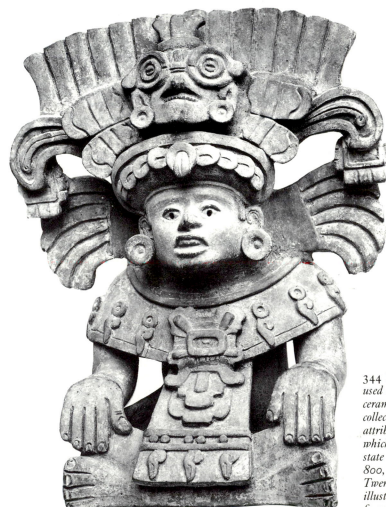

344 *Thermoluminescence can be used to test the authenticity of ceramic objects. The Museum's collection of seventy-three ceramics attributed to the Zapotec culture which flourished in the Mexican state of Oaxaca from* AD *200 to 800, was tested by this process. Twenty items, including the one illustrated here, were shown to be forgeries.*

FURTHER READING

The following list is a selection of books on the Museum's collections from British Museum Publications. A full and up-to-date list of all British Museum publications, including scholarly catalogues on specific aspects of the collections, can be obtained by writing to:

British Museum Publications Ltd
46 Bloomsbury Street
London WC1B 3QQ

GENERAL

* *The British Museum Guide and Map*, 1981: also available in French, German, Italian, Japanese and Spanish translations
CAYGILL, M. *The Story of the British Museum*, 1981
CAYGILL, M. *Treasures of the British Museum*, 1985
MOORE, H. *Henry Moore at the British Museum*, 1981
* NORWICH, J.J. *The British Museum Souvenir Guide*, 1989
RICHARDSON, J. *Inside the British Museum*, 1984
RICHARDSON, J. *From Aztecs to Zulus: Inside the Museum of Mankind*, 1986

THE CLASSICAL COLLECTIONS

BOWMAN, A.K. *Roman Writing Tablets from Vindolanda*, 1983
COOK, B.F. *The Elgin Marbles*, 1984
COOK, B.F. *The Townley Marbles*, 1985
JENKINS, I. *Greek and Roman Life*, 1986
PAINTER, K. AND WILLIAMS, N. *The Breaking and Remaking of the Portland Vase*, 1989
POTTER, T.W. *Roman Britain*, 1983
SWADDLING, J. *The Ancient Olympic Games*, 1980
TATTON-BROWN, V. *Ancient Cyprus*, 1988
WALKER, S. AND BURNETT, A. *The Image of Augustus*, 1981
WALKER, S. *Memorials to the Roman Dead*, 1985
WILLIAMS, D. *Greek Vases*, 1985

COINS AND MEDALS

CRIBB, J. (ED.) *Money: From cowrie shells to credit cards*, 1986
HEWITT, V. AND KEYWORTH, J. *As Good as Gold, 300 Years of British Bank Note Design*, 1987
JONES, M. *Contemporary British Medals*, 1986
JONES, M. *Medals of the French Revolution*, 1977
JONES, M. *Medals of the Sun King*, 1978

EGYPTIAN ANTIQUITIES

ANDREWS, C. *Egyptian Mummies*, 1984
ANDREWS, C. *The Rosetta Stone*, 1981
* JAMES, T.G.H. *The British Museum and Ancient Egypt*, 1981
JAMES, T.G.H. *Egyptian Painting*, 1985
JAMES, T.G.H. (ED.) *An Introduction to Ancient Egypt*, 1979
JAMES, T.G.H. AND DAVIES, W. V. *Egyptian Sculpture*, 1983
QUIRKE, S. AND ANDREWS, C. (introduction and trans.) *The Rosetta Stone: Facsimile Drawing*, 1988
ROBINS, G. AND SHUTE, C. *The Rhind Mathematical Papyrus*, 1987
STEAD, M. *Egyptian Life*, 1986

THE ETHNOGRAPHIC COLLECTIONS

* BAQUEDANO, E. *Aztec Sculpture*, 1984
HOUSTON, S.D. *Maya Glyphs*, 1989
KING, J.C.H. *Arctic Hunters, Indians and Inuit of Northern Canada*, 1987
KING, J.C.H. *Thunderbird and Lightning, Indian Life in Northeastern North America 1600–1900*, 1982
KONIECZNY, M.G. *Textiles of Baluchistan*, 1979
MACK, J. (ED.) *Ethnic Jewellery*, 1988
MACK, J. *Madagascar: Island of the Ancestors*, 1986
MCLEOD, M.D. *The Asante*, 1981
MCLEOD, M. AND MACK, J. *Ethnic Sculpture*, 1984
PAOLOZZI, E. *Lost Magic Kingdoms*, 1985
RICHARDSON, J. *From Aztecs to Zulus: Inside the Museum of Mankind*, 1986
WEIR, S. *Palestinian Costume*, (forthcoming) 1989

THE MEDIEVAL AND MODERN COLLECTIONS

BACKHOUSE, J., TURNER, D.H. AND WEBSTER, L. *The Golden Age of Anglo-Saxon Art*, 1984
COLLINS, M. *Towards Post-Modernism, Design since 1951*, 1987
EAMES, E. *English Medieval Tiles*, 1984
EVANS, A.C. *The Sutton Hoo Ship Burial*, 1986
KITZINGER, E. *Early Medieval Art*, 1940 (3rd edn 1983)
LOVERANCE, R. *Byzantium*, 1988
TAIT, H. *Clocks and Watches*, 1983
TAIT, H. (ED.) *Seven Thousand Years of Jewellery*, 1987 (paperback edn 1989)
* TAIT, H. *The Waddesdon Bequest*, 1981
TAYLOR, M. *The Lewis Chessmen*, 1978
WILSON, T. *Ceramic Art of the Italian Renaissance*, 1987

THE ORIENTAL COLLECTIONS

BARKER, R. AND SMITH, L. *Netsuke: The Miniature Sculpture of Japan*, 1976
HILLIER, J. AND SMITH, L. *Japanese Prints: 300 Years of Albums and Books*, 1980
RAWSON, J. *Ancient China: Art and Archaeology*, 1980
RAWSON, J. *Chinese Bronzes, Art and Ritual*, 1987
RAWSON, J. *Chinese Ornament, The Lotus and the Dragon*, 1984
SMITH, L. *Contemporary Japanese Prints, Images of a Society in Transition*, 1985
SMITH, L. *Ukiyo-e, Images of Unknown Japan*, 1988
SMITH, L. AND HARRIS, V. *Japanese Decorative Arts from the 17th to the 19th centuries*, 1982
ZWALF, W. *Buddhism: Art and Faith*, 1985

PREHISTORY AND ROMAN BRITAIN

BROTHWELL, D. *The Bog Man*, 1986
LONGWORTH, I.H. *Prehistoric Britain*, 1985
POTTER, T.W. *Roman Britain*, 1985
STEAD, I.M. *The Battersea Shield*, 1985
STEAD, I. M. *Celtic Art*, 1985
STEAD, I.M., BOURKE, J.B. AND BROTHWELL, D. *Lindow Man*, 1986

PRINTS AND DRAWINGS

CAREY, F. (ED.) *Henry Moore: A Shelter Sketchbook*, 1988
CHRISTIAN, J. *Letters to Katie from Edward Burne-Jones*, 1988
GERE, J.A. AND TURNER, N. *Drawings by Raphael*, 1983
GOLDMAN, P. *Looking at Prints, Drawings and Watercolours*, 1988
* GOLDMAN, P. *Sporting Life, An Anthology of British Sporting Prints*, 1983
GOLDSCHEIDER, I. *Czechoslovak Prints from 1900 to 1970*, 1986
GRIFFITHS, A. *Prints and Printmaking*, 1980
GRIFFITHS, A. AND KESNEROVA, G. *Wencelaus Hollar: Prints and Drawings*, 1983
GRIFFITHS, A. AND WILLIAMS, R. *The Department of Prints and Drawings in the British Museum – User's Guide*, 1987
HAYDEN, R. *Mrs Delany: Her Life and Her Flowers*, 1980
* HULTON, P. *America 1585: The Complete Drawings of John White*, 1984
ROWLANDS, J. *Master Drawings and Watercolours in the British Museum*, 1984
ROYALTON-KISCH, M. *Adriaen van de Venne's Album*, 1988
STAINTON, L. *Turner's Venice*, 1985
STAINTON, L. AND WHITE, C. *Drawing in England from Hilliard to Hogarth*, 1987
TURNER, N. *Florentine Drawings of the Sixteenth Century*, 1986
WILTON, A. *Turner Abroad*, 1982

WESTERN ASIATIC ANTIQUITIES

COLLON, D. *First Impressions: Cylinder Seals in the Ancient Near East*, 1987
MITCHELL, T.C. *The Bible in the British Museum*, 1988
READE, J. *Assyrian Sculpture*, 1983
SOLLBERGER, E. *The Babylonian Legend of the Flood*, 1971 (3rd edn)
STEPHENSON, F.R. AND WALKER, C.B.F. (EDS) *Halley's Comet in History*, 1985
WALKER, C.B.F. *Cuneiform*, 1987

CONSERVATION AND RESEARCH

PAINTER, K. AND WILLIAMS, N. *The Breaking and Remaking of the Portland Vase*, 1989
WILLIAMS, N. *Porcelain: Repair and Restoration*, 1983

* Books available only from British Museum Bookshops

THE GALLERIES OF THE BRITISH MUSEUM

While every effort has been made to ensure that the information given below is correct, the Museum's continual programme of renewal means that galleries may be rearranged from time to time. The most up-to-date information and a gallery plan is available from the Information Desk in the Front Hall.

COINS AND MEDALS

ROOM 69a

Temporary displays of coins, medals, paper money, tokens and badges from the Department's collections.

Coins are also displayed in other galleries in the contexts of the cultures in which they have been used:

Ancient Iran: Room 51
Ancient Palestine: Room 24
Celtic Europe: Room 39
Far East: Rooms 33, 93 (in preparation)
Greek and Roman: Rooms 3, 69, 70, 71 (in preparation), 72, 73
Islam: Room 34
Medieval Europe: Rooms 41, 42
Renaissance Europe: Rooms 46, 47
Roman Britain: Room 40
South Asia: Rooms 33, 34

EGYPTIAN ANTIQUITIES

ROOM 25

Egyptian Sculpture Gallery
Sculpture; architecture from temples and tombs; inscriptions; small selection of objects in wood, metal or terracotta, offerings and tomb-paintings

ROOM 56

Sixth Egyptian Room Until 1990: seals and scarabs; jewellery; glass; pottery; bronze temple equipment; Predynastic and Early Dynastic material

ROOMS 60/61

First and Second Egyptian Rooms
Coffins, mummies and mummy cases, mummy masks; offerings; funeral equipment; animal mummies

ROOM 62

Third Egyptian Room
Wall-paintings from private tombs; papyri; objects connected with the burial cult

ROOM 63

Fourth Egyptian Room Aspects of daily life

ROOM 64

Fifth Egyptian Room Sculptures and bronze figures; small objects of ivory, bone and terracotta

ROOM 66

Coptic Corridor Roman Period portraits; carved stonework, textiles, jewellery and ritual objects from the second to the ninth century AD

GALLERY ALTERATIONS

ROOM 56 Closing at the end of 1989. Will reopen at the end of 1990 as the George and Beverly Sackler Gallery of Mesopotamia (see under Western Asiatic Antiquities)

ROOM 65 Will open in 1991 as the George and Beverly Sackler Gallery of Egypt in Africa, including the Nubian and Sudanese collections.

ETHNOGRAPHY (MUSEUM OF MANKIND)

Housed at Burlington Gardens, near Piccadilly, the Museum of Mankind contains anthropological collections from Africa, Australia, the Pacific Islands, North and South America, Asia and Europe. Temporary exhibitions mainly concentrate on the way of life of particular peoples, specific aspects of culture, arts and technologies. Current long-term exhibitions include:

ROOM 1

Turquoise Mosaics from Mexico

ROOM 5

Introduction to the Collections

ROOM 7

Treasures from the Ethnographic Collections

ROOM 12

Until 1993: Toraja: Ricebarn Carvers of Indonesia

GREEK AND ROMAN ANTIQUITIES

ROOM 1
Cycladic Room Early Bronze Age artefacts from the Cycladic Islands

ROOM 2
Prehistoric Greek Room Pottery, statuettes, jewellery, stonework, weapons of the Bronze Age and Early Iron Age

ROOM 3
Archaic Greek Room Black-figured pottery; statuettes; stone sculpture; jewellery; coins

ROOM 3a
First Vase Room Early Greek vases; Greek mythology

ROOM 4
Andokides Room 'New Techniques in Vase-painting': red-figure and other pottery techniques

ROOM 5
Room of the Harpy Tomb The Harpy Tomb; red-figured vases; bronze and terracotta statuettes; sculpture

ROOM 6
Bassae Room Marble frieze from Temple of Apollo at Bassae

ROOM 7
Nereid Room The Nereid Monument from Xanthos

ROOM 8
Duveen Gallery Sculptures from the Parthenon

ROOM 9
Caryatid Room Sculptures from the Acropolis at Athens; Greek pottery, terracottas, bronzes, 430–400 BC

ROOM 10
Payava Room The tomb of Payava from Xanthos; Greek pottery, terracottas and bronzes, 400–330 BC

ROOM 11
Second Vase Room Athenian and South Italian red-figure, white-ground and black-glaze vases

ROOM 12
Mausoleum Room Statues and relief sculpture from the Mausoleum at Halicarnassus, the Lion Tomb at Cnidus and the Temple of Artemis at Ephesus

ROOM 13
Hellenistic Room Marble and ivory sculpture; bronzes; terracottas; jewellery and glass

ROOM 14
First Roman Room Until 1990: pottery and glass; gold and silver vessels; bronzes; terracottas; wall-paintings; statuettes; jewellery

ROOM 15
Second Roman Room Portraits; sculptures; mosaic

ROOM 68
Terracotta and Bronze Room Greek and Roman terracottas; bronzes; lamps; mirrors

ROOM 69
Greek and Roman Life Room Objects used in daily life

ROOMS 70–71
Closed for preparation of new exhibitions on Rome, the Roman Empire and the pre-Roman cultures of Italy

ROOM 72
A.G. Leventis Gallery of Cypriot antiquities Bronze, copper and limestone artefacts from ancient Cyprus; Cyriot sculpture, jewellery and weaponry

ROOM 73
'The Greeks in Southern Italy': pottery; terracottas; coins; bronzes

ROOM 77
Architecture Gallery Greek and Roman architecture

ROOMS 78–85 The Wolfson Galleries
ROOM 78
Room of Latin and Greek Inscriptions

ROOM 79
Lycian Room Sculpture from Lycia

ROOM 80
Archaic and Classical sculpture from Greece and Asia Minor; Athenian grave reliefs

ROOM 81
Later Greek Sculpture: monuments from Greek Asia Minor, including the Mausoleum, the temple of Artemis at Ephesus, and the temple of Athena at Priene; later funerary monuments

ROOM 82
Ephesus Gallery Sculpture from Ephesus and Greek sites; small sculptures from the Townley Collection; Roman funerary reliefs

ROOM 83

Roman Room Large sculptures from sanctuaries and public buildings; sarcophagi

ROOM 84

Townley Room Charles Townley's collection of sculpture

ROOM 85

Portrait Room Roman portraits and heads of deities and heroes

GALLERY ALTERATIONS

ROOM 14 Gallery closing 1990; new display to open: 'Second Hellenistic Room'

ROOM 70 Gallery closing mid-1989. New display due to open in 1991: 'Rome, City and Empire' ·

ROOM 71 Gallery closing mid-1989. New display due to open in 1991: 'Italy before the Romans'

JAPANESE ANTIQUITIES

The new Japanese galleries are due to open at the beginning of 1990 in Rooms 92, 93 and 94. At present there is a small selection of Japanese objects on display in Oriental Gallery 1 (Room 33): lacquerware; swords and sword-fittings; ceramics; sculpture; netsuke and *inrō*.

The new galleries will consist of Rooms 92 (Urasenke Gallery), 93 (Main Japanese Gallery), 94 (Konica Gallery).

The lobby outside the Urasenke Gallery will house a permanent display of netsuke, *inrō* and sword furniture.

The Urasenke Gallery will house on permanent display a tea-house and classic teawares.

The other two galleries will house both general and thematic exhibitions from the Museum's wide collections and also loans from Japanese collections.

MEDIEVAL AND LATER ANTIQUITIES

ROOM 41

Early Medieval Room Objects from the fourth to eleventh centuries AD; early Christian ivories and silver treasures; European and Anglo-Saxon antiquities, including archaeological burial finds

ROOM 42

Medieval Room Antiquities from the Byzantine, Carolingian, Romanesque and Gothic periods, dating from the ninth to the fifteenth centuries AD; ivories and metalwork; icons; jewellery; objects from secular and religious life; arms and armour

ROOM 43

Medieval Tile and Pottery Room

ROOM 44

Gallery of Clocks and Watches

ROOM 45

Waddesdon Room The Waddesdon Bequest of medieval and Renaissance treasures

ROOM 46

Renaissance Corridor European and British objects from the Renaissance to the eighteenth century AD

ROOM 47

Renaissance and Later Room European pottery; porcelain; glass; the Hull Grundy Gift of jewellery

ROOM 48

Modern Gallery

ORIENTAL ANTIQUITIES

ROOM 33

Sculpture from South and South-East Asia; bronzes, sculpture, decorative arts and ceramics from China; antiquities from Korea and Central Asia

ROOM 34

The John Addis Gallery Opening mid-1989: antiquities from the Islamic collections, especially ceramics and metalwork

ROOM 91

Opening end of 1989: temporary exhibitions, especially paintings, from the Oriental Department

PREHISTORIC AND ROMANO-BRITISH ANTIQUITIES

ROOM 35

Hinton St Mary mosaic; recent acquisitions and temporary exhibitions

ROOM 36

'Man Before Metals' display of Stone Age art, flint- and wood-craft; rare materials and pottery of the first farmers

ROOM 37

Bronze Age goldwork, jewellery, pottery, funerary objects, weapons; Lindow Man

ROOM 38

Bronze Age and Iron Age metalwork; arms and armour; pottery; tools

ROOM 39
Celtic art; pottery; jewellery; weapons; metal technology; Celtic coins; chariotry

ROOM 40
Roman Britain Room Daily life; Roman army; medicine; tableware; glassware; jewellery; statuettes; ironwork; mosaics; coins; religious sanctuaries

PRINTS AND DRAWINGS

The collections of this Department are not on permanent display because of their fragility and susceptibility to light. A new gallery due to open in 1990 (Room 90) will display temporary exhibitions.

WESTERN ASIATIC ANTIQUITIES

ROOM 16
Khorsabad Entrance Sculptures from the palace of Sargon at Khorsabad

ROOM 17
Assyrian Saloon Sculptures and reliefs from the palaces of Sennacherib (siege of Lachish) and Ashurbanipal (lion-hunts) from Nineveh

ROOM 19
Nimrud Gallery Sculptures from the palace of Ashurnasirpal at Nimrud

ROOM 20
Nimrud Central Saloon Sculptures from the palace of Tiglath-pileser at Nimrud; Black Obelisk

ROOM 21
Nineveh Gallery Sculptures from the palace of Sennacherib at Nineveh

ROOM 24
Ancient Palestine Room Pottery; jewellery; ivories; coins; ossuaries; metalwork; reconstructed tomb

ROOM 26
Assyrian Transept Assyrian gateway figures; stelae; Balawat Gates

ROOMS 51/52
Anatolian and Iranian Rooms Hittite, Urartian, Luristan, Achaemenian, Parthian and Sassanian antiquities

ROOM 53
Hittite Landing Neo-Hittite sculptures from Carchemish

ROOM 54
Prehistoric Room Pottery; architecture; art; adornment; tools and weapons

ROOM 55
Room of Writing Cuneiform texts; early alphabetic inscriptions; seals

ROOM 57
Syrian Room Syrian, Phoenician and Punic antiquities. Limestone stelae; pottery; jewellery; seals; Palmyrene funerary busts; bronzes; reliefs

ROOM 58
Ivory Room Phoenician, Syrian, Assyrian and Urartian carved ivories, mainly from Nimrud

ROOM 59
South Arabian Landing Sculpture, stelae, seals and bronzework from ancient South Arabia

ROOM 65
Babylonian Room Until 1990: Sumerian and Babylonian antiquities, particularly from the 'Royal Tombs' at Ur

ROOM 88a
'Ishtar temple'; Assyrian sculpture

ROOM 89
Assyrian Basement Assyrian sculpture; daily life; history of early excavation of Assyria

GALLERY ALTERATIONS

ROOM 65 Closing late 1990; will reopen as new display 'Egypt in Africa' (see under Egyptian Antiquities)

ROOM 56 Opening December 1990 as the George and Beverly Sackler Gallery of Mesopotamia, including Sumerian, Babylonian and Assyrian antiquities from the Sumerian Early Dynastic Period to the Neo-Babylonian Period

KEY TO THE ILLUSTRATIONS

With the following exceptions, all of the photographs in this book were provided by the Photographic Service of the British Museum:

Lee Boltin 2, 102, 114, 221
Geoffrey House 7
A. L. Pacitto 3

The references given in the list below are to the British Museum accession numbers. The abbreviations to the Museum Departments are:

CM Coins and Medals
EA Egyptian Antiquities
ETH Ethnography
GR Greek and Roman
JA Japanese Antiquities
MLA Medieval and Later Antiquities
OA Oriental Antiquities
PD Prints and Drawings
PRB Prehistoric and Romano-British Antiquities
WA Western Asiatic Antiquities

Half-title page MLA 1980,3–7,118
Title page GR 1945.9–27.1
Back cover MLA 1980,5–19,1

2. MLA 1756,6–19,1 (photo Lee Boltin)
5. PD 1982.3–27.4
9. GR 1805.7–3.337
10. GR 1971.5–21.1
11. GR 1982.5–20.8
12. GR 1897.4–1.1150
13. GR 1971.11–1.1
14. GR 1843.11–3.31
15. GR 1863.7–28.312; 1874.11–10.1; 1873.8–20.303
16. GR 1892.7–21.1
17. GR 1958.4–18.1
18. GR 1816.6–10.11
19. GR 1816.6–10.97
20. GR 1805.7–3.183
21. GR 1815.10–20.18
22. GR 1859.11–26.26
23. GR 1872.6–4.815; 1867.5–8.537; 1914.10–16.1
24. GR 1874.3–5.69
25. GR 1897.4–1.996
26. GR 1910.6–20.1
27. GR 1920.12–20.1
28. GR 1848.10–20.34, etc.
29. GR 1847.4–24.270 & 269
30. GR 1904.7–3.1
31. GR 1890.2–10.1
32. GR 1872.6–4.667
33. GR 1850.2–27.1
34. GR 1824.4–97.1
35. GR 1888.11–10.1
36. GR 1887.4–2.1
37. GR 1875.3–13.30
38. GR 1867.5–7.484
39. GR 1866.8–6.1
40. GR 1907.5–18.8–10
41. GR 1872.6–4.670; 1814.7–4.1203; 1903.7–17.3
42. GR 1851.8–13.175
43. GR 1824.4–24.1
44. GR 1869.2–5.4; 1972.9–27.1; 1867.5–8.686; 1868.5–1.257
45. GR 1859.4–2.102
46. CM 1957.10–10.1–34; 1965.12–2.1–3
47. CM 1873.7–2.9; 1846.6–30.11; 1982.7–35.3
48. CM 1978.10–21.1
49. CM 1987.6–49.303; 1887.6–9.1; 1969.6–8.1
50. CM BMC 1; BMC 1; BMC 9
51. CM 1867.1–1.31
52. CM 1959.7–4.1
53. CM 1964.12–3.235
54. CM 1919.2–13.318; 1919.2–13.338
55. CM BMC 65; De Salis Coll.; 1924.6–3.15
56. CM 1913.12–13.1; Bank Collection M1
57. CM 1857.9–1.8; 1838.7–10.285; 1935.11–17.476; BMC 19; E2203
58. CM 1909.10–6.48; 1915.5–7.599
59. CM 1885.4–5.36; 1915.5–7.469
60. CM 1956.4–8.1; 1935.4–1.2021
61. CM 1855.3–21.15; S. S. Banks, pp. 132–60; 1988.1–30.1
62. CM 1983. 8–17.2; 1897.12–7.4; 1976.9–16.40; 1979.3–2.12; 1921.10–18.3; CH 0150
63. CM 1894.5–7.4; BMC 1; BMC 52; 1918.6–3.2; BMC 23; 1844.4–25.49
64. CM BMC 27; 1874.7–6.1; 1974.9–16.341; 1865.8–4.40; 1875.5–1.20; CH 0420; BMC 36
65. CM 1844.4–25.24; M6903; George III, English Medals 67; M7357; M7364; George III, English Medals 15
66. CM 1979.5–17.71; 1920.2–33.71; 1982.5–3.2; 1976.4–5.1
67. CM George III, Naples 9
68. CM 1981.11–22.258
69. CM 1984.6–5.1711
70. EA 37977
71. EA 20790
72. EA 37996
73. EA 1239
74. EA 684–6
75. EA 569, 570
76. EA 986
77. EA 19
78. EA 36
79. EA 2
80. EA 55253
81. EA 64391, 37348
82. EA 1242
83. EA 5601
84. EA 37993
85. EA From a copy by Nina de Garis Davies
86. EA 24
87. EA 117
88. EA 1848
89. EA 9901/3
90. EA 5624
91. EA 32751
92. EA 6665

93. EA 22542
94. EA 13595
95. EA 64659 (top left); 23092 (top right); 54412 (centre); 20639 (bottom left); 12235 (bottom right)
96. EA 41548
97. EA 52947
98. EA 2469 (table); 2472 (stool); 2480 (chair); 26227 (cup); 41578 (sandals); 59775 (jar)
99. EA 42515
100. EA (back row) 32531, 29923, 35297, 36347; (centre) 4716 (bowl), 43034 (jug), 36358, 26242, 26971, 35074, 22823; (front) 4735 (vase), 56843, 35306, 24416
101. EA (back row) 57385, 4790, 26226; (front row) 12968, 65802, 7865
102. EA 55193 (photo Lee Boltin)
103. EA 54460; 59194; 57699–700; 57698; 7876
104. EA (back row, left to right) 21895, 12753, 37234, 2598; (centre to foreground) 5946, 5965, 2662, 37187
105. EA 43049
106. EA 679
107. ETH 98.1–15.44
108. ETH 1979.Am8.7
109. ETH 1976.Am3.28
110. ETH Q72.Am17
111. ETH 1976.Am3.79
112. ETH 1929.7–12.1
113. ETH
114. ETH 1894–634 (photo Lee Boltin)
115. ETH 1940.Am11.2
116. ETH 7204
117. ETH 78.11–1.48a,b,c
118. ETH Q74.Af2925
119. ETH 1909.12–10.1
120. ETH 1979.Af1.2397
121. ETH 1925.11–23.35
122. ETH 1901.11–13.51
123. ETH 1934.3–7.198
124. ETH 1937.2–20.3
125. ETH 1968.As4.31
126. ETH 1965.As7.10
127. ETH 1981.As2.4
128. ETH 1971.Eu1.260
129. ETH 1973.As7.3
130. ETH 5068
131. ETH 1986.As9.29
132. ETH 1859.12–28.448

133. ETH 98.7–3.134
134. ETH 1905–818
135. ETH HAW 133
136. ETH TAH 78
137. ETH IMS 19
138. ETH 1900.7–21.1
139. ETH Q72.Oc.95
140. ETH 1927–113
141. ETH 1954.Oc6.158
142. ETH 1906.10–13.5
143. ETH 1987.Oc4.7
144. MLA 1939,10–10,4–5
145. MLA 66,12–29,1
146. MLA 63,7–27,11; 98,7–19,1
147. MLA 1921,11–1,221; 91,10–19,24; 1978,5–3,1; 65,3–18,1
148. MLA 1922, 6–1, 244
149. MLA 1952,4–4,1
150. MLA 1870,8–11,1
151. MLA 69,3–1,1
152. MLA 61,10–24,1
153. MLA OA4312
154. MLA 1986,7–8,1
155. MLA 1926,4–9,1
156. MLA 78–159 (complete set)
157. MLA 50,11–27,1
158. MLA 56,7–18,1
159. MLA 92,5–1,1
160. MLA 53,3–15,1
161. MLA Af 2768–70
162. MLA 1922,12–2,4
163. MLA Waddesdon cat. 125, 115, 111
164. MLA 1969,7–5,11
165. MLA 1986,4–3,1
166. MLA 80,3–10,1
167. MLA G619
168. MLA Pottery cat. D49
169. MLA Pottery cat. I 712
170. MLA Porcelain cat. II 28
171. MLA 78,12–30,660
172. MLA 1948,12–3,69 & 70
173. MLA Slade cat. 361
174. MLA 1823,1–1,1
175. MLA Dalton no. 181; HG 898 (left); HG 877 (right); HG 952 (centre); HG 940 (bottom)
176. MLA HG 983
177. MLA 1979,11–2,1
178. MLA 1982,7–2,1
179. MLA CAI–2316; CAI–2381
180. MLA 57,11–16,1
181. OA 91.6–23.5
182. OA 1936.11–18.1
183. OA 1903.4–8.1

184. OA 1919.1–1.014
185. OA 1913.11–12.1
186. OA 1936.10–12.206
187. OA 1975.10–28.19
188. OA 1885.12–28.79
189. OA 1963.5–20.03
190. OA 1983.12–12.1
191. OA 1966.12–21.1
192. OA 1880–482; 1880–615; 1879.12–1.9, 31; 1882.10–9.9; 1880–459
193. OA 1900.2–9.1
194. OA 1880.6
195. OA 1955.10–8.069
196. OA 1949.11–12.01
197. OA 1987.3–14.1
198. OA 1830.6–12.4
199. OA 1971.7–27.1
200. OA 1958.12–18.1
201. OA 1967.12–11.1
202. OA 1950.7–25.1
203. OA 1948.12–11.023
204. OA 1855.7–9.1
205. OA 1983.66
206. OA 1925.9–29.01
207. OA 1830.6–12.1
208. JA F2228
209. JA 1885.12–27.98
210. JA 1974.5–13.13
211. JA HG 700
212. JA 1920.7–13.1
213. JA 1984.7–23.1
214. JA 1974.2–26.81
215. JA F498A
216. JA 1987.10–14.04
217. JA 1906.12–20.220
218. PRB 1951.4–2.2
219. PRB SL24
220. PRB P1964.12–6.1059
221. PRB Peccadeau 550 (photo Lee Boltin)
222. PRB Peccadeau 551
223. PRB 1953.2–8.1; P1976.12–1 & 2
224. PRB 1921.3–15.1
225. PRB 1901.2–6.1
226. PRB 1939.7–4.1
227. PRB WG 2126–9
228. PRB P1981.3–1.1; 1879.12–9.700; 1879.12–9.1201; 1862.7–7.5; 1915.12–8.206
229. PRB On loan from His Majesty King Edward VIII
230. PRB 1893.12–28.15–17
231. PRB 1873.2–10.1
232. PRB 45.1–22.1

233. PRB 1836.9–2.1
234. PRB 1838.1–28.1
235. PRB 1929.5–11.1
236. PRB 1967.2–2.42–65
237. PRB 1886.11–12.3–5
238. PRB 1953.4–2,1; P1976.5–1
239. PRB 1857.7–15.1
240. PRB P1987.4–4
241. PRB 1924.1–9.1
242. PRB 1892.9–1 (Hod Hill);
 1883.4–7.1 (Fulham)
243. PRB P1984.10–2.1
244. PRB 1852.8–6.2; 1935.7–12.1
245. PRB 1891.11–17.1
246. PRB P1980.3–3.28
247. PRB P1983.11–3
248. PRB 1870.2–24.3
249. PRB 1848.11–3.1
250. PRB POA 201
251. PRB P1975.10–2
252. PRB 1946.10–7.1
253. PRB 1965.4–9.1
254. PRB P1981.2–1.1
255. PD 1981.12–12.17
256. PD PG 37
257. PD 1887.5–2.116
258. PD 1895.9–15.447
259. PD 1908.6–16.45
260. PD 1986.7–26.32
261. PD 1895.9–15.975
262. PD 1910.2–12.105
263. PD 1982.3–27.5
264. PD 1952.4–5.9
265. PD 1824, Oo.9–50
266. PD 1973.U.1344
267. PD 1895.9–15.1279
268. PD 1962.7–14.1(4)
269. PD 1957.12–14.168
270. PD 1895.9–15.941
271. PD 1981.2–21.1
272. PD 1979.12–15.17
273. PD 1862.7–12.187
274. PD 1882.8–12.224
275. PD 1910.2–12.250
276. PD 1910.2–12.272
277. PD 1987.4–11.4
278. PD 1988. 3–5.7
279. PD 1983.4–16.4
280. PD 1988.10–1.44
281. PD 1972.U.1047
282. PD 1868.6–12.1
283. PD 1984.6–9.7
284. PD 1936.11–16.31
285. PD 1860.7–14.41
286. PD 1854.6–28.73
287. PD V8–182

288. PD 1848.7–21.41
289. PD 1979.7–21.67
290. PD 1868.8–22.2113
291. PD 1949.4–16.3600
292. PD 1983.7–23.24
293. PD 1981.7–25.14
294. WA 130762–4; 130767
295. WA 117007; 117119
296. WA 125381
297. WA 126251; 126445; 126448
298. WA 127414
299. WA 116730
300. WA K3375
301. WA 122216
302. WA 120000
303. WA 121201
304. WA 122200
305. WA 91435; 91440; 91442;
 118572; 128487; 128493
306. WA 139738–9
307. WA Jericho tomb P19
308. WA 125091
309. WA 135851
310. WA 126389
311. WA 132915
312. WA 118158
313. WA 135781
314. WA 124864
315. WA 118885
316. WA 124906
317. WA 90859
318. WA 91253
319. WA 129378
320. WA 132525
321. WA 124081
322. WA 124017
323. WA 123908
324. WA 123894
325. WA 125019
326. WA 126395
327. WA 124091
328. WA 135738; 135158
329. WA 124094
330. WA 134693
332. PRB 1960.4–5.906
334. GR 1869.6–15.1
335. OA + 0323
339. GR 1939.10–10.95
340. MLA 1868.6–6.7
341. GR 1904.2–4.1249
343. MLA 1901,4–27,3; 1896–2–1, 79
344. ETH 1946. Am16.7

INDEX

The numbers in italic type refer to illustrations